Swiss Painting

Swiss Painting

*From the Middle Ages
to the Dawn of the Twentieth Century*

FLORENS DEUCHLER

MARCEL ROETHLISBERGER

HANS LÜTHY

RIZZOLI
NEW YORK

Published in the United States of America in 1976 by:

RIZZOLI INTERNATIONAL PUBLICATIONS, INC.
712 Fifth Avenue/New York 10019

© 1976 by Editions d'Art Albert Skira, Geneva

English translation by James Emmons

Reproduction rights reserved by Cosmopress, Geneva

Library of Congress Catalog Card Number: 76-15491
ISBN: 0-8478-0056-3

PRINTED IN SWITZERLAND

Switzerland is a country of three cultures, cemented politically by a federalist structure. The geography and political development of the country never favored the rise of major art centers of unchallenged authority, like those of the royal and princely courts which in neighboring France and Italy offered artists a privileged place of inspiration and production.

But from the peculiar nature and circumstances of their country Swiss artists have never ceased to draw an inspiration of their own, stimulated and enriched by frequent contacts with foreign art. Here then are the two sources on which Swiss painting steadily drew down to the nineteenth century, and which it combined in endlessly different ways: on the one hand, the great movements and personalities of European art; on the other, the powerful, at times uncouth, and all too often underrated strains of a native tradition rich in talents and original forms.

It was on the strength of that native tradition, gradually shaped and directed as the cantons joined together and grew in number and cohesion, that Switzerland was able to defend and preserve its democratic way of life and its ideal of liberty.

After tracing the course of Swiss painting from the Early Middle Ages through the intervening centuries, this survey ends at the dawn of the twentieth century with the mature works of Ferdinand Hodler, which are very much in the spirit of the early 1900s. With the last canvases of this powerfully gifted painter, whose career spans the late nineteenth and early twentieth centuries, art entered a new age—our own—in which the personality of the artist came to prevail over the specific characteristics of a given country. At that point the great national schools of painting came to an end, and in Switzerland, as in other countries, there began an entirely new period, no less rich in creative achievements, which cannot be dealt with here, for it would require a whole volume of its own.

* * *

We take pleasure in thanking the private collectors and museum curators who have so generously placed at our disposal the works in their keeping; and we would also like to thank the members of the Schweizerisches Institut für Kunstwissenschaft in Zurich for their unfailing courtesy and assistance. Without the cooperation of them all, this book could never have been made.

Contents

FROM THE BAROQUE ERA TO THE AGE OF ENLIGHTENMENT 89

By Marcel Roethlisberger

THE SENSE OF A COMMON HERITAGE FROM THE LATE EIGHTEENTH
TO THE EARLY TWENTIETH CENTURY 129

By Hans Lüthy

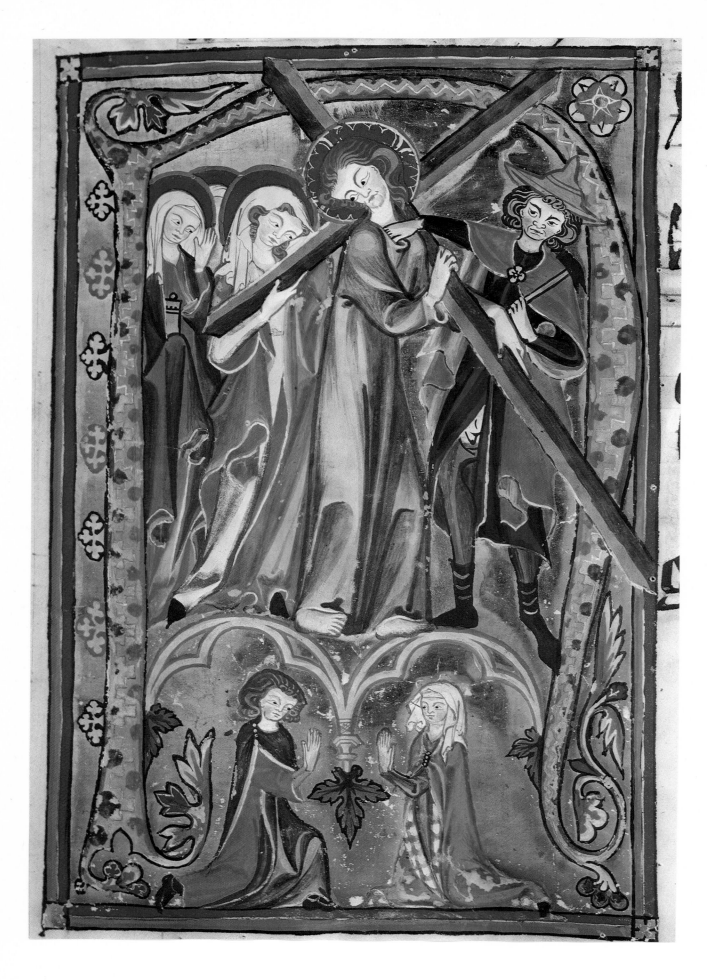

Bearing of the Cross. 1312
Miniature in the Gradual of
Saint Katharinenthal, folio 90 recto
Landesmuseum, Zurich

Swiss Art or Art in Switzerland?

The Beginnings
of Painting

This survey of paintings produced within the frontiers of present-day Switzerland raises the question: do these works exemplify a genuinely Swiss art or would it be more accurate to call them the products of art in Switzerland?

The problem arises at once with the *Bearing of the Cross* in the Gradual of Saint Katharinenthal. This fine manuscript was written and illuminated in 1312 for the Dominican convent of Saint Katharinenthal, near Diessenhofen in the present canton of Thurgau, a region which only became part of the Swiss Confederation some one hundred and fifty years later.

The 314 pages of this manuscript contain 46 full-page illustrations and 25 illuminated initials with scenes from the lives of the two saints John and Christ, together with figures of the Apostles and the patron saints of altars in the convent church.

In many of the ornamental initials there are pictures of the donors, all of them nuns, churchmen, and especially nobles of the region around Lake Constance. This manuscript is, in fact, an ambitious and distinguished work. It bears the stamp of late medieval court art and accordingly produces an "un-Swiss" effect. In spite of the small size of the paintings, the style is broad, flowing, and elegant. It reveals the impact of the refined forms of French court art on the native Germanic idiom of Constance and the neighboring region.

Constance was the focal point of an art region which, on the one hand, extended far into South Germany and, on the other, conditioned or influenced many works created in what is now northern Switzerland. Such, for example, are the stained-glass windows in the church of Kappel am Albis (Zurich), commissioned by the Austrian nobles who then ruled this part of Switzerland.

Art regions in the Middle Ages took form irrespective of political frontiers. They extended around the great creative centers, such as Constance, Strasbourg, Dijon, and Milan, or roughly coincided with the territory of the diocese. Switzerland itself has never formed an ecclesiastical unit. Thus the Gradual of Saint Katharinenthal does not reflect anything

that can be called a "Swiss element." It is a characteristic product of the art region centering on Constance in the fourteenth century and may be taken here as summing up medieval painting as a whole. It shows clearly why, in the Middle Ages, there was not and could not be a "Swiss" art, but only local offshoots, some of them highly significant, of the prevailing tendencies which took effect in what is now Switzerland and gave rise to various forms which could be described as an "art of the Swiss plateau" or "Alpine art."

The movement then of art styles and iconographical formulas followed quite different laws than in earlier times, when the country had been systematically colonized by the Romans. Many important mosaics testify to their presence on Swiss soil: those of Münsingen, Herzogenbuchsee, Orbe, Nyon, Cormerod, and Avenches, to mention only the best known. Such works as these do not have any specific local character; they could have originated anywhere within the Roman Empire. Not so the great medieval works, like the frescoes of Müstair, the ceiling panels of Zillis, or the stained-glass windows of Königsfelden; they have a distinctly local character and could not have taken the form they did anywhere else.

Standing in the heart of Europe and often likened to a mighty heap of stones, Switzerland is a watershed region where important rivers rise; and since the earliest times it has been a crossroads of important trade routes. Geographically and ethnically, it is divided into three distinct cultural areas which extend far beyond the present frontiers of the country. In the south, the Italian-speaking canton of Ticino is, culturally, a part of Lombardy. In the north, the German-speaking cantons extending to the Rhine are oriented toward South Germany and Alsace. French-speaking Switzerland faces westward toward the Rhone Valley and Burgundy. Even in the eastern part of the country, where main waterways and overland routes are lacking, the presence of Austria makes itself felt.

The decisive step toward the creation of Switzerland as we know it today was taken in the Middle Ages with the pact of 1291 between Uri, Schwyz, and Unterwald, the so-called Waldstätten or Forest Cantons. And it was not until the battle of Morgarten in 1315 that the three Forest Cantons proved themselves a power to be reckoned with in the Europe of that day. Even the Confederation of 1513, loosely uniting thirteen cantons, was much smaller than present-day Switzerland. For a long time the essentially rural Confederation comprised few towns of any size or importance: Lucerne from 1332, Zurich from 1351, Bern from 1353. In 1460 the Swiss seized Thurgau from Austria, which recognized its new western neighbors only in 1474, on the eve of the Burgundian wars. The towns of Basel and Schaffhausen entered the Confederation in 1501; Geneva, Valais, and Neuchâtel only in 1815.

The first serious challenge to the political and cultural cohesion of the Swiss Confederation came in the sixteenth century with the Reformation, which divided the thirteen cantons into two opposing factions. In 1526 the forest and mountain cantons of central Switzerland rejected the Protestant Reformation, clinging to the old faith of the Roman Church. Zurich, Bern, Basel, and Schaffhausen accepted it. Out of the thirteen cantons that regularly attended the confederate Diets, these four wholeheartedly embraced the Reformation. six opposed it resolutely (Lucerne, Zug, Fribourg, Schwyz, Uri, and Unterwald), and three were hesitant or divided (Glarus, Appenzell, and Solothurn) and acted as mediators between the two opposing parties.

This division had momentous consequences for the future of the arts and intellectual life, for in cultural terms it produced a breakdown of the Confederation into a cluster of small, individual units.

If the first works of painting in Switzerland are to be placed in the right historical perspective, it is necessary to go back to the Early Middle Ages. In the seventh and eighth centuries the lands between the Lake of Geneva and Lake Constance formed part of the Kingdom of the Franks, then of the Carolingian Empire. After the Treaty of Verdun (843), the region between the Jura and the Alps was divided between the Kingdom of Lothair and the Kingdom of Louis the German. Around the year 1000 the Swiss plateau and the Alpine regions were ruled in the north by the Duke of Swabia, in the west by the Kingdom of Burgundy, and in the south by the Kingdom of Lombardy. The linguistic division so characteristic of modern Switzerland was already taking shape.

Three art regions prevailed successively, each exerting a strong and enduring influence on Switzerland: Lombardy from the time of the Longobards, acting on the southern confines by way of the Alpine passes; Burgundy and Alsace from the Early Middle Ages; Alsace again and the Lake Constance region chiefly in the fourteenth century (the border country of Lake Constance acted as a connecting link rather than a dividing line). These last two regions decisively influenced the evolution of the arts in German Switzerland.

Medieval Constance, an imperial free town and the seat of a bishopric, was an active and stimulating center, with a distinctive art of its own quite different from anything to be found in Alsace or Swabia. Judging by the extant works, the art of Constance enjoyed its finest flowering around and shortly after 1310, and in spite of a perceptible falling off some two decades later, it made its influence powerfully felt in Zurich. Witness the stained-glass windows at Kappel am Albis (soon after 1310) and Frauenfeld-Oberkirch (c. 1320): both in the vicinity of Zurich, they derive from the art of Constance. Pervasive elements of this art are even to be found in one of the unquestioned masterpieces of this century, the stained-glass windows in the choir of the abbey church of Königsfelden (1325-1330), in spite of the very different backgrounds from which they spring. The illuminated Gradual of Saint Katharinenthal belongs to this same art current.

The impact of Alsace, also discernible at Königsfelden, steadily gained in strength toward 1400. The stained-glass windows at Zofingen, Münchenbuchsee, and Staufberg derive from the art of the Upper Rhine, centering in Strasbourg and Colmar and reaching out along the Rhine southward into the valley of the Aare. After about the middle of the century, many artists took inspiration either from Ulm or from Dijon.

In connection with the social background of Swiss art, it must be remembered that the country never had any of those princely courts which so stimulated art elsewhere. The rulers of the Swiss lands before the formation of the Confederation were notable rather as founders and builders of towns. The most active of the great nobles in this respect were the Dukes of Zähringen, who founded Fribourg, Morat, and Bern in the twelfth century, and the Dukes of Savoy in southwestern Switzerland. The patronage of art on a princely scale, as in late medieval Dijon, Milan, and Innsbruck, was almost wholly lacking in Switzerland. The fine works commissioned in Zurich by the Manesse family or later by Hans Waldmann, the latter with the lavishness of a Renaissance patron, are the great exceptions that prove the rule.

From the beginning of the sixteenth century, Switzerland began to grow steadily richer. A magnificent booty fell into the hands of the doughty Swiss warriors who defeated Charles the Bold of Burgundy at Grandson and Morat (1476), and Swiss mercenaries in the service of foreign princes brought home a steady flow of money. Social and economic changes were thereby set in motion which were to have far-reaching effects. A luxurious style of life came within the reach of some, and social distinctions became more marked.

In the absence of princely courts, art patronage lay in the hands of the municipal authorities and the guilds. Among the most notable works commissioned by them are the secular and heraldic stained-glass windows (*Standesscheiben* and *Wappenscheiben*), a peculiarly Swiss art form; also the guild halls and the richly decorated family chapels fitted up in old churches. In regard to the latter, it must be acknowledged that finer, more splendid examples are to be found in South Germany. North of the Rhine, the financial resources of an even more affluent bourgeoisie were such that they could commission works on a scale even rivaling that of the nobility.

Taste and style in such works remained, in Switzerland, very much that of a class of burghers, not nobles, and construction and decoration were undertaken with deliberate restraint. Once it was decided to carry out a work of uncommon scope or importance—which almost inevitably meant adapting a foreign model—due care was taken to do nothing hastily or in too "modern" a style. This abiding attitude or mentality, already characteristically Swiss, meant that the resulting style is always more conservative or *retardataire* than that of comparable works in neighboring lands. This is already noticeable in so early a work as the ceiling panels at Zillis, possibly even in the Müstair frescoes, though here one cannot be sure, for the sources and parallels no longer exist.

Bern Minster, a purely Gothic church, though only begun in 1421, and the Town Hall of Zurich, a Renaissance building begun as late as 1694, are further examples of this caution and prudence, this backward-looking attachment to well-established values. The reasons for this traditionalism are not hard to find. The Bernese of the fifteenth century were no more aware of the existence of Brunelleschi than the burghers of seventeenth-century Zurich were of the Baroque palaces of Vienna.

In the Middle Ages a genuinely autonomous art was created only in the scriptoria of the great abbeys. It is true that Einsiedeln, at least at first, followed in the steps of Reichenau, so that only within well-defined limits can one speak of a "school of Einsiedeln." Engelberg broke away sooner and more sharply from the tradition which it had taken over from its mother house at Sankt Blasien in the Black Forest and proceeded to create a style of its own, easily distinguishable from those of some more famous centers of book illumination. Only in the illuminated manuscripts of such great abbeys can the historian of medieval Swiss art study a style or a trend developing over a certain period of time. In the case of monumental painting, like the Müstair frescoes, he is confronted by isolated works, erratic fragments which here and there have survived the ravages of time. From such disconnected survivals it is difficult to trace any reliable line of evolution. Here the margin of error is too great for it to be possible to give any conclusive answer to the question about Swiss art which was raised at the beginning of this chapter.

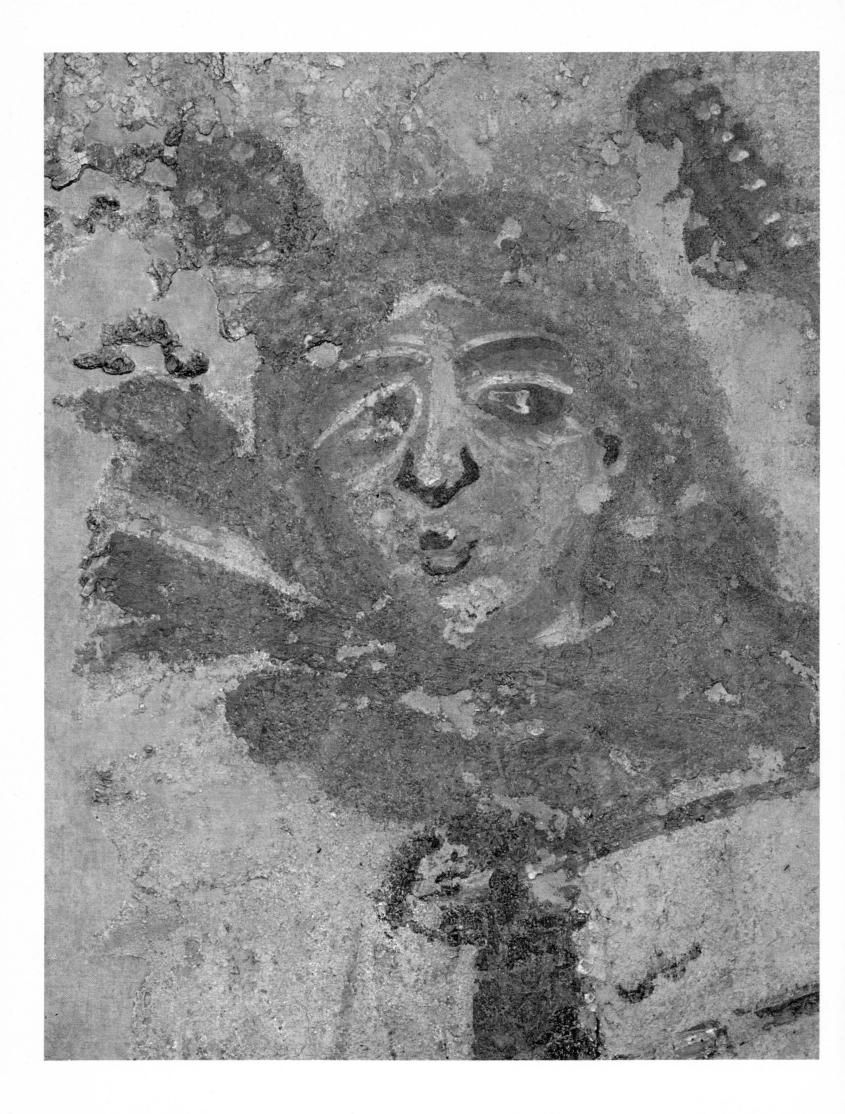

Fresco Painting from the Ninth to the Fourteenth Century

Müstair

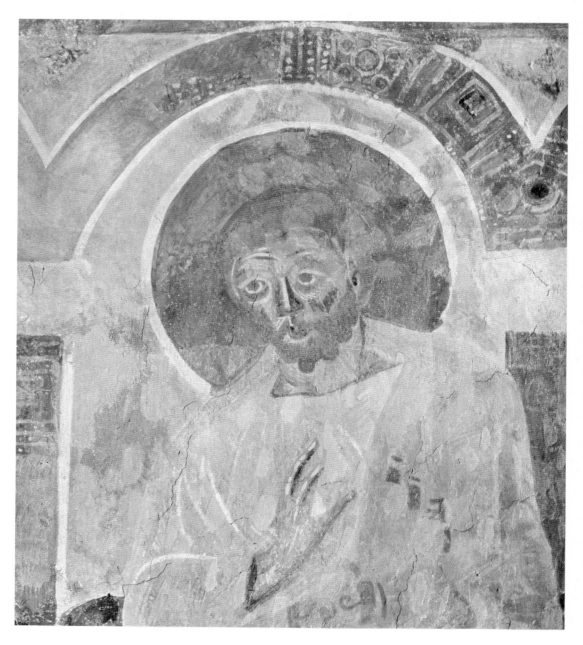

Standing in the mountains of eastern Switzerland (Grisons), the abbey of Saint John at Müstair *(monasterium)* is said to have been founded by Charlemagne shortly after 774 for strategic and political reasons. The abbey is first mentioned in the year 805. On grounds of style and technique, the wall paintings in the abbey church can be dated to about that time, when Müstair, then a place of some importance on the Alpine road into Italy, enjoyed a certain prosperity.

Carolingian churches were, as a rule, entirely painted in the interior, and the Müstair frescoes, with their eighty-two scenes dating from the ninth century, are the largest surviving narrative cycle of that period. The life of Christ, from the Annunciation to the Ascension, is depicted in the nave on four registers. Many of the scenes are wholly or partially obliterated. Originally sixteen of them were devoted to the story of the Savior's youth, twenty-two to his teaching and miracles, and ten to the Passion. The lower part, preserved only in scattered fragments, must have consisted of scenes subsequent to the Resurrection and the legends of the Apostles. Following an ancient custom, this zone also included a decoration of marble slabs and Greek key patterns painted in illusionistic perspective.

This extensive Gospel cycle in the nave was brought to a close on the west wall with a Last Judgment, the first monumental representation of this subject in the West. The apse frescoes date from 1165 to 1180 and take over some of the themes of the Carolingian decoration.

Müstair (Grisons),
Church of Saint John

Figure of an Apostle. c. 800
Fresco

◁ *Detail of a fresco.* c. 800
Landesmuseum, Zurich

17

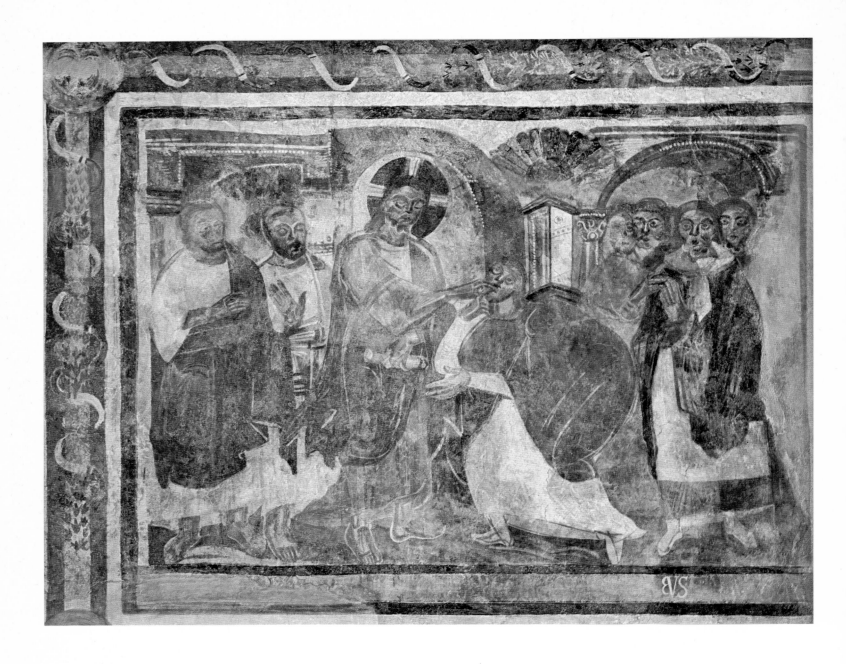

Müstair (Grisons),
Church of Saint John

*Christ Healing the Deaf and
Dumb Man*. c. 800. Fresco

Strangely enough, the Müstair frescoes fail to reveal any connection with contemporary miniature painting. Their style lends itself at most to an inconclusive comparison with the Godescalc Gospel Book (781-783). For here again, as so often in medieval art, we are dealing with isolated works of different dates which have survived by chance in widely different places.

This situation confronts us at the outset in Carolingian art and continues down to the beginning of the Renaissance. It is a pity that the heritage of medieval art in Switzerland is so meager. No convincing parallels can be drawn with any known models of Late Antique or Early Christian art, whose influence, nevertheless, can be felt at Müstair. It may be assumed that the Müstair frescoes had some connection with those at San Vincenzo al Volturno in South Italy (Abruzzi) and with the abbeys of Reichenau and Saint Gall; but there is no proof.

In studying the Müstair frescoes, it must not be forgotten that the uppermost layer of paint and the delicate modeling are all but worn away, so that the scenes often appear coarsely painted and devoid of relief. In many places the lights and shadows are seen to be superimposed or juxtaposed over a uniform ground. This technique goes back to late antiquity; it was taken over by Byzantine painting, which in turn influenced the technique of Western painting not only in France and Italy but also in the Germanic empire.

Negrentino

San Carlo in Negrentino, the parish church of Prugiasco (Ticino), a remote village in the upper reaches of Val Blenio, appears to date from the eleventh century. The frescoes on the inner west wall of the original nave were undoubtedly painted between 1050 and 1100.

The subject is unusual: Christ in Majesty, standing, aureoled with a cross-marked nimbus and holding in an antiquizing pose the *arma Christi*: the spear, the reed with the sponge soaked in vinegar, and the crown of thorns. On either side, Peter and Paul approach the haloed Christ, each followed by Apostles whose names are inscribed over their heads; the group on the right behind Saint Paul has been almost wholly destroyed by humidity.

The iconography of this composition is similar to that of Syrian works representing the Ascension of Christ, and this is almost certainly the real subject of the San Carlo fresco. A frieze of Greek key patterns runs overhead, just below the timber roof, and on either side of the large aureole is a rectangular panel with the Lamb of God.

Unlike those of Müstair, the frescoes of San Carlo in Negrentino are one of a well-known series of interrelated works in the Lombard-Milanese style; other examples are to be found in Lombardy at Galliano near Cantù (c. 1006) and at San Pietro sopra Civate (probably c. 1095). Together with the wall paintings of San Clemente in Rome and Berzé-la-Ville and Saint-Savin in France, Negrentino numbers among the significant works of pre-Romanesque painting, even though it is on a smaller scale than some of the other great cycles of early medieval wall painting.

Negrentino (Ticino),
Church of San Carlo

Christ and the Apostles
Second half of the 11th century
Fresco

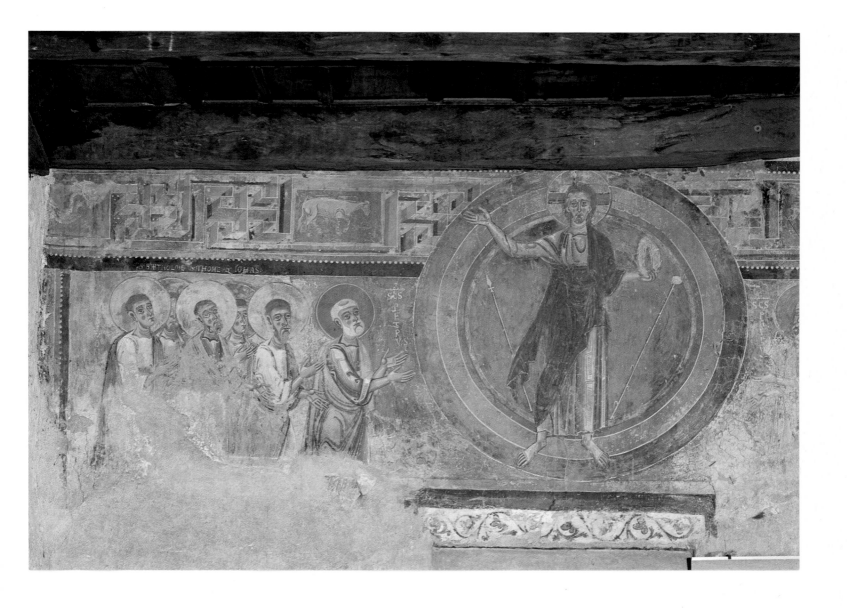

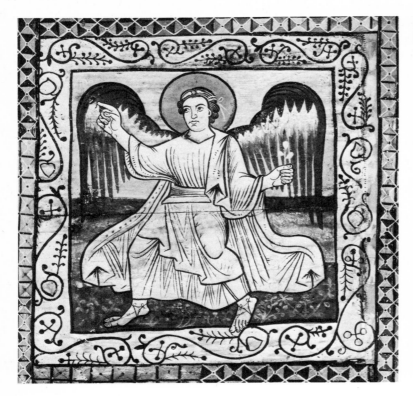

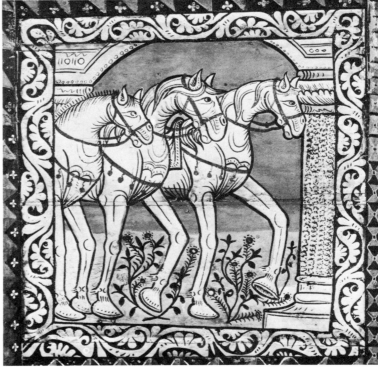

From Zillis
to Waltensburg

Zillis (Grisons),
Church of Saint Martin

Angel. 12th century
Panel painting

The Horses of the Three Magi
12th century. Panel painting

Master of Waltensburg
Scenes from the Passion of Christ
c. 1350. Fresco
Parish Church, Waltensburg (Grisons) ▷

The church of Saint Martin at Zillis (Grisons) is world famous for its painted ceiling: 140 panels are preserved, the last few having been brought to light in 1940.

The main theme of this large cycle of panel paintings is the life of Christ, to which are added some scenes from the legend of Saint Martin. The panels at each end of the ceiling represent the four winds as personified by angels. Between them extends a zone of sea, an image of chaos and the realms which are not governed by the Christian order. Legendary figures, mermaids, sea monsters, music-making nereids, and fish-tailed rams and geese symbolize this chaotic world. The central panels depict the life and sufferings of Christ, beginning with pictures of his ancestors, David, Solomon, and Rehoboam, while two other panels represent the Synagogue (the old order, now vanquished) and the Church (the new order, now victorious). Then come the Christological scenes, opening with the Annunciation and closing with Christ Crowned with Thorns. Surprisingly enough, the events subsequent to the Passion are absent—the Bearing of the Cross, the Crucifixion, and the Resurrection. This gap suggests that the Zillis cycle has only come down to us in fragmentary form. Possibly the sequence of ceiling panels originally continued into the choir, which no longer exists (the present choir was built by Andreas Bühler in 1509). Yet this seems unlikely owing to the small size of the original choir, whose dimensions are known from excavations.

The question of dating has yet to be finally resolved. All the stylistic evidence for a twelfth-century date is based exclusively on parallels with book illuminations and the Ottonian wall paintings of Reichenau and its environs. But a case can be made for considering the Zillis ceiling as a creation of the second third of the eleventh century. Its dating thus remains an open question. Unlike the Müstair frescoes, which have come down to us as an isolated masterpiece in a remote valley of the Alps, the wall paintings of San Carlo in Negrentino can be paralleled by similar works not very far away in Lombardy. But in neither case can any other paintings be attributed to the artist responsible for them. And the same is true of the ceiling panels at Zillis: it is impossible to place the painter in any wider context, for in spite of the presumable link with Reichenau and Lake Constance it would be going too far to assume that he came from there.

Only from the fourteenth century on is it possible to single out the style of individual artists and trace their development over a certain period. Even though their names remain unknown, certain related works can be grouped together. The best example is that of the Master of Waltensburg, who was active in the Grisons in eastern Switzerland.

The church of Waltensburg has an extensive sequence of wall paintings in the nave, executed about 1350 and rediscovered in 1932. In view of their high quality, the anonymous master has taken his name from this cycle.

The story of the Passion is pictured on the north wall of the nave in a composition in continuous bands. The Bearing of the Cross is treated in a more popular and theatrical style than in the Gradual of Saint Katharinenthal. The courtly elegance of the manuscript of 1312 has given place to narrative formulas. The Gradual focused attention on the tender farewell of mother and son, while the Waltensburg fresco shows the procession toward Golgotha, with Mary and John looking on from the side.

The hand of the Master of Waltensburg can be traced in eleven different places and twelve buildings, notably in the churches of Saint Martin at Ilanz and Saint George at Rhäzuns, both in the Grisons. The decorations in the Rhäzuns church, dating from about 1340 and from the last years of the fourteenth century, have been preserved in their entirety. There the Master of Waltensburg executed the paintings in the choir as well as the cycle relating the legend of Saint George, the scene with Saint George and the dragon on the north wall, the Virgin of Mercy and the donor portrait. His spirited narrative style has close parallels in book illuminations of the period.

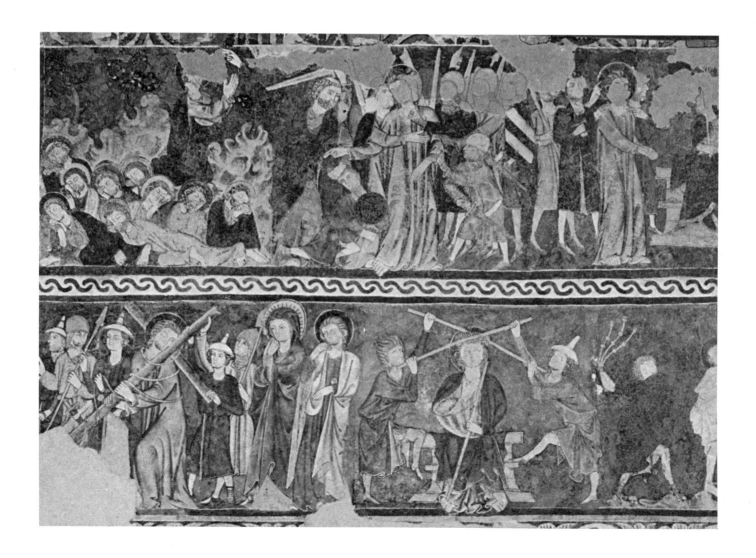

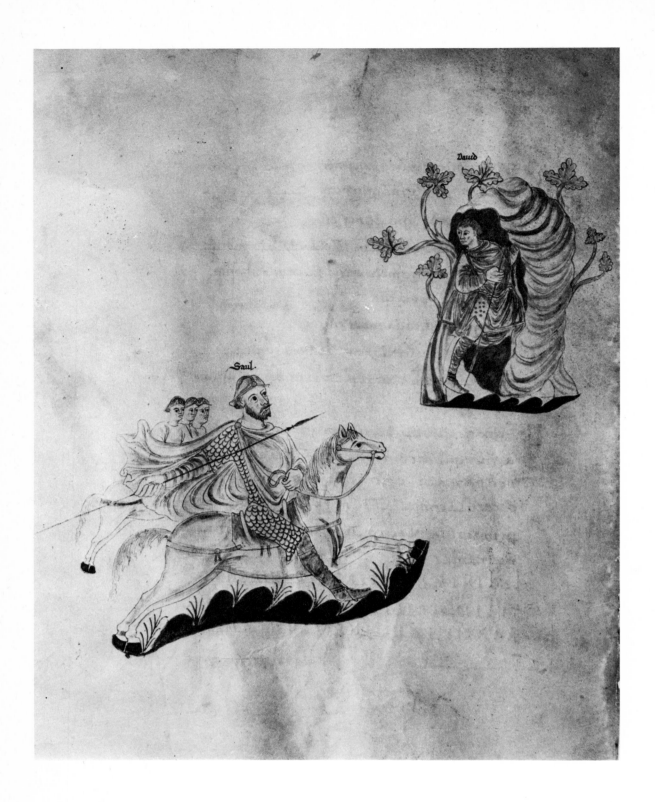

David Pursued by Saul. c. 880-890
Miniature. *Psalterium aureum*,
Codex 22, folio 132 recto
Abbey Library, Saint Gall

Initial Q. c. 870
Miniature, 15 × 11 ½″
Psalter of Folchard,
Codex 23, Psalm 52
Abbey Library, Saint Gall ▷

The foundation of the abbey of Saint Gall in northeastern Switzerland, near Lake Constance, goes back to the Irish monk and missionary Gallus. Parting in 612 from his master, Columban, who founded the abbey of Luxeuil in eastern France, Gallus settled in a hermit's cell in the Steinachtal and there built a chapel.

In 747 the community of monks that had sprung up on that spot, now named in honor of the founder, adopted the Benedictine rule and soon enjoyed a considerable prosperity, thanks to the emperor's support and numerous donations. The fame of the abbey school and scriptorium spread throughout Europe.

After its rather provincial beginnings, Saint Gall achieved a high degree of perfection in the copying and illumination of manuscripts. As early as the period 720-770, the abbey scriptorium employed forty scribes; by 790 there appear to have been as many as sixty, possibly even eighty. The growing staff of scribes and illuminators vouches for the intellectual importance of the abbey.

In the course of more than three centuries from the Irish manuscripts of the mid-eighth to the pre-Romanesque codices of the eleventh century, Saint Gall produced an outstanding series of illuminations whose stylistic evolution can be followed almost step by step.

A fine example is the Psalter of Folchard, illuminated by the monk of that name, active between 864 and 872; he was the greatest book painter of his time. The beautiful ornamental letters are set off by a uniform ground, like the Q

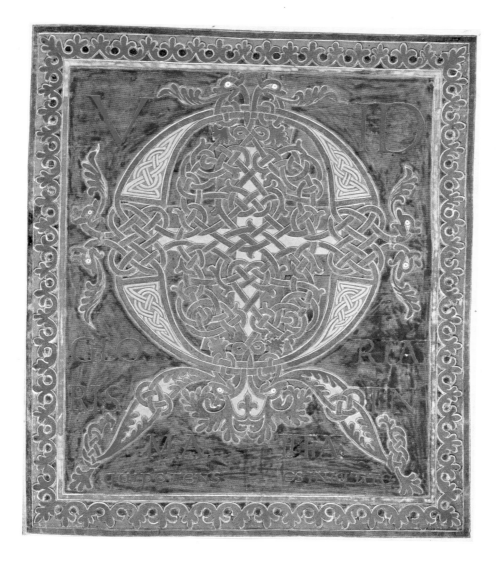

beginning Psalm 52 ("Quid gloriaris in malitia...": Why boastest thou thyself in mischief, O mighty man?), whose crimson background recalls the manuscripts of Late Antiquity, which were often imitated at the Carolingian court.

Saint Gall manuscript illuminations are often based on very early models. Such is the case with the famous *Psalterium aureum* or Golden Psalter. The illuminated page is devoid of margins and sparingly filled, thus setting off the figures and scenes with telling effect. The superlative drawing is matched only by that of the schools of Reims, Tours, Saint-Denis, and Metz.

The *Psalterium aureum* contains sixteen illustrations. The one reproduced on the opposite page shows David hiding from Saul "in the wilderness of Enge-di... where was a cave." Accompanied by three men, Saul gallops toward the cave, placed at the top of the composition to render the effect of distance. The three men symbolize the "three thousand chosen men out of all Israel" (1 Sam. 24:1-3).

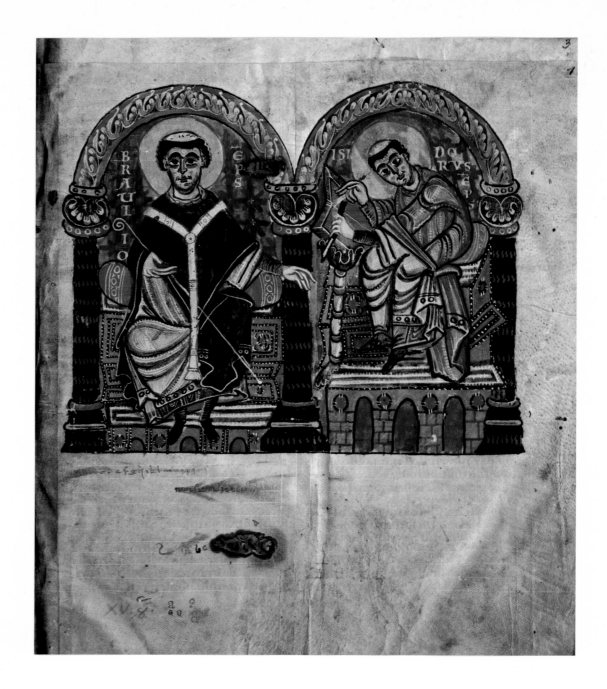

In 861 Saint Meinrad, a monk from Reichenau who had settled as a hermit in the Finstern Wald, the "dark forest" of Schwyz in central Switzerland, was murdered by a band of robbers. But his fame as a holy man drew other monks to his plundered hermitage: in 934 the community adopted the Benedictine rule and in 947 the emperor Otto I confirmed the foundation of the abbey of Einsiedeln. It developed rapidly and enjoyed its first great period of wealth and power from the tenth to the twelfth century. Even today Einsiedeln is one of the most important places of pilgrimage in western Christendom.

Codex 167, containing writings of Isidore of Seville, belongs to an initial group of manuscripts illuminated in the Einsiedeln scriptorium and strongly influenced by the great art center of Reichenau. The high, arching eyebrows of the figures, the stereotyped faces, and the slack shaping of the hands denote a derivative, provincial style. One of the most interesting miniatures represents, side by side, Bishop Braulio of Saragossa, a great bibliophile, and the author of the book, Isidore of Seville (c. 560-636). The writings of this scholar and saint, shown here with pen in hand, were sedulously copied in all the monasteries of the West throughout the Middle Ages and were considered to be infallible.

The Ottonian tradition that marked the early manuscripts illuminated at Einsiedeln was subsequently replaced by the influence of Engelberg.

Einsiedeln
and
Engelberg

◁ *Bishop Braulio and Isidore of Seville*
Second half of the 10th century
Miniature, 13 ⅜ × 11 ½″
Isidore's *Libri originum*, Codex 167
Abbey Library, Einsiedeln (Schwyz)

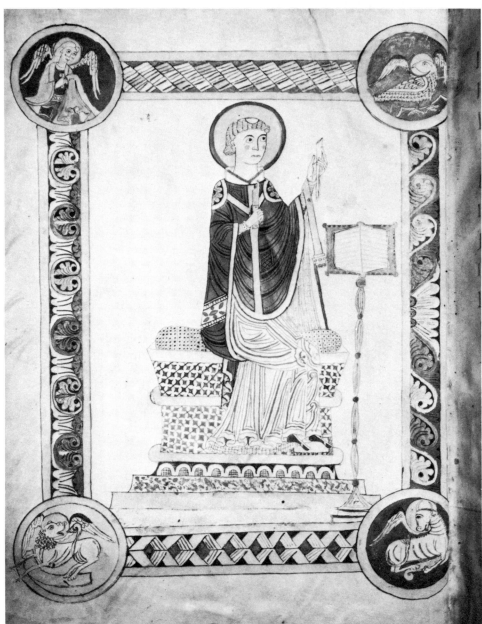

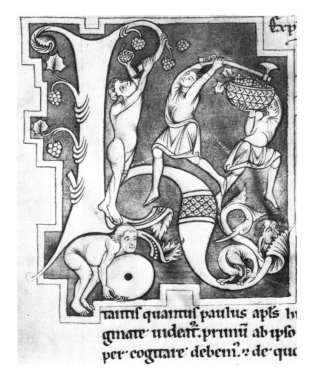

Initial H. 1197-1198
Miniature. Saint Augustine's *De trinitate*,
Codex 14
Abbey Library, Engelberg (Obwalden)

The Venerable Bede Sharpening His Pen
c. 1170. Miniature
Bede's *Omiliae sancti evangelii*
Abbey Library, Engelberg (Obwalden)

The monastery of Engelberg was founded in 1120 by monks from Sankt Blasien in the Black Forest of South Germany. Engelberg was destined to create a great tradition. Its early heyday extends from the twelfth century until it was taken under the protection of the Forest Cantons in 1425.

The leading personality of that period was Abbot Frowin (1143-1178), a monk from Sankt Blasien who settled first at Einsiedeln, then at Engelberg. He was not only the author of scholarly works, but also a skillful scribe and gifted miniaturist. Thirty-five manuscripts from the period of his abbacy are still preserved at Engelberg, in particular Bede's commentary on the Gospel *(Omiliae sancti evangelii venerabilis Bedae)*. One of the illustrations shows Bede seated in front of his writing stand, pausing to sharpen his pen. The Venerable Bede (672-735) is best known for his *Ecclesiastical History of England*, written in 731.

The figure of the saintly scholar, drawn with a deft, if slightly hesitant hand, is framed by four ornamental borders, linked at the corners by medallions with the four Evangelist symbols, the eagle (John), the winged ox (Luke), the winged lion (Mark) and the winged man (Matthew).

This page is one of the finest examples of manuscript drawings, as opposed to paintings, unfortunately very few in number, which have come down to us from the Alpine monasteries of the Middle Ages.

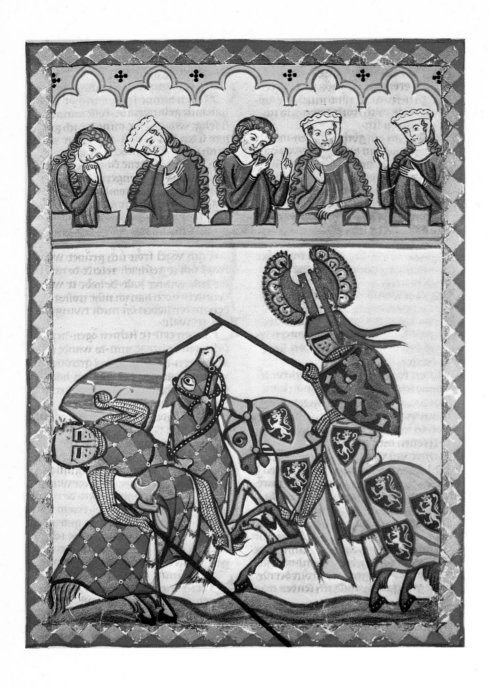

Walter von Klingen in a Tournament
Early 14th century. Miniature
Manesse Manuscript, folio 52 recto
University Library, Heidelberg

King David with Musicians and a Scribe
c. 1350. Miniature, 6½ × 7¾″
Chronicle of Rudolf von Ems, Codex Rh. 15
Zentralbibliothek, Zurich ▷

The unquestioned masterpiece of secular illumination in Switzerland is the Manesse Manuscript of the fourteenth century, which appears to have been written and painted in Zurich. It is a collection of poetry whose opening verse sets the mood of the book: *Ich grüesse mit gesange die süessen* (I greet the sweet ladies with songs). It glorifies the love of women and their virtues. Pictures of hunting, battles, and tournaments alternate with portraits of the authors writing, dictating, or reading their poems and messages of love.

The hands of four different masters can be distinguished in the illustrations of this great manuscript. One of them in particular, who illuminated the third supplement, differs from the others in his familiarity with French models, while the other three keep to the art tradition of Constance. For the latter, the closest parallels are the frescoes in the Haus zur Kunkel or Distaff House in Constance (before 1316) and the miniatures in the Weingarten poetry manuscript (c. 1300, now in Stuttgart). Comparable works are to be found in Zurich itself, such as the frescoes from the Haus zum langen Keller (House with the Long Cellar); dating from before 1308, they are now in the Swiss National Museum, Zurich. Links can also be traced with the Zurich Heraldic Scroll (c. 1335-1347, Swiss National Museum), which originated in what is now eastern Switzerland.

During the fourteenth century the monastic scriptoria lost much of their importance. The decline of Engelberg, for example, becomes very marked after

about 1340. Not only did the creative impulse begin to fail in the monasteries, but art patrons were looking elsewhere for different kinds of books, often with a secular appeal. Collections of love songs and secular chronicles were especially popular in South Germany. Some of them were on a very considerable scale. The Manesse Manuscript, presumably originating in Zurich, contains 432 pages of poems by 140 writers, illustrated with 138 full-page illuminations, remarkable for their epic breadth of treatment.

A comparable wealth of imagery, inspired by a spirited narrative, appears in illuminated copies of the *Weltchronik* (World Chronicle) compiled by the epic poet Rudolf von Ems, a native of the Vorarlberg in present-day Austria. While keeping mainly to the Old Testament narrative, the text also incorporates episodes written by Petrus Comestor and other medieval authors. This vast chronicle of Biblical antiquity comes to a stop, however, with King Solomon: Rudolf von Ems died in 1251 before he had had time to continue it any further. The Zurich copy of his *World Chronicle* is the last of a handsomely illuminated series that begins with the Munich version (between 1255 and 1270) and includes that of Saint Gall (c. 1290).

Unlike the painters of the Manesse Manuscript, who depended in part on French models, the illustrators of the Zurich manuscript of the *World Chronicle* worked largely in a native style and only took over Gothic forms with some hesitation, even in their representations of architecture.

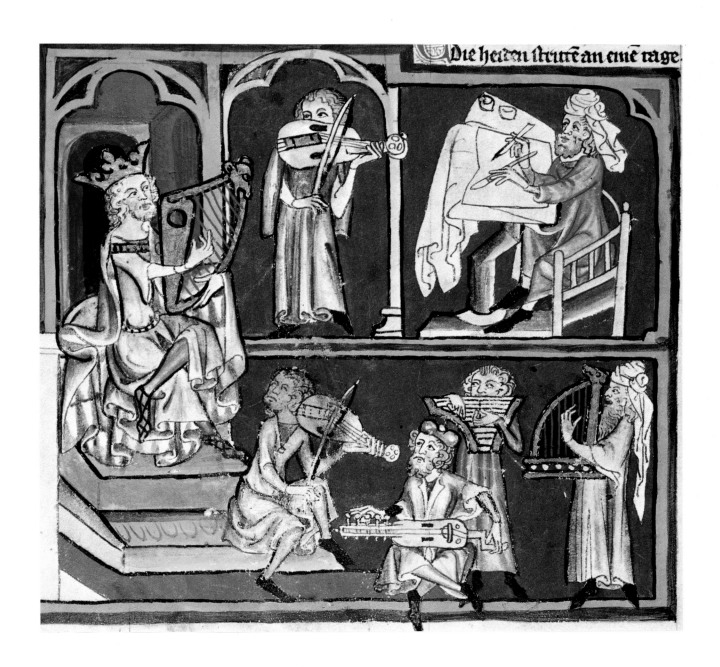

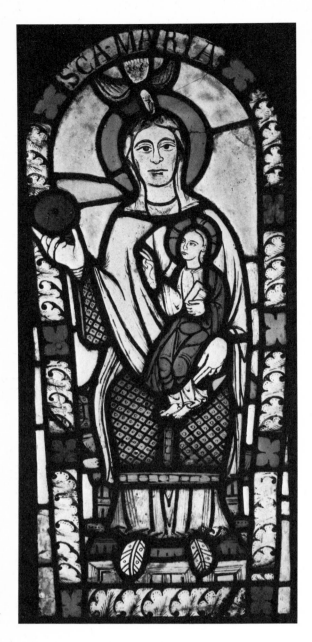

Flums (Saint Gall),
Chapel of Saint Jacob
Virgin and Child. c. 1200
Stained-glass window, 24¾ × 11″
Landesmuseum, Zurich

The *Virgin and Child* of Flums (Saint Gall) is one of the very few pre-Gothic stained-glass windows to have come down to us in the German-speaking lands, and it is the earliest known example of glass painting in Switzerland. Executed about 1200, during the period of transition from Romanesque to Gothic, it keeps distinctly to the earlier style. The figure of the Virgin is of the Byzantine type known as the Hodegetria, from the ancient icon preserved in the Hodegos Church in Constantinople. Dating as it does from a time of rapid changes from which few comparable works survive, it is impossible to assign it to any particular art center. One is tempted, nevertheless, to see a connection with the illuminations of the monastery of Hirsau in the Black Forest, whose scriptoria were very active during the eleventh and twelfth centuries.

The rose window in the south transept of Lausanne Cathedral, dating from about 1235, is easier to place. Its forms hark back to an earlier generation. The rhythm of the medallions is not yet accentuated by rays, as in the contemporary Gothic style of the Ile-de-France, nor is it heightened with flame patterns, as in the coming phase of flamboyant Gothic.

This masterpiece, restored in part with modern glass, consists of 105 elements which together make up an *imago mundi*, an image of the world. Easily recognizable are the stars, day, night, the seasons, then the symbols of the months followed by the signs of the Zodiac, the personifications of the four rivers of Paradise, and the figures, some of them monsters, representing the legendary tribes at the uttermost ends of the earth. Similar subjects had already appeared in the marginal compositions of the Zillis ceiling.

The magnificent rose window of Lausanne Cathedral is an outstanding example of medieval stained glass. About 1240 it was seen and admired by the architect Villard de Honnecourt, who copied it in his sketchbook, now preserved in the Bibliothèque Nationale in Paris.

French influences are obvious in the Lausanne rose window, but no direct connection with a known French workshop has yet been traced; owing to the destruction of so many of these fragile works, there are too many gaps in our knowledge of stained glass in this early period. All we know is that some windows were executed for Lausanne Cathedral by one Peter of Arras shortly after 1235. Though his name tells us where he came from, no other works can be attributed to this artist.

At Kappel (canton of Zurich) we enter a different world. The Cistercian church here, at the foot of Mount Albis, was founded in 1185 by Walter I of Eschenbach and after the middle of the thirteenth century became a thriving center. The monastery was then enlarged and the church was rebuilt in 1255. It is one of the finest pieces of Gothic architecture in Switzerland. The stained-glass windows installed in the choir of the Kappel church in 1310 were later transferred to the nave.

Rose Window of Lausanne Cathedral
April and May. c. 1235.
Stained glass, diameter 22⅞″

Kappel (Zurich), Cistercian Church
Christ on the Cross. c. 1310.
Stained-glass window, 31½ × 17½″

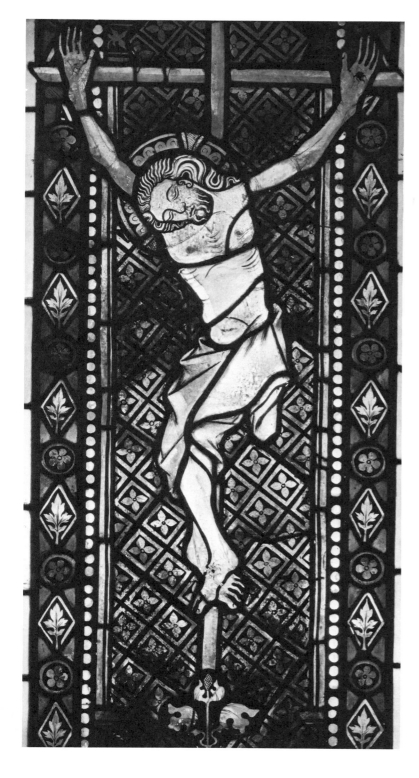

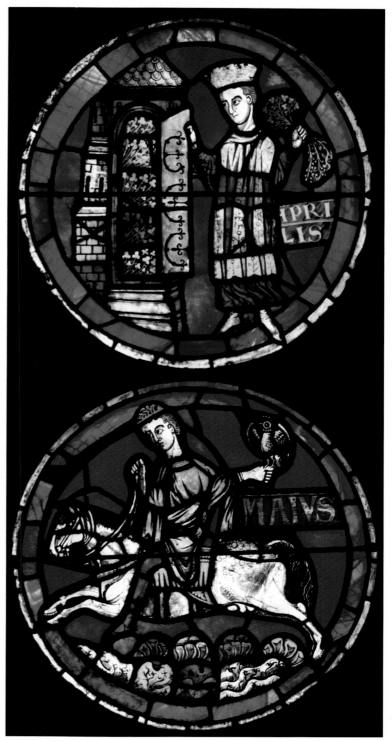

It is important to note that the artists responsible for the fine windows at Flums, Lausanne, and Kappel were already intent on exploring and representing space, an element that was to loom large in later examples of stained glass. An initial step in this direction lay in the negation of the frame, which was often overlapped by the subjects represented: by the Virgin's hand at Flums, by the mounted falconer at Lausanne, by the Cross at Kappel. Elements in perspective are still rare, though the open door in the month of April (a play on the words "Aprilis-aprire," meaning "to open") stands on a base represented in perspective.

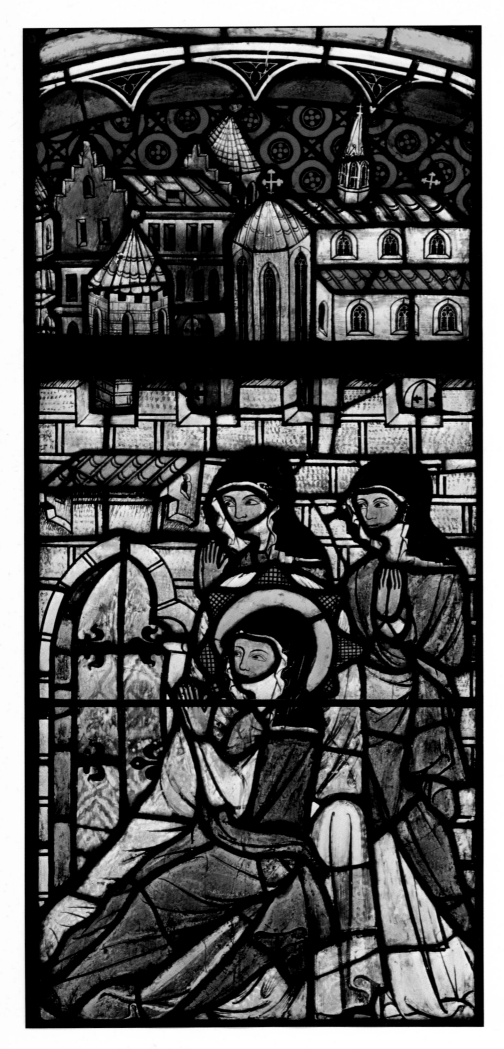

When, in 1308, the German ruler Albert of Hapsburg was treacherously murdered by his nephew near Brugg (Aargau), the Hapsburgs founded the abbey of Königsfelden on the site of the crime. It consisted of a Franciscan monastery and a convent of Poor Clares. It was patronized by Albert's widow, then, after her death in 1313, by his daughter Agnes, Queen of Hungary. The abbey was completed and consecrated in 1330.

The eleven stained-glass windows in the Königsfelden choir, donated by members of the Hapsburg family, date from 1325-1330. They are unique in their balanced summing up of the main trends of fourteenth-century art—Franciscan, Alsatian, Austrian, and Italian. The full-bodied, three-dimensional forms are based on the style of Giotto, which, from the 1320s on, had begun to exert its influence in the Alpine regions and northern Europe. It remains, however, very difficult to trace the exact relations between Italy and the German-speaking lands at that time. One can only guess at the contacts that made the revolutionary innovations of the Florentine master known in the North. Sketchbooks, known to have been in circulation from the thirteenth century, may have provided one channel of transmission; itinerant artists, both Italian and German, fresh from Padua, Florence, and Assisi, may have provided another. Space is rendered very much in the Italian manner, as in the illustration on this page, where houses and churches rise up sharply behind the battlements drawn in perspective. It is an imaginary view of Assisi, saved by Saint Clare from an invasion of Imperial troops: she had herself carried from her sickbed to the gates of the town and there, together with two nuns, invoked divine aid and protection.

The refinement and elegance of the Königsfelden windows can be gauged by a comparison with the Gradual of Katharinenthal. The well-balanced compositions and the color harmonies, not only in the lancet windows but throughout the choir, entitle this work to an unchallenged position as the masterpiece of fourteenth-century art in Switzerland.

The choir of the country church of Saint Nicholas at Staufberg (Aargau) was rebuilt in 1420 and adorned with stained-glass windows at the same time. They illustrate scenes from the early life of Christ and the lives of the saints.

Nearly a century separates the Staufberg windows from those of Königsfelden. Courtly elegance has given way to a narrative of popular appeal, typical of the painting of that period, in which the descriptive element is often overstressed.

In the three panels of the *Adoration of the Magi*, the doors at either side, set out slantwise, focus attention on the scene, which takes place in a self-contained space. The central figure stands under a groined vault, while those in the side panels are represented under a paneled ceiling. The division into three parts, due to the stone mullions, does not break up the spatial unity. Most distinctive of early fifteenth-century art are the genre details that enliven the narrative: the Christ Child fingering the contents of the box presented by the first king, while looking up with a questioning glance at his mother; or the Moorish king on the right taking the heavy chalices from his servant so that he may turn and present them himself.

The stained-glass windows at Staufberg stem from the art of the Upper Rhine. They exemplify, on Swiss territory, the later phase of the International Style which had arisen around 1400, drawing its iconography and its forms from many sources. This style extended over the Upper Rhine, as represented by the centers of Strasbourg and Colmar; to Bohemia, characterized by the highly refined court art of Prague; to Austria, whose artists took their cue from the supple elegance of the Viennese workshops; and even to Italy and France. In these last two countries the prevailing style was set by such dominant centers as Milan and Verona, and Paris and Bourges. Dynastic ties between the reigning families so much facilitated cultural exchanges that it is often impossible to tell where a particular iconographical formula originated.

◁ Königsfelden (Aargau), Abbey Church
Saint Clare Praying for the Safety
of Assisi. c. 1325-1330
Stained-glass window, 33 × 21 ¼″

Staufberg (Aargau), Church of Saint Nicholas
Adoration of the Magi. c. 1420
Stained-glass window, each panel 29 × 15¾″

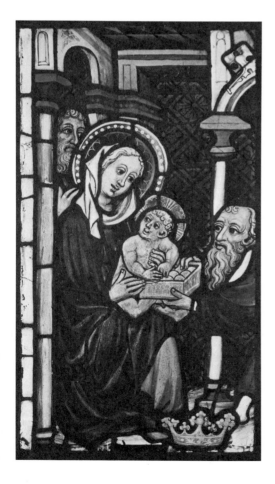
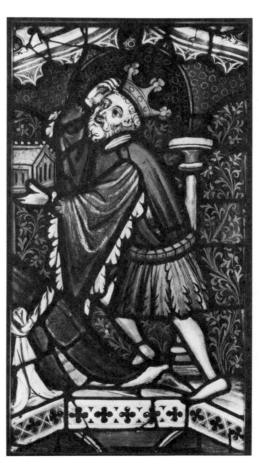
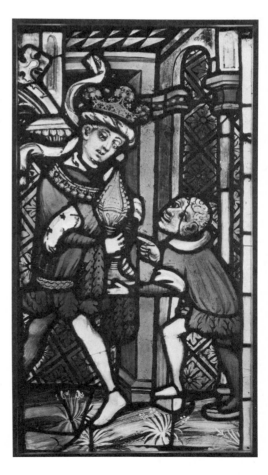

The *Annunciation* from the church of Romont (canton of Fribourg) is in a very different style. Here, unlike Staufberg, the architectural setting is no longer simply a background: its pattern is interwoven with that of the figures. The latter are handled with breadth and flawless ease; the artist may have modeled them on a print, simply adding a few touches of color. From the right, the angel Gabriel enters a room furnished with a bench, a high-backed chair, and a prie-dieu. The floor tiles are laid out in perspective. This work, surprising for its studied precision, undoubtedly owes much to Flemish painting.

Begun in 1421, the stained-glass windows in Bern Minster testify to the multiplicity of influences at work on the Swiss plateau in the fifteenth century. Among the windows in the choir is a typological composition; that is, a series of scenes, side by side, drawing parallels between the Old and the New Testament. Judging by the donor figures, this window was designed between 1448 and 1450-1451. Nothing is known about the artist or where he may have come from. The style harks back to Konrad Witz, who died in 1445, and it may well have been a master from his workshop who executed the *Baptism of Christ*. This scene marks the birth of a new art which was to find expression chiefly in panel painting.

Romont (Fribourg),
Church of Notre-Dame
Annunciation. c. 1460-1470
Stained-glass window, 59 × 57½″
Musée d'Art et d'Histoire, Fribourg

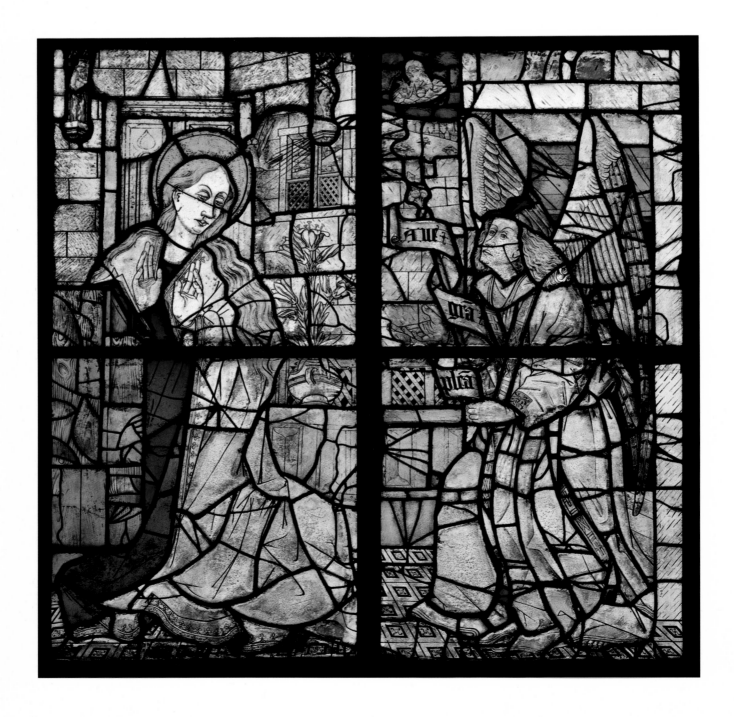

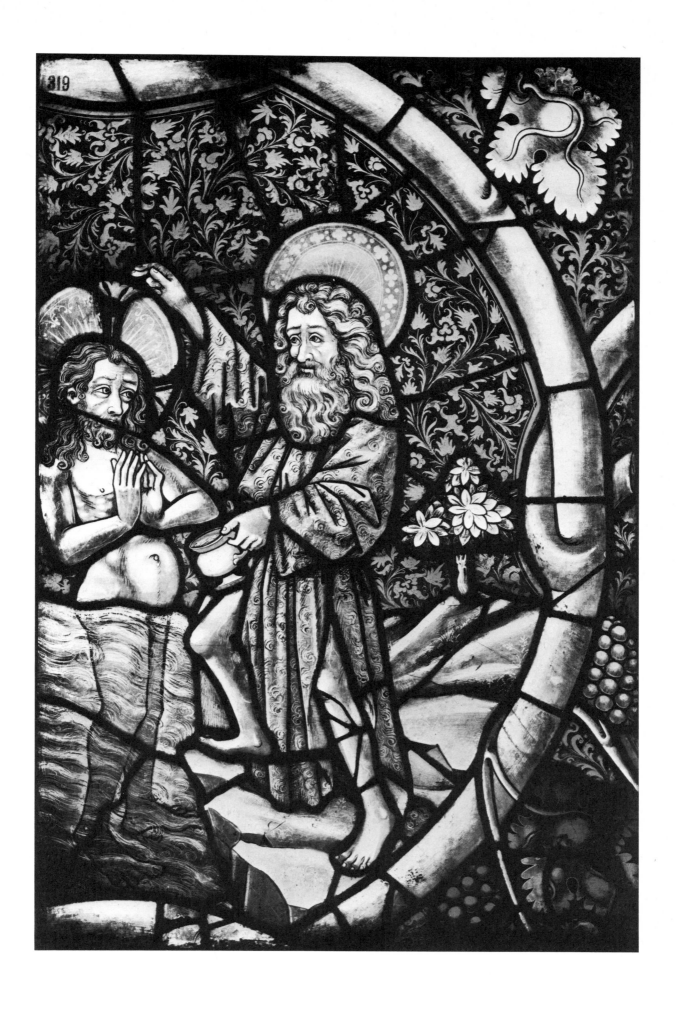

Bern Minster
Baptism of Christ. c. 1450
Stained-glass window, 35¾ × 23½″

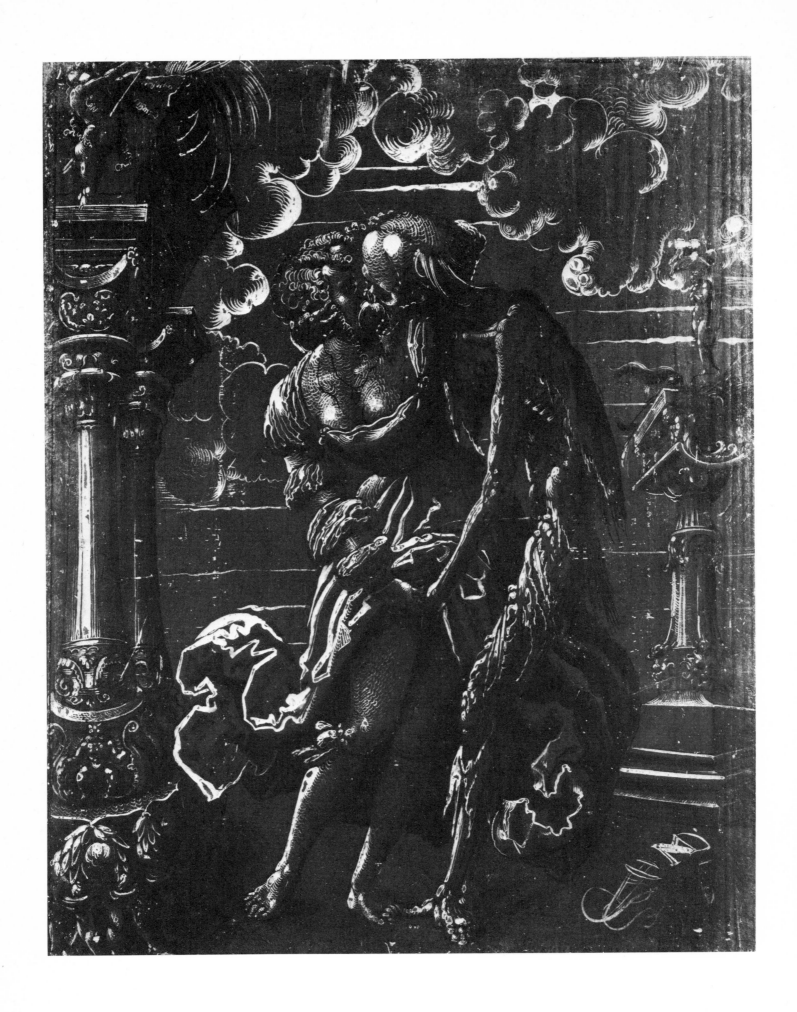

Niklaus Manuel Deutsch (1484-1530)
Death as a Warrior Embracing a Young Woman. 1517
Tempera on panel, 15 × 11½''
Öffentliche Kunstsammlung, Basel

Late Gothic and Renaissance Art

The chiaroscuro panel of *Death as a Warrior Embracing a Young Woman* is a magnificent example of the art of line drawing as practiced by the best masters of this period. The two figures are rendered with full-bodied realism and vivacity, while the allegorical content is conveyed with telling simplicity and immediacy. The draperies recall the Late Gothic style of Germany. The architectural setting, however, is resolutely modern: it represents an adaptation by the South Germans of the art of North Italy. The scene is set in a well-defined space which the artist has refrained from emphasizing; a few pen strokes represent clouds and suffice to evoke the presence of nature. Death dressed as a mercenary and the dagger beside the artist's monogram remind us that this was an age of wars, fraught with death and violence. Every line in these graceful yet powerful figures expresses the personality of Niklaus Manuel Deutsch, the greatest of Swiss painters, the very embodiment of the Bernese spirit and indeed of a whole period extending historically from the Burgundian and Swabian wars to the Reformation, and culturally from Late Gothic to the Renaissance.

For the historian of Swiss art it is not a very rewarding period to study, for the iconoclasm of the Reformation destroyed nearly all the paintings. This gap in the Swiss art tradition was widened in the course of the following centuries owing to the Protestant rejection of imagery. The main works of Late Gothic and Early Renaissance painting were ruthlessly destroyed in the great centers, Basel, Zurich, Bern, and Geneva (the Ticino was an exception). Not a single complete altarpiece by Witz, Fries, or Manuel has come down to us. For most painters only a few scattered pictures have survived from a whole life's work, two dozen in the best of cases. For artists like Heinrich Büchler, Giovanni Antonio Lagaia, and the Fribourg Master of the Carnation, only a single picture is known. Of the work of many painters whose names have come down to us, like H. Ballauff and B. Rutenzweig, nothing remains. It is true that some vestiges of Late Gothic painting survive on the walls of many village churches, but all too often they are of no artistic interest.

Apart from these very serious gaps in our knowledge, there is a second point to be made here: for the study of this early period, the geographical term "Switzerland" must be used with caution. Witz, for example, was a native of Swabia and worked in Basel and Geneva, which at that time were not yet members of the Swiss Confederation; any attempt to single out the "Swiss" element in his work would be futile. Nor was the Ticino a part of Switzerland at that time. Holbein, too, like Witz, was an outsider who became a citizen of Basel; but he is a South German in his background and training and English in his international reputation as a portraitist.

The works that concern us here originated for the most part in Bern, Basel, and Zurich, with Fribourg, Schaffhausen, and Lucerne as secondary centers. Whatever their cultural achievements in other fields, French-speaking Switzerland, together with the Valais and the Grisons, contributed nothing to the painting of this period; even allowing for the wholesale destruction of pictures during the Reformation, the fact remains that few painters were then active there, and none of any note. This is by no means true of the Ticino, but at this period, artistically and culturally, it was an integral part of Lombardy. In spite of the Milanese campaigns of the Swiss at the beginning of the sixteenth century, no artistic ties were established between the Ticino and the Swiss lands north of the Alps. Manuel, Graf, and possibly Holbein visited North Italy, but the Italian elements in their art reached them rather by way of Augsburg and Nuremberg than by Lombardy.

The surviving works have largely remained in the places where they were made. The principal collections of paintings of this period are accordingly to be found in the museums of Basel and Bern, in the Swiss National Museum in Zurich, the church of the Cordeliers in Fribourg, the Geneva museum (two famous altar panels by Witz), and in the churches of the Ticino. In this book no account can be taken of the sculptured altarpieces of Late Gothic art, closely connected though they were with painting: some magnificent examples are preserved in the mountainous regions of strategic importance, such as the Upper Valais and the Grisons, and also in the Swiss National Museum in Zurich. Patronage in the fifteenth century came almost exclusively from the Church and the municipalities, and the practice of art was governed by the guilds. In Switzerland the nobility was nonexistent. The prosperity of towns like Zurich and Basel depended on trade and handicrafts. Later, the university and the activities of printers and publishers combined with trade in Basel to create an international humanism. In the sixteenth century, merchants and burghers came forward more and more as patrons of art.

During the fifteenth century the painting of German-speaking Switzerland was simply an offshoot of that of South Germany, which in turn, like all German painting of that period, followed in the steps of the great Flemish masters. From the surviving works, it is not always possible to distinguish between the art of the Upper Rhine and that of Lake Constance, which flourished both north and south of the Rhine. From Piedmont to the Tyrol, cultural conditions were very similar; yet the notion of an Alpine art or style scarcely seems tenable. Within the context of European art as a whole, the major development was the rise of the International Style at the courts of Dijon and Paris at the beginning of the fifteenth century: it is not represented by any outstanding work in Switzerland, with the sole exception of the wall paintings in the choir chapel of Santa Maria in Selva, near Locarno (Ticino), which derive directly from Milan. The so-called "hard style," arising in South Germany about 1440, found its greatest exponent in Konrad Witz. The origins of his art are difficult to trace with any certainty, but it remains largely traditional in comparison with the realistic delineation of nature, the symbolism and the technical refinements of the Flemish masters Jan van Eyck and Rogier van der Weyden, whose works precede those of Witz by some years. But for all that, his altar panel in the Geneva museum, with the mystical apparition of Christ, before a landscape which is recognizably that of a particular spot on the Lake of Geneva, represents an unprecedented innovation, soon to be followed up by the lake landscapes of Niklaus Manuel Deutsch. More light would be shed on Witz if we knew the historical significance of his Basel and Geneva altarpieces in relation to the tensions of the Council of Basel (1431-1449), but such background information is almost wholly lacking.

Bern, with the Minster and the Town Hall under construction, had some important commissions to distribute in the fifteenth century. The stained-glass windows in the choir of Bern Minster are practically contemporary with Witz: they stand out as the major achieve-

ment in that medium, at that time, in German-speaking Switzerland. During the latter half of the fifteenth century, painting became more ornate, the accent was laid increasingly on narrative, and composition and space became more intricate. The prevailing influence was that of Flemish art as represented by Memling. The Bernese master Heinrich Büchler was probably the outstanding figure in Switzerland, but only one of his paintings is extant. The major surviving work of this period is the main altarpiece in the church of the Cordeliers in Fribourg (1479), in which several hands from the Upper Rhine and eastern Switzerland can be discerned; the heritage of Rogier van der Weyden is most evident in the wing panels. From then on, German influence steadily increased. Dating from between 1480 and 1510, the less ambitious panels of the Masters of the Carnation retain a distinctly local (i.e. Germanic) character, even though there is no very close connection between them. Already the Zurich Master of the Carnation shows a knowledge of Schongauer's prints and takes inspiration from them.

In the later fifteenth century, Basel was a notable center of tapestry weaving in a traditional style; the stock themes were those of courtly love, wild creatures, and the medieval Mirror of Human Salvation *(Speculum Humanae Salvationis)*. These local works developed on lines of their own, uninfluenced by the great contemporary tapestries of the Flemish weavers. Switzerland then had no equivalent of the fine early woodcuts and engravings of South Germany. But about 1500 it produced a particular type of historical chronicle of its own, illustrated by gifted amateur artists; of these the most famous are the Schillings. At the very end of the Gothic period the Fribourg painter Hans Fries stands out as a leading artistic personality, eager to explore modern forms, though still steeped in the themes and attitudes of traditional religious art.

As compared with the great developments of Italian art, shaped and stimulated by the revival of classical antiquity, by humanist ideals and the scientific use of perspective, all northern art of the fifteenth century may seem backward; but it is none the less interesting for that. The one part of present-day Switzerland that lies south of the Alps is the Italian-speaking Ticino, and the art of this region is inseparable from the Lombard and Piedmontese centers. Its finest flowering occurred between 1510 and 1530, in the period of the High Renaissance. The local masters who painted the altarpieces of Ascona, Gandria, and San Biagio of Bellinzona reflect the style of the Milanese school as represented by Borgognone and Foppa. And some of the leading Italian masters worked on occasion in the Ticino: Ferrari at Bellinzona, Luini and Bramantino at Lugano. North of the Alps, closer contact with Italy and the ideals of classical antiquity was fruitfully combined with the influence of Dürer, who became the great model for the German Renaissance. The fifteenth century had worked out the problems of form; the Renaissance focused attention on the individual man and the space in which he lived and moved.

Niklaus Manuel Deutsch of Bern, Urs Graf of Solothurn, and Hans Leu of Zurich, all three of the same generation, embody the art of the Renaissance in Switzerland: they mark the most brilliant flowering, unfortunately all too brief, of Swiss painting. While their works convey all the exuberant vitality of the Swiss mercenaries of that period, their sensitive handling of line and form far transcends the world of common soldiers. Manuel is the finest artist of the three, and the only one who can be called a true humanist; he was also a poet and a statesman of wide experience. Neither a methodical seeker after the truths of nature in the manner of Dürer, nor a master of visionary expression like Grünewald, he stands out nevertheless from his German contemporaries for the pictorial intensity and intuitive poetry of his pictures. He was at his best in fanciful scenes, secular and classical themes, and studies of the nude. The age in which he lived is most memorably reflected in his drawings, both in his hasty sketches and his elaborate calligraphic drawings, to which the colored backgrounds often lend a pictorial aspect. Though widely practiced in foreign

schools, printmaking was uncommon in Switzerland. Urs Graf, though he made a few engravings, was almost exclusively a draftsman: his spirited figures, drawn in pen and ink, are a direct expression of his humorous and sceptical personality. The years which Holbein, an emigrant from Augsburg, spent in Basel, from 1515 to 1526, with some absences, mark the height of the Renaissance in Switzerland, best represented by his portraits and altarpieces, his façade paintings, his wall paintings in the Basel Town Hall and many fine drawings. A younger man than Manuel and Graf, Holbein left Basel after the Reformation, perhaps because of the disturbances that came in its wake, and settled in London for good in 1532, where he began a new life and worked out a new style. His years in Basel left strong local traces, but his European importance derived from his work in England.

The great cleavage of this period in Switzerland was wrought by the Reformation. It marked the triumph of the guilds and the bourgeoisie and spelled the decline of the arts; indeed, even the Catholic cantons were affected and produced little painting in the sixteenth century. While Italy was then laying the foundations of European art for two centuries to come, Switzerland, after 1530, has little to show apart from local art forms and specialties. Foremost among these are heraldic stained glass, tiled stoves, book illustrations, and façade paintings. Historically, culturally, and artistically, these local forms of expression have a definite interest, the heraldic stained-glass windows in particular, for they created a fashion and gave rise to a rich and varied production. But in the broader European context they are marginal manifestations.

The fierce iconoclasm of the Reformation put an end to ecclesiastical commissions, and painting now was practically limited to portraiture. In this field Asper, Kluber, and Bock continued to draw on the heritage of the Renaissance. The more gifted artists emigrated, seeking an outlet for their talents abroad. The greatest of them was Tobias Stimmer, whose *Portrait of the Schwytzer Couple* rises to the level of the finest works of the past. For the ducal court of Baden-Baden, in South Germany, Stimmer painted some monumental decorations which were to exert a decisive influence on the course of Baroque art in that region. His book illustrations and his masterly drawings infused a new vitality into the tradition of Holbein. Book illustrations, in the form of thousands of woodcuts, were also produced by Jost Amman, working in Nuremberg. The only Swiss painter to participate actively in the development of European Mannerism was Joseph Heintz: together with Bartholomeus Spranger and Hans von Aachen, he was the leading artist at the court of Rudolf II in Prague at the end of the sixteenth century. Stimmer, Amman, and Heintz are duly considered here because all three were native Swiss, trained in Switzerland. By the end of the sixteenth century, Swiss painting begins to show a greater variety than in the stricter decades immediately following the Reformation. And now, too, the first representative collection of Swiss art, and one of considerable scope, was made in Basel by Basilius Amerbach. The finest private collection of its time, it is still preserved in the Basel museum.

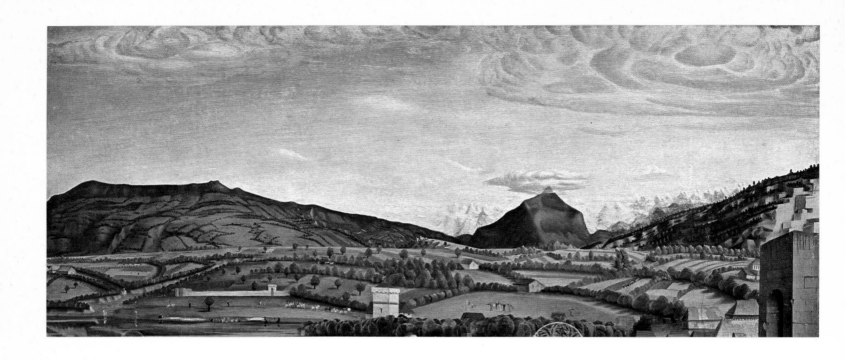

Konrad Witz

Konrad Witz (c. 1400-c. 1446)
Miraculous Draught of Fishes
(Whole and detail). Panel of the
Saint Peter Altarpiece. 1444
Tempera, 52 × 60½″
Musée d'Art et d'Histoire, Geneva

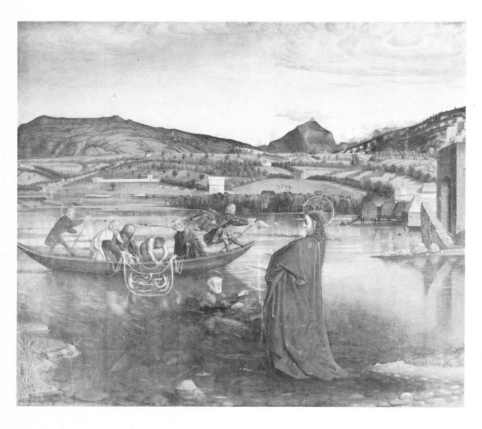

The son of an artist, Konrad Witz was born at
Rottweil am Neckar (Swabia) but became a citizen
of Basel in 1435 and died there some time between
1444 and 1447. Not very much is known about him,
but a score of surviving altar panels, one of them
signed, make him easily the greatest Swiss painter
before Holbein and one of the foremost European
masters of his day. His strong individuality is ex-
pressed directly in the forthright plasticity of his
stocky figures, each standing in vigorous isolation
and playing to the full its own part in the composi-
tion. One is struck at once by the concision and
force of his figures. Their draperies reveal a keen
tactile sense and a fondness for surface patterning.
Composition and color are built up in terms of ele-
mentary contrasts. Figures are constantly varied
and enhanced by the abstract shapes taken by the
draperies, whose angular folds and edges are like
the work of a sculptor's hand. Witz, then, treats
forms in a way that brings to mind artists like Giot-
to, Masaccio, or the Burgundian sculptor Claus
Sluter, who was active around 1400. Witz has
moved resolutely away from the niceties of the In-
ternational Style which had prevailed at the begin-
ning of the century and which, with Stefan Loch-
ner, his contemporary and countryman active in
Cologne, continued to thrive until the middle of the
century. He avoids both the narrative style of
Lucas Moser and the crowded composition of Hans
Multscher.

Witz does not linger over naturalistic details of
anatomy and expression like the great Flemish
masters who preceded him, such as Jan van Eyck.
His style remains monumental and even archaic.
The origin of his style is uncertain; points of com-
parison are to be found, on the one hand, in the
Master of Flémalle and, on the other, in the Master
of the Aix Annunciation (1445).

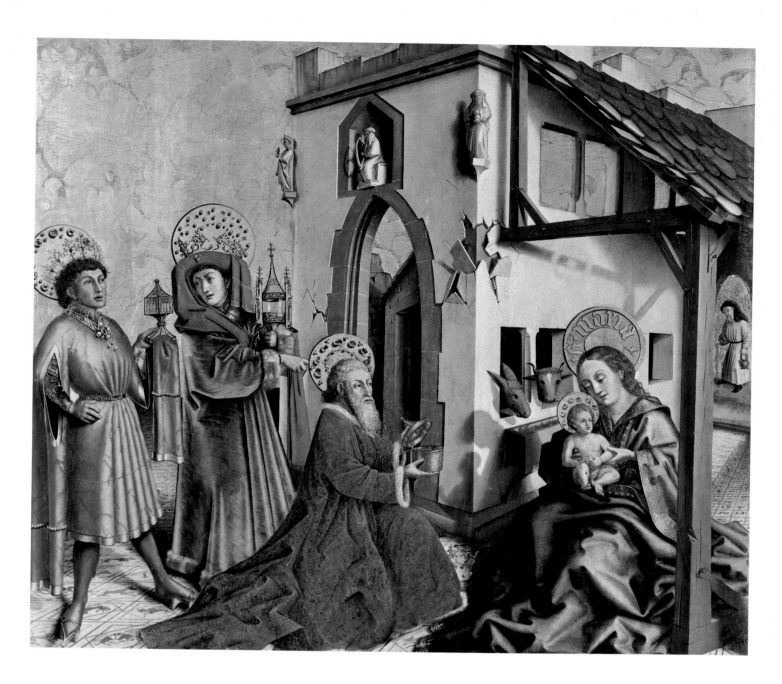

Konrad Witz (c. 1400-c. 1446)
Adoration of the Magi
Panel of the Saint Peter Altarpiece. 1444
Tempera, 52 × 60½″
Musée d'Art et d'Histoire, Geneva

Twelve of the panels attributed to Witz appear to belong to an altarpiece usually known as the *Heilsspiegelaltar*, but its connection with the iconography of the Mirror of Salvation is by no means certain. A fine inner panel represents *Esther Before Ahasuerus*, against a gold ground. The apostle *Saint Bartholomew* on an outer panel is almost a grisaille; the sculpturesque figure is set off by the cast shadow behind it. This altarpiece, parts of which are missing, was probably designed for a church in Basel, perhaps in connection with the Council of Basel (1431-1449), which was trying to effect a reconciliation between the Eastern and Western Churches. Three other panels, slightly larger, apparently come from an Altarpiece of the Virgin. But Witz's finest works are the two large panels in Geneva, one of them signed and dated 1444; they are all that remains of an altarpiece commissioned by Bishop François de Mies, probably for the cathedral of Saint Peter in Geneva. The inner sides depict, on the right, *Bishop François de Mies Before the Virgin* and, on the left, the *Adoration of the Magi*. The outer sides show, on the right, the *Liberation of Saint Peter* and, on the left, the *Miraculous Draught of Fishes*, with Christ walking on the waters of the sea of Tiberias after the Resurrection. This scene, for the first time in European painting, represents an actual landscape, the hill of Cologny just outside Geneva on the south shore of the lake, with the mountains of Savoy in the immediate background (Voirons, Môle, and Salève) and the peaks of the Mont Blanc massif on the horizon.

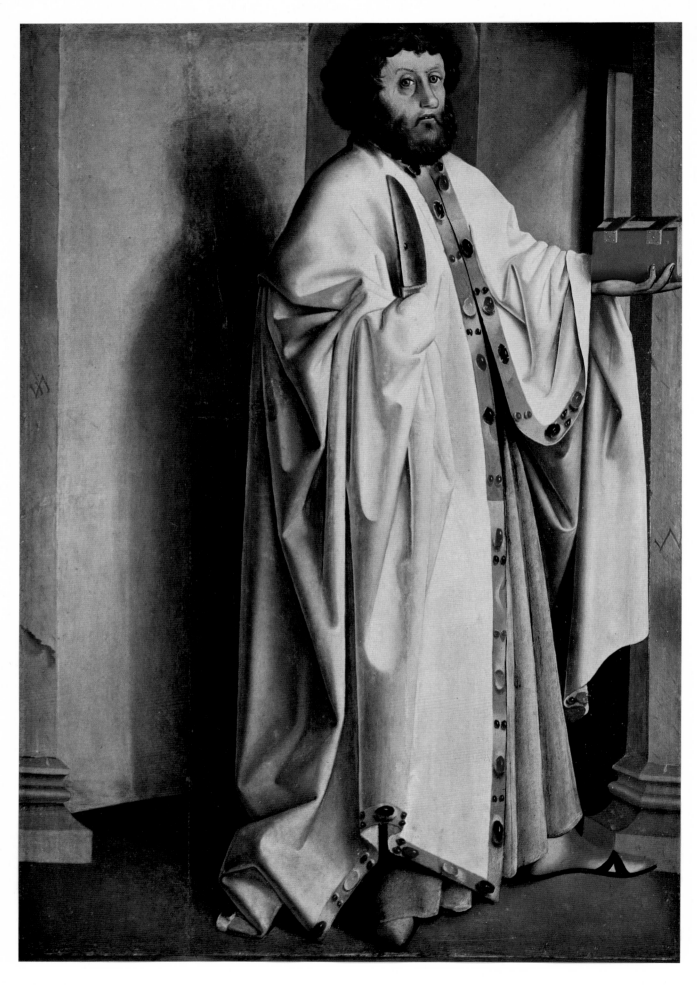

Konrad Witz (c. 1400-c. 1446)
Saint Bartholomew. c. 1434-1435
Altar panel. Tempera, 39 ¼ × 27 ⅜ ″
Öffentliche Kunstsammlung, Basel

Konrad Witz (c. 1400-c. 1446)
Esther Before Ahasuerus. c. 1434-1435
Altar panel. Tempera, 33¾ × 31¼″
Öffentliche Kunstsammlung, Basel

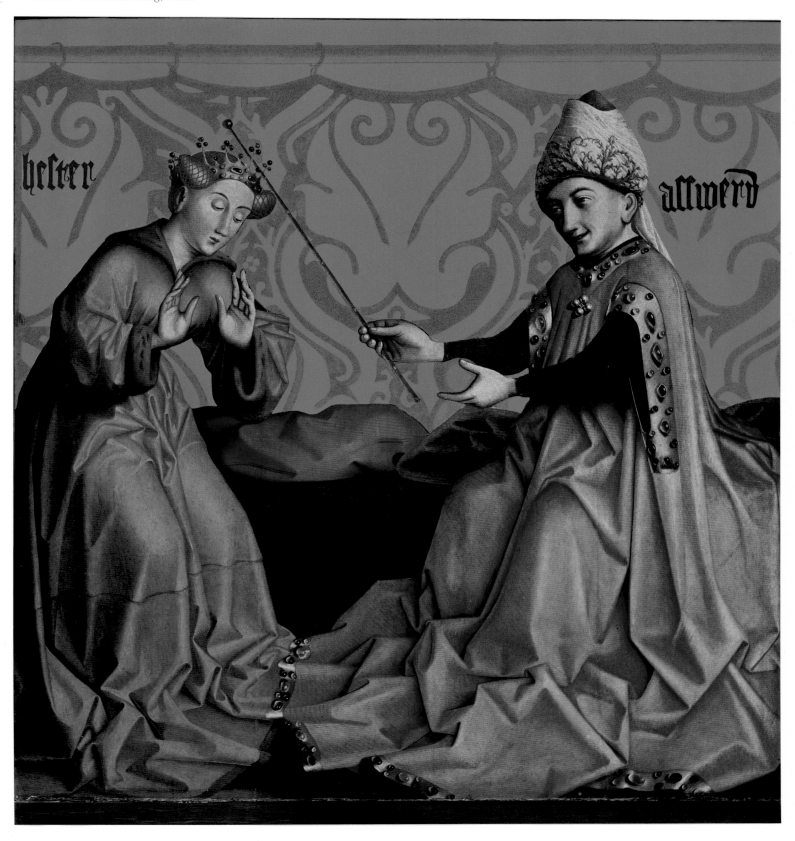

The Heritage of Witz

No particular school carried on the work of Konrad Witz, but his influence is apparent in a number of panels and wall paintings of the mid-fifteenth century. The *Dance of Death* formerly in the Dominican church in Basel, known to us now only from copies, may well have been painted by Witz; if not, it was by one of his closest followers. The lyrical panel of 1445 with *Saint Anthony and Saint Paul* stems from his immediate circle, as does an altar panel in Basel representing, on the outer side, *Christ and God the Father* and, on the inner side, the *Nativity*, with the *Annunciation to the Shepherds* in the background. Here the spatial layout, the figure types, the elaborate draperies of the Virgin, and the details of the tumbledown shelter and the landscape are all connected stylistically with the two remaining panels of the Geneva altarpiece. A *Trinity* in the Berlin museum reveals a very similar style, while two panels with *Saint Martin and Saint George* by the Master of Sierenz continue it in a more frankly narrative vein. It is difficult to trace the influence of Witz in French-speaking Switzerland, where almost all the paintings of this period were destroyed during the Reformation. There are, however, a few fragments in the church of Valère at Sion (Valais) which bear the unmistakable imprint of the Geneva altarpiece, showing that it was imitated even in these remote Alpine valleys. The stocky figures of the Swabian Master of the Playing Cards are also close to those of Witz. But in the latter half of the fifteenth century his influence waned; the predominant style now was based on the more refined and elegant models of the Flemish masters, as opposed to the sturdy, forceful forms of Witz. His art and reputation gradually sank into oblivion, from which it was rescued by modern scholars four centuries later.

School of Konrad Witz
Nativity. c. 1450
Altar panel
Tempera, 53 ½ × 65″
Öffentliche Kunstsammlung, Basel

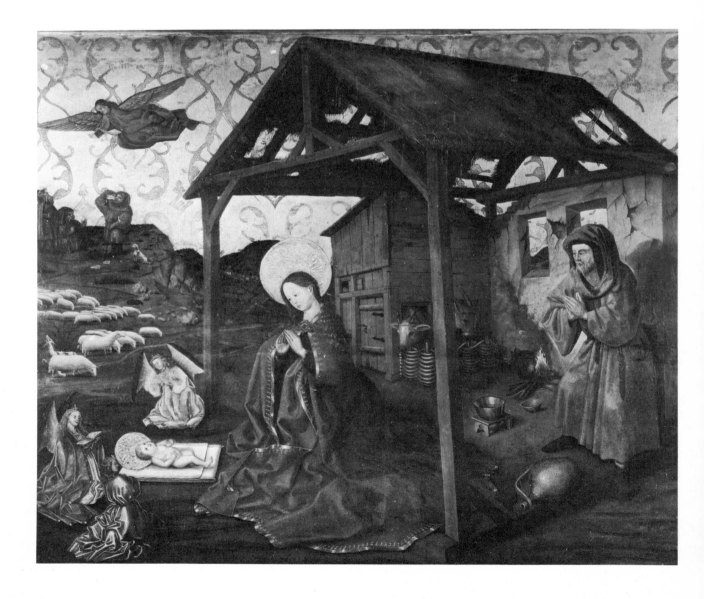

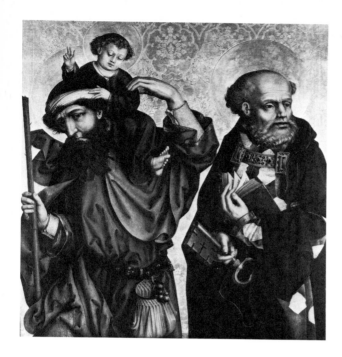

Altarpieces
of Bern Minster

Bern wielded the political power in the Swiss Confederation, and it expressed its predominance at the beginning of the fifteenth century with the construction of the new Minster and the Town Hall. Of the twenty-four altarpieces that once adorned the choir of Bern Minster, only three panels have survived: this gives some idea of both the artistic wealth of this church in its heyday and the destructive fury of the iconoclasts at the time of the Reformation. Of the main altarpiece (1468), the largest, most ambitious work of its day in Switzerland, only the panel with *Saint Christopher and Saint Peter* is preserved, and even here the figures have been cut off at the knees. This is the only surviving picture by the great Bernese painter Heinrich Büchler. His style is at once monumental and refined. Standing midway between the sculptural power of Witz and the realism of Manuel, this work, more mystical and inward, appeals to the heart and soul of the believer. Forty years later, the *Altarpiece of the Dead* by an anonymous Bernese master illustrates one of those excesses of the religious mind which led to the Reformation. The carved central panel represents the torments of souls in limbo. The painted side panels exhort the living to order masses to be said for the dead and illustrate the gratitude of the dead who are thereby saved. The scene reproduced here shows an army of dead men coming to the aid of a prince who had prayed for their souls. This composition has much in common with the popular art of the illustrated chronicles of that period.

Heinrich Büchler (active 1466-1483)
Saint Christopher and Saint Peter. 1468
Panel from the High Altar of Bern Minster
Tempera, 52 × 57''. Kunstmuseum, Bern

Anonymous Master
The Dead Coming to the Aid of the Living. 1506
Panel of the Altarpiece of the Dead. Tempera, 58⅝ × 24⅜''
Kunstmuseum, Bern, on deposit from the Gottfried Keller Foundation

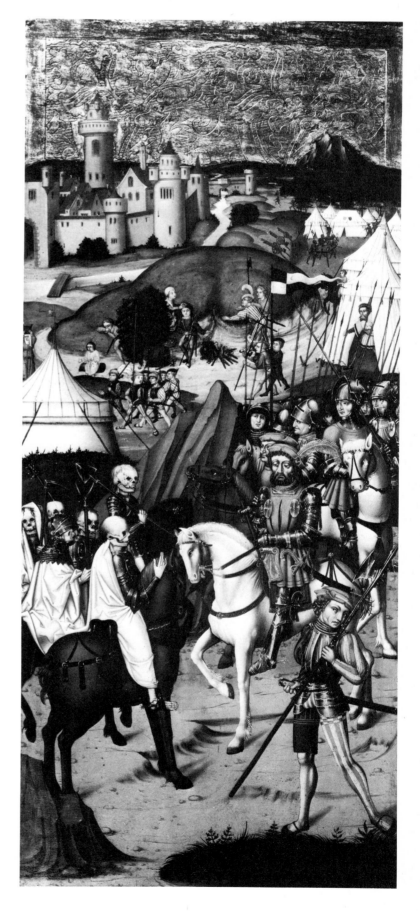

The Masters of the Carnation

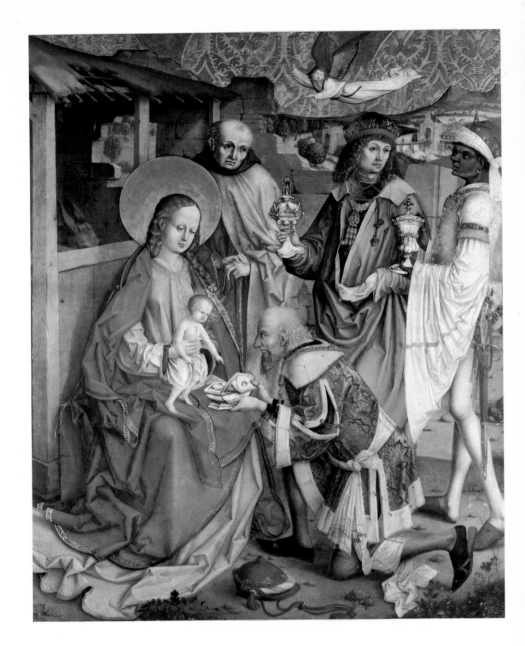

Fribourg Master of the Carnation
Adoration of the Magi. 1479
Inside right panel of the Cordeliers Altarpiece
Church of the Cordeliers, Fribourg

Bern Master of the Carnation
(active in Bern c. 1490-1500)
Angel of the Annunciation. 1490-1500.
Altar panel from the Dominican Church, Bern
Tempera, 46⅞ × 33⅞″
Kunstmuseum, Bern

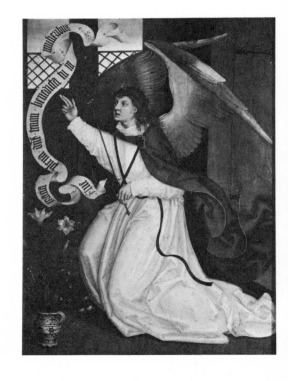

Among the finest works of Late Gothic painting in Switzerland—which, so far as we know, was confined to German-speaking Switzerland—are a number of anonymous altarpieces which fall into several quite distinct stylistic groups, but all of them bear a common mark in the shape of one or two carnations painted in the lower corner. Datable to between 1480 and 1510, these works can be localized in half a dozen places: Fribourg, Bern, the Bernese Oberland, Zurich, and Constance. Stylistically they belong to the art of the Upper Rhine. The symbol of the carnation has yet to be convincingly explained, and efforts to attribute the paintings to known masters have not been successful. The carnation would seem to imply neither a school nor a studio, but rather a kind of brotherhood; it is unlikely that it refers to a series of commissions from the Nägeli family (the word Nägeli meaning "carnation" in Swiss-German). Each local group of works seems to be by the hand of several masters.

The finest of them all is the altarpiece in the church of the Cordeliers in Fribourg, of which the *Adoration of the Magi* is reproduced here. It remains in the very place for which it was ordered in 1479 by Albrecht Nentz of Rottweil, who was then living in Solothurn. Nentz died shortly thereafter and the altarpiece was completed by one or several members of the Basel studio of B. Rutenzweig; the hem of the Virgin's robe in the *Nativity* bears the ambiguous signature

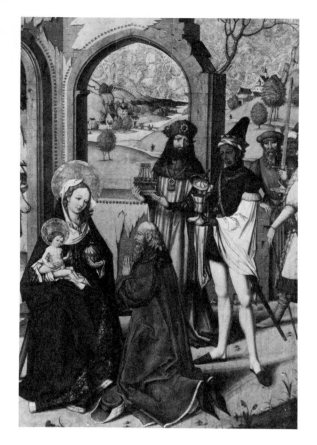

"Grun. B. Bitlor. Aribon" (Beutler of Arbon?). The overall width of twenty-six feet exceeds that of Rogier van der Weyden's *Last Judgment* in Beaune. The three inner panels with the Crucifixion group and saints are by one hand; a different and slightly later hand appears to be at work in the wing panels with the *Nativity* and *Adoration of the Magi* on the inside and the *Annunciation* on the outside. The deft composition of these panels recalls the graphic art of Schongauer; their exquisite quality can be linked with the tradition of Rogier van der Weyden. Flemish-Burgundian art also underlies the courtly refinement of the Three Kings. The bright coloring stems from the earliest painting of the Constance region. Here as nowhere else in Swiss art Netherlandish influence makes itself felt in garments, landscape, and texture.

The Bern Master of the Carnation painted the panels of the *Altarpiece of Saint John* (apparently for Bern Minster), some wall paintings in the Dominican church of Bern and, for the same church, two altar panels with the *Virgin* and the *Angel of the Annunciation* on the outer sides (the latter is reproduced here). Though they fall short of the spatial and linear mastery of the Fribourg *Annunciation*, these panels are fine works in their own right, imbued with a distinctly Bernese spirit.

Belonging to the Zurich group is the *Adoration of the Magi* which comes, it would seem, from an altarpiece originating in Baden (canton of Aargau). The Zurich Master of the Carnation took over his composition from a Schongauer print on the same theme; but the figures are elongated and the draperies flattened, while the Schongauer landscape is replaced by a view of Baden (?). This unknown master might well have been Hans Leu the Elder, who painted the main altarpiece of the Grossmünster in Zurich, of which only fragments survive; it represented the *Crucifixion* and the patron saints of the town, behind whom appear views of the Limmat quays in Zurich, these being among the very earliest identifiable views of a particular town.

There are marked differences between these Masters of the Carnation, and the knotty problem of identifying them remains unsolved. What is certain is that all of them are closely connected, artistically and culturally, with South German painting of the later fifteenth century, in particular with the Master of the Housebook, Martin Schongauer, and the School of Ulm.

Zurich Master of the Carnation (active 1490-1505)
Adoration of the Magi. c. 1500
Tempera on panel, 66⅞ × 46"
Kunsthaus, Zurich

Hans Leu the Elder (c. 1465-1507)
View of Zurich, Right Bank of the Limmat
c. 1500. Fragment of an altar panel
Tempera
Landesmuseum, Zurich

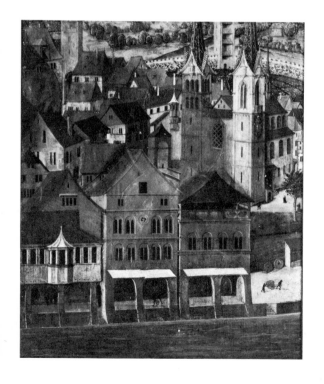

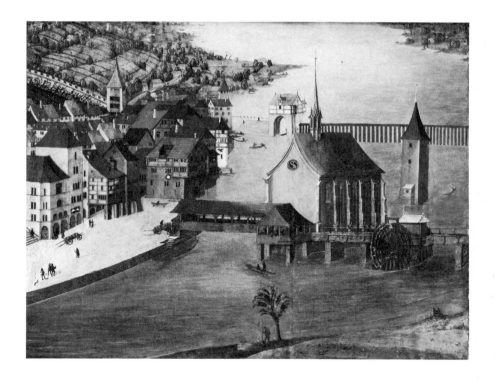

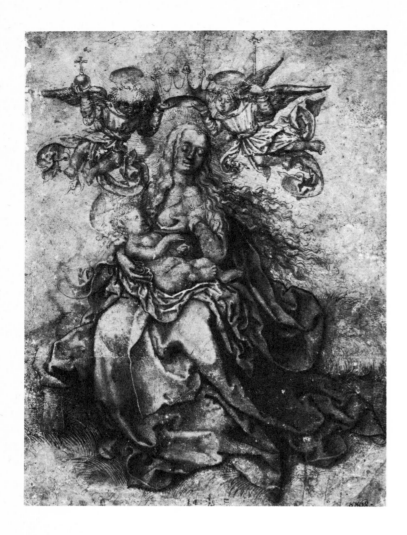

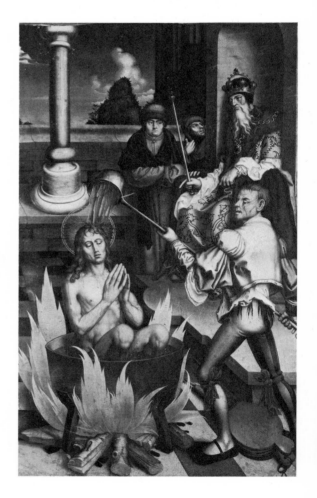

Hans Fries of Fribourg was the only Swiss painter of importance to appear between the Masters of the Carnation and the generation of Niklaus Manuel Deutsch, Urs Graf, and Hans Leu. His outlook stamps him as the last of the Late Gothic masters, while his sweeping composition, his use of light and his broad range of colors give his pictures a distinctly modern character. Both his forms and his subject matter, however, show that he was untouched by the Renaissance interest in classical antiquity.

About two dozen altar panels by his hand have survived (mostly in Basel and Fribourg), but not a single complete altarpiece. They enable us to trace his evolution from 1500 to 1514, beginning with works of a studied realism. In addition to its great altarpiece by the Fribourg Master of the Carnation and an impressive carved altarpiece by an anonymous master (1513), the church of the Cordeliers in Fribourg also contains the largest and finest work by Hans Fries: two altar panels with *Saint Anthony of Padua Preaching at the Funeral of a Miser*. At the top of the right-hand panel, in an upper chamber, is the deathbed scene; below, the miser's heirs open his hoards and find there his bleeding heart, illustrating the New Testament saying, "Where your treasure is, there will your heart be also." At the top, spanning both panels, is the miser's soul being carried off by devils. This altarpiece dates from the brief interval between the execution of Savonarola and the Reformation. The harsh indictment of the mercenary spirit of the new merchant class is not just part of the prescribed theme; it is the artist's personal message, conveyed here and in other works like the two Apocalypse panels and perpetuating the mysticism of the Late Middle Ages. In spite of its modern features, the *Saint Anthony Altarpiece* remains in its forms and design a Late Gothic work: four episodes are represented simultaneously on the two remaining panels, space is indicated schematically, and proportions are often unrealistic.

Hans Fries (c. 1460-c. 1523):

Virgin and Child. c. 1500
Pen and ink wash, 10¼ × 7½"
Staatliche Graphische Sammlung, Munich

Martyrdom of Saint John the Evangelist. 1514
Tempera on panel, 49¼ × 29½"
Öffentliche Kunstsammlung, Basel

Saint Anthony of Padua Preaching at the Funeral of a Miser. 1506
Altar panels. Tempera
Each panel 69½ × 28½"
Church of the Cordeliers, Fribourg ▷

To begin with, Fries took inspiration from the Bern Master of the Carnation and from Heinrich Büchler. Then, during his pilgrimage years he was influenced by the painting of South Germany and Austria. At the very end of the fifteenth century, he settled in Basel as a full-fledged master; he moved on to Fribourg, where for ten years he was town painter, and finally settled in Bern. His mature style is akin to that of his Augsburg contemporaries, Hans Holbein the Elder and Hans Burgkmair; it also shares common features with that of Lucas Cranach the Elder. In most of Fries' paintings, the figures, precisely and painstakingly drawn, and clad in draperies with sharp-edged folds, are set off by a complex architectural background. The contrast is emphasized by the broad cool surfaces of the buildings and the warm intense colors of the figures, modeled in arbitrary patterns by the impinging light. In the nine extant panels of the *Altarpiece of the Virgin*, scenes of middle-class life appear under the influence of Dürer's graphic art. The *Martyrdom of Saint John the Evangelist in a Cauldron of Boiling Oil* also derives from a print by Dürer, but the astonishing color effects of the flames are very much the artist's own. Here, as always with Fries, naturalism is subordinated to stylization.

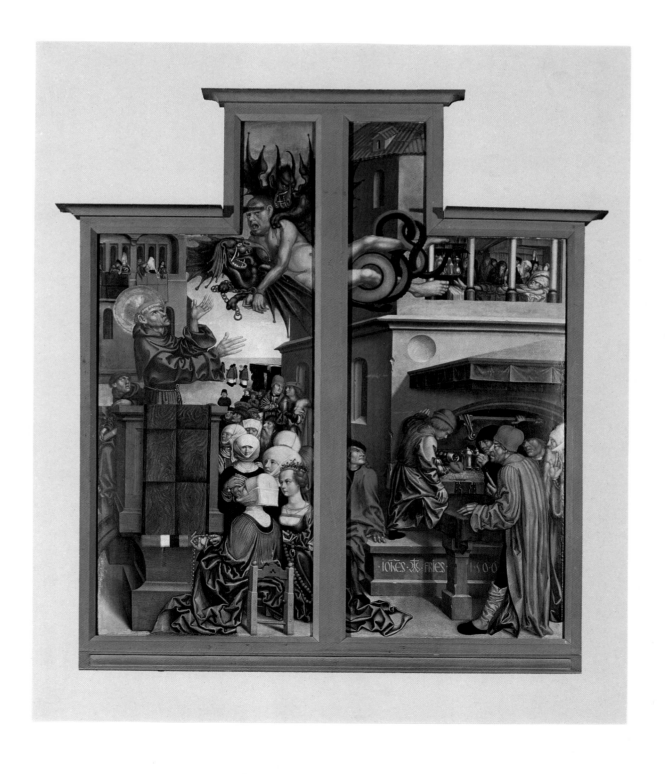

Late Gothic Tapestry

Switzerland played no part in the history of the great cycles of tapestries woven in Flanders, France, and Italy from the Middle Ages to the eighteenth century. It did, however, in the period from about 1440 to 1500, develop a peculiar type of small tapestry of its own, of which about a hundred examples are extant (mostly in the Historical Museum, Basel, and the Swiss National Museum, Zurich). They represent a late but most attractive flowering of Gothic art. As an expression of the national spirit, they have a place beside the illustrated chronicles and the heraldic stained-glass windows. Stylistically, they form a coherent group related to the tapestries of the Upper Rhine and Franconia; thanks to the armorial bearings of the donors, many of them can be localized in Basel. They served as altar hangings—hence their elongated format—or as mural decorations in private homes. The themes could therefore be either religious, often taken from the Mirror of Salvation in particular, or secular. Unlike the marriage chests (cassoni) of Renaissance Italy, they make no use of antique themes.

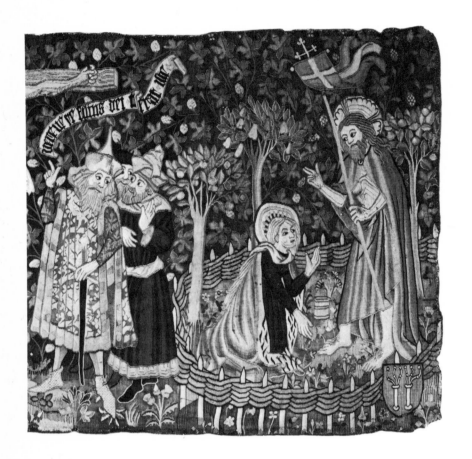

The detail of Christ with Mary Magdalen in the garden is the right side of an antependium from the monastery of Rheinau, showing the Crucifix in the center and on the left the Annunciation in an architectural setting. The trees, represented schematically, stand out against a dark green ground. One of the oldest Swiss tapestries is a fragment in Zurich with fabulous animals. Here there is no attempt at a spatial representation. The lower part consists of flowers, plants, and three small hunting scenes with

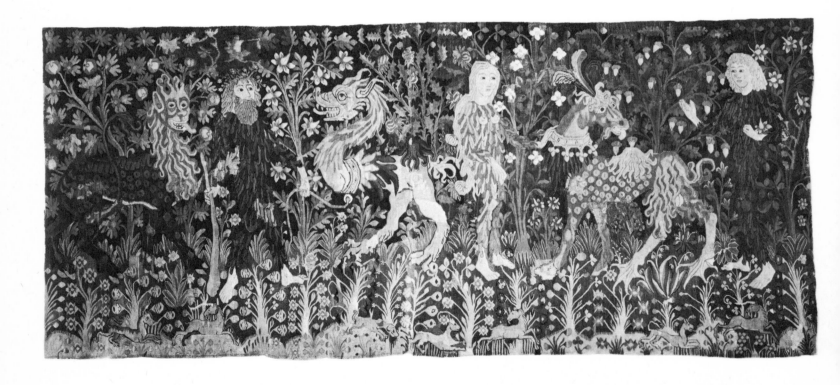

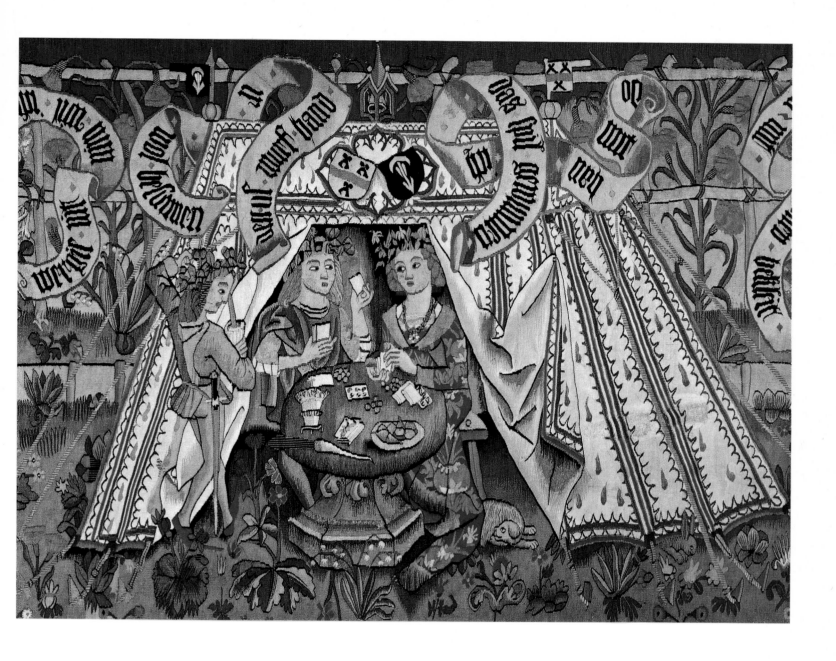

unicorns. In the upper part two wild men and a woman hold three fabulous animals on leashes. These outlandish motifs were common in Gothic art and in medieval poetry and legend. The monster represents the powers of evil and the wild men represent the powers of nature; over these stands love, and the creatures of nature are often combined with pairs of lovers. The commonest themes are those connected with hunting and love; tapestries appear to have been favorite wedding presents. With such a theme as card and chess players, Swiss tapestry approaches more closely the aristocratic world of that day, though with a time-lag as compared with France and Italy. For all the blithe and worldly charm of this card-playing couple in a gaudy tent, with their colorful, courtly clothes, the theme of love, in its lavish symbolism, repeatedly approximates to the religious sphere.

The same spiritual tradition appears in the German graphic art of the Master of the Playing Cards and Master E.S., whose prints, widely circulated in the fifteenth century, were taken up and imitated by weavers in their own medium. In keeping with the technique of tapestry weaving, the hangings make the most of surface patterning and are devoid of plasticity or any illusion of depth. Their charm lies in the decorative arrangement of plants and leafage, of figures and banderoles, standing out against a dark ground.

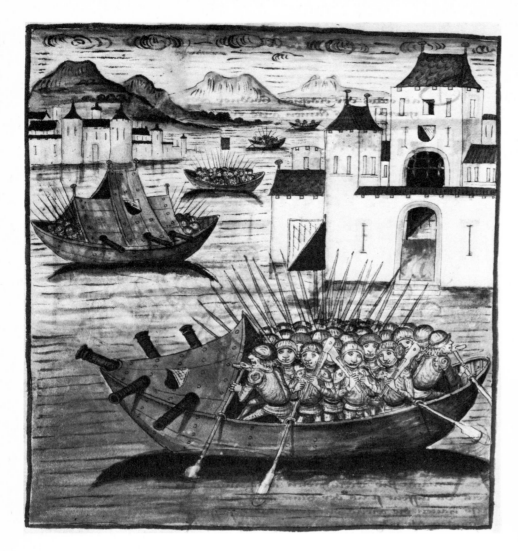

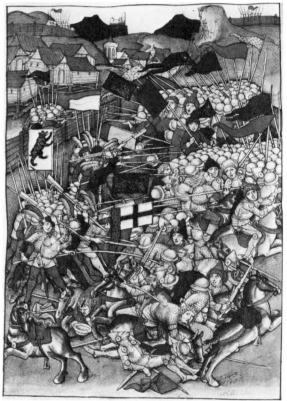

Out of the medieval tradition of illumination and of written but unillustrated historical chronicles, there developed in the late fifteenth century a new type of illustrated chronicle peculiar to Switzerland. Many such manuscripts were produced in the course of a century or more, most of them dealing with the history of the Swiss Confederation from the time of its foundation. The finest of them are those illuminated by Diebold Schilling the Elder and the Younger. They are important not only as art, but as literature and history, as signal memorials of Swiss culture and national politics. About ten of these folio-size manuscripts have come down to us, some of them running to several volumes; the text is adorned with hundreds of full-page illustrations. These are, for the most part, pen drawings, often heightened with watercolor. Surprisingly enough, the artists also wrote the chronicles, but the latter are usually compilations made from earlier writings.

The earliest *Chronicle of Bern* was written and illustrated by Tschachtlan. But it is to Diebold Schilling, the town clerk of Bern, that we owe the most interesting and representative group of illustrated chronicles. The text of his manuscripts is an adaptation from the works of the early Bernese historians Justinger and Fründ, ending, however, with a contribution by Schilling himself. The first two volumes, containing the fine picture of the war fleets of Zurich and Schwyz in line of battle on the Lake of Zurich, are illustrated by another hand. But the third volume, represented here by the *Siege of Waldshut by the Swiss in 1468*, was both written and illustrated by Schilling and it stands out for its quality. Also by his hand are the 340 illustrations of the so-called *Private Chronicle of Spiez*, written by Rudolf von Erlach, which includes a scene with the *Battle of Vögelinsegg*.

Diebold Schilling the Elder (?-1485):

Naval Battle between Zurich and Schwyz on the Lake of Zurich in 1445
(Workshop of Diebold Schilling)
Colored drawing on vellum, 9 × 8″
From the *Official Chronicle of Bern*, 1474 and 1483
Burgerbibliothek, Bern

Battle of Vögelinsegg in 1403
Colored drawing on paper, 14¼ × 8⅝″
From the so-called *Private Chronicle of Spiez*, 1483-1485
Burgerbibliothek, Bern

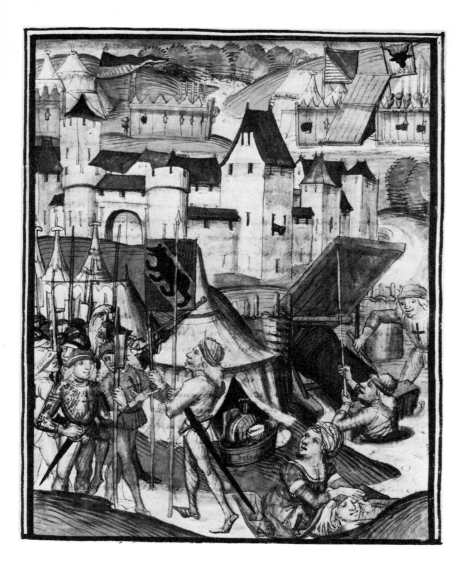

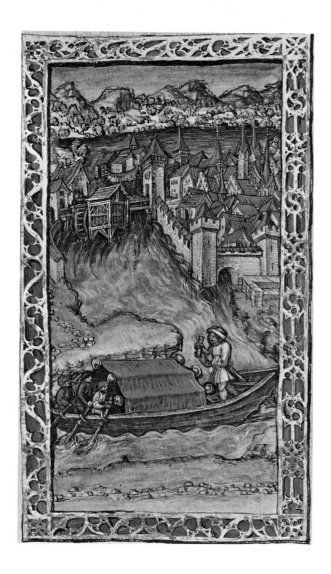

Diebold Schilling the Elder (?-1485)
Bernese Camp at the Siege of Waldshut
by the Swiss in 1468
Colored drawing on vellum, 9¼ × 6⅞″
From the *Official Chronicle of Bern*, 1474 and 1483
Burgerbibliothek, Bern

Diebold Schilling the Younger (1460-after 1515)
Flight of the Antipope John XXIII
from Constance in 1415
Gouache, 15¾ × 11½″
From the *Chronicle of Lucerne*, 1513
Burgerbibliothek, Lucerne

This treasury of lively and picturesque imagery is the Swiss equivalent of the early German woodcuts and engravings which were coming into existence at the very same time. It is useless to look to these Swiss manuscripts for any of the courtly refinement of the miniatures painted in France at the same period by Jean Fouquet. What they do offer is a spirited narrative of appealing amateurism often marked by the use of repetitive formulas. Towns and landscapes are stereotyped, and events of the Middle Ages are rendered with the costumes and urban settings of the fifteenth century. Quite free of princely rhetoric and pathos, these manuscripts convey a vivid picture of the age—the years of the Burgundian wars when the Swiss resoundingly defeated their most powerful and determined enemy, the Duke of Burgundy, and a little later the Swabian wars when they finally broke free for good from the German Empire. The ideal of liberty and independence that impelled the early Swiss is already fully alive in these pages and pictures. In Diebold Schilling's day the Oath of the Rütli and William Tell were already old legends, but legends of lasting significance destined to retain their spiritual and political magnetism down to the eighteenth century, with Schiller, and to the nineteenth, with German historicism.

The most lavishly illustrated chronicle is that of Lucerne by Diebold Schilling the Younger, represented here by the *Flight of the Antipope John XXIII from Constance in 1415*. More than the others, this volume is centered on the pictures, which are all framed and tinted with gouache. The composition is dense and painterly, and the town views are remarkable for their topographical accuracy. The scope of the illustrations goes well beyond war and soldiering, recording many other aspects of late medieval life: the plague, superstition, witch-hunting, religious conflicts.

Painting in the Ticino

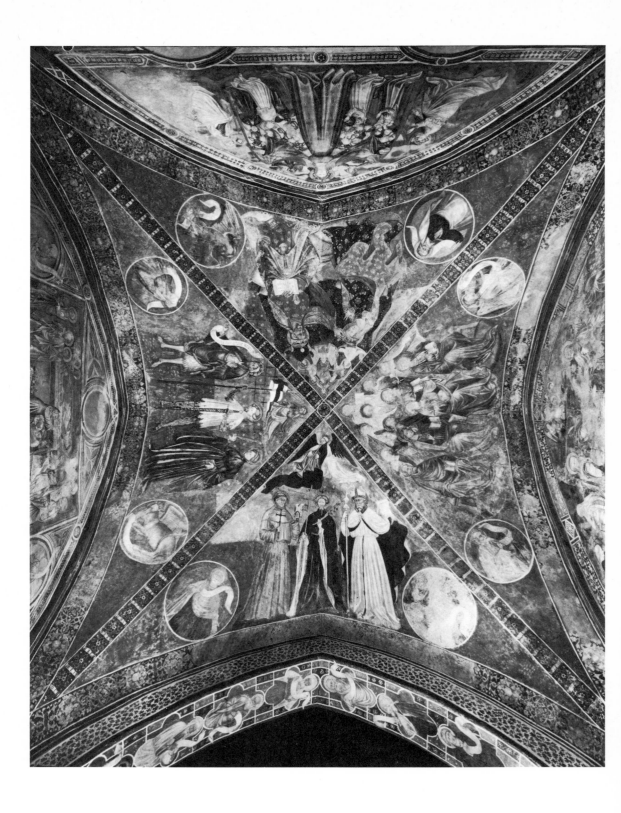

Artistically the Ticino and the southern valleys of the Grisons were at this time a part of Lombardy, even though both came for a few years under Swiss control (they were not to enter the Swiss Confederation until 1803). A number of northern artists, however, such as Niklaus Manuel Deutsch, came into direct contact with the art of North Italy in the course of the Milanese expeditions of 1500-1516, in which Swiss mercenaries took part.

While many church frescoes in the Ticino are merely of provincial interest, there are two cycles of about 1400, belonging to the International Style, which rise far above the average. The first is the *Last Judgment* in the Ghirli church at Campione, on Lake Lugano. This church is a treasure chest of Lombard painting from the fourteenth to the seventeenth century; as early as about 1365 a cycle of frescoes on Saint John the Baptist was executed there in the Giottesque tradition of the school of Giovanni da Milano. The church of Santa Maria in Selva, near Locarno, also possessed an extensive series of fifteenth-century wall paint-

Locarno (Ticino),
Church of Santa Maria in Selva
Virgin of Mercy, Coronation of the Virgin,
and *Apostles and Saints*
1400-1410. Ceiling fresco

54

ings, but only those in the choir chapel have survived; they date to about 1400-1410. On the east side of the vaulted ceiling, above the *Virgin of Mercy* with outspread mantle and the *Crucifix*, is the *Coronation of the Virgin*, with the seated Apostles looking on from the neighboring compartment together with six saints in the two other compartments. The long slender figures, the sinuous draperies, fashionable clothes, and refined coloring reveal the genial, courtly style of the Milanese school. These very fine paintings, probably by the workshop or entourage of Giovannino de' Grassi, show stylistic affinities with contemporary Burgundian art and illumination. In the following decades the art of the Ticino failed to maintain this high level of achievement.

The high point of Renaissance painting in the Ticino was reached between 1510 and 1530, and the altarpiece by Giovanni Antonio de Lagaia, the only known work by this artist from Ascona, is typical of the Lombard Renaissance. The upper part represents the *Annunciation* and the *Assumption*, the lower part the *Virgin of Mercy*, sheltering a group of figures under her mantle, to whom the church is dedicated. The stiff, hieratic style of this altarpiece derives from the Milanese master Ambrogio Borgognone. At San Biagio, near Bellinzona, an altarpiece with the *Virgin and Child with Saint Blaise and Saint Jerome*, dated 1520, is the work of Domenico Sursnicus (or Firgnicus) of the Lake of Lugano. The style is broader and more painterly, the color scheme rich and brilliant, and the figures stand against a landscape background.

Giovanni Antonio de Lagaia of Ascona
Polyptych of the Virgin of Mercy
1519. Oil on panel
Church of Santa Maria della
Misericordia, Ascona (Ticino)

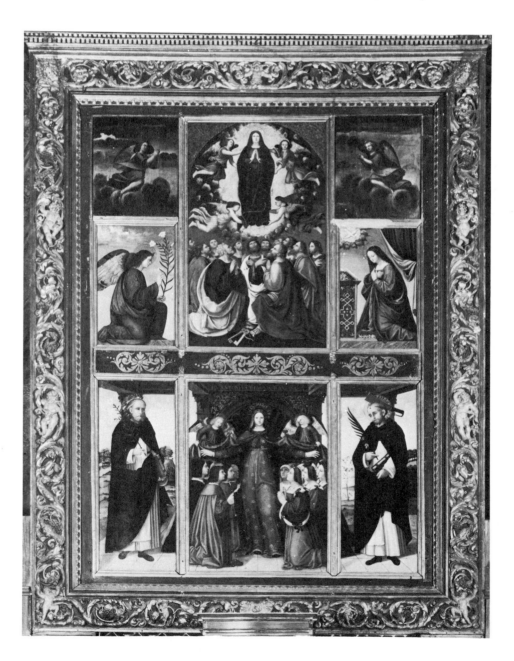

Among the grandest Renaissance frescoes in the Ticino are two extensive series of Passion scenes covering entire walls in churches at Bellinzona and Lugano. Indeed, Santa Maria delle Grazie at Bellinzona is like a museum of Lombard and Piedmontese painting in the 1500s. The scenes from the *Annunciation* to the *Resurrection* are set off by painted frames; the realistic style of this anonymous cycle derives directly from Gaudenzio Ferrari (Varallo frescoes) and Spanzotti (Ivrea frescoes). In the same church two other frescoes of the *Annunciation* and the *Dormition of the Virgin* may be by the young Ferrari himself. At Lugano, in the Franciscan church of Santa Maria degli Angioli, Bernardino Luini painted in 1529 the largest work of his later years. The *Calvary* and its many figures occupy the foreground, while the other scenes of the Passion are set out in the middle distance. Luini also painted a Leonardesque *Virgin and Child* in the same church and two fine altarpieces in the church of Magadino. The art of the Ticino is thus seen to depend heavily on Italian contributions. Some architects, sculptors, and painters of the Ticino, including the famous Andrea Solario, spent their whole career in Italy, while many Italians worked in the Ticino, among them Bramantino and Bernardino de' Conti at the Madonna del Sasso in Locarno. Leonardo's *Last Supper* was copied in 1547 at Ponte Capriasca and, in a popular style, at Roveredo. Michelangelo's *Last Judgment* was copied by G.D. Pezzi at San Giorgio of Carona in 1584. Another impressive *Last Judgment* was painted by Tarilli at Giornico in 1589.

Bernardino Luini (1480/90-1532)
Choir screen with Passion scenes
1529. Fresco
Church of Santa Maria degli
Angioli, Lugano (Ticino)

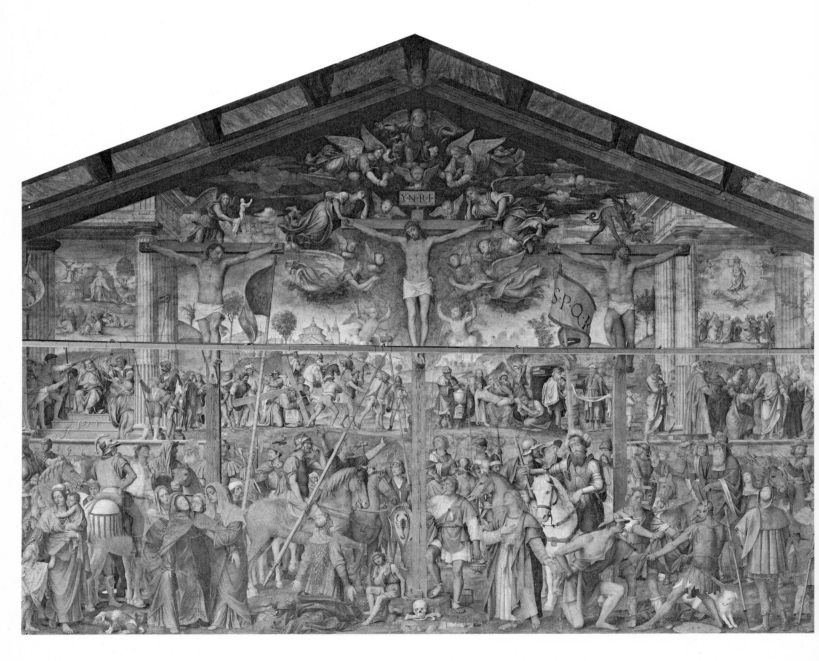

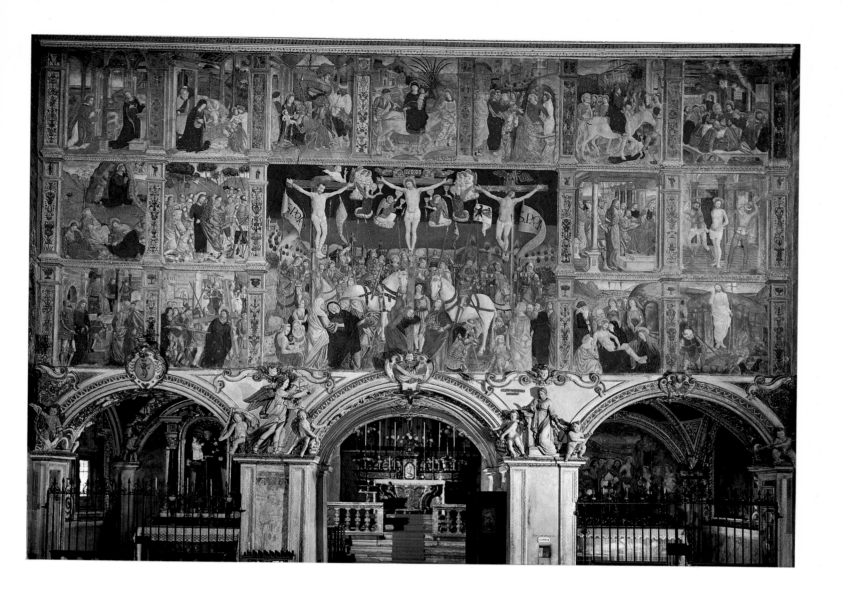

Bellinzona (Ticino), Church of Santa Maria delle Grazie
Choir screen with Scenes from the
Life of Christ. c. 1500. Fresco

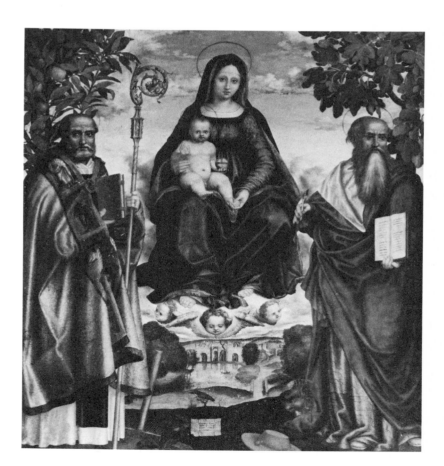

Domenico Sursnicus (or Firgnicus) of the Lake of Lugano
Virgin and Child with Saint Blaise and Saint Jerome
1520. Oil on panel
Church of San Biagio,
Ravecchia near Bellinzona (Ticino)

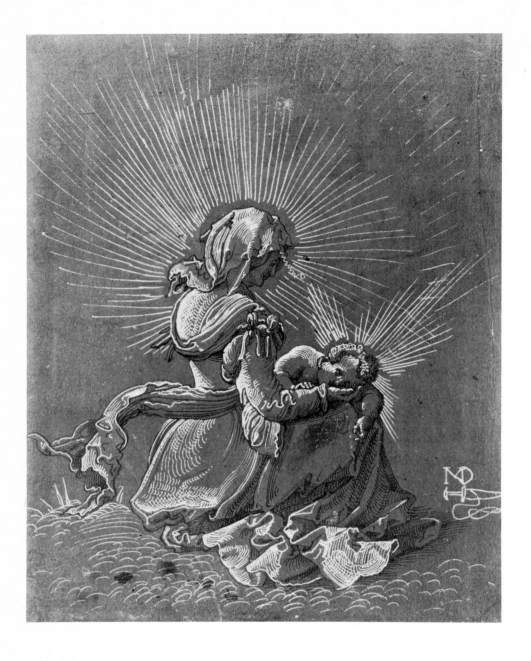

Niklaus Manuel Deutsch

Niklaus Manuel Deutsch (1484-1530)
Virgin and Child
Pen and ink with
white highlights, 9¼ × 7¼″
Staatliche Kunsthalle, Karlsruhe

The art of the Renaissance, a brilliant but all too brief period in Switzerland, is represented by three almost exactly contemporary masters: Niklaus Manuel Deutsch, Urs Graf, and Hans Leu the Younger. Generally speaking, the Swiss artists worked in the spirit of the German Renaissance masters, their elders by a few years, but their local characteristics remain unmistakable. Manuel— "Deutsch" being the translation of the family name Alleman—is the most interesting and versatile personality of them all, and a worthy contemporary of Altdorfer and Baldung. He was not only a painter of the first rank, but a practicing poet, an army officer, and a Bernese statesman; from 1523 on, he was governor of the district of Erlach. His output included altarpieces, pictures on secular themes, wall paintings, and a considerable graphic work. Among the Swiss artists of the Renaissance, he is the only one who can be said to embody the humanist ideal of creative activity in many fields, and in all of them his strong personality is stamped on his work. Twice he served with the Swiss mercenaries in their Italian campaigns, acting as military chronicler, and soldiering provided the themes of many of his pictures and drawings; he added a dagger to his monogram, and his verse is characterized by an unflinching frankness and pungency. He illustrated the, for him, familiar theme of death, for example in the drawing at the beginning of this chapter (page 34) and in the *Martyrdom of the Ten Thousand* (Grandson Altarpiece, 1517); it is a theme that occurs frequently in Swiss painting after the incessant wars of the fifteenth century.

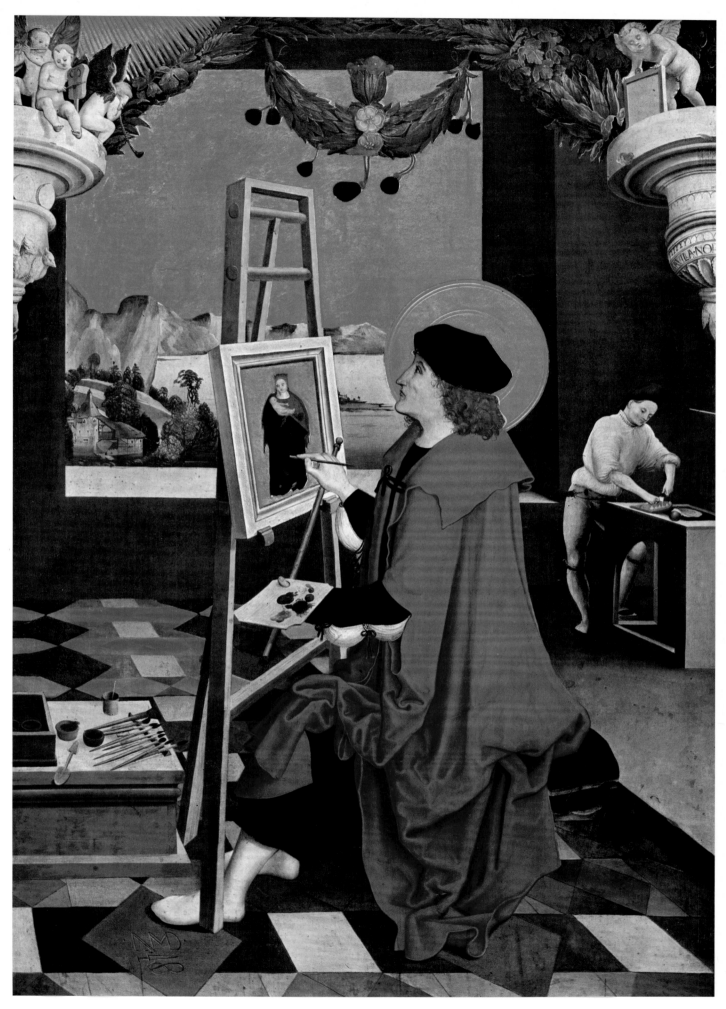

Niklaus Manuel Deutsch (1484-1530): *Saint Luke Painting the Virgin.* 1515
Altar panel. Tempera, 46 × 32 ¼″. Kunstmuseum, Bern

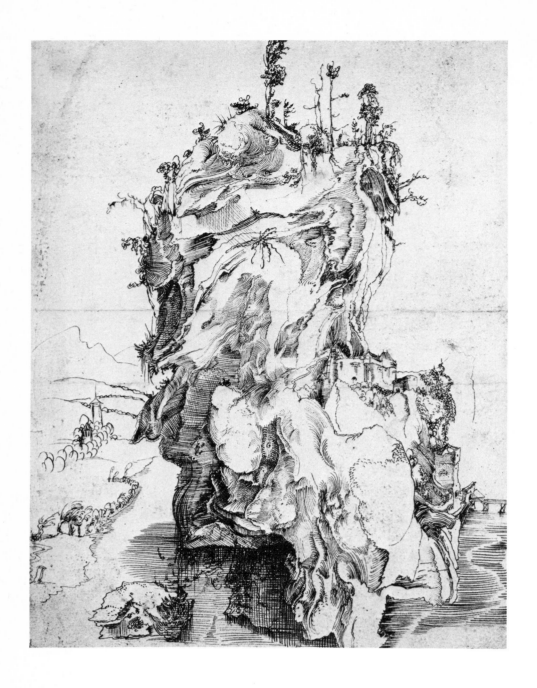

Niklaus Manuel Deutsch (1484-1530)
A Rocky Island
Pen and ink, 10 ¼ × 7 ⅞″
Staatliche Museen, Berlin

Manuel's art, vigorous and earthy, is based on his first hand experience of life and its often crude realities. Details of clothing and landscape are carefully delineated. His works sometimes have a didactic purpose; such was that of the *Dance of Death* in the Dominican church in Bern, once his most famous painting. They are steeped in a poetic quality that is most clearly felt in the colors and the mood-creating landscapes. All this is characteristic of the Bernese spirit at its best, as embodied in the art of Niklaus Manuel Deutsch.

He received his training in Bern, possibly from the Bernese Master of the Carnation and Hans Fries. He was a wholehearted supporter of the Reformation, in which the iconoclasts destroyed most of his paintings. On the strength of a few dated works, it is possible to follow his rather brief career as a painter, spanning about ten years, and to trace his evolution toward a picturesque style characterized by a rich interplay of surface effects. Among his early pictures are *Saint Luke Painting the Virgin* and *Saint Eligius in His Workshop*. Like Vermeer over a century later, Manuel did not represent the artist's or craftsman's atelier realistically; he represented an ideal space, but one that is soundly designed and ordered with luminous clarity. In the small panel with the *Beheading of Saint John the Baptist*, one of his masterpieces, the action of the elegantly dressed figures is dramatized. In the background, closed off by stone walls on either side and the gold garland overhead, the fatal moment is marked by a storm bursting

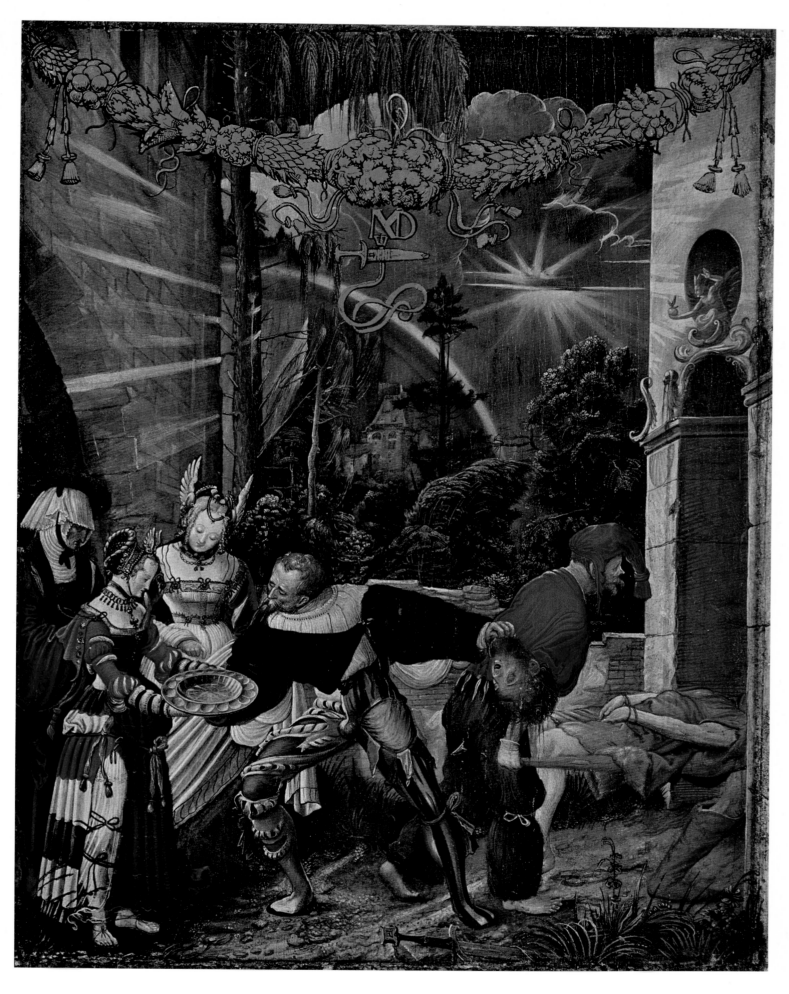

Niklaus Manuel Deutsch (1484-1530)
Beheading of Saint John the Baptist. Tempera on panel, 13 × 10″
Öffentliche Kunstsammlung, Basel

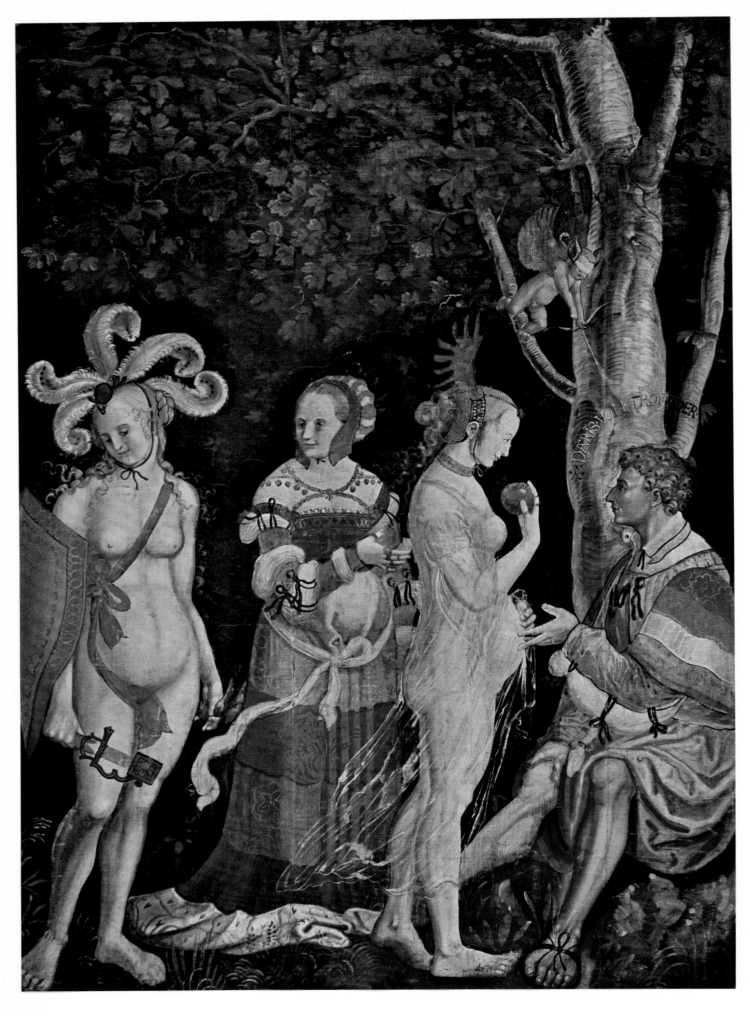

Niklaus Manuel Deutsch (1484-1530): *Judgment of Paris*
Tempera on canvas, 88 × 63″. Öffentliche Kunstsammlung, Basel

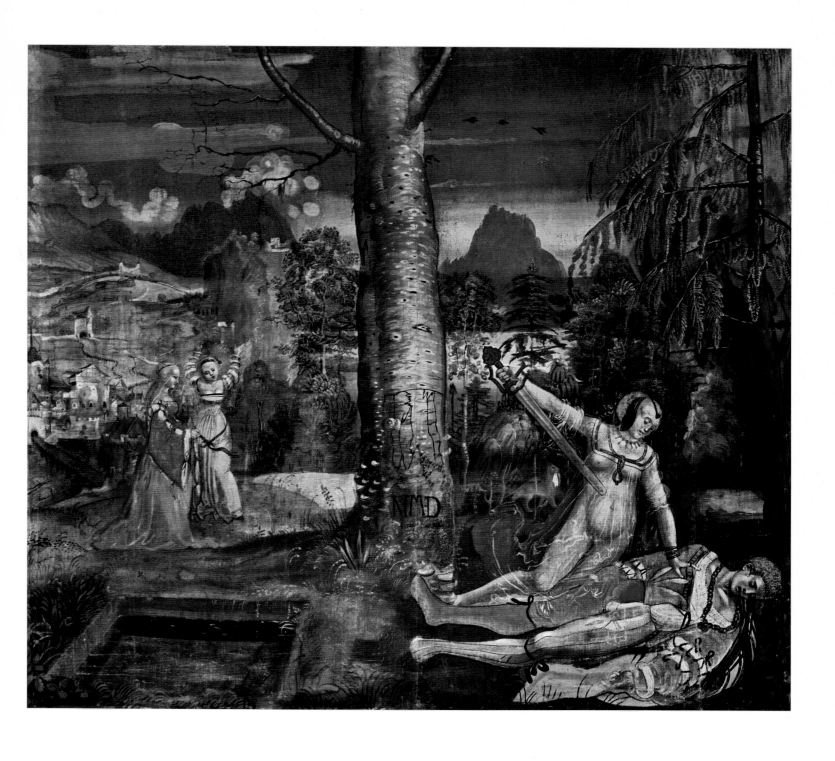

Niklaus Manuel Deutsch (1484-1530)
Pyramus and Thisbe
Tempera on canvas, 59¾ × 63½″
Öffentliche Kunstsammlung, Basel

over the landscape; a comet flashing across a visionary sky points toward the saint's head (a detail taken from the *Golden Legend*). Such cosmic landscapes reappear in the *Saint Anthony Altarpiece* of 1520, a work which shows that Manuel was familiar with Grünewald's *Isenheim Altarpiece*. The 140 surviving drawings represent a very wide range of expression and techniques. Most of them are works of original inspiration in which the artist gives free rein to his imagination. The line is calligraphic. The drawing of a high rocky island, in Berlin, has an Oriental flavor but may have been inspired by Dürer's *Saint Jerome*; the seated, radiant Virgin in Karlsruhe invites comparison with the title page of Dürer's *Life of the Virgin*. A few tempera paintings on canvas, whose dry pigment is reminiscent of frescoes or hangings, appear to belong to his early maturity: the *Judgment of Paris* and *Pyramus and Thisbe* were common themes of the period. The nocturnal setting of the latter, with its eerie atmosphere and imaginary lake landscape, marks an important stage in the advance toward the discovery of nature, undertaken at the same period by the masters of the Danube School.

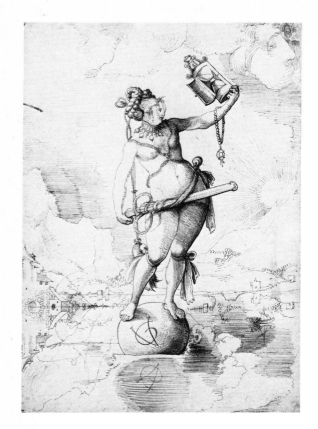

An exact contemporary of Niklaus Manuel Deutsch, Urs Graf spent his early years at Solothurn, a free imperial town which had joined the Swiss Confederation in 1481, shortly before his birth. A goldsmith like his father, he completed his training in Strasbourg and Zurich and settled in Basel as a practicing goldsmith in 1509. Like Manuel, he served with the Swiss mercenaries in the Italian campaigns, which took him as far as Rome; and so like Manuel he adopted the soldier's dagger as part of his monogram. He was active chiefly as a stained-glass designer, an engraver, and a medallist, rarely as a painter. Over a hundred woodcuts by him are known, often containing ornaments in the Renaissance style taken over from Dürer and French graphic art.

His most original works are some two hundred fanciful and uninhibited drawings. Almost all are pen drawings and the unerring line reveals him as a born draftsman. Brisk, lively, often humorous, most of them are figure studies; but some, among the finest, are completed with landscape elements. The themes are usually taken straight from the life he knew so well: mercenaries, peasants, lovers, women of easy virtue. Some are genre scenes of more general import, either with mordant allusions to the vanity of life or in the guise of classical subjects like satyrs or Phyllis and Aristotle. In his adventurous life as a mercenary, Graf had more than one brush with death, which he sometimes included as a lurking, fiendish presence in his drawings. For example, in a recruiting scene, with a French officer trying to hire the seated Swiss mercenary with a broad-brimmed hat, and with a German lansquenet on the left, he comments ironically on the trade of soldiering by means of the exultant skeleton on the left and the laughing zany at the end of the table on the right. The fickle figure of Fortune on a floating sphere is certainly more than a stock device for Graf: it is a familiar reality. It is also—like Manuel's *Fortune* in Basel—a continuation and a parody of Dürer's *Nemesis*.

Spatial transparency is suggested by pure line with masterly economy of means. The large sheet in Basel with the *Naked Woman Stabbing Herself* is one of his most elaborate and well-knit compositions. The bare and broken treetrunk (a frequent motif with Graf), the unfurling scroll, and the lake landscape frame the dramatic figure, which suggests the theme of Lucretia and also brings to mind the figure of Thisbe in Manuel's painting. Graf's drawing, however, would appear to be a reflection of some personal experience rather than a treatment of a literary theme.

Urs Graf

Urs Graf (1485-1529):

Fortune on a Floating Sphere. c. 1516
Pen and ink, 12½ × 8⅜″
Öffentliche Kunstsammlung, Basel

Recruiting Scene with a Swiss Mercenary and French and German Soldiers.
Pen and ink, 8⅜ × 12½″
Öffentliche Kunstsammlung, Basel

Naked Woman Stabbing Herself. 1523
Pen and ink, 12⅞ × 8⅞″
Öffentliche Kunstsammlung, Basel ▷

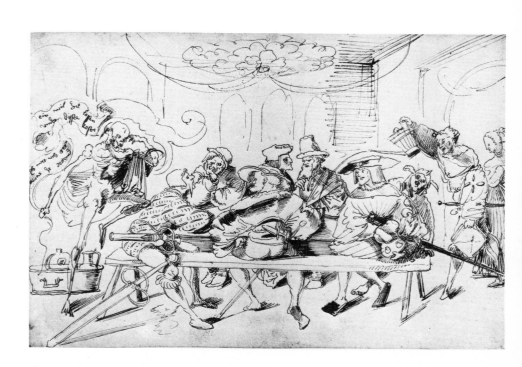

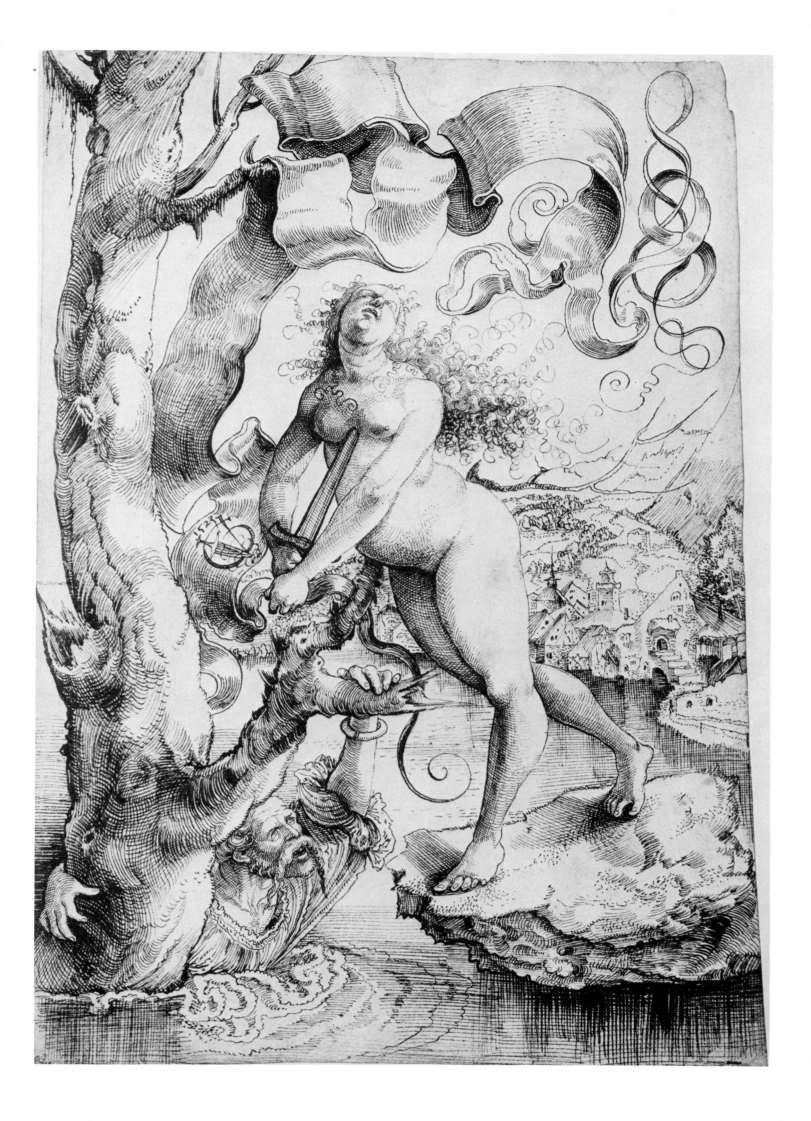

Hans Leu the Younger

Niklaus Manuel Deutsch and Urs Graf are inseparable from a third master of the same generation: Hans Leu the Younger of Zurich. All three served as mercenaries. Leu shared Manuel's keen interest in landscape, and like Graf he led a profligate, swashbuckling life which continually got him into trouble. He was trained in the studio of his father, Hans Leu the Elder, whom one would like to identify with the Zurich Master of the Carnation. In the course of his early wanderings in South Germany he came into contact with Dürer, with his exact contemporary Hans Baldung Grien, and also with the masters of the Danube School. All his Zurich altarpieces and his wall paintings were destroyed during the Reformation. By the irony of fate he himself was killed fighting on the side of the Reformers at the battle of the Gubel (1531).

Judging by the small number of drawings and canvases that have been preserved, Leu was the most poetic artist of the Swiss Renaissance. His art illustrates the new feeling for nature and the discovery of landscape. Perhaps the best example is his unfinished picture of *Orpheus* as a bearded minstrel charming the trees and animals with his music. Behind him stretches a Swiss mountain landscape, laid out with unobtrusive symmetry and carefully framed by two trees. Across receding planes of different tones, the eye is led smoothly from the figure of Orpheus to the Alpine peaks and the gleaming horizon beyond. Unlike

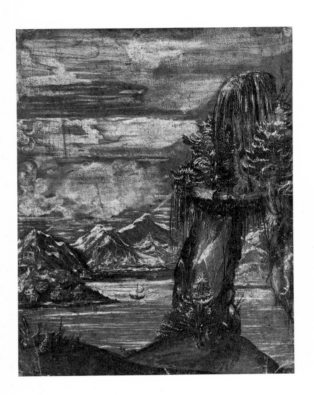

Hans Leu the Younger (c. 1490-1531):

Lake and Mountain Landscape
Gouache on tinted paper,
10⅞ × 8⅜''
Öffentliche Kunstsammlung, Basel

Virgin Mourning the Dead Christ. 1519
Pen and ink wash with white highlights,
10⅞ × 8⅛''
By courtesy of the Fogg Art Museum,
Harvard University, Cambridge, Mass.

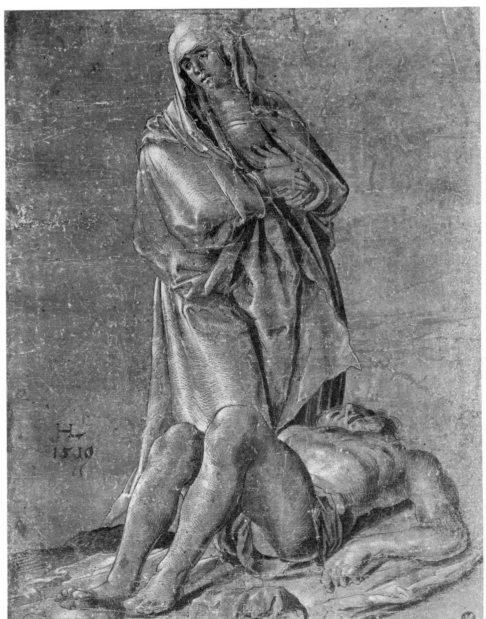

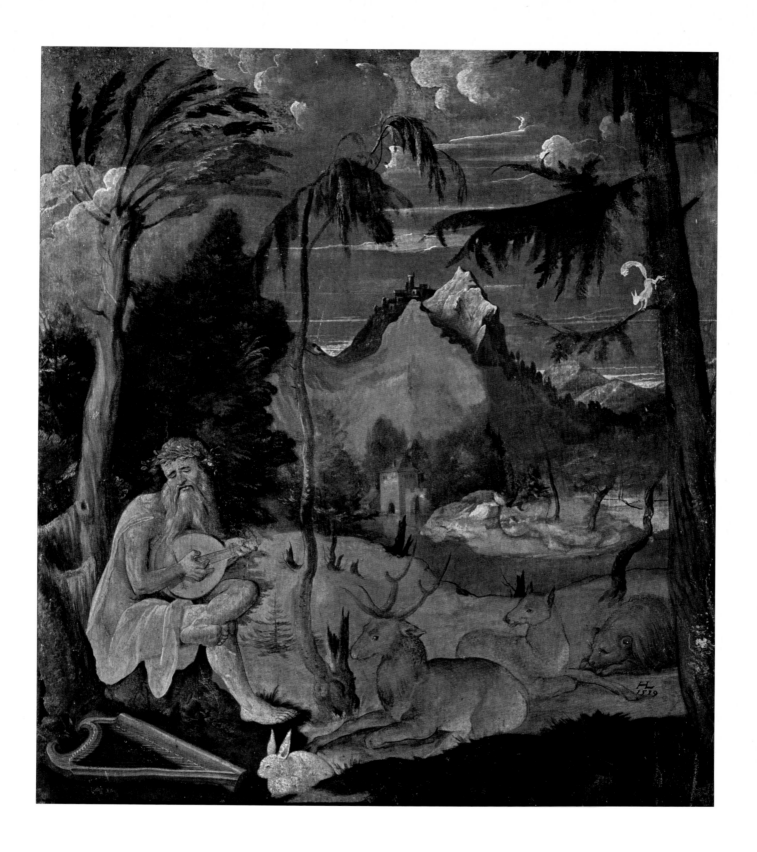

Hans Leu the Younger
(c. 1490-1531)
*Orpheus Charming
the Animals*. 1519
Tempera on canvas, 22⅞ × 20⅛″
Öffentliche Kunstsammlung, Basel

the objective topography of Witz, this fanciful landscape suggests the union of man, wild life, and nature in the spell of a common emotion. While Witz made use of verticals and horizontals, the composition here is based on curving lines; even the treetrunks seem to spiral upward.

In the two dozen surviving drawings, Leu shows his kinship with Altdorfer and Wolf Huber. Most of them are pen drawings, in a deft, sometimes outlandish calligraphy. Leu rarely drew on a tinted ground, as he did in the romantic *Lake and Mountain Landscape*, with a tree-like rock in the foreground and glaciers rising in the background. Distance, reflections, and sky are effectively suggested by white highlights. In the fine figure drawing of the *Virgin Mourning the Dead Christ*, Leu displays a depth of feeling only matched by Dürer and Baldung.

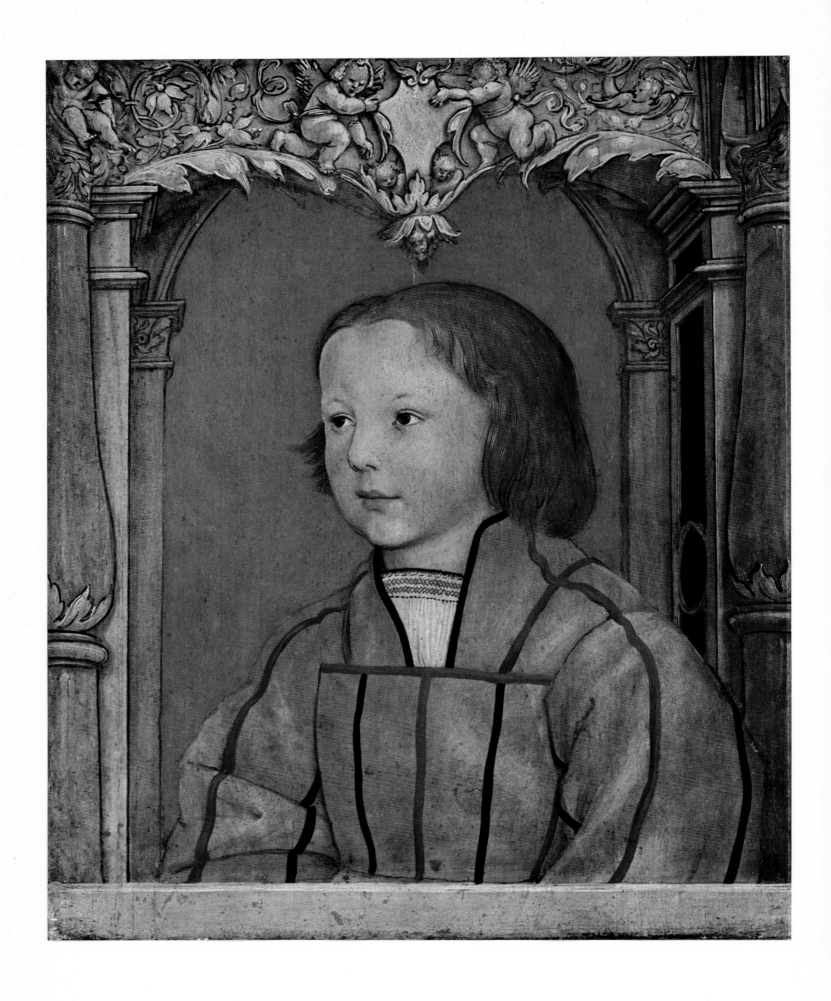

Ambrosius Holbein (1494?-1519?)
Portrait of a Boy. c. 1516
Tempera on panel, 13 ¼ × 10 ⅝″
Öffentliche Kunstsammlung, Basel

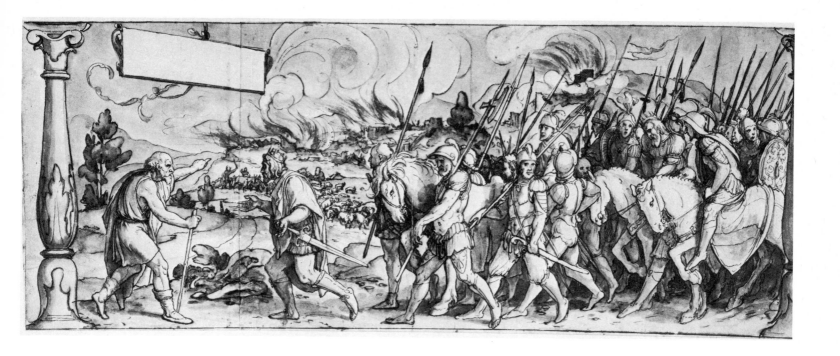

Ambrosius and Hans Holbein

Hans Holbein (1497/98 -1543)
The Prophet Samuel Cursing Saul. 1530
Design for a decoration
in the Basel Town Hall
Pen and ink with watercolor, 8 ¼ × 20 ⅞″
Öffentliche Kunstsammlung, Basel

The first three decades of the sixteenth century are unique in the history of painting in Switzerland for their wealth of fine work. The heritage of Late Gothic art was enriched and expanded by the powerful personalities of the Renaissance masters, until the Reformation put a drastic end to this flowering. The series of major painters culminated in Hans Holbein the Younger, the only one of them who continued his career abroad and whose genius is comparable to that of the great Italian and German masters of the High Renaissance. The younger son of an important Augsburg painter of the same name, he was trained in his father's studio but settled in Basel about 1514, where he worked with some interruptions for the next dozen years and became a citizen. From 1526 he worked chiefly in London, where he became court painter to Henry VIII and where his art and personality acquired an international character.

Basel was then the most thriving and cosmopolitan of the Swiss towns (it had joined the Confederation in 1501). To its banks and merchants, its annual fair, and its position on the Upper Rhine, it owed its importance as a great commercial center. The university, founded in 1460, the printing and publishing firms of Amerbach, Froben, and others, and the presence of Erasmus made it an outstanding intellectual center. Hans Holbein settled there with his elder brother Ambrosius, who was entered as a master painter in the Basel guild in 1517 and died soon afterward at the age of about twenty-five. The surviving works of Ambrosius consist of panel paintings and drawings, among them some very sensitive and attractive portraits, like this *Portrait of a Boy*, which is one of a pair (perhaps of twins) painted in the same tones but with different settings. Its unusual effect is due to the spare linear design, the color scheme reduced to two main tones, and the contrast between the figure and the architectural setting in the Augsburg style; the subtle modeling enhances the beauty of this panel.

The varied output of Hans Holbein ranges from façade paintings to miniatures; it includes altarpieces, portraits, drawings, and designs for stained glass, jewelry, and title pages for the Basel printers. All his wall paintings, notably the great façades in Lucerne and Basel, have been destroyed. His famous decorations in the council room of the newly built Town Hall in Basel are known from copies, preparatory designs, and a few fragments. As in the old Town Halls of

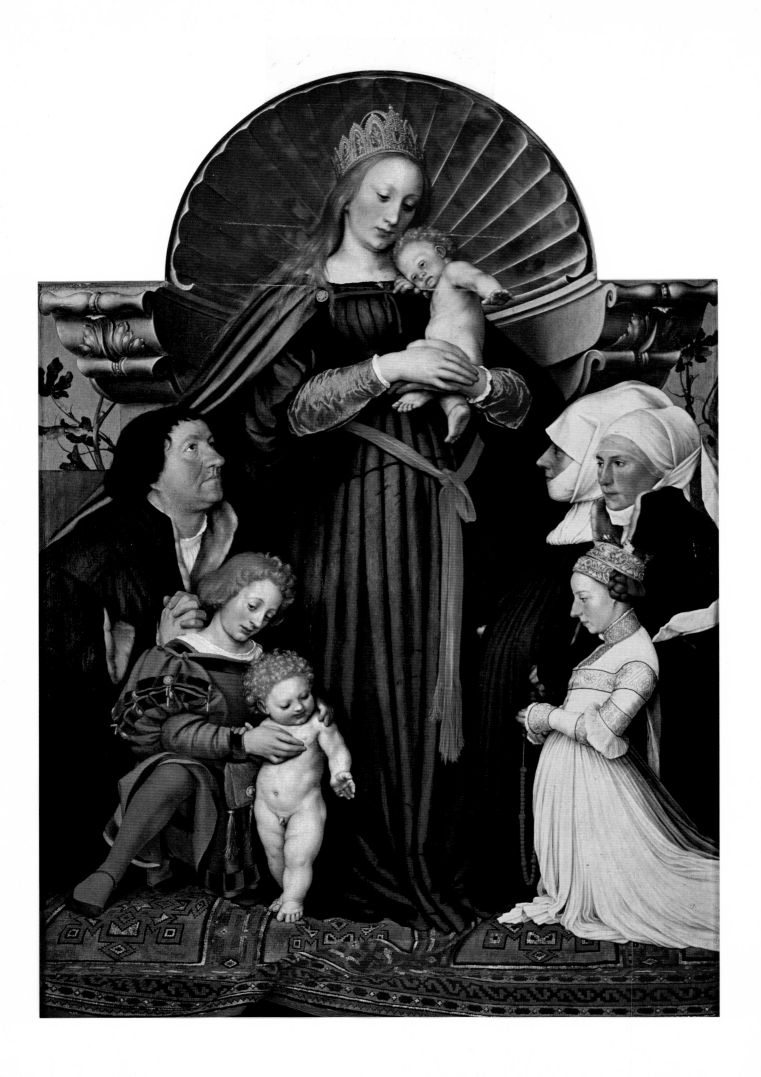

Hans Holbein (1497/98-1543):

◁ *Virgin of Mercy with
the Family of Burgomaster Jakob Meyer*
1526 and 1528-1529
Oil on panel, 57¾ × 40¼″
Collection of Prince Ludwig von Hessen,
Ducal Palace, Darmstadt

Annunciation
Design for a stained-glass window
Pen and ink, 15¾ × 11⅞″
Öffentliche Kunstsammlung, Basel

Saint Catherine
Design for a stained-glass window
Pen and ink wash, 23⅝ × 14¾″
Öffentliche Kunstsammlung, Basel

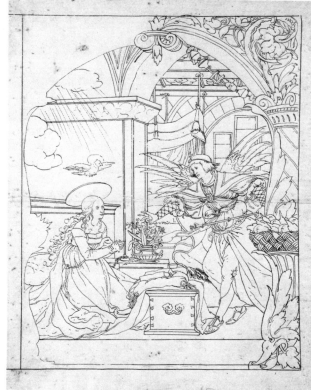

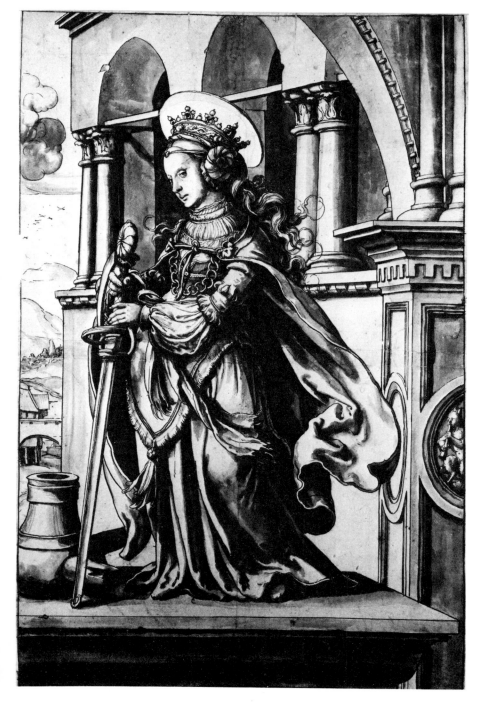

the Low Countries and Italy, the humanist program
called for scenes from the Old Testament and classi-
cal antiquity illustrating honor, integrity, and jus-
tice. Holbein's finest surviving study shows *Samuel
Cursing Saul* for failing to destroy the Amalekites
completely; the implied cruelty of the theme was
characteristic of the early Reformation.

Among the works of Holbein's Basel period are
altarpieces, the predella with the *Dead Christ*,
woodcut designs for the Old Testament, and por-
traits. Altar painting and portraiture are magnif-
icently combined in the *Virgin of Mercy with the
Family of Burgomaster Jakob Meyer*, Holbein's most
influential patron in Basel. The composition is
monumental, the execution plastic and highly
finished. The kneeling donors sheltered under the
Virgin's outspread mantle give a worldly tone to
the picture. By contrast, a portrait of Holbein's
wife and two children has more of a sacred charac-
ter. Unlike his elders, Dürer and Manuel, Holbein
was fully at home with High Renaissance art and
his contact with Lombard painting is reflected in
his work. Having assimilated the classical spirit un-
derlying the Renaissance, he proved himself an ob-
jective, self-assured master, whose art was soundly
based on line. His designs for stained glass are
superlative pen drawings; modeling is created by
ink washes, and the restless, expressive line of pre-
decessors like Manuel and Graf has given place to a

71

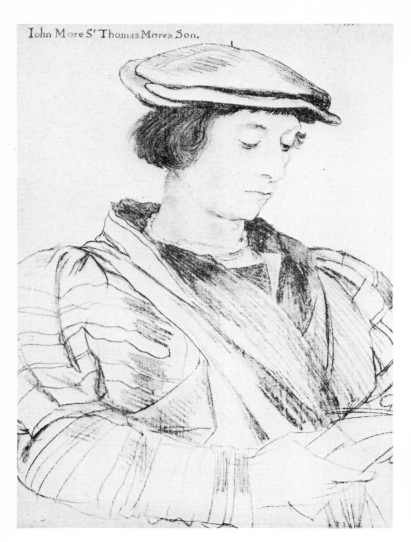

Iohn More Sᵗ Thomas Mores Son.

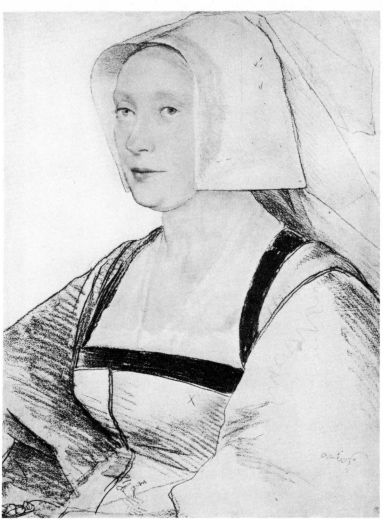

Hans Holbein (1497/98-1543):

John More, Sir Thomas More's Son
1526-1528
Pencil and charcoal heightened with color
Royal Library, Windsor Castle

Lady with a White Cap. 1526-1528
Pencil and charcoal heightened with color
Royal Library, Windsor Castle

serene mastery. Set out with the utmost clarity, forms have the effortless breadth of High Renaissance art.

The disturbances of the Reformation prompted him to move to London in 1526; after returning to Basel for a time (1528-1532), he settled in London for good in 1532. There, too, religious painting was practically banned, but there was no lack of portrait commissions. Recommended by his friend Erasmus, he worked at first for Sir Thomas More, then for the German Steelyard merchants, and finally for Henry VIII; court patronage, however, failed to exploit the full range of his matchless talents. Among the masterpieces of his English period are the *Group Portrait of the More Family* (1526, lost but known from copies), the double portrait of *The French Ambassadors* (1533, National Gallery, London), and the wall painting in Whitehall Palace of Henry VIII with his father and mother and his third wife, Jane Seymour (1537, lost but known from copies). Compared with the Basel portraits, which are still linked with the German tradition, the English ones reveal a noble and harmonious perfection well calculated to satisfy the merchants and aristocrats of London. His method was to make careful drawings of the sitter, often in colored chalk (a medium taken over from the school of Leonardo), and to paint from them. Thanks to his powers of observation and detachment, Holbein was able to capture a personality in its totality. His motionless, expressionless, flawlessly designed portraits are arresting in their immediacy and internal cohesion. In spite of the wealth of details, it is the overall effect that remains dominant. His portraits are among the great masterpieces of European painting and set the course of English portraiture down to the time of Van Dyck.

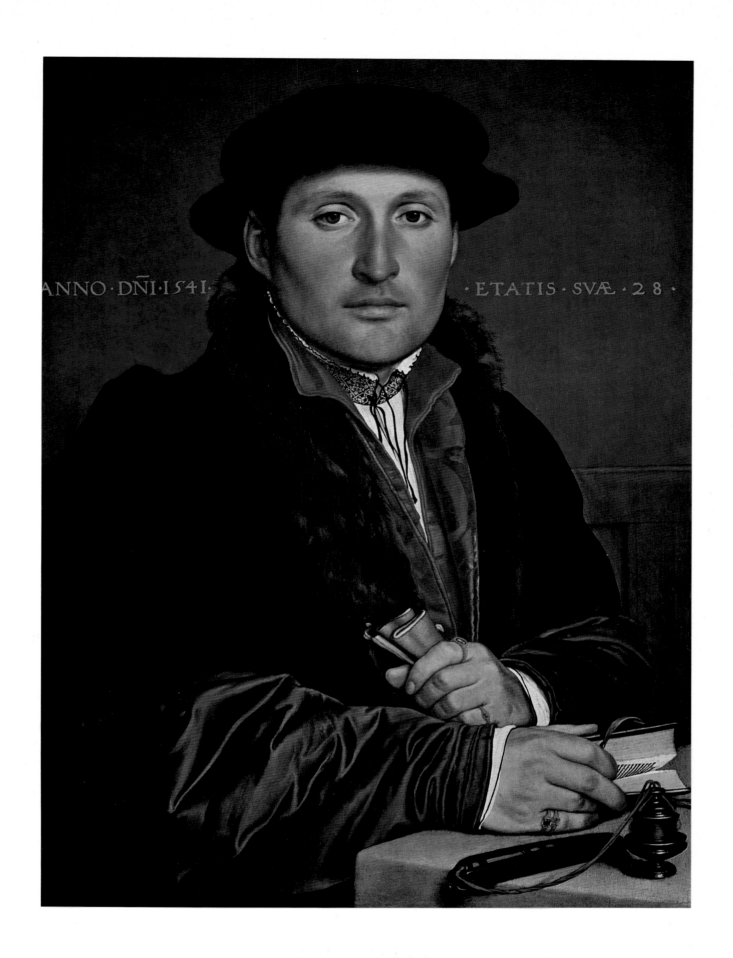

Within the painting: ANNO · DÑI · 1541 · ETATIS · SVÆ · 28 ·

Hans Holbein (1497/98-1543)
Portrait of a Young Man. 1541
Oil on panel, 18½ × 13¾″
Kunsthistorisches Museum, Vienna

The Reformation was opposed to the adoration of images, even to their presence in churches, and fierce iconoclastic outbreaks occurred in which paintings were destroyed. There ceased to be any demand for religious pictures, and artists had either to emigrate to Catholic countries or depend on portraiture and occasional commissions. With few exceptions, the Swiss painters of the sixteenth century were provincial masters of no more than local importance. Hans Asper, a contemporary of Holbein, earned a meager living as a portraitist and rarely had the opportunity of painting anything else, apart from an occasional battle scene or a floral design. After the death of Hans Leu, he was the leading painter of Zurich. His half-length portrait of *Cleophea Holzhalb* shows the influence of Holbein's Basel paintings, though the different parts of the figure are not well coordinated, modeling gives place to surface expression, and the color scheme is limited to a few tones. The linear, decorative style is also reminiscent of late works by Lucas Cranach and Hans Baldung Grien. The archaic simplification is characteristically Swiss; it is even more marked in Asper's portraits of the Zurich Reformer, Ulrich Zwingli.

The Basel master Hans Kluber, though belonging to the later generation of Tobias Stimmer, was still dominated by the influence of Holbein, Dürer, and Baldung. Kluber made a number of individual portraits and genre drawings, but his most ambitious picture is the group portrait of the Basel goldsmith *Hans Faesch and his Wife* (seated on the left) with their ten children, gathered together for a symbolic meal. The most famous example of the group portrait was that of Sir Thomas More and his family, painted by Holbein thirty years before in London. But Kluber was apparently unfamiliar with it, and his own group portrait, which was to remain an isolated type in Swiss art, was based on the earlier Dutch corporation portraits, like those of Teunissen.

Middle-Class Portraiture: Hans Asper and Hans Kluber

Hans Kluber (1535/36-1578)
Hans Faesch and His Family. 1559
Oil on canvas, 50¼ × 81¾″
Öffentliche Kunstsammlung, Basel

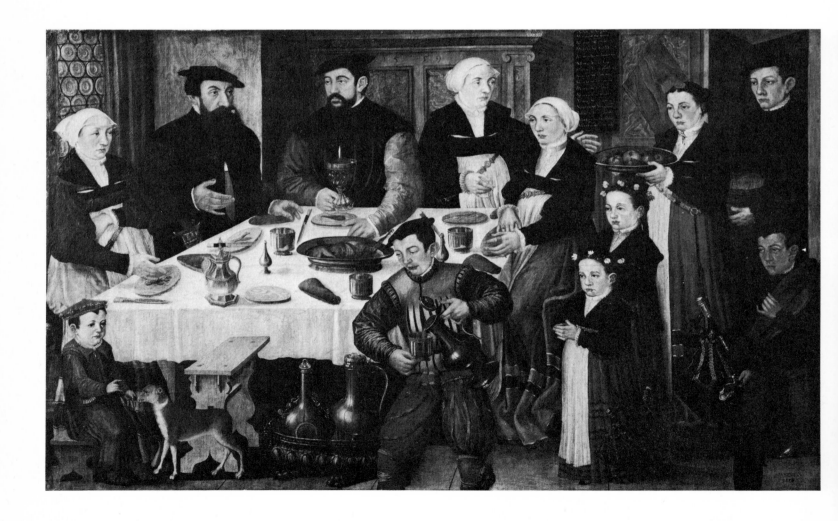

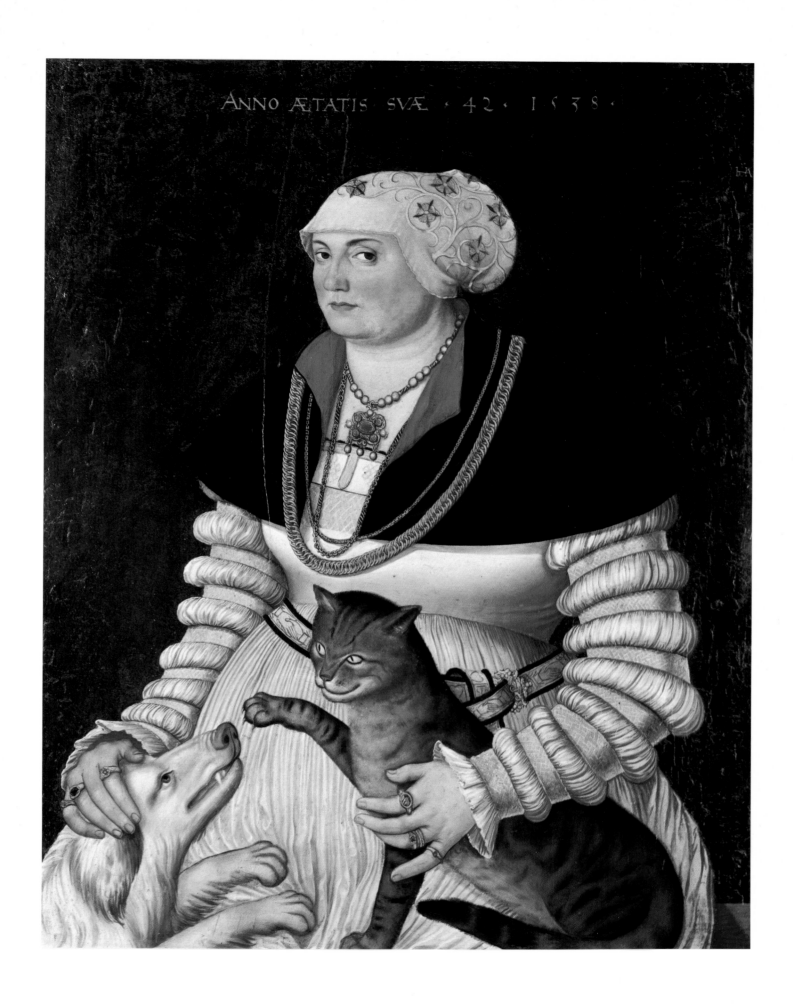

ANNO ÆTATIS SVÆ · 42 · 1538 ·

Hans Asper (1499-1571)
Cleophea Holzhalb 1538
Oil on panel, 30¾ × 24″
Kunsthaus, Zurich

Tobias
Stimmer

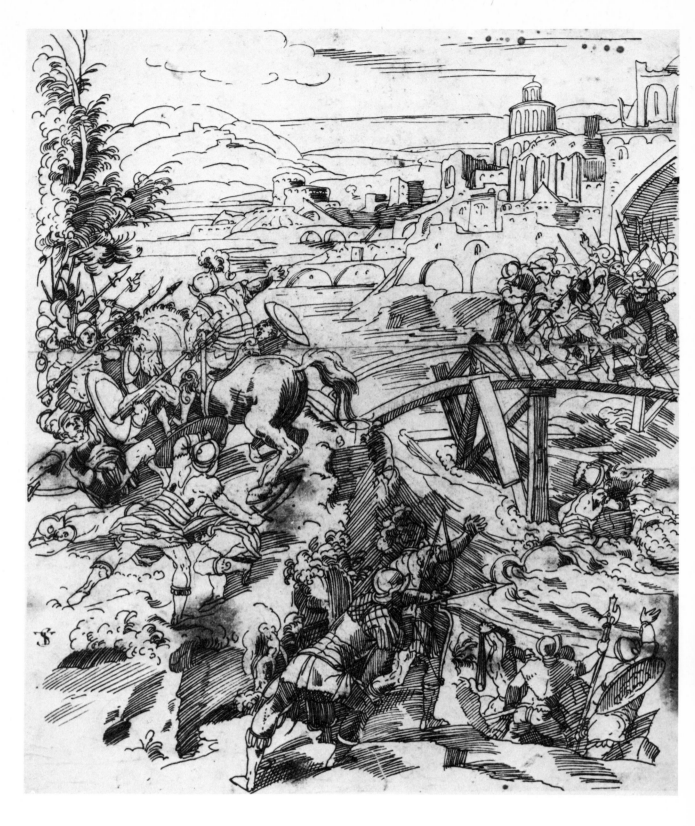

The strongest and most independent artistic personality in sixteenth-century Switzerland was Tobias Stimmer of Schaffhausen, the son of a painter who had emigrated from Salzburg. At the age of twenty-five he painted full-length, lifesize portraits of Elsbeth Schwytzer and her husband (with a picture of Death holding an hourglass on the back). With the full-bodied plasticity of the figures and their gripping lifelikeness, with their broad handling and the rich depth of the colors, these two panels dominate Swiss painting of the sixteenth century in the period after Holbein. Representing a

highly personal synthesis of Dürer and Holbein, the two Schwytzer portraits, as an expression of Swiss middle-class life, rank alongside the princely portraits of this period painted in neighboring countries.

Like Holbein, Amman, and Heintz, Stimmer spent much of his all too brief life abroad, where working conditions were more favorable than in Switzerland: first in Strasbourg, then from 1576 in Baden-Baden, where he was appointed court painter to the Grand Duke. There he decorated the ceiling of the main hall of the castle with frescoes glori-

fying virtue, full of figures and movement. This was no doubt his masterpiece, but it is only known today from studies and copies. In addition to his fresco decorations and his façade paintings (see page 79), he produced a large number of drawings; they are heightened drawings in the Holbein tradition, but with more spirited figures and linework. The brush sketch of *The Artist and His Muse in his Studio* is one of the finest examples of his dynamic style, prefiguring Rubens. Stimmer also made hundreds of woodcuts with intricately patterned Mannerist borders, designed as book illustrations; among the best known are those for the Bible and for Paolo Giovio's biographies of famous men *(Elogia virorum illustrium)*. Stimmer was an influential precursor of Baroque art.

Tobias Stimmer (1539-1584):

◁ *Horatius Cocles Defending the Tiber Bridge*
1568-1569. Pen and ink, 11½ × 9½″
Museum zu Allerheiligen, Schaffhausen

Elsbeth Schwytzer. 1564
Oil on panel, 75¼ × 26¼″
Öffentliche Kunstsammlung, Basel ▷

The Artist and His Muse in His Studio
India ink brush drawing,
15⅞ × 12⅜″
Öffentliche Kunstsammlung, Basel

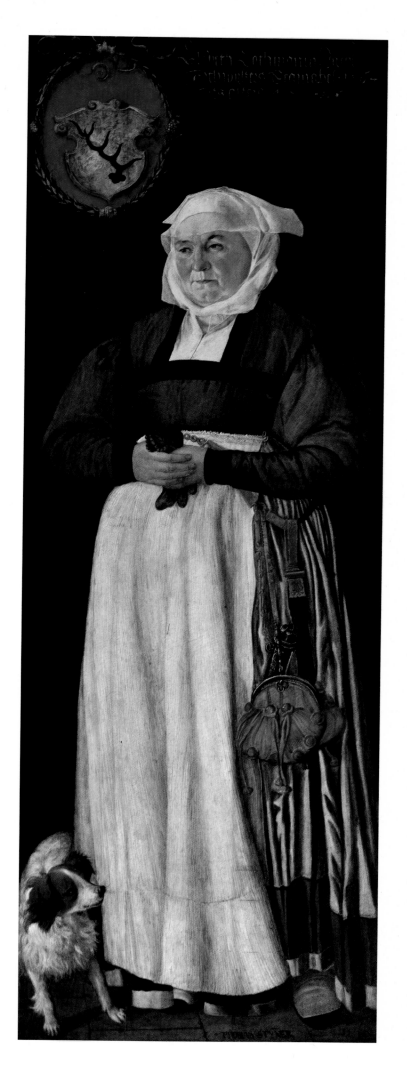

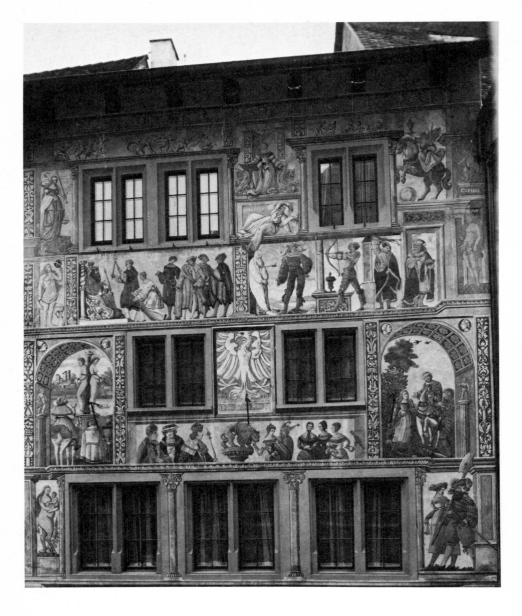

From the early fifteenth century on, it became a common practice in North Italy to decorate housefronts with frescoes depicting architectural elements and figures. The fashion for such outdoor frescoes later spread, chiefly through Holbein, to German Switzerland and South Germany. In fact, façade paintings were found to be an economical substitute for architectural refinements and sculptured decorations. Being exposed to the weather, none have survived unrestored, and our knowledge of most of them is based on designs. Though mostly much later in date, the façades at Stein am Rhein give a good idea of the wealth of color and imagination that went into these paintings. One of the earliest is the façade of the Haus zum weissen Adler (House of the White Eagle). Holbein's façade for the house of Mayor Hertenstein in Lucerne was probably similar in design. But for the Haus zum Tanz (House of the Dance) in Basel, Holbein fully exploited the resources of painting by "piercing" the wall with simulated architecture in illusionist perspective: over the real arcades is a frieze with a country dance; then, over the real windows above, is an intricate architectural composition in *trompe l'œil*. Two generations later Tobias Stimmer took over the style of Holbein in the house of Mayor Ritter in Schaffhausen. His design for another façade (reproduced here) is more dramatic. The frieze consists of a serried procession of (mostly elderly) figures bearing crosses; at the top is the Resurrection of Christ seen from below. The tradition of Holbein and Stimmer was kept alive down to the eighteenth century in many painted façades.

Stein am Rhein (Schaffhausen)
Painted façade of the House
"Zum weissen Adler." 1520-1525

Hans Holbein (1497/98-1543)
Design for the façade of
the House "Zum Tanz" in Basel
Pen and ink wash, 21 × 13⅝"
Öffentliche Kunstsammlung, Basel

Tobias Stimmer (1539-1584)
Design for a painted façade
Pen and ink wash, 16¼ × 12¼"
Öffentliche Kunstsammlung, Basel ▷

Hans Bock (c. 1550-1624)
Copy (1596) of the *Dance of Death* (1440)
in the Dominican Church of Basel
Pen and India ink, 7 ½ × 12 ⅜''
Öffentliche Kunstsammlung, Basel

The Dance of Death

Hans Holbein (1497/98-1543)
Death and the Rich Man
Woodcut, 2 ⅝ × 2''
From *Les simulacres et historiees
faces de la mort*, Lyons, 1538

Der Rych man.

The Dance of Death is a late medieval theme which arose in Paris in the 1420s and from there spread throughout Europe. It became especially popular in Switzerland, figuring on the walls of churchyards and monasteries. It normally represents people from all walks of life, from pope or emperor to beggars, and these figures alternate with capering skeletons, who are blowing horns, brandishing human bones and setting the pace of the dance. It is an allegory—often mixed with social satire—of the inevitability of death and the stern equality of all men in death. The most famous Swiss Dance of Death was the one in the Dominican church of Basel. Painted by Konrad Witz or a pupil of his after the plague year of 1439, it was later modernized by Kluber and engraved by Merian; a copy by Hans Bock shows the first of these thirty-nine macabre couples. An imitation of the Witz cycle was painted soon afterward in the Klingenthal monastery in Kleinbasel; it, too, is known today only from copies. The most extensive and influential cycle was the Dance of Death painted by Niklaus Manuel Deutsch for the Dominican monastery in Bern; the verses accompanying it were probably written by the painter himself. Executed on a series of wooden panels over 330 feet in length, these paintings were destroyed but are known from the complete copy made by Albrecht Kauw in 1649. Proud figures alternating with skeletons are caught up in an exuberant dance against a background of arcades and landscapes. With Holbein's famous set of forty woodcuts, the Dance of Death becomes rather a series of genre scenes in which living men are surprised by death. Later cycles combine the two types: dances and death scenes. Such is the case with the eight paintings by Jakob von Wyl originally in the Jesuit college in Lucerne, which in turn inspired Kaspar Meglinger's roof paintings inside the Spreuer-Brücke, one of the covered wooden bridges in Lucerne (1626-1632). Also worth mentioning is a fine series of prints on the Dance of Death theme by Conrad Meyer (1650).

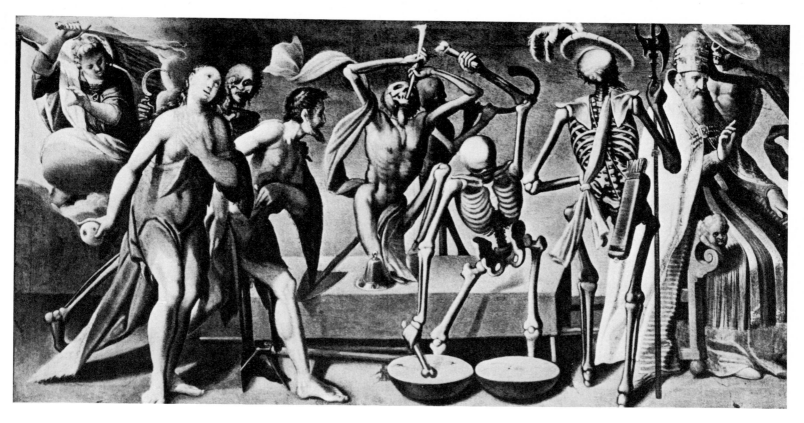

Jakob von Wyl (1586-1619)
*Adam and Eve Driven out of Paradise
and Music-Making Skeletons*
One of the eight panels of his
Dance of Death painted for the
Jesuit College in Lucerne
c. 1615. Oil on panel, 45 ½ × 90″
Regierungsgebäude, Lucerne

Albrecht Kauw (1621-1681)
Copy (1649) of a panel of the
Dance of Death by Niklaus Manuel
Deutsch (early 16th century)
Watercolor
Historisches Museum, Bern

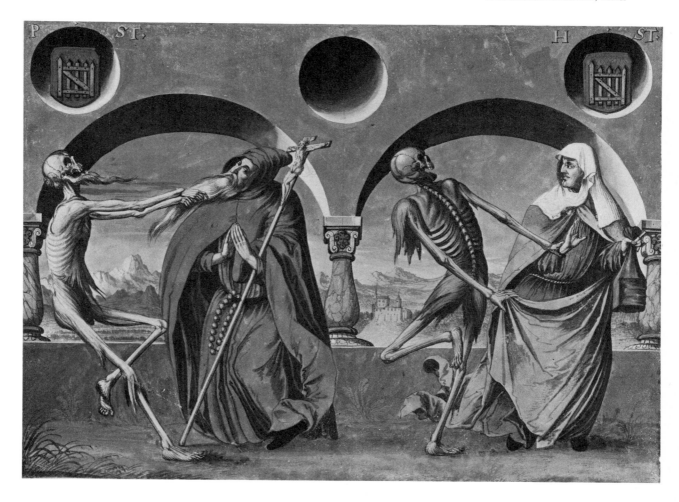

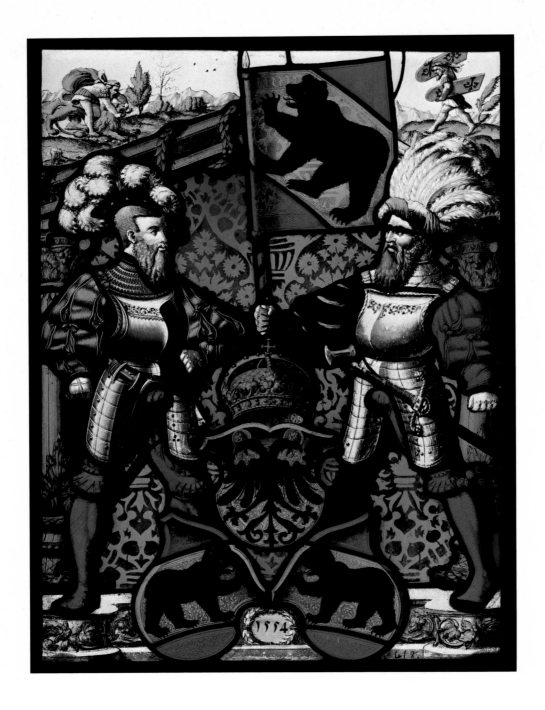

The great tradition of stained glass waned during the later Middle Ages, but in Switzerland it took a new, secular form, determined by civil and domestic instead of church patronage. Small heraldic windows, which enjoyed immense popularity until 1700, figured in almost every middle-class home. Thousands of such windows survive, together with the preparatory designs, and like the illustrated chronicles they constitute a genuinely Swiss art form. Though largely craft work, many of these windows are closely connected with important artists. Heraldic panels arose after about 1500 in a social context, when it became the custom (based in fact on a medieval tradition) for the municipal authorities, the Church, the trade guilds, and even individuals to offer a stained-glass window, often bearing the donor's arms, whenever a new building was erected. The offering of such windows gave rise to social emulation, catered for by specialized workshops of glass painters. The designs were sometimes ordered from leading masters like Leu, Graf, Stimmer, and Lindtmayer, sometimes based on ornamental or Biblical prints by Dürer, Holbein, Solis, and others. Common themes were the armorial bearings of a town or a guild, the coats of arms of two families united by marriage, and patriotic subjects like William Tell and the Oath on the

Heraldic
Glass Painting

Joseph Gösler
Heraldic Window with the Arms
of Bern. 1554. Stained glass
Historisches Museum, Bern

Hans Leu the Younger (c. 1490-1531)
Lot and His Daughters, with the Destruction of Sodom and Gomorrah. 1526. Design for a stained-glass window
Pen and ink wash, 12 × 8 ¼''
Landesmuseum, Zurich

Christoph Murer (1558-1614)
Annunciation. 1593. Design for a stained-glass window. Pen and ink wash, 24 ⅞ × 25 ¼''
Kunsthaus, Zurich, on deposit from the Gottfried Keller Foundation.

Hans Ulrich Wägmann (1583-1648)
William Tell. Design for a stained-glass window
Pen and ink wash, 13 ½ × 10 ¼''
Zentralbibliothek, Zurich

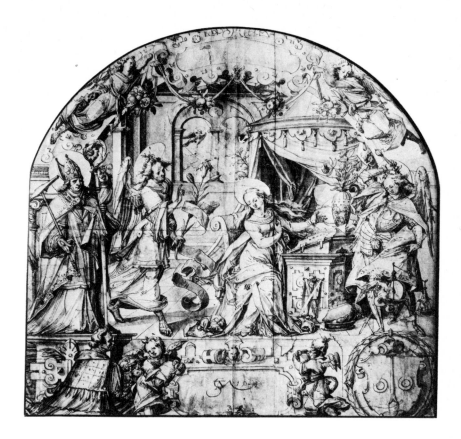

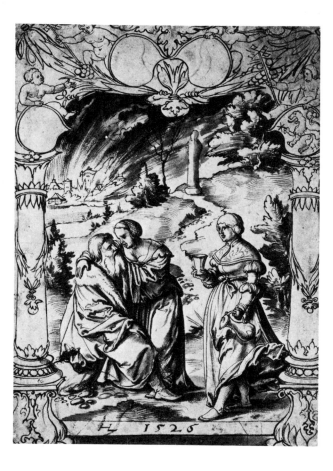

Rütli. The windows on these last two themes are among the earliest representations of them.

Some of the earliest heraldic windows were made in the Zurich workshop of Lukas Zeiner. But Holbein established the pattern of the Renaissance window, flanked by columns, with the figures on a level platform and a decorative garland overhead, and it lasted throughout the sixteenth century. Then, as the examples here show, a Mannerist decor was gradually introduced. The image itself became more dependent on easel painting and surface patterning gave way to intricate spatial compositions and perspective effects. The outstanding Swiss workshops were those of Funk and Gösler in Bern, Han and Ringler in Basel, and the Murer brothers in Zurich. Glass painting continued throughout the seventeenth century, but the standard of quality fell off steadily.

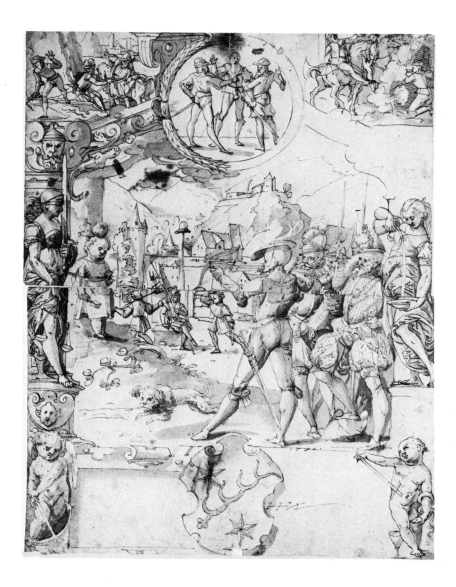

Jost Amman
and
Daniel Lindtmayer

Jost Amman (1539-1591):

Nymph and Bear with a Bagpipe
Woodcut from *Kunst- und Lehrbüchlein,*
Frankfurt-am-Main, 1578

Allegorical Horseman. 1588
Pen and ink with white
highlights, 11⅞ × 7¾″
Cabinet des Dessins,
Louvre, Paris

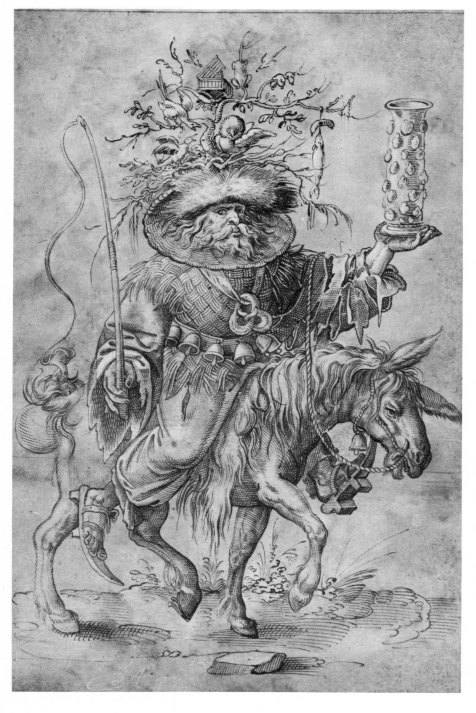

With his output of thousands of woodcuts, hundreds of engravings, and many drawings, Jost Amman was the most prolific illustrator of his day. A native of Zurich, he was trained there, possibly in the studio of Hans Asper, and in 1560, at the age of twenty-one, he settled in Nuremberg where he remained for the rest of his life, working chiefly for the Frankfurt publisher Siegmund Feyerabend. Reflecting the cultural history of his century, his work combines the tradition of Dürer with Italian beauty of form. Though he was overproductive, spurred on by commercial motives, his illustrations are striking and spirited, maintaining a high standard of quality. Among his most personal works are drawings like this *Allegorical Horseman*, notable at once for its plasticity and its accurate delineation of details. Among Amman's many sets of woodcut illustrations are those for the Bible, for books on war, hunting, tilting, costumes, trades, heraldry, and the Turks, and a manual of the arts, the *Kunst- und Lehrbüchlein*, containing a variety of attractive illustrations, like this *Nymph and Bear with a Bagpipe*.

A somewhat younger artist, Daniel Lindtmayer came of a family of glass painters of Schaffhausen. Trained in Tobias Stimmer's studio, he specialized in designing stained-glass windows and mural decorations. Lindtmayer's fine draftsmanship is exemplified by this pen drawing of *Bathsheba*. The scene is reminiscent of Altdorfer's *Susannah at Her Bath*. The technique is that of the old masters, but in spite of the perspective the effect remains flat. The architectural forms and the overcrowding are both typical of Mannerist art.

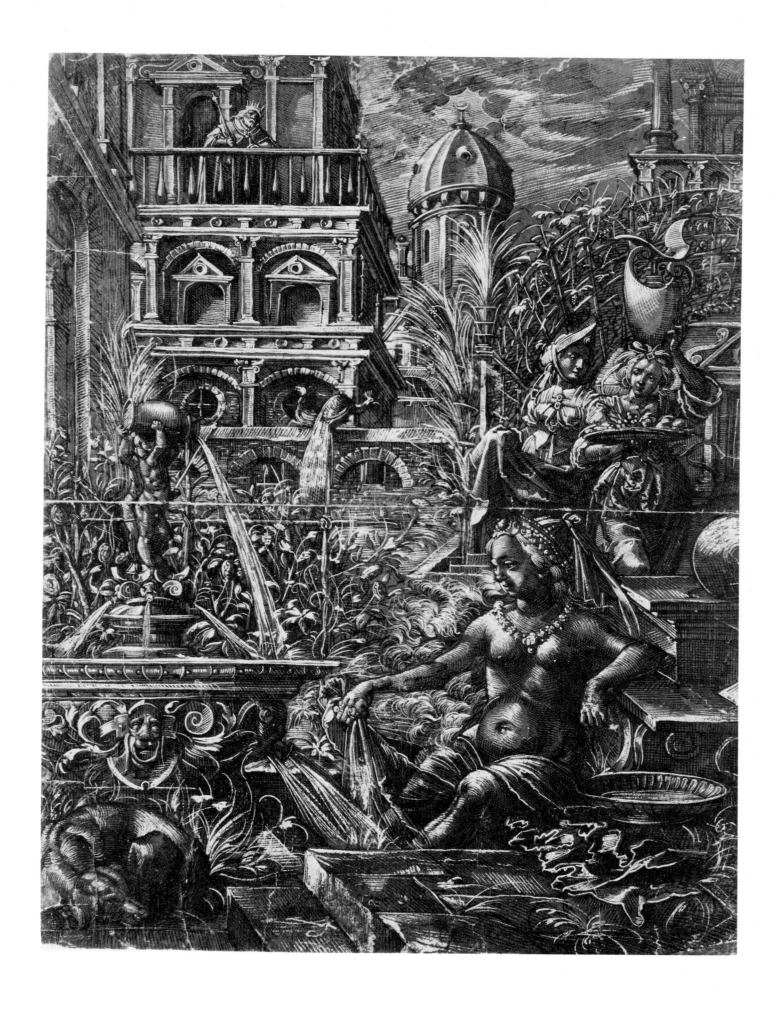

Daniel Lindtmayer (1552-c. 1607)
Bathsheba Washing Herself, Seen by King David
1578. Pen and ink on brown ground, 15 ¼ × 11 ⅜ ″
Öffentliche Kunstsammlung, Basel

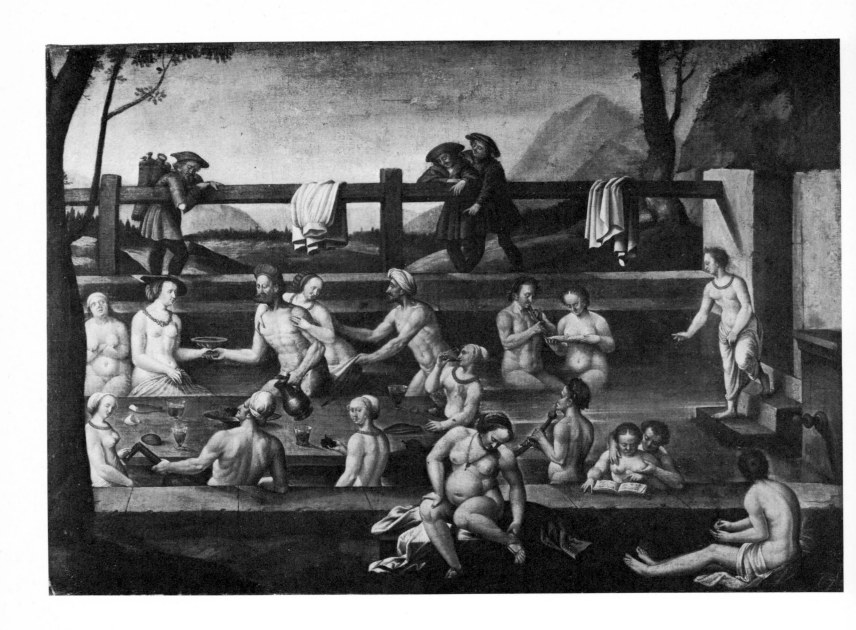

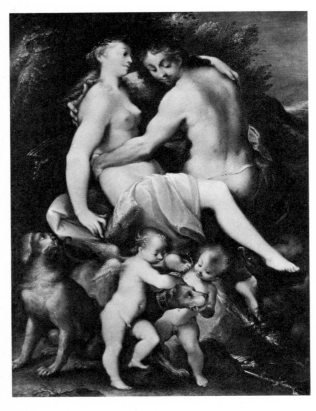

In the great European movement of Mannerism in the sixteenth century, Switzerland occupies a minor place. The aristocratic style of the Catholic world, based on the culture of antiquity and the masters of the Italian Renaissance, and radiating out from Rome to Brussels, Fontainebleau, Madrid, and Prague, found few echoes in Protestant Switzerland, where the system of values was so different. The Swiss contribution, such as it is, lies in the adaptation of foreign models by the local master Hans Bock and in the creative activity of the Basel painter Joseph Heintz at the court of the emperor Rudolf II in Prague.

An Alsatian who settled early in Basel and studied under Kluber, Hans Bock was the chief continuator of the Holbein tradition in the Basel of his day. His portraits perpetuate the hard style of Kluber, but he enlarged on the latter's bust portraits so as to bring out not only the facial features but the whole personality of the sitter. Bock's most ambitious piece of work, the mural decorations of the façade, courtyard, and interior of the Basel Town Hall (1608-1610), have only survived in part and have been overrestored; they consisted of monumental Biblical scenes on the theme of justice, deriving from Italian models. In addition to extensive cartographic work for the municipality of Basel, Bock painted a series of mythological pictures largely based on foreign models. Thus his allegories of *Day* and *Night* (Basel) take over motifs from Michelangelo, Tintoretto, and Frans Floris. Perhaps the most attractive of his paintings to us today is *The Baths at Leuk*, with a glimpse of the Valais Alps in the background and amused peasant onlookers eyeing the bathers; this scene can be linked with

Two Mannerists:
Hans Bock
and
Joseph Heintz

Dürer's pictures of men and women bathing, with Baldung, Cranach's *Fountain of Youth*, the bathing scenes of the School of Fontainebleau, and also with a print by Abraham Mignon after Francesco Penni. Bock's painting provides first hand evidence of the popularity of Swiss spas, which from the fifteenth century on attracted many visitors, both Swiss and foreign; after Leuk, in the Valais, the most popular baths were those of Baden near Zurich.

With Joseph Heintz we move on to the larger stage of European art. Born in 1564 (the year of Michelangelo's death) and trained in Basel, probably in Hans Bock's studio, Heintz spent ten years of his all too brief career in Rome, a couple of years in Augsburg and in travels, and ten years in Prague; his works today are correspondingly scattered. The son of an architect, he was the father of the Venetian view painter of the same name. Heintz's work is comparable to that of his exact contemporaries, Rottenhammer, Cornelis van Haarlem, and Wtewael. In Rome he was inspired chiefly by Polidoro da Caravaggio, Taddeo and Federico Zuccaro, and the German virtuoso Hans von Aachen, who was then working there. At the age of twenty-seven Heintz was summoned to Prague by Rudolf II. The court of this cultivated, art-loving emperor, whose political life was overshadowed by the Turks and the intrigues of his brother, was, after Rome, the principal art center in Europe around 1600. In Prague and Augsburg Heintz painted allegorical pictures, religious subjects, and aristocratic portraits. The large panel of a *Reclining Courtesan* takes over in new and personal terms the theme of the reclining Venus previously treated by Titian, Bronzino, and the masters of the School of Fontainebleau.

The small oil on copper representing *Venus and Adonis* shows even better the degree to which this art was based on standard models. Here, by way of the style of his elder contemporaries Spranger and Hans von Aachen, both active in Prague, Heintz harks back to Correggio, Parmigianino, the Sienese, and Barocci. The pose is complicated, recherché, even confused, the lighting soft, the modeling smooth, the line refined, the colors glowing and transparent. Highly esteemed by the emperor, Heintz was ennobled and his work was widely diffused in the form of prints.

Hans Bock (c. 1550-1624)
◁ *The Baths at Leuk (Valais)*. 1597
Oil on canvas, 30½ × 42¾″
Öffentliche Kunstsammlung, Basel

Joseph Heintz (1564-1609):

◁ *Venus and Adonis*. c. 1605
Oil on copper, 15¾ × 12¼″
Kunsthistorisches Museum, Vienna

Reclining Courtesan. c. 1600
Oil on panel, 31½ × 63¾″
Kunsthistorisches Museum, Vienna

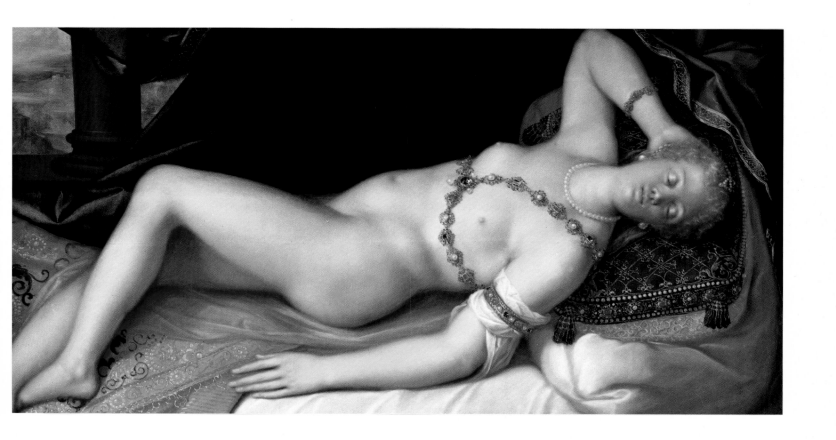

Henry Fuseli (1741-1825)
An Artist Despairing Beside the Remains of the
Colossal Statue of Constantine the Great. 1778-1780
Red chalk and wash, 16½ × 13⅞''
Kunsthaus, Zurich

88

From the Baroque Era
to the Age of Enlightenment

Fuseli at the foot of an antique statue, the artist brooding on the grandeur of classical art, a Swiss in England obsessed with antiquity—these attitudes, summed up in the drawing on the opposite page, characterize not only the sole Swiss artist of his day to enjoy a European reputation, but the position of Swiss art as a whole at that time. It had lost the distinctive identity which it had had in the time of Niklaus Manuel Deutsch. Painting had given way to mediums of secondary importance, like graphic art and folk art. The finest achievements were those of Swiss artists working abroad: the prints of Merian in Frankfurt, the frescoes of Mola in Rome, the portraits of Liotard in Vienna, Paris, and London, the portraits of Anton Graff in Dresden, the work of Fuseli in London. Though all of them spent the greater part of their lives abroad, the Swiss element peculiar to each can readily be singled out.

In the seventeenth century, the age of Rubens, Rembrandt, Poussin, Velazquez, and Caravaggio, Swiss painting sank to its lowest point. The drastic slackening of artistic activity in the later sixteenth century, caused by the Reformation, continued throughout the following century. Now, however, it was not because of the fanaticism of the Reformers or the wars of religion. For, in fact, Switzerland remained neutral during the Thirty Years War (1618-1648); she even enjoyed a certain prosperity, thanks in large part to the military contracts entered into with France, and at the Peace of Westphalia (1648) she was recognized as an independent state. But in the stern climate of political and ecclesiastical absolutism then prevailing on all sides, Switzerland could only defend and preserve her hard-won democratic liberties by staunchly upholding her native tradition. Baroque painting, essentially a court art, was in complete contradiction with the Swiss spirit; the result was a certain provincialism and stylistic backwardness. Furthermore, German Switzerland was then deprived of its traditional source of inspiration or stimulus, German art, which itself was lying stagnant in war-torn Germany. To this must be added the fact that comparatively little research has been done into the Swiss art of this period.

In speaking of seventeenth-century Switzerland, we refer, once again, to the Protestant, German-speaking areas, which were economically preponderant. The religious conflict had sealed the cultural division between the two denominations. Under the influence of the Jesuits, the Catholic cantons looked to Italian art; but they found no salvation there, for north of the Alps it inspired only feeble local imitations. Protestant German Switzerland

looked to the Netherlands for its models. It is fashionable today to draw parallels between puritan Holland and Switzerland, but as far as art is concerned one is struck rather by the contrasts between them. Switzerland had neither the artistic and humanistic tradition nor the commercial wealth which, together, fostered and stimulated the flowering of Dutch art. The main forms of European Baroque painting—allegory, religious pictures, historical pictures—were almost entirely lacking in Switzerland. Joseph Werner, it is true, specialized in allegorical painting but, unlike Heintz in the previous century, he remained an imitator of Roman and French art and kept chiefly to miniatures. An outstanding example of the historical art of that day is Lebrun's great tapestry representing *The Alliance between Louis XIV and the Swiss* (Swiss National Museum, Zurich) from the Gobelins series of *The History of the King*. Toward the end of the seventeenth century, several local masters in Zurich—J.J. Schärer, J.U. Schnetzler, and J.B. Bullinger—painted allegorical ceiling frescoes in patrician houses.

While in all the other schools of the seventeenth century landscape painting emerged as an independent genre, nature remained in Switzerland a rude antagonist from which a living could be wrested only at the cost of hard work. The discovery of mountain scenery was made by the Dutch, chiefly by Jan Hackaert. The indigenous landscape art of Matthäus Merian, Conrad Meyer, and Felix Meyer was largely restricted to prints and drawings. Merian's early landscape prints done in Basel keep to Flemish models; once he had settled in Frankfurt, his output of topographical prints took on commercial dimensions and he enlisted the help of many collaborators. Genre painting, too, which flourished in all the other schools, failed to appear in seventeenth-century Switzerland, with the exception of Conrad Meyer's tradition-bound prints. Painting was pretty much limited to individual portraits, mostly in half length. The leading portraitist was Samuel Hofmann, who had learned his craft as an assistant in Rubens's studio in Antwerp. The transition from Hofmann to Conrad Meyer, Johannes Dünz, and J.R. Huber is a transition from the Baroque society portrait toward a more intimate portraiture. As for still life, by now a widespread art form in the other European schools, it too failed to thrive in Switzerland. The display of luxury objects, exotic fruit, and rare flowers was out of keeping with the Swiss spirit of frugality. Hofmann's occasional still lifes introduced the Dutch style, which was taken over by Dünz and Byss. Albrecht Kauw contrived to create a specifically Swiss still life of an old-fashioned type, whose ingredients were the characteristic fruit, vegetables, and poultry of the Swiss farm.

The notion of Baroque painting is, in fact, only applicable to the Ticino masters, whose art was aligned with that of Italy. The Ticino was the birthplace of a whole series of famous Baroque architects: Domenico Fontana from Melide, Carlo Maderna, and Francesco Borromini, both from Bissone, and Baldassare Longhena, the chief architect of Venetian Baroque, from Maroggia. The sculptors Stefano Maderna and Antonio Raggi were also natives of the Ticino. During the seventeenth century there was also a new flowering of painting in the Ticino. Its finest painter was Giovanni Serodine, who spent most of his brief career in Rome as one of the most independent-minded of the later followers of Caravaggio; his importance has only recently been recognized. Pier Francesco Mola also worked in Rome, but under the classical influence of the Bolognese school and Poussin. In the latter part of the century several masters from the Ticino, working independently of each other, turned their hand to decorative frescoes: Tencalla renewed fresco painting in Austria and the Carlone family was productive in several countries over several generations. German Switzerland was supplied with Baroque altarpieces by F.I. Torriani. The artists of the Ticino continued to be active throughout the eighteenth century. The most interesting and many-sided personality among them was G.A. Petrini, whose style is similar to that of the Venetian master Piazzetta. The Orellis, another family of Ticino artists, worked on both sides of the Alps.

Dating from the seventeenth and eighteenth centuries are a number of important Baroque churches built for the Jesuits and other religious orders in German Switzerland, from the Jesuit church in Lucerne to the abbey church of Saint Gall (1660-1760). In painting there is no equivalent of these masterpieces, which were the collective achievement of Austrian architects from the Vorarlberg and Italian and South German stucco workers and painters. To the Asam brothers of Munich is due the masterpiece of this art, the decoration of the abbey church of Einsiedeln. Other churches were similarly decorated in the Rococo style by the South German painters Stauder, Kraus, Herrmann, Wenzinger, and Zeiller, by the Ticino painters Giorgioli and Torricelli, and by the Milanese master Appiani. The influx of foreign artists into the Catholic areas of Switzerland was counterbalanced by the activity of Swiss decorators abroad: Johann Rudolf Byss in the bishopric of Würzburg in collaboration with the architect Neumann, and Georg Gsell in Russia as court painter to Peter the Great. Other Swiss artists abroad became academy directors: Werner in Berlin, Wyrsch in Besançon, Graff in Dresden.

In the eighteenth century, Switzerland finally broke out of its cultural isolation. Her intellectual and artistic ties with the rest of Europe became much closer and indeed gave her a central position. In the Age of Enlightenment her democratic institutions, her countrified way of life, the lure and lore of the Alpine world, and her patriotic ideal of liberty and independence began to arouse general interest. With Haller, Rousseau, Lavater, Pestalozzi, and others, Switzerland took an active and stimulating part in the intellectual life of Europe. The steadily growing stream of tourists, the opening of hotels, and the intrepid beginnings of mountain-climbing went hand in hand with the rise of landscape painting in Switzerland (see page 134). In portraiture the worldly, class-conscious likeness of the Baroque age gave way under French influence to an expression of moods and an immediacy of human contact, as in the Rococo pastels of Liotard, Handmann, and Johann Caspar Füssli. With Liotard, in spite of his colorful personality, a Calvinistic attachment to nature imitation and the rooted heritage of the miniature technique prevented the freer development which is so characteristic of French portraitists like Quentin de La Tour. In due course the portrait became the mirror of the soul, as in the likenesses of Anton Graff, the greatest of Swiss portrait painters, and an intellectual equivalent of them is to be found in the physiognomical studies of his compatriot and contemporary, Lavater. From the same cultural context sprang the portraits and mythological paintings of Angelica Kauffmann, who was born in Chur (Grisons) in 1740 and worked chiefly in Rome and London.

Now, for the first time, one can speak of local schools and a national conception of art largely shaped by patriotic themes and native handicrafts: local views, minor arts, rural scenes, costume pictures, glazed stove tiles, peasant painting and woodcarving, peasant houses—marginal art forms which in Switzerland were particularly rich and distinctive. In the heart of the country the Bernese school set the example of this racy, earthbound ideal with the landscapist Aberli and the genre artists Freudenberger, Dunker, König, and others, whose favorite mediums were drawing, watercolor and the colored print. Their small-sized, unassuming delineations of the Bernese Oberland and its quiet, happy peasant life owe nothing to foreign art; they represent a genuinely native art with a place of its own in the European evolution of style then dominated by France. No less than the views of Guardi and Piranesi, these Bernese prints perpetuated the beauty of that landscape both for the foreign travelers who purchased them and for the local inhabitants who hung them in their homes.

In Zurich, with men like Bodmer, Breitinger, and Gessner, the intellectual climate was a literary one, closely connected with Germany and with liberal, humanitarian trends of thought in England. Johann Jakob Bodmer, a scholar and historian, translated the *Iliad* and Milton's *Paradise Lost* into German, resurrected medieval German poetry, editing the

Minnesingers and the *Nibelungenlied*, and so made accessible to German readers a wealth of great literature; he pleaded for the freedom of the imagination from the restrictions imposed on it by French pseudo-classicism, and his work and example stimulated Henry Fuseli to write the romantic poetry of his youth and gave him an ardent, lifelong attachment to literature. Salomon Gessner was both a poet and a painter, but first and foremost a poet; the success of his engravings rested chiefly on the verses that accompanied them. Becoming known in Zurich, the German genre scenes of Daniel Chodowiecki inspired similar works by Heinrich Werdmüller, Heinrich Freudweiler, and Konrad Gessner the Younger. Now, for the first time, the Swiss began to make a contribution to art theory with the Lives of Swiss artists written by Johann Caspar Füssli, the essay on landscape painting by Salomon Gessner, the art criticism and Royal Academy lectures of Henry Fuseli, the aesthetic writings of Johann Georg Sulzer, and the admittedly rather amateurish treatise on painting written by Liotard in his old age. The intellectual and artistic ferment of mid-eighteenth-century Zurich shaped the mind of Fuseli, whose art represents an astonishing, ever renewed confrontation with the European cultural heritage. While his individual works stem from literary sources, his themes are generally dominated by his concern with the realm of the supernatural and the demonic powers underlying life. In this respect one may compare him with another great artist who was almost his exact contemporary, Goya, while readily acknowledging Goya's greater mastery of the brush, his far deeper knowledge of human nature and human motives, and his grasp of the forces which have continued to shape the course of modern times.

The Geneva school of painting naturally arose in the shadow of France, and after slow and tentative beginnings only reached its full maturity in the late eighteenth and nineteenth centuries. The earlier Geneva painters were almost exclusively portraitists and enamelists, and the best of them worked abroad: Jean Petitot in London and Paris, Jacques-Antoine Arlaud in Paris at the court of the Regent, Philippe II, Duc d'Orléans, and Robert Gardelle the Younger and Barthélemy du Pan in London. Occasional still lifes and French genre scenes appeared with Liotard, and landscapes in the manner of the Dutch Italianists with Jean Huber and his son Jean-Daniel Huber. The Neoclassical style is represented by Pierre Louis de La Rive and by the brothers Jacques and Antoine Sablet, sensitive figure painters from the canton of Vaud who studied together with Jean-Pierre Saint-Ours of Geneva in the Paris studio of Joseph Vien, the teacher of David. In his large history paintings Saint-Ours sometimes achieved the monumentality of David, although he remained, like all the other Genevese painters of the eighteenth century, a provincial emulator of the Paris school. The next generation of men like the Toepffers, Agasse, and Massot, of whom something more can be said, is treated here with the nineteenth century (see pages 138 and 149). The chapter that now follows does not end at any very marked point of division, but leads up rather to a broad range of trends and styles extending from local art forms, still very much alive, to the growing involvement of Swiss artists in the major international movements.

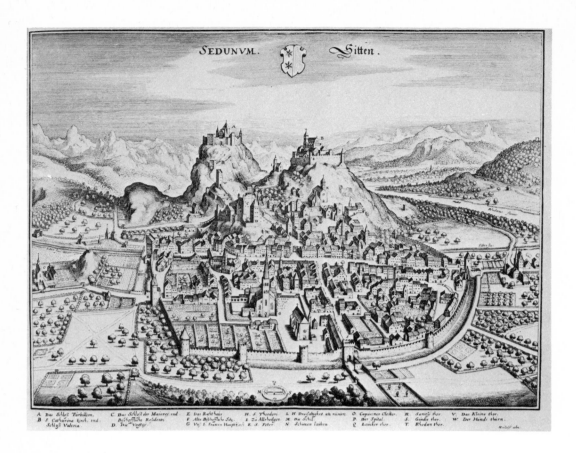

SEDUNVM. Sitten.

A Das Schlos Turbillion. C Das Schlos der Mauren, vnd E Das Rathhaus H. S. Theodori L. H Dreifaltigkeit alt ruinirt O Capuciner Clöster R Samesch thor V Das Kleine thor.
B S Catharina kirch, vnd Bischoffliche Residentz F Alte Bischoffliche Sitz I Zu Alterheylgen M Die Statt P Der Spital S Gundis thor W Der Hundt thurn
Schlosz Valeria D Drei Vogtej G Vsg' L Francis Haupkirch K S Peter N Schumen lauben Q Leuker thor T Rhodan thor

The Prints of Matthäus Merian

Matthäus Merian (1593-1650)
View of the Town of Sion or Sitten (Valais)
Copperplate engraving from *Topographia Helvetiae Rhaetiae et Valesiae*,
Frankfurt-am-Main, 1654

Switzerland, which with Witz, Manuel, and Leu had contributed significantly to the beginnings of landscape painting, failed to produce any masters in this field in the seventeenth century, the great age of European landscape art. Her one landscapist of note was Mola, who worked in Rome, and he was no innovator, keeping to the classical landscape of his day. The discovery of the Swiss Alps was made not by Swiss but by Dutch artists, first of all by Jan Hackaert (1628-1699), who in the 1650s drew a large number of Alpine views, preserved in Vienna. The Dutch style accordingly prevailed in the few Swiss artists who worked in this field: in the landscape drawings of the portraitist Conrad Meyer, a friend of Hackaert's, and in those of Felix Meyer (no relation), the first to specialize in Swiss landscape; the latter's drawings and rare paintings were also influenced by the earlier German landscapists. Significantly, Felix Meyer (Winterthur, 1653?-Zurich, 1713) worked chiefly for foreign patrons. Swiss landscape painting only really begins in the eighteenth century, with the scientific investigation of nature.

Highly successful in the seventeenth century, however, were the topographical prints of Matthäus Merian. His enormous output makes him the most prolific of all Swiss artists. Born into a cultivated family of Basel burghers, Merian was trained as an engraver in Zurich, Nancy, Paris, Stuttgart, and the Low Countries. In 1624 he settled for good in Frankfurt, taking over the business of the publisher J.T. de Bry, whose daughter he had married. His finest engravings belong to his early years in Basel; they include several hundred landscapes and compositions of his own invention. An example is the *Camp Fire with Roman Ruins*, a nocturnal riverscape in the style of Elsheimer; other landscape prints are in the manner of Martin de Vos, the school of Frankenthal, and Paul Bril. To the later, Frankfurt years belong the well-known sets of prints: the Bible illustrations, like the *Destruction of Sodom* in the Flemish manner; the nineteen volumes of the *Topographia*, descriptions of various countries, beginning in 1642 with Switzerland, illustrated by copper plates; and the great series entitled *Theatrum Europaeum*, a historical chronicle of events in Europe from 1617 on, continued by his son Matthäus Merian the Younger and others down to 1738.

Matthäus Merian (1593-1650):

Camp Fire with Roman Ruins
Copperplate engraving, 4 ¼ × 5 ⅞″
Öffentliche Kunstsammlung, Basel

*Lot and His Daughters, with the
Destruction of Sodom and Gomorrah*
Copperplate engraving, 4 ¼ × 5 ¾″
from *Icones Biblicae,*
Frankfurt-am-Main, 1625

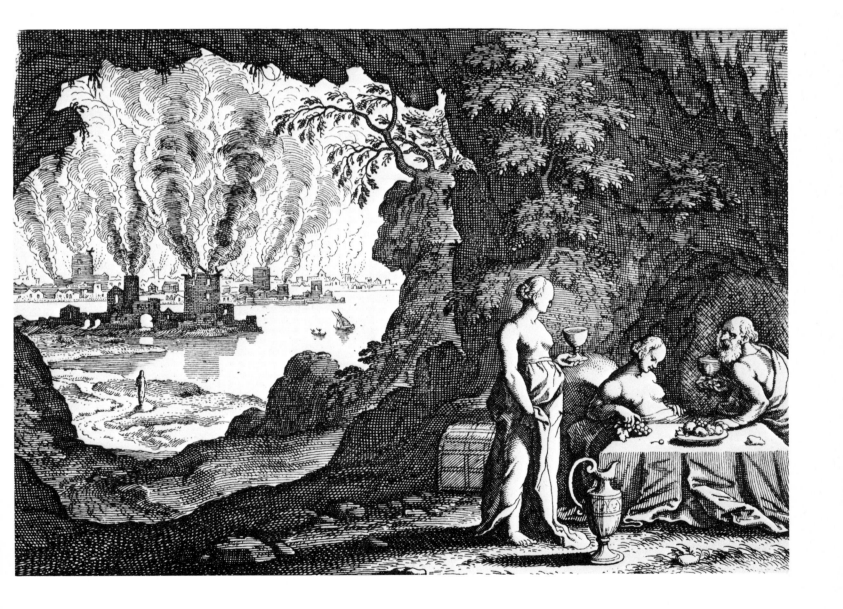

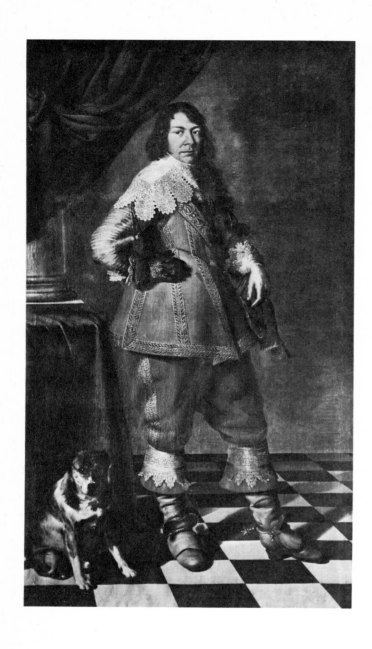

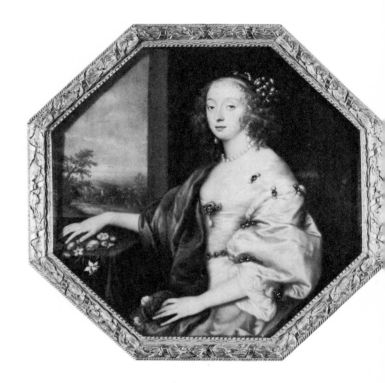

During the Baroque age, painting in Protestant Switzerland was largely confined to portraiture. Its history during this time was shaped, on the one hand, by the influence of the Dutch portraitists and, on the other, by the strong and continuing currents of local tradition. Galleries of family and ancestor portraits came into existence (two of them still survive in Einsiedeln and at Castle Elgg, near Winterthur). The thriving commercial town of Zurich produced the one outstanding Swiss Baroque portraitist, Samuel Hofmann, who in his youth became a leading assistant in Rubens' studio in Antwerp, worked in Amsterdam, then returned to Zurich for twenty years, and finally settled in Frankfurt. Through him, Flemish influence impinged on Swiss portraiture, history painting, and still life. His cavalier portrait of the young *Hans Rudolf Werdmüller* (still in Castle Elgg) takes over the bright coloring and the stock setting, with curtain, column, and dog, of his younger contemporary

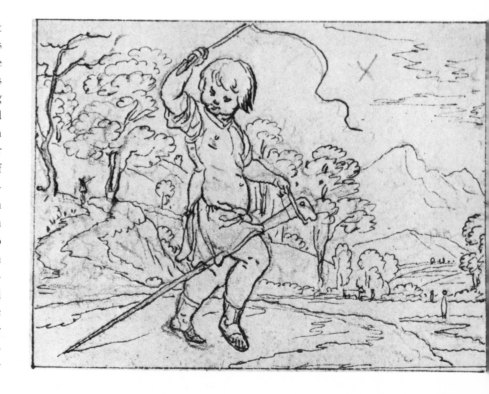

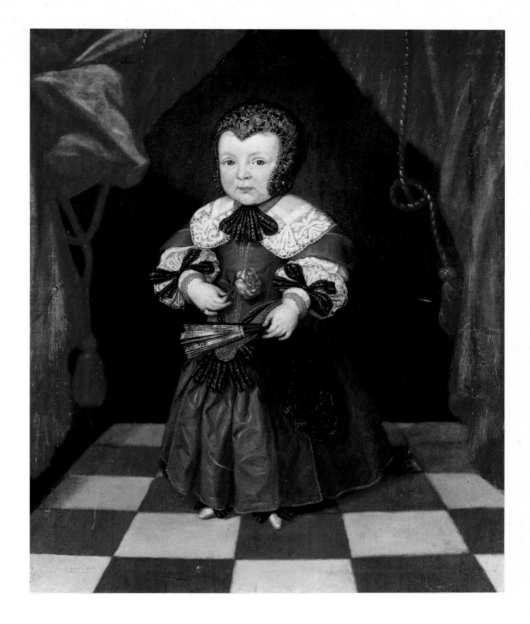

Samuel Hofmann (1591-1648)
◁ *Hans Rudolf Werdmüller*. 1633
Oil on canvas
Otto Werdmüller Family Foundation,
Castle Elgg (Zurich)

Jean Petitot (1607-1691)
◁ *Mary, Duchess of Richmond*. 1643
Miniature on enamel
National Museum, Stockholm

Conrad Meyer (1618-1689)
◁ Design for a print in the series
of *Children's Games*. 1657
Pen and ink with pencil
Kunsthaus, Zurich

Conrad Meyer (1618-1689)
Joseph Orell. 1657
Oil on canvas, 36⅞ × 22½"
Landesmuseum, Zurich

Anonymous Master
Barbara Orell. 1682
Oil on canvas, 35½ × 29½"
Landesmuseum, Zurich

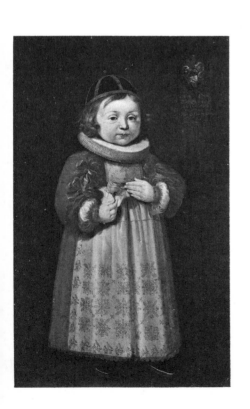

Van Dyck. But the aristocratic full length portrait remained unusual in Switzerland. Hofmann's cogent half-length figures combine the breadth of Rubens with the delicacy of such Dutch masters as Mierevelt and Wybrand de Geest.

Hofmann's work was followed up in Zurich by Conrad Meyer, who began as a portraitist in Germany. Born into a family of engravers, Meyer later devoted himself entirely to graphic work: landscape drawings, and sets of prints on the *Passion*, the *Dance of Death* and *Children's Games* (1657, and so contemporary with the *Children's Games* of the French etcher Jacques Stella). Among his two hundred Zurich portraits is that of the sixteen-month-old *Joseph Orell*, holding a stiff pose in his fancy clothes; the same style lingers in the later, anonymous portrait of the little *Barbara Orell*.

Portraiture in Geneva arose in connection with the watch and jewelry industry, founded in the sixteenth century, chiefly by Huguenot refugees. Enamel painting, taken over from France in the early seventeenth century, became a Genevese specialty, miniature portraits and mythological scenes going to adorn watch cases. The chief Genevese families of enamel painters were Huaud, André, and Petitot in the seventeenth century, Liotard and Thouron in the eighteenth. Many were active abroad, like Jean Petitot, who learned enamel painting in France and worked for years with Jacques Bordier in England, where portrait miniatures had a noble tradition behind them, before returning to France and finally to Geneva. His miniature of the *Duchess of Richmond* follows the Van Dyck style of aristocratic English portraiture.

Johann Rudolf Huber
Johannes Dünz

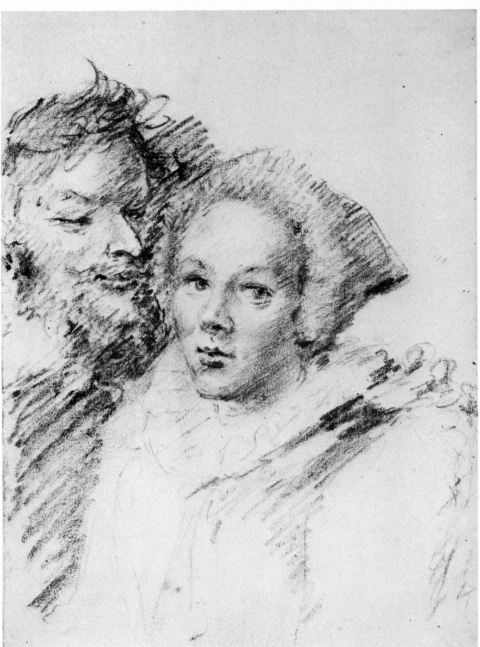

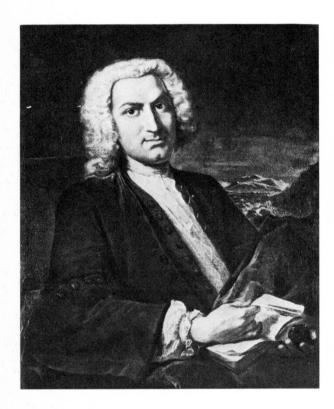

Johann Rudolf Huber (1668-1748):

Double Portrait (The Artist and His Wife?)
Charcoal and red chalk, 11 × 8¼″
Öffentliche Kunstsammlung, Basel

Albrecht von Haller. 1736
Oil on canvas, 27½ × 23⅝″
Collection Fred Zeerleder, Brugg (Aargau)

In the decades before and after 1700, Swiss portraiture is well represented by Johannes Dünz. Trained in Bern, he worked there almost exclusively. With its dark tonality and the fur cap and oval frame, his *Portrait of Elisabeth Ott* exemplifies the earnest and measured tenor of the Bernese spirit. Dünz painted one of the few group portraits of this period in Switzerland *(The Library Committee)* and also some excellent still lifes in which he carried on the Dutch tradition.

A generation later came Johann Rudolf Huber. Trained in Zurich and Bern under Conrad Meyer and Joseph Werner, he continued his schooling in Venice under Cavaliere Tempesta and then in Rome and Paris; he worked chiefly in Bern and Basel, where he had a highly successful career as a portraitist and became a member of the town council. His style of portraiture ranged from late international Baroque to intimate likenesses, such as that of the Bernese poet, scholar, botanist, and physiologist *Albrecht von Haller*. The glimpse of mountains in the background is an allusion to Haller's poem *Die Alpen* (1729), the literary fruit of his many botanizing tours through the Alps; this poem of 490 hexameters is historically important as one of the earliest signs of the awakening appreciation of the mountains. With Huber, for the first time, we get a reflection of the elegant society portrait of eighteenth-century France.

I love only these Swiss girls, who make up their faces with spring water, and to please them I want to discover the knack of looking handsome ... But let me explain that with them the best light to show yourself in is that of goodness, friendliness, modesty, and all the other virtues.

Johann Jakob Bodmer and Johann Jakob Breitinger,
Die Discourse der Mahlern, Zurich, 1721

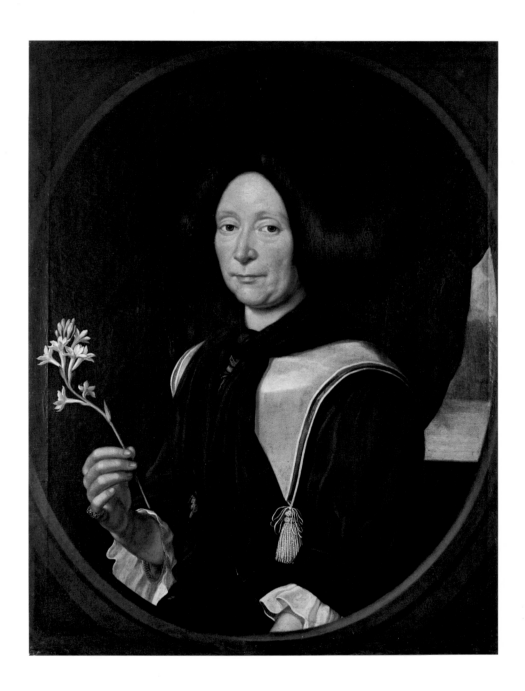

Johannes Dünz (1645-1736)
Elisabeth Ott. 1704
Oil on canvas, 34¾ × 26⅜″
Collection
Marie-Hélène Hagenbach-Staehelin,
Reinach (Aargau)

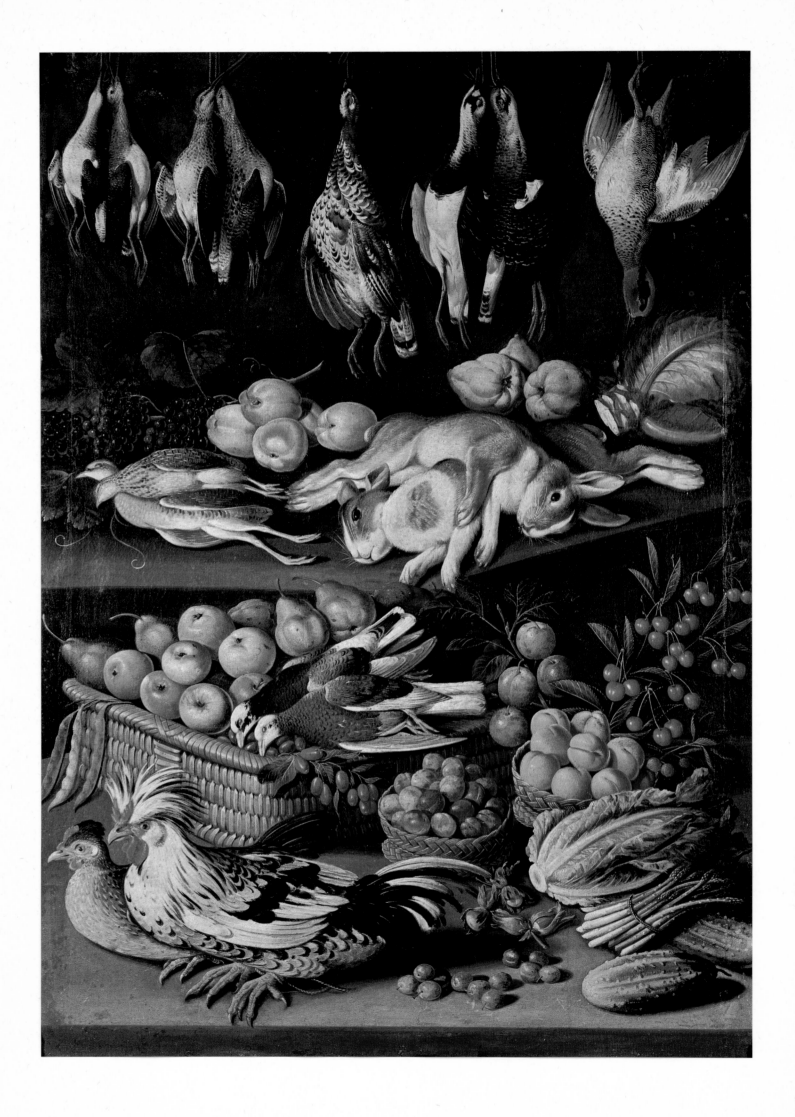

Still Life Painting

Johann Caspar Füssli (1706-1782)
Trompe l'œil with Portraits of the Artist's Zurich Friends and Antique Heads. 1736
Oil on canvas, 20¼ × 24⅝″
Cantonal Library, Trogen (Appenzell) ▷

Johann Rudolf Byss (1660-1738)
Flower Piece
Oil on canvas, 23⅝ × 15⅜″
Collection Raymond Wander, Bern

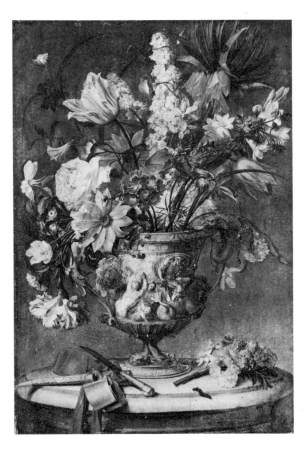

Albrecht Kauw (1621-1681)
◁ *Still Life.* 1678
Oil on canvas, 57½ × 39¾″
Kunstmuseum, Bern

The seventeenth century was the great age of still life painting in all the European schools. But in Switzerland no such flowering occurred; the prevailing level of art consciousness, of commercial prosperity, and of humanistic culture was apparently insufficient to create any demand for still lifes. Only a few painters occasionally tried their hand at them, imitating Dutch models.

The first was the Zurich portraitist Samuel Hofmann, who had worked in Antwerp and Amsterdam; his elaborate still lifes are in the Flemish manner of Frans Snyders. Then came the simpler compositions of Joseph Plepp of Bern (1595-1642) and those of the Bernese portraitist Johannes Dünz. More distinctive are the kitchen and larder still lifes of Albrecht Kauw, born in Alsace but established in Bern, who found his models in the sixteenth-century food pieces of Pieter Aertsen, Vincenzo Campi, and Jacopo Chimenti. Kauw displays the abundance of the earth—fruit, vegetables, and poultry from the farm, small game from the hunt. The bright colors and plastic shapes are set out in almost geometrical order, in rising tiers, while the Dutch masters often prefer to dwell on the purely pictorial value of a few chosen objects. The decades just before and after 1700 are represented by Johann Rudolf Byss, from Chur (Grisons), who worked in Vienna for the imperial family and in Würzburg in the service of the Counts of Schönborn. His great frescoes (Schloss Pommersfelden, Imperial Chancery in Vienna, the Abbey of Göttweig, and the Würzburg Residenz) typify the brilliant, eye-fooling illusionism of Rococo decoration. Byss also painted some easel pictures in the manner of Velvet Brueghel and some fine flower pieces in the Dutch style. But flower painting was never much practiced in Switzerland.

The eighteenth century is represented by the Geneva still lifes of Liotard's old age (see page 113) and the *trompe l'oeil* exercises of Johann Caspar Füssli of Zurich, a portrait painter, historian, and scholar, and the father of the celebrated Henry Fuseli. Füssli is best known today for his *Geschichte der besten Künstler der Schweiz* (1755). His still lifes in the manner of Vaillant and Gysbrechts simulate drawings and prints pinned to the wall. This one is a record of his friendships and intellectual interests: at the lower left is a self-portrait; to the right of it, a portrait of the writer Johann Jakob Bodmer; at the upper right, the poet and painter Salomon Gessner, one of whose best known poems was *Daphnis* (1754).

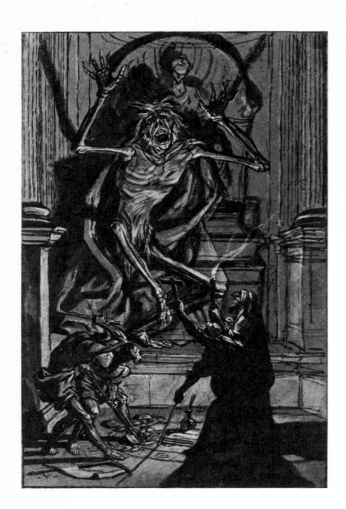

History painting on the grand scale, which in the Baroque period flourished so remarkably in Rome, Paris, and Brussels and from there spread to all the princely courts, is represented in democratic Switzerland only by Joseph Werner. Of his work, only about sixty drawings, paintings, and miniatures have come down to us; they show no stylistic unity but are associated with different international trends. A native of Bern and a celebrity in his day (though little known at home), Werner sank into oblivion after his death and has only recently begun to be studied. He left Bern in his youth to work with Merian in Frankfurt, spent ten years in Rome, then five in Versailles working with Lebrun for Louis XIV, and finally moved on to Augsburg, Bern, and Berlin. A versatile and restless artist and a brilliant technician, he made his reputation first as a miniaturist. Miniatures on vellum had been very popular at the princely courts since the sixteenth century, and for the famous Kunstkammer of the Elector of Bavaria he painted a set of them on the *Life of the Virgin*. At this same period the art of miniature enamel painting was flourishing in Geneva.

Werner's miniature in gouache of *Diana Resting from the Hunt*, painted in Paris, illustrates the

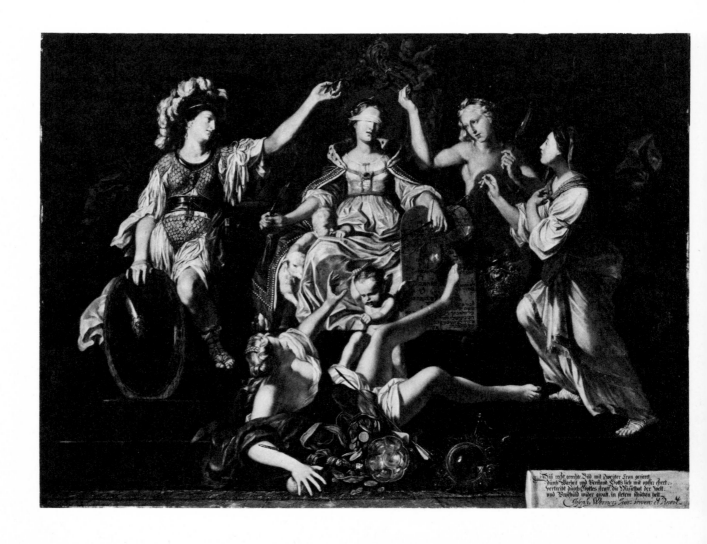

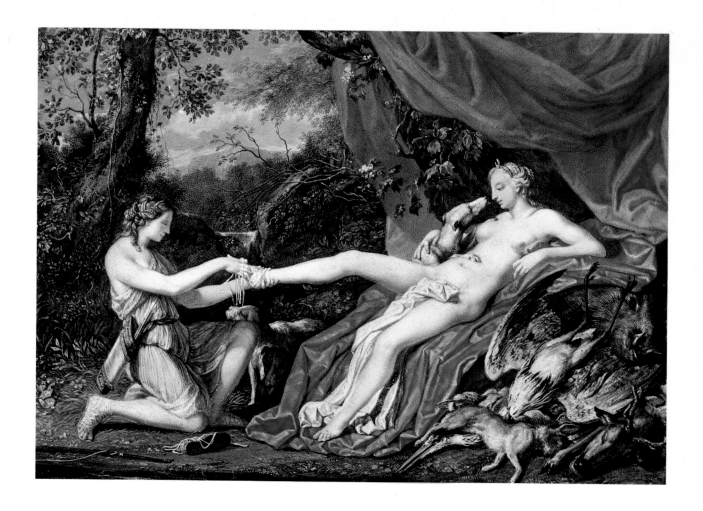

refinements of this painting: elongated figures, a mythological theme, still life trophies of the hunt, a wealth of landscape details, all deriving from the tradition of Elsheimer, Maratta, and French court art. In Rome the young Werner came under Poussin's influence, which only deepened in the work of his Paris years. There he painted his allegorical portrait miniatures of the royal family, including *Louis XIV as Apollo in the Chariot of the Sun*. Besides these works on the classical plane, Werner made some lively drawings of witches and treasure-seekers, after the manner of Salvator Rosa and G. B. Castiglione; similar themes were treated by the German little master Schönfeld, who was in Augsburg at the same time as Werner. These macabre scenes also owe something to the Swiss tradition of Urs Graf, to be revived again in the later eighteenth century by Henry Fuseli.

In Paris, where a poem of 822 verses in praise of his art was published by Bahier in 1671, Werner witnessed the founding of the Academy; later, in Bern, he founded an academy of his own, the first in Switzerland, which trained several generations of Bernese painters, among them Johann Rudolf Huber. But the unresponsive burghers of Bern could only disappoint so ambitious an artist. Yet he succeeded in obtaining a commission for an *Allegory of Justice* in the Town Hall and there again, two decades later, painted an *Allegory of Bern with Felicity and Faith*. In the first, Justice sits blindfold with the scales and the table of the laws, surrounded by Minerva, naked Truth, and Faith, while Crime clad in an ass's hide falls at their feet in a theatrical pose. Not surprisingly, such compositions, inspired by the glorification of princes, remained unusual; they were alien to the Swiss spirit, and even more so a century later, when another rare example occurs, Sablet's *Allegory of Bern as Patroness of the Arts* (see page 120). Late in life, Werner was called to Berlin as founder and director of the Berlin Academy, and his new duties there put an end to his work as an artist.

Joseph Werner (1637-1710):

◁ *Treasure Seekers Calling up a Ghost*
Ink brush drawing, 13⅞ × 8⅞"
Kunsthalle, Hamburg

◁ *Allegory of Justice*. 1662
Oil on canvas, 65¼ × 88½"
Kunstmuseum, Bern

Diana Resting from the Hunt. c. 1663
Gouache, 4⅝ × 6½"
Landesmuseum, Zurich

Giovanni Serodine

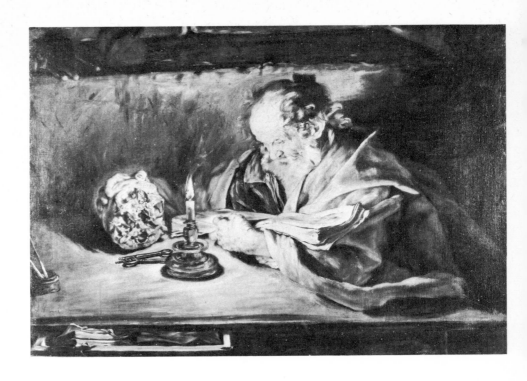

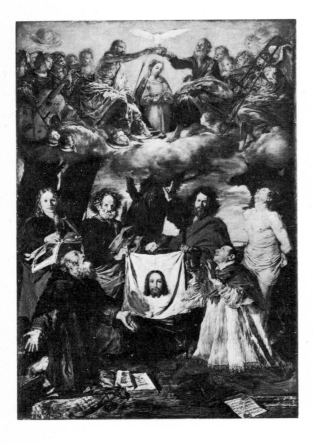

Giovanni Serodine (1594-1631):

Saint Peter in Prison. c. 1625-1630
Oil on canvas, 35½ × 50″
Pinacoteca cantonale Giovanni Zuest,
Rancate (Ticino)

*Coronation of the Virgin
with the Sudarium of Saint Veronica*
(Whole and detail). c. 1625-1630
Oil on canvas, 157½ × 107″
Parish Church, Ascona (Ticino) ▷ △

A native of Ascona (Ticino), near Locarno, Giovanni Serodine was an artist of European stature and the only one to rise above the provincialism of Swiss painting in the Baroque period. "One of the greatest of the whole seventeenth century in Italy": so he has been described by the late Roberto Longhi, a leading authority on Baroque painting, who has thrown so much light on this long-forgotten personality. While most of the Ticino masters, like the Late Mannerist G.B. Discepoli (1590-1660), belong to the Lombard school, Serodine settled in Rome (in 1615) and there joined the group of Caravaggesque painters; Mola, coming to Rome some years later, followed the more widespread classical trend of Roman painting. Unlike Mola, Serodine remained in close touch with his native Ticino. Born into a family of artists which already had connections with Rome, he went there at the age of twenty-one and died there at thirty-seven after an unsuccessful career. Only about a dozen important paintings have survived. Apparently he also practiced sculpture and architecture.

At Ascona, where the Serodine family house still exists, richly decorated with stuccoes about 1620, there are three altarpieces by him, the finest being the *Coronation of the Virgin with the Sudarium of Saint Veronica*, a very late work. In the lower part, Saints Peter and Paul hold the veil or sudarium of Saint Veronica with the true image of Christ; beside them are Saint John the Baptist (left) and Saint Sebastian (right); kneeling in front are Saint Anthony (left) and Saint Charles Borromeo (right). The composition was taken over from an earlier fresco which still exists behind the painting. The scene is set out of doors, figures and features being rendered with an arresting naturalism far in advance of its time. The vibrant colors are laid on with a full brush, with a vivid play of lights and shadows, especially striking in the hands of Saint Charles (see page 105). Above, in the heavenly zone, forms are dematerialized. Serodine's youthful freshness and vivid colors set him apart from the many Caravaggisti who kept to stock formulas. For all their impetuous novelty, his works have in common with Caravaggio a mood of religious seriousness. The profane side of Caravaggism is quite absent in Serodine. His painterly brush-work and rich creamy pigments link him with Ribera, Strozzi, and Feti.

No less fine than his altar paintings, and even more striking in their effect, are Serodine's smaller pictures, like the *Portrait of the Artist's Father as Saint Thomas* (1628, Lugano) and *Saint Peter in Prison* reading by candlelight, beside a skull, symbolizing the vanity of earthly things.

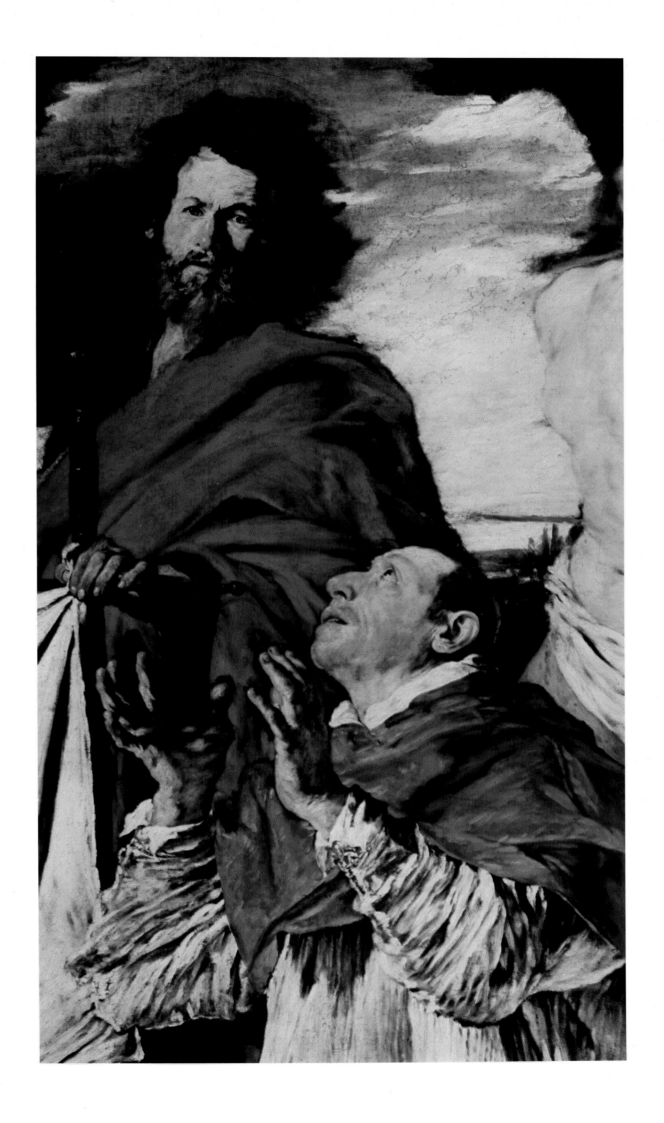

Like Serodine, Mola has his assured place in the Roman school, not indeed as a major master, but as a significant one of unmistakable individuality. His religious, mythological, and allegorical paintings represent a fusion of Roman Baroque with the tradition of Titian. While following the classical line laid down by Domenichino and Poussin, his seniors by several decades, he also responded to the warm Venetian coloring, the elaborate staging of Pietro da Cortona, and the bold romanticism of Salvator Rosa. Mola settled in Rome about 1642 and remained there for the rest of his life, except for occasional stays in Venice, in Bologna with Albani, and in his birthplace, Coldrerio, near Lugano, where the choir of the village church contains his earliest known frescoes, *God the Father* and two *Madonnas with the Rosary*. The beauty of his frescoes and pictures lies in the free handling of the paints, the rich color harmonies and the broad, well-conceived design. Like his contemporaries Dughet and Grimaldi, he was fond of placing his figures in a romantic wooded landscape. The picture of *Socrates Teaching*, as he holds a mirror before his pupils, illustrates the philosopher's motto: "Know thyself." The meditative theme and the broad style are reminiscent of Poussin's Venetian phase. Mola's major works include canvases, like the *Vision of Saint Bruno* and the *Barbary Pirate* in the Louvre, and his fresco decorations in Rome (church of San Marco, the Quirinale Palace, and the Ravenna chapel of the church of Gesù) and in the Villa Pamphili at Valmontone, near Rome. His dynamic pen and brush drawings are among the finest works of Baroque graphic art.

Pier Francesco Mola and Giuseppe Antonio Petrini

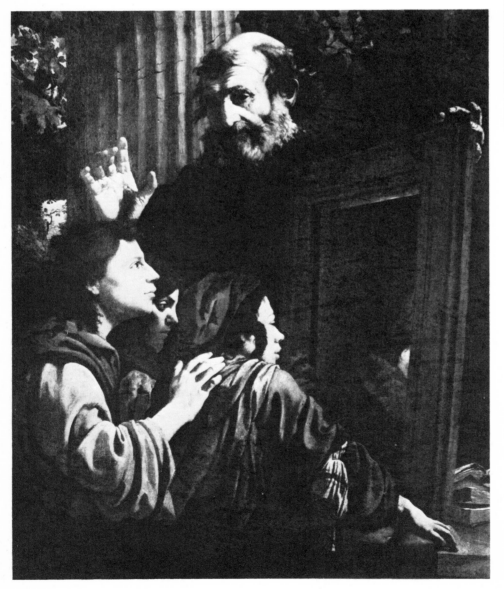

Pier Francesco Mola (1612-1666):

Virgin and Child
Design for the Coldrerio fresco
Pen and ink with red chalk, 10⅞ × 8″
National Museum, Warsaw

Socrates Teaching. c. 1655
Oil on canvas, 47¼ × 34⅝″
Museo Civico di Belle Arti, Lugano (Ticino)

Giuseppe Antonio Petrini (1677-1757/58)
The Holy Family
Oil on canvas, 36¼ × 29⅛″
Museo Civico di Belle Arti, Lugano (Ticino) ▷

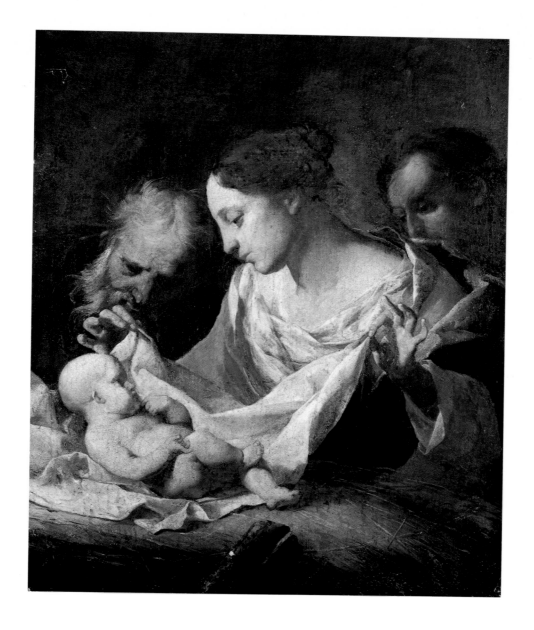

The leading artistic personality of the eighteenth century in the Ticino was Cavaliere Petrini. Trained by the Genoese master Bartolomeo Guidobono, Petrini lived mostly in his native Ticino, though he executed many commissions in Como, Bergamo, Pavia, and other places in Lombardy. His work was decisively influenced by his Venetian contemporary Giovanni Battista Piazzetta. Admittedly, Petrini has none of the brio and resourcefulness of the Venetian, but his pictures and frescoes, almost all on religious themes, reveal an impressive breadth of style.

Some of them, like the *Holy Family* in the Lugano museum, are reminiscent of the best work of Barocci and Correggio; in others, like the frescoes at Carona, near Lugano, the composition is pervaded by Mannerist elements. Bodies are etherealized, figures become flickering, weightless apparitions. Broad empty spaces are set in contrast to passages of strenuous movement and flashing lights. Clouds and billowing clothes appear to be made of the same substance. Often the design is based on a sequence of lines of force abruptly broken off. Boldly foreshortened figures seen from below, expressive gestures, color contrasts ranging from dark atmospheric tones to strident local colors—these are the characteristics of Petrini's spirited and emotional art, always in the service of religious rapture. Several of his works are in the church of Sant'Antonio Abbate in Lugano, notably the fine *Altarpiece of Saint Anthony Abbot* in the choir; other churches in the Ticino have altarpieces by him.

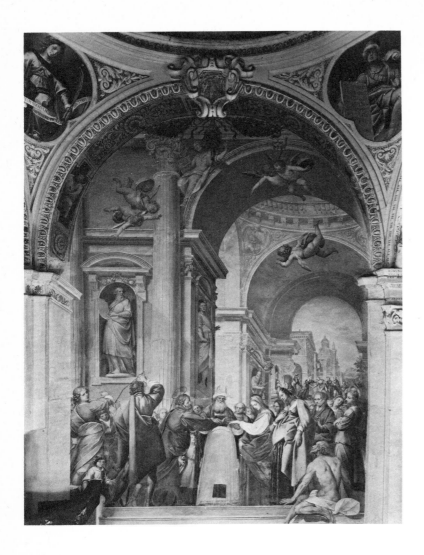

Fresco Painting in the Ticino:
Isidoro Bianchi
and
Giuseppe Orelli

Isidoro Bianchi (1602-1690)
Marriage of the Virgin. 1628-1634
Fresco. Church of the
Madonna dei Ghirli, Campione (Lombardy),
near Lugano.

After the fine flowering of the years around 1520, the art of the Ticino sank into unrelieved mediocrity during the later decades of the sixteenth century. A fresh spurt of creative vitality came only with the Baroque period. It began with the frescoes of Isidoro Bianchi in the already venerable pilgrimage church of the Madonna dei Ghirli at Campione (Lake of Lugano). With his assistants, Bianchi redecorated the interior of the church. In the choir is the cycle of the *Life of the Virgin*, in which the *Marriage of the Virgin* stands opposite the *Presentation in the Temple*. They are large, majestic, highly decorative works; the lively figures constitute a direct continuation of those of Morazzone, while the illusionist setting with its great vistas of space derives from High Renaissance art. Bianchi's influence extended throughout the Ticino and the Lombard regions of Como and Varese. The Torriani family of Mendrisio (Ticino) supplied German-speaking Switzerland with altarpieces in the style of Bolognese and Roman Baroque. This tradition was continued in the eighteenth century by Carlo Carlone.

The Orellis of Locarno were another outstanding family of painters. For some years Giuseppe Orelli was the pupil and assistant of the great Tiepolo in Milan, Bergamo, and Venice; thereafter he worked chiefly in his native Ticino. His *Concert of Angels* in the collegiate church of Bellinzona is set in an imposing architectural perspective; the fresco of *Selene and Endymion* in Lugano is a fine example of a Late Baroque ceiling fresco, with the figures seen from below in illusionist perspective. The same style of illusionist wall painting, with simulated buildings in perspective, was practiced by F.A. Giorgioli, who worked much in German Switzerland (Muri and Rheinau) and by the Torricelli brothers (choir of Lugano Cathedral). One of the most brilliant works of Swiss Baroque decoration, by an as yet unidentified painter, is in the main hall of the château at Saint-Légier, near Vevey, above the Lake of Geneva.

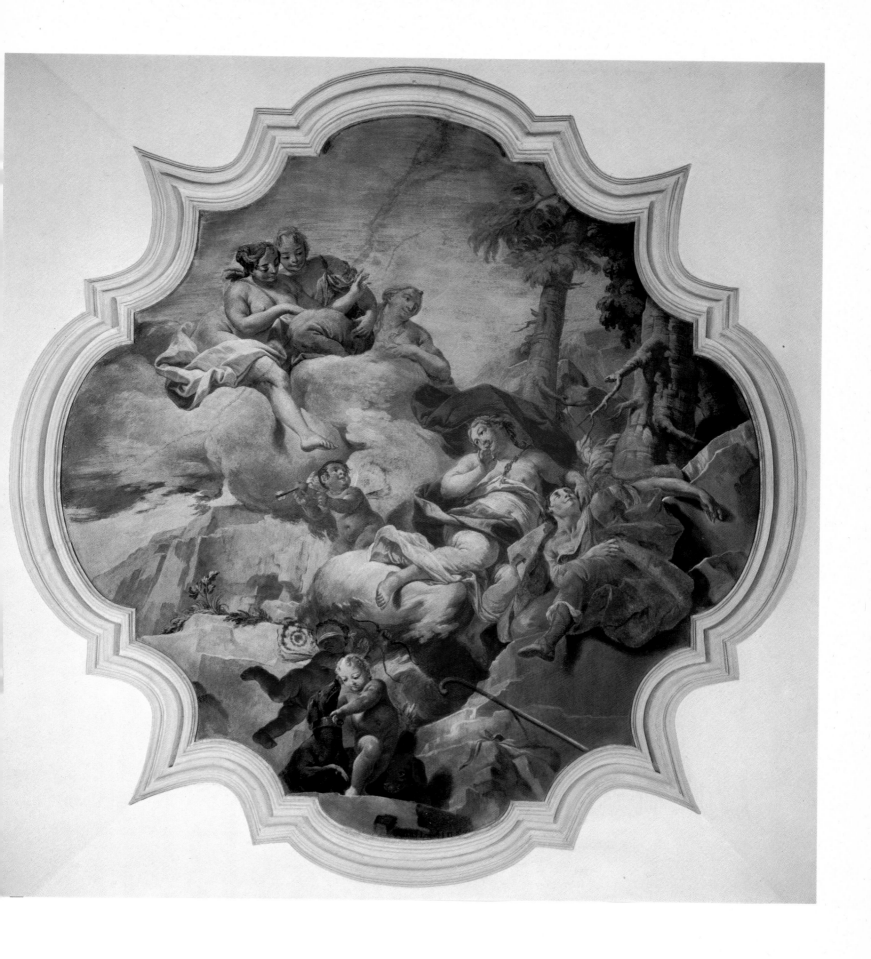

Giuseppe Antonio Felice Orelli (1706-1776)
Selene and Endymion
Fresco
Palazzo Riva, Banca della Svizzera Italiana,
Lugano (Ticino)

Painting in Geneva:
Jean-Etienne Liotard
and
Jean Huber

I think myself fortunate if, ever striving for the glory of an art to which I have given over sixty years of my life, and for the glory of those who will practice it after me, I can still be of service to my successors by showing them the means of preserving one of the most beautiful of the arts in all its purity.

Jean-Etienne Liotard, *Traité des principes et des règles de la peinture*, Geneva, 1781

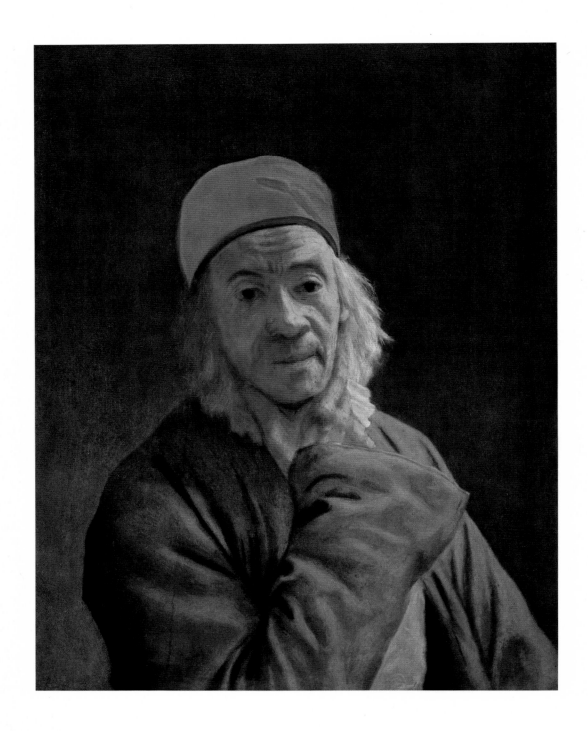

Jean-Etienne Liotard (1702-1789)
Self-Portrait. 1773
Pastel on canvas, 24¾ × 20½″
Musée d'Art et d'Histoire, Geneva

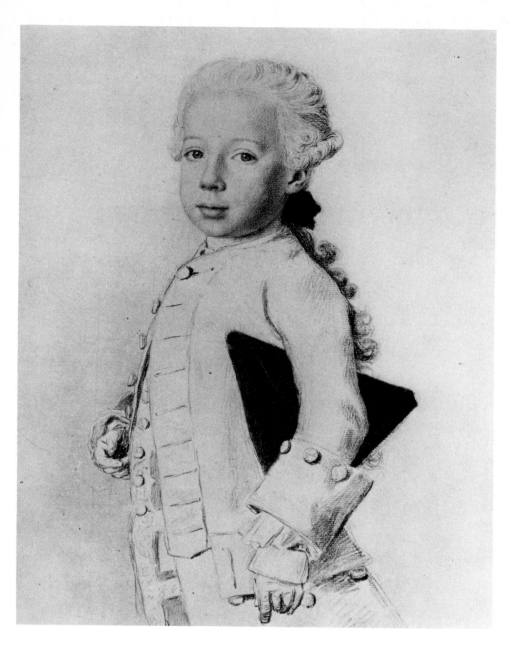

Jean-Etienne Liotard (1702-1789):

The Austrian Archduke Maximilian Franz
1762. Red chalk and charcoal, 12¾ × 10½″
Musée d'Art et d'Histoire, Geneva,
on deposit from the Gottfried Keller Foundation

The Austrian Archduchess Maria Karolina
1762. Red chalk and charcoal, 12¾ × 10½″
Musée d'Art et d'Histoire, Geneva,
on deposit from the Gottfried Keller Foundation

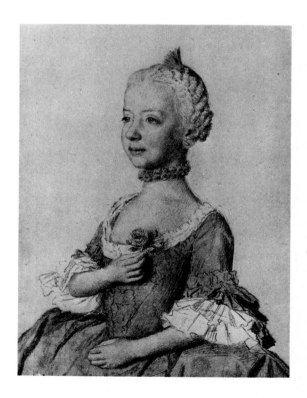

The iconoclasm of the Reformation had put an abrupt end to artistic activity in Geneva. Calvin's sumptuary laws, enacted in the mid-sixteenth century, imposed a stern and unbending puritanism. As late as 1739 one such law ran: "Any busts or statues serving to adorn the inside or outside of houses are forbidden, any costly paintings used for the same purpose and any display of china beyond a few cups for ordinary use, on pain of a fine of 25 crowns." No art could flourish in such an atmosphere. Painting was limited to portraiture and the minor art of miniature enamel painting on watch cases, snuff boxes, etc.; the latter industry arose in the seventeenth century and was largely in the hands of Huguenot émigrés. While German-Swiss portraiture was beholden to Dutch and Flemish influence, Geneva lay in the French sphere of influence. In Paris, down to the middle of the eighteenth century, reigned the elegant court style of Rigaud, Largillière, and Nattier. Liotard, the first Genevese artist of note, belonged to the generation of Boucher, Chardin, Hogarth, Pietro Longhi, and Pompeo Batoni. The son of French émigrés from Montélimar, he learned the technique of enamel and miniature painting in Geneva at an early age. The unerring precision of the miniature remained characteristic of his work throughout his life.

Liotard's features are familiar to us from a score of self-portraits, whose only equivalent in Swiss painting are those of Anton Graff and Ferdinand Hodler. In contrast with the courtly manner of French portraiture, Liotard's

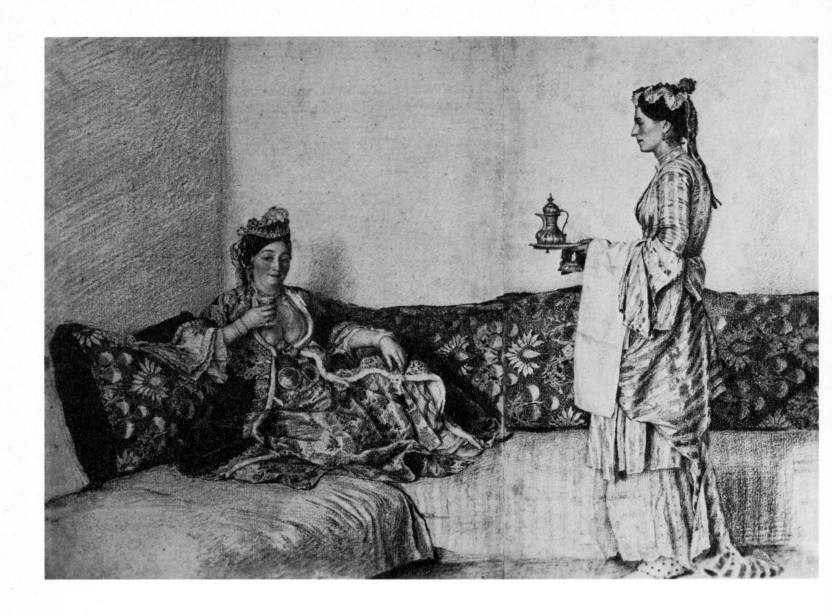

portrait style is generally plain and straightforward; his sitters, with their easy natural pose and strong modeling, have a characteristically eighteenth-century directness of gaze and attitude. His portrait drawings, executed as small, independent pictures, often give a foretaste of the clarity and technical purity of Ingres' drawings. Liotard is at his best in his pastels, a medium much favored in the eighteenth century for its subtlety and lightness; as pastel does not darken under the effect of light, these works have retained an unimpaired freshness.

Pastel portraits had been made fashionable at the European courts by the Venetian artist Rosalba Carriera, and Liotard met with great success when, in Vienna in 1762, he portrayed the Austrian emperor and his twelve children in this medium. He met with the same success at the courts of Paris and London. Parisian connoisseurs, however, were critical of his incisive line and bright local colors; as Mariette put it, "these pastels were esteemed for their value, but they were thought dry and laborious." In Paris, Quentin de La Tour (1704-1788), Liotard's exact contemporary and a no less engaging and eccentric personality, executed pastels which show a deep understanding of the art of portraiture, less concerned with mere realism. A number of contemporary French masters worked in the pastel medium, in particular Drouais the Elder, Tocqué, Aved, Perronneau, and Roslin; their works are comparable to those of Liotard, though they are more atmospheric, more lyrical, and more subdued in coloring. Beside theirs, the art of Liotard seems reserved and prosaic, shy of virtuosity; therein lies perhaps its Genevese element. He portrays aristocrats no differently than Genevese burghers.

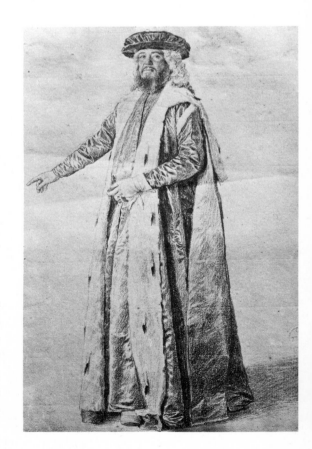

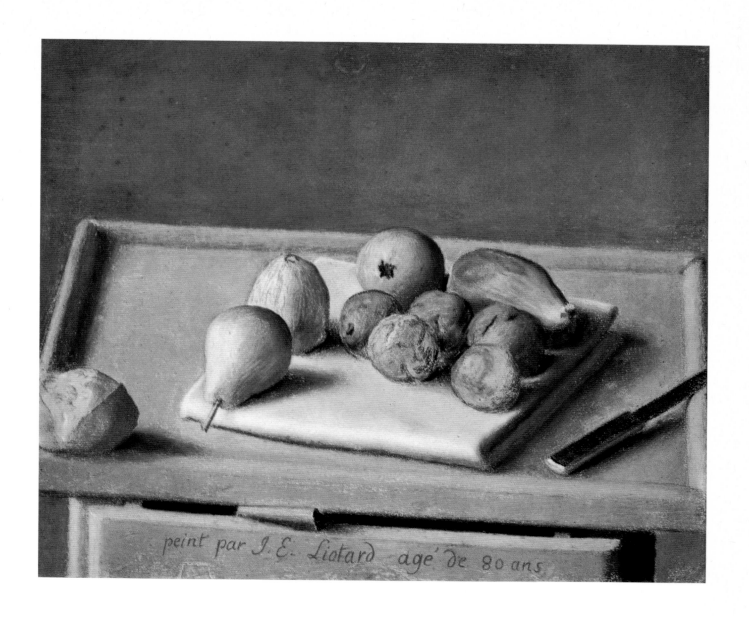

Jean-Etienne Liotard (1702-1789):

◁ *Turkish Lady and Her Slave Girl.* 1738-1742
Red and black chalk, 8¼ × 11½"
Oskar Reinhart Foundation, Winterthur

◁ *A Hospodar of Jassy in Moldavia.* c. 1742-1743
Pencil and red chalk, 9 × 6½"
Musée d'Art et d'Histoire, Geneva

Still Life. 1782
Inscribed: "painted by J.E. Liotard
at the age of 80"
Pastel, 13 × 15"
Musée d'Art et d'Histoire, Geneva

The Artist's Room in Constantinople
c. 1738-1739
Pencil and red chalk, 7¼ × 9⅝"
Musée d'Art et d'Histoire, Geneva

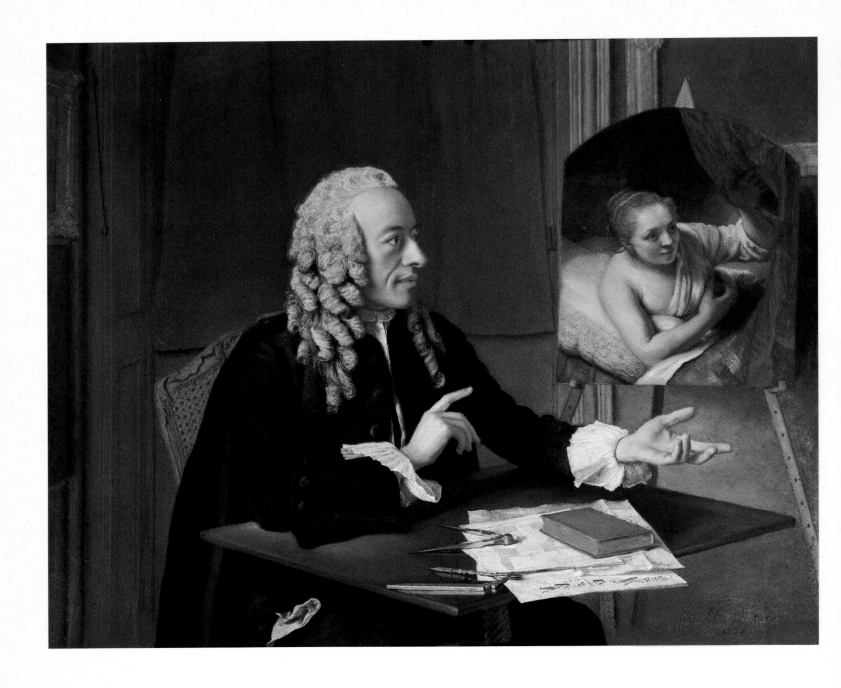

In Geneva in 1781, when he was nearly eighty years old, he wrote and published a small treatise on the art of painting. The more conventional passages are relieved by some personal observations based on his experience. "The first requisite for the painter is to put grace into everything he does." He sums up his working methods as follows: "Finish as painstakingly as possible. Finish is one of the most agreeable features of painting... Aim at effect; effect is the element of the painting which most attracts and strikes the spectator's eye... No traces of the brush."

Liotard owed his reputation in part to his original manners, his witty tongue, and the Turkish costume he was so fond of wearing. Restless and inquisitive, he worked in Paris (1725-1738), Italy (1738), Constantinople (1738-1742), and later in Vienna, Holland, and England. Some of his best genre scenes were done in Turkey; he made the most of the effects to be obtained from the bare white walls of Turkish interiors. Interest in the Levant had been growing steadily for a century. Turkish themes were taken up repeatedly in the literature, painting, and applied arts of the eighteenth century, most prominently in the work of Liotard and Tiepolo and in French tapestries from the Gobelins and Beauvais workshops; these themes were to be given a new lease of life in the nineteenth century with the Romantics.

Life is indeed worth very little, but it is pleasant to live out one's days near the Tronchins and above all near you, Sir, whose friendship is so staunch and agreeable.

Voltaire, letter to Councillor
François Tronchin, Prangins (Geneva),
January 27, 1755

From Liotard's old age date some pastel still lifes whose simple, symmetrical design owes something to Chardin. In the Geneva still life reproduced here, "painted by J.E. Liotard at the age of eighty," there is already a hint of Cézanne's later still lifes. During the eighteenth century a more liberal atmosphere gradually came to prevail in Geneva and several fine picture collections were brought together, in particular that of François Tronchin, a prominent Geneva businessman and a friend of Voltaire, Diderot, and Grimm. Liotard painted a portrait of him in the characteristic pose of the enlightened dilettante of that day, with one of his Rembrandts on an easel beside him. (Tronchin sold his collection *en bloc* in 1771 to Catherine the Great of Russia, but this picture of *Hendrickje Stoffels in Bed* is now in the National Gallery of Scotland, Edinburgh.)

Jean Huber the Elder, a Geneva landowner and town councillor, was trained as a painter in Germany. A versatile artist, he introduced into Geneva not only landscape painting in the manner of the Dutch Italianists but also the art of silhouettes and that of caricature. He is best known as a close friend of Voltaire, who settled at Ferney, near Geneva, in 1758 and whom Huber portrayed many times in the privacy of his home. "He has made me ridiculous from one end of Europe to the other," was Voltaire's ironical comment on his friend's pictures of him.

Jean-Etienne Liotard (1702-1789)
◁ *François Tronchin with His Painting by Rembrandt*. 1757
Pastel on vellum, 14¾ × 18⅛"
Private Collection, Geneva

Jean Huber (1721-1786)
The Artist Painting a Portrait of Voltaire
Pastel, 24¾ × 19¾"
Musée d'Art et d'Histoire, Geneva

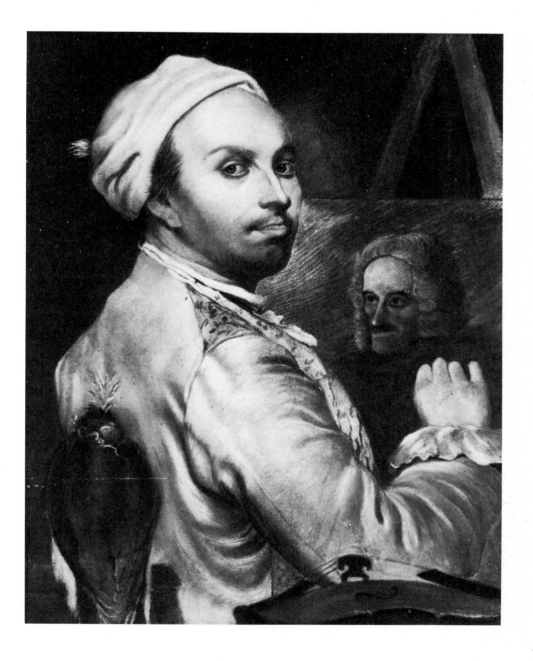

Anton Graff
and
Felix Maria Diogg

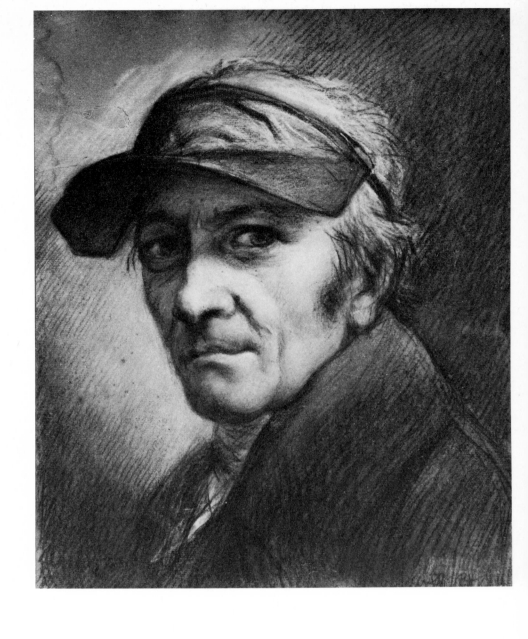

Anton Graff (1736-1813):

Self-Portrait with an Eyeshade. 1813
Black and white chalk, 13¾ × 10⅞″
Kunstmuseum, Lucerne

Prince Reuss. 1775
Oil on canvas, 44½ × 33″
Neue Pinakothek, Munich

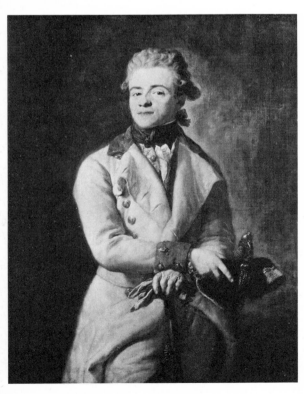

A generation after Liotard, German Switzerland also produced a portrait painter of international stature: Anton Graff, born in Winterthur in 1736. From his historical position and the sheer extent of his work, he is an artist of considerable importance, well represented in the museums of central Europe, for he made his career in Dresden, where he was the great specialist in middle-class portraiture. The pastel portrait was unknown in Germany until he introduced it. Graff was trained in the studio of the Winterthur landscapist and portraitist Johann Ulrich Schellenberg. In 1766, at the age of thirty, he was appointed director of the newly founded Dresden Academy. There, for nearly fifty years, he portrayed the Saxon burghers and aristocrats, generally in half-length against a neutral ground, sometimes in full-length groups. The portrait of *Prince Reuss* is a fine specimen of his art. The easy pose of the accomplished gentleman and the faint smile lurking at the corners of the mouth are tellingly conveyed. The painterly execution, emphatic colors and delicate modeling give his figures an individual presence over and above the social type they represent. A careful and steady worker, Graff maintains a high standard of quality throughout an oeuvre consisting of nearly two thousand paintings and drawings. Even more frequently than Liotard he studied his own face, with searching persistence. Reproduced here, out of his eighty self-portraits, is a forcefully modeled chalk study with an eyeshade, done at the age of seventy-seven as a preliminary drawing for one of his last pictures; one is reminded of Chardin's 1775 self-portrait with an eye-

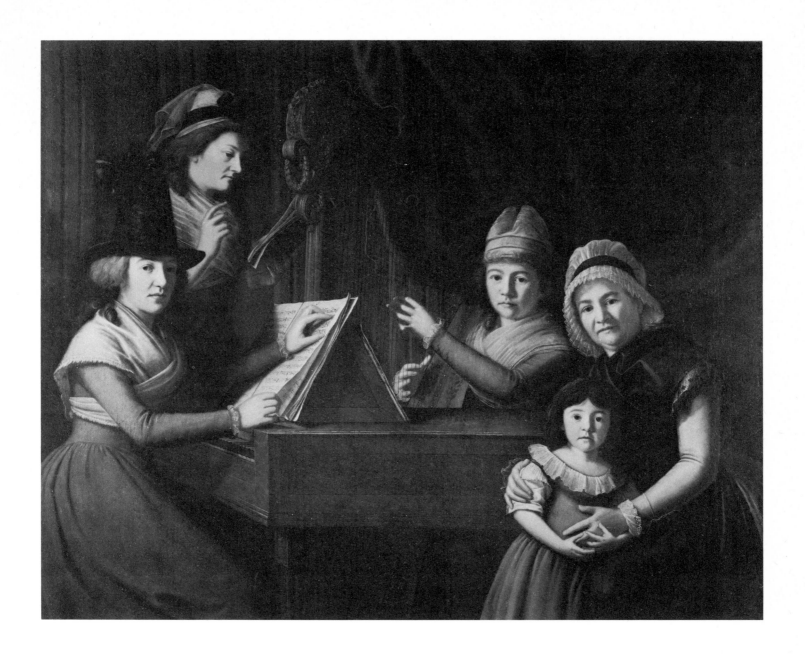

Felix Maria Diogg (1762-1834)
The Esslinger Family Making Music
c. 1793. Oil on canvas, 58 × 70″
Collection Willy Schweizer-Wehrli,
Küsnacht (Zurich)

shade in the Louvre. But there is, of course, no direct connection between them. Graff's stylistic antecedents are to be found in the work of the German little master Johann Kupetzky and his Bavarian pupil, Georg Desmarées.

Graff stands midway between the generation of Mengs and Romney and that of Angelica Kauffmann, Madame Vigée-Lebrun, and J.F.A. Tischbein. Admittedly his work has a certain monotony, for he kept almost exclusively to portraiture. He had neither the stylistic versatility of Reynolds, nor the quick grasp of character of Gainsborough, nor the graceful virtuosity of F.H. Drouais in France. But in the limited field of German portraiture Graff marks a high point. In Germany he portrayed some celebrities like Lessing and Schiller. During visits to his native country he painted portraits of Bodmer, Johann Caspar Füssli, and Salomon Gessner, and several of his father-in-law, the Winterthur aesthetician and philosopher Johann Georg Sulzer.

With Felix Maria Diogg, a generation later, we find a distinctively native type of portraiture, tinged, however, with Neoclassicism, for this artist worked abroad for many years, in particular in France at the Academy of Besançon under its founder, the Swiss little master Johann Melchior Wyrsch. Diogg and Wyrsch, in fact, are the only two painters of any note to come from the original Forest Cantons of central Switzerland. A real charm emanates from Diogg's single figures and family groups (these latter reminiscent of English "conversation pieces") in the domestic setting of middle-class homes.

Rural Life and the Alpine World

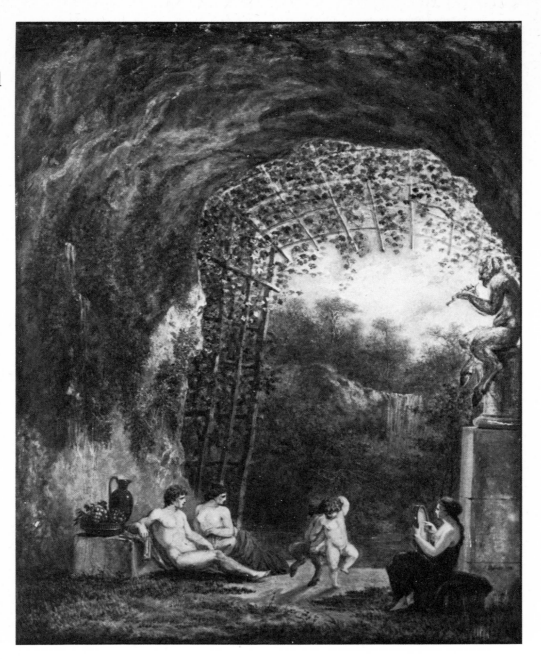

O may I, ye Gods, may I sing my rapture and my thanks in accents worthy of you! All nature glows in ripest beauty and the earth overflows with her blessings. Everywhere reign grace and gladness.

Salomon Gessner, *Idylls*, "The Autumn Morning", 1756

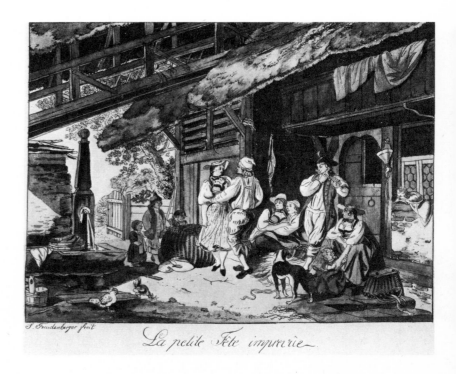

Salomon Gessner (1730-1788)
Arcadian Idyll with Dancing Children
1781. Gouache on paper, 14 × 11"
Kunsthaus, Zurich

Sigmund Freudenberger (1745-1801)
A Festive Moment on a Bernese Farmstead
("La petite Fête imprévue")
Pen and ink wash, 6¼ × 8¼"
Private Collection, Zurich

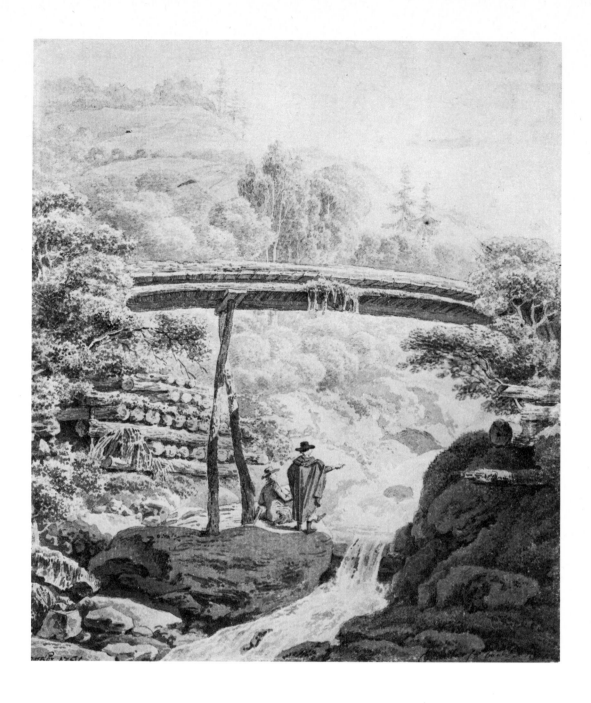

The growing interest in the mountains and the growing vogue for Swiss views gave rise in the mid-eighteenth century to the lyrical landscape, whose best-known representative is the Zurich painter and poet Salomon Gessner, a contemporary of Gainsborough and Fragonard and a very popular artist in his day both in Germany and Switzerland. The son of a bookseller, he made his name as a bucolic poet with *Daphnis* (1754) and *Idyllen* (1756), before gradually concentrating his efforts on etching, book illustration, and landscape. His poetic conception of nature, inspired by Rousseau and the English, gave free rein to the imagination and, it must be said, to a sentimental effusiveness. Most of his paintings are small Arcadian landscapes based on those of the Italianizing Dutch masters of the seventeenth century; the simple design and the figures are characteristic of early Neoclassicism, while the mood is already that of Romanticism.

At the same time, in the work of little masters like Balthasar Dunker and Sigmund Freudenberger, rural and Alpine life was being depicted in less idealized terms. Freudenberger worked at first in Paris for Boucher, Greuze, and the illustrator Moreau the Younger. Later, in Bern, he created and popularized those colored prints illustrating the simple enjoyments of Bernese peasant life. Continuing and renewing the Dutch tradition of Van Ostade, these are the first Swiss genre scenes.

Balthasar Anton Dunker (1746-1807)
Alpine Landscape with Stream and Figures. 1791-1792
Pen and ink with watercolour, 8½ × 7″
Kunstmuseum, Saint Gall

In addition to portraiture and miniature painting on enamel, the Genevese school is conspicuous for its landscapists. The Dutch tradition of Jan Both was continued by Jean Huber (see page 115) and his son Jean-Daniel Huber (1754-1845) and, in a broader range of moods, by Pierre-Louis de La Rive. The latter, in the course of his travels through Holland, Germany, and Italy, gradually moved on from lyrical Italianizing landscapes to a more classical Louis XVI style, as in the small allegorical scene with a tomb—reminiscent of Gessner's Arcadian landscapes. De La Rive's later work is remarkable for some fine landscape sketches and, in painting, for his last majestic views of Mont Blanc.

Genevese figure painting arose from the start within the orbit of the French school, and while the art of Fuseli developed in London in uninhibited freedom, that of his younger Genevese contemporary, Jean-Pierre Saint-Ours, was shaped by the influence of Paris. The son of French émigrés, Saint-Ours was sent to Paris by his father in 1768 at the age of sixteen. There he studied at the Académie Royale as a pupil of Vien, together with David, his senior by four years. In 1780 he went to Rome and spent twelve years there with De La Rive. By 1792 he was back in Geneva, a convinced revolutionary. His many-sided oeuvre, still little known, includes history paintings, imaginative compositions like *The Earthquake*, some Poussinesque landscapes, and many portraits. Like so many Neoclassical painters, he was a fine draftsman. The strict classical schooling he

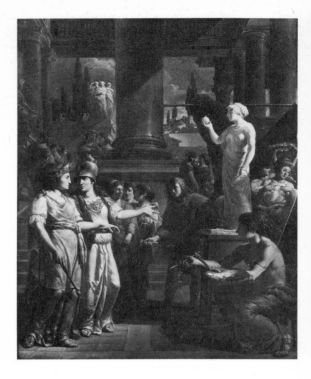

Neoclassical Painting in French Switzerland

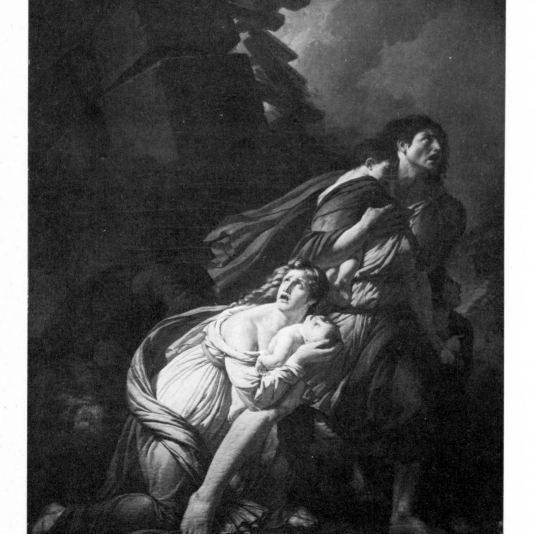

Jacques Sablet (1749-1803)
*Allegory of Bern
as a Patron of the Arts.* 1781
Oil on canvas, 89½ × 70½"
Kunstmuseum, Bern

Jean-Pierre Saint-Ours (1752-1809)
The Earthquake. 1799
Oil on canvas, 104½ × 84¾"
Musée d'Art et d'Histoire, Geneva

Pierre-Louis de La Rive (1753-1815)
The Tomb of S. de La Rive. 1787
Oil on canvas, 31⅛ × 27½"
Musée d'Art et d'Histoire, Geneva ▷

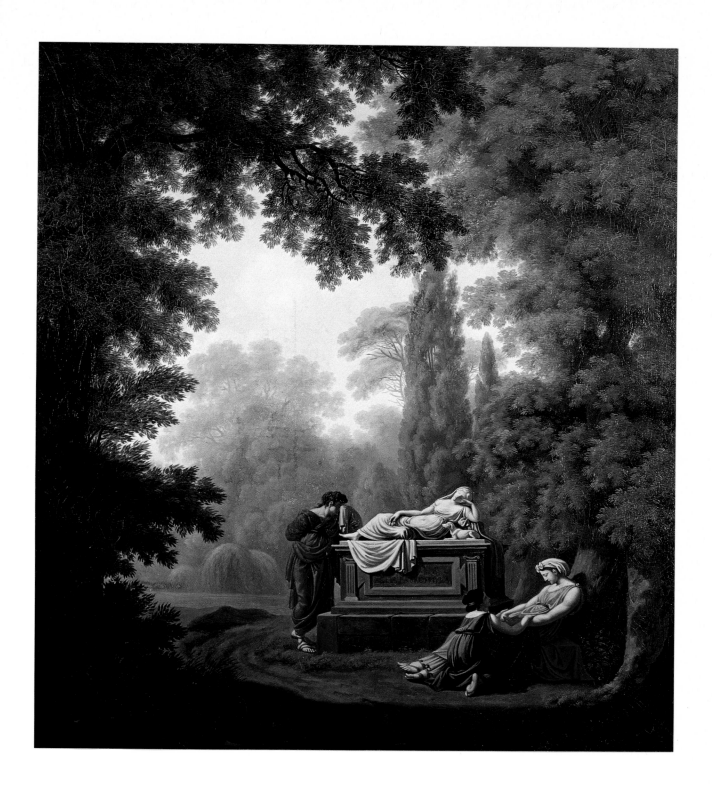

received from Vien makes itself felt in all his work and never more so than in the elaborate classicism of his last painting, *The Triumph of Beauty* (1809). Such grandiloquent, over-lifesize canvases as *The Earthquake* are characteristic of Neoclassicism in one of its moods. The theme is paralleled by Fuseli's contemporary pictures of nightmares. It was his disillusionment with the disruptive effects of the French Revolution that inspired Saint-Ours to paint his *Earthquake*. Showing a group of men, women, and children fleeing from a Greek temple that is crashing in ruins, it symbolizes the cataclysmic destruction overwhelming humanity.

Neoclassicism is also represented in French Switzerland by Vaucher, Brun of Versoix, and the Sablet brothers of Morges. The tradition of secular Baroque allegory was continued by Jacques Sablet with his personification of Bern, being introduced by Minerva into the temple of beauty, painting, and sculpture. Jacques Sablet also painted some charming group portraits in a landscape setting, comparable to those of Ferdinand Kobell in Germany.

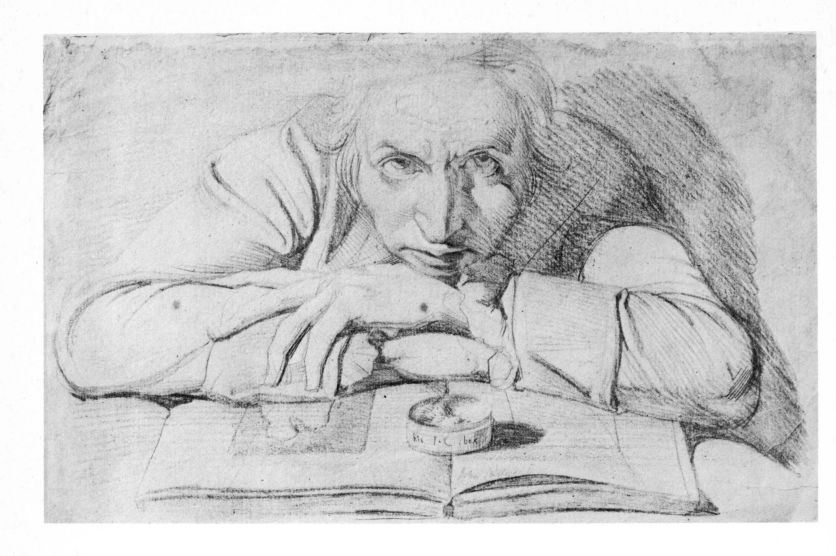

"In everything extreme—Shakespeare's painter... his spirits are hurricane, his servants flames of fire. He goes on the wings of the wind. His laugh is the mockery of Hell, and his love a murderous lightning flash" (Lavater on Fuseli, 1773-1774). "I found him the most grotesque mixture of literature, art, scepticism, indelicacy, profanity, and kindness" (Benjamin Robert Haydon on his master Fuseli, in 1805).

The chalk and charcoal *Self-Portrait* of about 1777, drawn in Rome at the height of the Sturm und Drang period, is a brilliant, intensely expressive line drawing; the hatching technique gives the face its sharp, sculptural plasticity. Fuseli is probably the most significant and influential of Swiss-born artists. A native of Zurich, christened Johann Heinrich Füssli, the son of Johann Caspar Füssli, he spent only his youth in Switzerland, living in Berlin, London, and Paris in the 1760s, in Rome from 1770 to 1778, and then in London for the rest of his life where he was known as Henry Fuseli. The "wild Swiss" became a leading personality in the London art world. Elected to the Royal Academy in 1790, he was made Professor of Painting at the Academy in 1799 and Keeper of the Academy in 1804. His professional standing may be judged from the fact that David Wilkie, Haydon, Etty, Constable, Landseer, and Mulready were among his students, and personalities as varied as Sir Thomas Lawrence and William Blake were close friends. His schooling, however, was Swiss. His father, a portraitist, scholar, and historian, gave him a lifelong taste for both art and literature. The cultivated Zurich circle in which he grew up was imbued with the English spirit of liberal democracy and humane letters; it included such men as Breitinger, Bodmer, Salomon Gessner, Lavater, Usteri, and Pestalozzi. His father's friend Bodmer, who translated Milton into German and edited the *Nibelungenlied*, familiarized him from childhood with the great works of world literature which were to inspire Fuseli all his life.

Henry Fuseli

Henry Fuseli (1741-1825):

Self-Portrait. c. 1777
Charcoal and white chalk, 12¾ × 19¾"
National Portrait Gallery, London

The Rütli Oath. 1779-1781
Oil on canvas, 105 × 70"
Town Hall, Zurich

Edgar and King Lear. 1815
Pencil and charcoal, 12⅛ × 19⅛"
Kunsthaus, Zurich

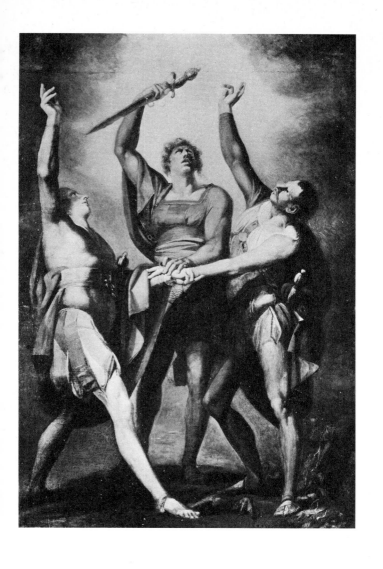

In 1779, on his way back to London after eight years in Rome, Fuseli stopped in Zurich and painted the large *Rütli Oath* for the Town Hall. It marks the starting point of Swiss patriotic painting. The history of the Swiss Confederation begins with the oath on the Rütli, a meadow above the Lake of Lucerne, sworn in 1291 by patriots of the three Forest Cantons (Uri, Schwyz, Unterwalden). In the eighteenth century, for the first time, it became a subject of literature, art, and historiography. Unlike David in his innovative *Oath of the Horatii*, painted four years later, Fuseli based his *Rütli Oath* on an already existing iconography. But its glorification of liberty was an eminently topical theme at that time, and though the style is rooted in the Italian Renaissance and Mannerism, it is no less personal and expressive for that, heralding already the art of the Romantic period.

Fuseli's contacts with the aesthetician and philosopher Sulzer in Berlin and with Rousseau and Hume in Paris were decisive in the development of his art. The enemy of dogmatism in any form, he turned away, while in Italy, from the Neoclassical ideals of Winckelmann and Mengs; but he was strongly influenced there by his study of Michelangelo and his friendship in Rome with such contemporaries as the Swedish sculptor Sergel and the English painters Runciman and Romney. His drawing (see page 88) of the artist despairing beside the colossal remains of antiquity illustrates his view of antique art; this theme was treated from the sixteenth century down to Hubert Robert, but Fuseli alone imbued it with tragic intimations, in a spirit reminiscent of Goya's famous etching, *The Sleep of Reason Breeds Monsters*.

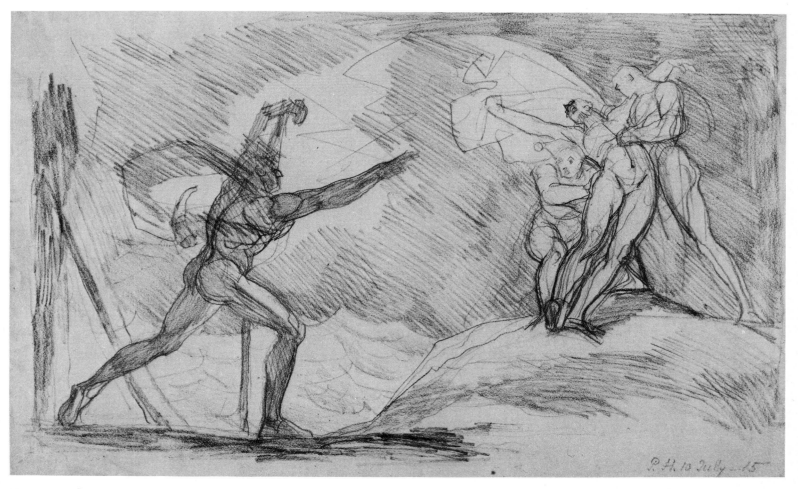

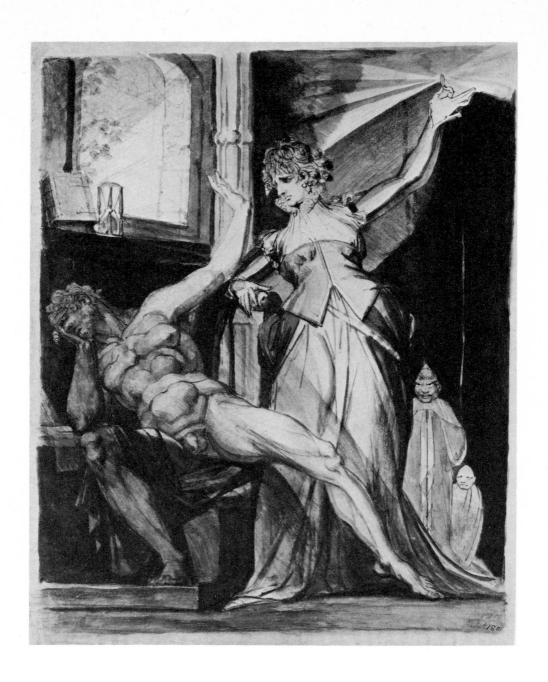

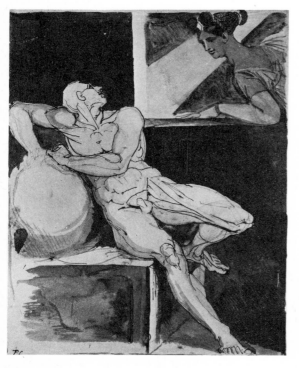

In comparison with David and Goya, Fuseli's development remains uniform. The survival of Rococo is discernible only in his early work. The composition is always focused on the human figure. Just as his themes are often taken from literature, so his forms often derive from those of the old masters. Composition and figure grouping are worked out in terms of strong chiaroscuro and powerful masses to the neglect of detail. His is an art of dynamic movement, striking contrasts, overwrought pathos, and unreal space in which everything is pitched on an ideal scale. Bright, clear colors are set off by darker areas which unfortunately have all too often blackened and deteriorated owing to his reckless use of bitumen.

Fuseli's finest works are his drawings, in pencil, chalk, pen, wash, and brush: their restless drama, their clear-cut economy, his insight into moments of secrecy and terror, show him as a force beneath the smoother surface of his times. The telling, transparent design of *Edgar and King Lear* exemplifies his later style at its best; even the earlier *Cliffs near Devil's Dyke, Sussex*, with Channel shipping visible on the right, has an admirable spareness and breadth. Sheets like the 1810 *Nightmare* (page 126), with two women rousing themselves as the incubus gallops away, can stand comparison with the best drawings of Goya and Picasso.

Fuseli was essentially a literary painter. Literature indeed underlies the whole Neoclassical movement of the late eighteenth century, but with him its stimulus was all-important. A great part of his work is illustrative: he did forty-seven paintings, some of them very large, after Milton alone and many more after Shakespeare, besides hundreds of studies for illustrations for Homer, the Bible, Dante, the *Nibelungenlied*, Wieland, Lavater, Cowper, and many other poets. All his life he drew and painted scenes from Shakespeare, *Hamlet* and *Macbeth* providing him with his favorite themes. In the 1780s, with other English artists, he contributed pictures to the famous Shakespeare gallery then being organized in London by Alderman Boydell; prints after the pictures were put on sale in 1802. In the 1790s he exhibited his own gallery of paintings after Milton. To his series of Bible illustrations belongs the fine Michelangelesque drawing of *Delilah Visiting Samson in His Prison*. In later years he often turned for inspiration to the *Nibelungenlied*, which his old teacher Bodmer had edited and republished and which Schlegel had hailed as the German national epic.

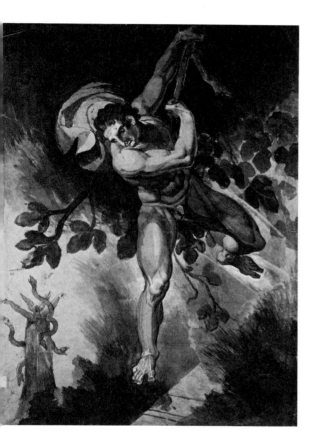

Henry Fuseli (1741-1825):

◁ *Kriemhild Showing the Nibelungen Ring to Hagen in Prison*. 1807
Watercolor, 19¾ × 15⅛"
Kunsthaus, Zurich

◁ *Delilah Visiting Samson in His Prison*
1800-1805. Pen and ink wash, 10 × 8"
Kunsthaus, Zurich

Odysseus Between Scylla and Charybdis. 1803
Watercolor, 28½ × 20⅝"
Kunsthaus, Zurich

Cliffs near Devil's Dyke, Sussex
c. 1790. Pencil, 12⅝ × 7¾"
Öffentliche Kunstsammlung, Basel

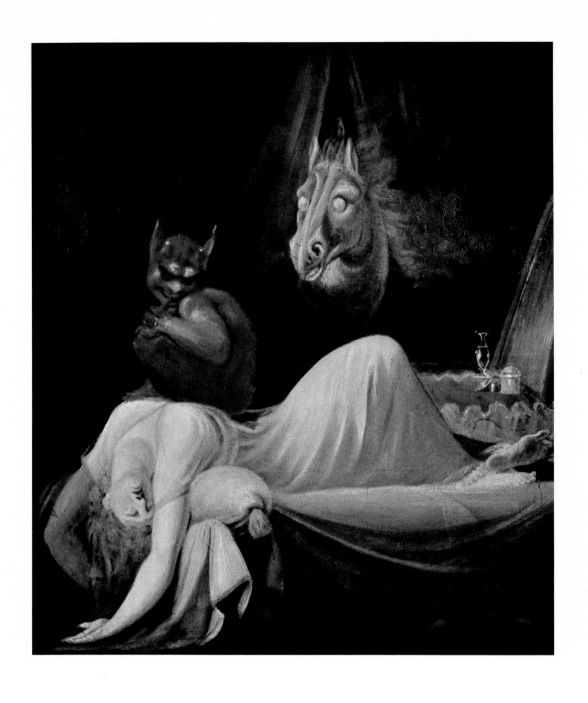

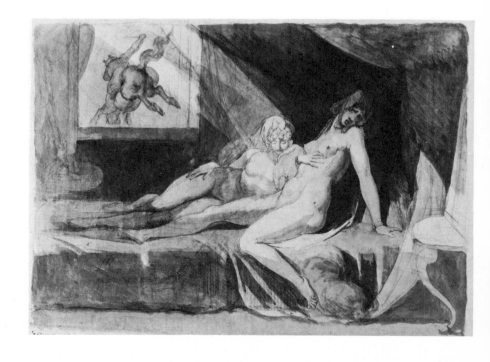

Henry Fuseli (1741-1825):

The Nightmare. 1790-1791
Oil on canvas, 29¾ × 25¼″
Goethemuseum, Frankfurt-am-Main

The Nightmare. 1810
Pencil and watercolor, 12⅜ × 16″
Kunsthaus, Zurich

His famous pictures of nightmares sprang from personal experience. With the earliest (1781, now in the Detroit Institute of Arts) he scored a major success in London; it can be interpreted as a psychological compensation for his passionate but unrequited love for Anna Landolt, a Zurich girl, whom he portrays oppressed by an incubus. The picture was commented on in a didactic poem by Erasmus Darwin, to which Fuseli reacted in turn with a second *Nightmare* (1790-1791, Frankfurt), reproduced here, and others followed. The imagery of these nightmares stems from rooted superstitions of the race, but it has contemporary parallels in the Gothic romances of Mrs. Radcliffe, Monk Lewis, and C.R. Maturin.

He sought out the most expressive subjects he could find in ancient literature and mythology (the Gorgon, Prometheus, the death of Dido, the shipwreck of Ulysses), the Bible (the madness of David), *Paradise Lost* (Satan), and so on. His interpretations of the *Nibelungenlied* are not patriotic, but personal. In the Shakespearean scenes he chose to treat, there is no lack of cruelty and horror; and, elsewhere, no lack of erotica, dream visions, witches, ghosts, raging jealousy, and glimpses of hell. No wonder that the figure of Fuseli, with his fetish for women's hair, his Lesbian couples, his masochistic sexual obsessions, has become a focus for psychoanalytical interpretation. Over and above his literary themes, Fuseli's hag-ridden dreamers, doomed supermen, and impending catastrophes embody his fundamental pessimism.

Henry Fuseli (1741-1825)
Nude Woman Listening to a Girl
Playing the Spinet. 1799-1800
Oil on canvas, 28¼ × 36¼″
Öffentliche Kunstsammlung, Basel

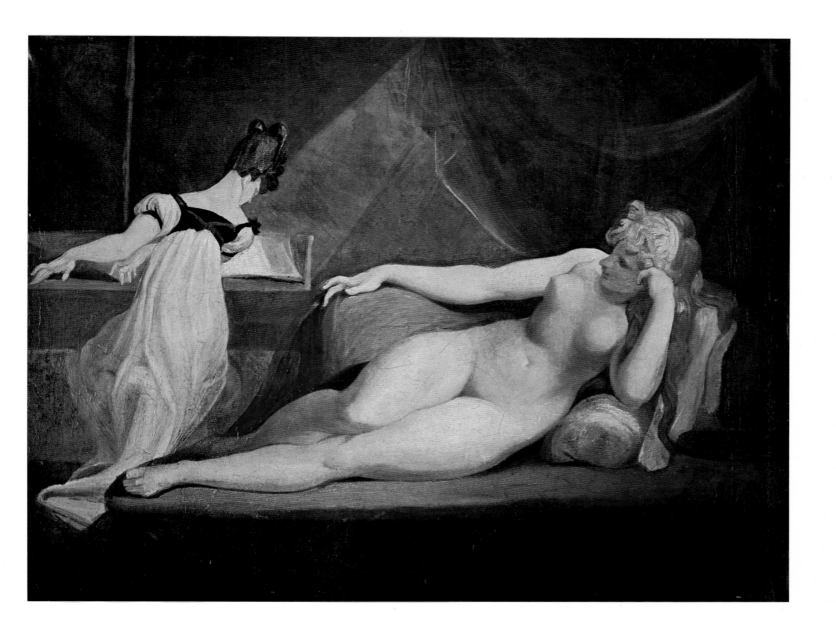

Rudolf Koller (1828-1905)
Rocky Path Above the Walensee
Pencil, 16 × 12½″
Private Collection, Cologne

The Sense of a Common Heritage
from the Late Eighteenth
to the Early Twentieth Century

Students of Swiss art agree that, if one can speak of a Swiss school of art at all, it is in this period that something like such a school took form. The dawning sense of a common art heritage was part of a wider movement in Switzerland in the direction of greater political cohesion. Down to the end of the eighteenth century, Switzerland had been a loose confederation of sovereign cantons, each governed by local patrician oligarchies. The disturbances caused by the French Revolution put an end to this system, and in 1798 the old confederation was converted into the Helvetic Republic. The latter was closely bound up with Napoleon and fell with him, but under Napoleon "Switzerland" was used for the first time as the official name of the republic and the political union of the cantons was gradually strengthened, until a central government was set up in Bern in 1848. The Constitution of 1848, revised in 1874, reorganized Switzerland as a federal union modeled in some ways on that of the United States.

The cultural history of this period shows how much importance was now attached to artistic and intellectual activities on, for the first time, a truly national scale. Efforts in this direction had already been made by Albert Stapfer, Minister of Arts and Sciences of the Helvetic Republic from 1798 to 1800; and the foundation of the Swiss Art Association in 1806 and the holding of the first Swiss art exhibition in 1840 helped to focus attention on Swiss artists and to foster a new sense of national purpose and achievement in the arts. By the 1840s public interest was strong enough for the founding in German Switzerland of the so-called "Turnus" (i.e. rotating) exhibitions and the opening of competitions for the design of national and historical monuments. Sponsored by the Swiss Art Association, the Turnus were traveling exhibitions held every two years, and their success shows that they answered a real cultural need. The second Turnus, for example, was held in Zurich, Bern, and Basel in 1842, a selection of it also being exhibited in Lucerne and Winterthur; over a hundred painters took part, and while French Switzerland made no effort to play host to this Turnus or to any other, it was nevertheless represented at the 1842 exhibition by the work of twenty-five Genevese artists. To stimulate sales, certain works chosen by the Swiss Art Association were raffled off at each exhibition. This initiative had a marked impact on the history of art in nineteenth-century Switzerland: for many artists the Turnus exhibitions were the only opportunity they had of bringing their work before the public and making sales. Drawings and sketches did not appeal to the taste of the public, but watercolors, answering by now to a well-established tradition, were regularly and successfully exhibited. The meager accounts published in the press dealt chiefly with the history paintings, to a lesser extent with genre scenes and landscapes, such being the descending scale of esteem in which these categories were then held.

The conflict between the prevailing taste of the German Swiss public and that of its best artists is well illustrated by the early career of Johann Jakob Ulrich, the master of Rudolf Koller. After making a name for himself in Paris, Ulrich returned to his native Zurich and tried at first to continue painting in the same style as before. But the fresh outdoor landscapes and watercolors which had been so successful at the Paris Salon met with no response in Zurich. His manner changed accordingly, and he began exhibiting dark-toned harbor scenes, cluttered with details, and spiritless seascapes. Nearly all these pictures were purchased at the Turnus exhibitions, either by raffle or by private collectors, while the fresher oil studies done in the open air were still unsold at the artist's death. The fact is that in Zurich Ulrich never regained the uninhibited mastery of his early work. His pupil Rudolf Koller likewise made concessions to the taste of the public. One of his principal works, *Oxen and Ploughmen* (see page 164), was conceived from the first as a meticulous assemblage of picture elements, the artist being intent above all on not leaving himself open to the charge of doing hasty or careless work. His studied purpose was divined at once by Charles Gleyre, who in his review of the art exhibition at the Paris World's Fair of 1867 criticized him in these terms: "Monsieur Koller lays too much emphasis on the secondary parts of his compositions." Koller was stung by this criticism, and his friend the Zurich novelist Gottfried Keller replied personally with a glowing tribute to his *Oxen and Ploughmen*, praising the poetry and truthfulness of the picture.

Such, in outline, were the circumstances prevailing in this period, and nineteenth-century Swiss painting cannot be rightly appreciated without bearing them in mind. The painter then felt himself to be, and was, a member of middle-class society; its judgments and standards carried weight with him, in spite of all his attempts to rise above them, and only a few Swiss artists, like Albert Anker, managed to bridge the gap between their own conception of art and the dogmas of official criticism. They were only too well aware of this rooted and inevitable conflict. Hence the self-reproaches we continually hear them voicing, when this or that concession weighed heavily on their conscience; hence their refusal at times to finish a picture and part with it. Ferdinand Hodler alone of nineteenth-century Swiss artists was uncompromising and went his own way regardless of the tastes and standards that his critics would have liked to impose on him. And paradoxically enough, of all the artists of that day, he was the one who benefited most from the official patronage which the Swiss government began to exercise in the latter half of the nineteenth century, for he was awarded the coveted commission for the *Marignano* frescoes in the Swiss National Museum in Zurich. From 1860 on, modest grants had been made regularly by the Swiss Art Association to artists considered to be deserving of them. Then, in 1883, Frank Buchser circulated a much publicized petition calling on the federal government to provide a permanent annual subsidy for the encouragement of art. This had its effect, and in 1887 the Federal Council (i.e. the government) carried a resolution pledging its support. The Turnus exhibitions were superseded by officially sponsored national exhibitions, and the acquisition of works of art and the organization of competitions by the government were decided on. From 1899 on, annual government grants were made to Swiss artists.

These concrete measures, heralded by the first Swiss National Exhibition in 1883, which was followed up by others, answered to a growing sense of solidarity founded on a national tradition and a national political consciousness. All this was embodied in the history paintings of the nineteenth century. Their immediate antecedent was Henry Fuseli's *Rütli Oath* (1779-1781) in the Zurich Town Hall (see page 123): it illustrates the (perhaps legendary) foundation of the Swiss Confederation by the oath of solidarity sworn by the men of Uri, Schwyz, and Unterwalden on August 1, 1291. This patriotic theme and others like it, including of course the William Tell Legend, were now taken up and repeatedly represented.

Theodor von Deschwanden, who worked at Stans (Unterwalden), is typical of the history painters active in the mid-nineteenth century. After Tell, the best known and most popular figure in the early history of the Swiss Confederation is Arnold von Winkelried, hero of the Battle of Sempach (1386), and Deschwanden's picture of *Winkelried's Farewell to His Family* (see page 134) was commissioned by the women of Stans, Winkelried's native town, to decorate the banqueting hall of a federal rifle meeting: it was designed as an exhortation to patriotic conduct. In French Switzerland, at the same period, the town council of Lausanne commissioned Charles Gleyre to paint two pictures glorifying the heroic past of the Canton of Vaud. Today most such works have been relegated to the storerooms of local museums, but art historians study and publish them occasionally, not only for their documentary interest but for their artistic value. True, with the signal exception of Ferdinand Hodler, who had the power of bringing history to life again, these history painters all too often fell short of the task they set themselves and lapsed into pathos or insipidity. Yet they did accomplish something of what their contemporaries expected of them: to embody an ideal of bygone greatness in imagery which would appeal to the common man and set him a patriotic example for the present and the future.

Reportage, the description of topical events, was another form of history painting in the days before photography. It is exemplified by David Alois Schmid's watercolor of the Goldau landslide of 1806 and Johann Jakob Ulrich's shipwreck scenes on the Walensee. In the same vein are the later pictures of Albert Anker and Edouard Castres showing the defeated French army corps under General Bourbaki taking refuge in Switzerland during the Franco-Prussian War of 1870. Even Hodler's *Ascension and Fall* alludes to a topical event: the first climb of the Matterhorn in July, 1865, by the English artist and mountaineer Edward Whymper and the fatal accident that occurred on the descent, when four members of the party slipped and were killed (Whymper himself only being saved by the breaking of the rope). The underlying theme here was the ever impending power of death over the living, a theme readily understandable to the mountain dwellers of Switzerland familiar with the threatening forces of nature. Death is alluded to again in Hodler's *Night*.

The genre scene, picturing the customs and life of the people and ranging from moral allegory to mordant criticism of society, is also rooted in the context of the period. Here Swiss painters struck out a line of their own, initiated by Léopold Robert. After executing many studies of popular life in southern Italy, Robert conceived the idea of painting a cycle of four great works representing the four seasons in Italy with their appropriate labors and ritual festivals. In carrying out this project, he arrived at "style painting"; that is, the transposition of the commonplace scenes of everyday life on to a higher, almost timeless plane.

Style painting may be considered as an offshoot of French Neoclassicism; after the death of Jacques-Louis David in 1825, it provided an alternative, attractive to many, to the realism and landscape painting of men like Courbet. The Swiss champion of that alternative and the successor to Léopold Robert was Charles Gleyre, both in his history paintings, rather few in number, and in his elaborate compositions on classical and Biblical themes. Yet, with Gleyre, there is not much point in trying to distinguish between pictures like *Minerva and the Graces* and *Boys Stealing Cherries*: each is a characteristic genre scene of this period. Gleyre is chiefly remembered today as a teacher: through his Paris studio (open from 1843 to 1863) passed Whistler, Monet, Renoir, and many Swiss pupils, attracted to him by his Swiss birth and background. Thanks to his academic celebrity and his thorough but tolerant methods as a teacher, he effectively played the part of an inspirer and oracle. Vallotton in his early days admired Gleyre and copied some of his works. Along with other symbolist pictures, Vallotton's early painting of *Bathers on a Summer Evening* (1893, Kunsthaus, Zurich) shows the influence of Gleyre.

Although Hodler, trained in Geneva by Menn, stood quite outside that sphere of influence, he does have more in common with his younger contemporary Vallotton than is generally realized. In their deliberate sublimation of a trite theme, as in Hodler's *Shooting Match* and *Procession of Wrestlers* and Vallotton's bathers and couples in the set of woodcuts called *Intimacies*, the two men, for all the striking differences between them, are seen to be pursuing a similar aim. Common to both, too, is their sustained interest in the nude.

Next, after history painting and genre, comes landscape. The course of its development will be illustrated in the following chapter, from Caspar Wolf (1735-1798) to Giovanni Segantini (1858-1899): between them lies a period rich in masterpieces. Here, as in some other art forms, one is surprised at the significant contribution made by Switzerland as compared with that of neighboring countries, while admitting that decisive interpretations of the Swiss landscape came also from foreign artists. It is in landscape that some of the finest achievements of nineteenth-century painting were made, and Swiss painters had their part to play in the discovery and delineation of their own country, of which they created a particularly satisfying image. This is true up to the generation of Menn and Koller. Then, with Hodler, the young Vallotton, and Segantini, landscape became a vehicle for the flight of the creative imagination. Hodler's *Autumn Evening* (1892, Musée des Beaux-Arts, Neuchâtel), like Vallotton's woodcuts of that same year which he called "portraits of mountains," built on the foundations laid by nineteenth-century Swiss landscape painting, but they radically departed from the established tradition in their novel manner of treating long familiar motifs.

Switzerland, standing in the heart of western Europe, has in course of time often acted as a crossroads or crucible of styles, so that there has never been much danger of self-centered aloofness. For what they cannot find in their own small country, Swiss artists are accustomed to looking abroad. They are travel-minded. The biography of practically every one of them tells of stays in Paris or Munich or journeys to distant places, not to mention their student years abroad. It may therefore be said that Swiss artists, more than most, are well informed about the art life of neighboring countries and easily keep abreast of the latest trends. The time lag with respect to stylistic developments elsewhere, so characteristic of earlier Swiss art, no longer exists in the nineteenth century.

A word about the Oskar Reinhart Foundation in Winterthur may be of interest here. One of the foremost collectors of his day, the Swiss industrialist Oskar Reinhart (1885-1965) began buying old master paintings in 1910, but his tastes were both discriminating and wide, and he went on in the 1920s and 1930s to build up a fine collection of pictures and drawings by Swiss artists—whom, in fact, he rescued from neglect. He made a point of exhibiting his collection, and it was thanks to him that a fresh interest was taken in the early nineteenth-century school of Geneva, in Caspar Wolf, and above all in the fine sketches and studies of the realist generation of Buchser, Koller, and Zünd. The Oskar Reinhart Collection in Winterthur, bequeathed to the Swiss government and today a public museum, now contains old masters and the French school, while the great collection of nineteenth-century Swiss, Austrian, and German painters forms a separate display on view at the Oskar Reinhart Foundation in Winterthur. But tastes change in unforeseeable ways, and the "academic" art written off as defunct in Dr. Reinhart's time is enjoying a revival of interest today, and it is precisely Gleyre, the "arch-academic," who is found to be unrepresented at the Foundation. But most of the Swiss masters dealt with in the following pages are represented at Winterthur by pictures of outstanding quality. Only the holdings of the government-owned Gottfried Keller Foundation are comparable to it; but the Keller pictures are deposited on loan in various Swiss museums, on the principle that each master can best be appreciated by grouping his works in the museum of his hometown—Buchser in Solothurn, Léopold Robert in Neuchâtel, Gleyre in Lausanne, and Böcklin in Basel.

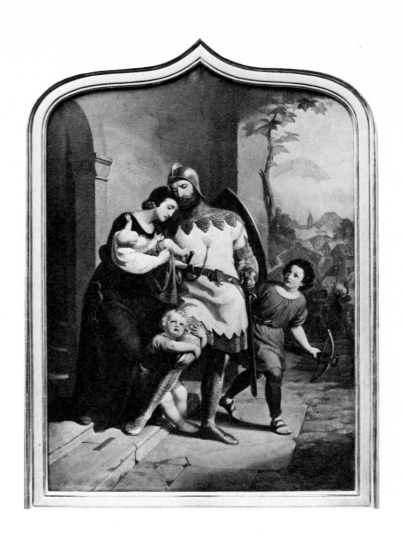

The Discovery
of Switzerland

Theodor von Deschwanden (1826-1861)
Winkelried's Farewell to His Family
Before the Battle of Sempach. c. 1860
Oil on canvas, 60 × 41¾″
Historisches Museum, Stans (Unterwalden)

In the latter part of the eighteenth century, the Swiss began to become conscious of the individuality of their country. Its nature and history began to be seen with fresh eyes, and in exploring them men gained, or so they believed, some insight into the creation of the world. With the publication of Albrecht von Haller's poem *Die Alpen* (1729) and the taste for Alpine climbing that arose in the eighteenth century, the mountains came to seem less forbidding and lost their old terrors. The first *History of the Swiss Confederation* was published from 1786 on by Johannes von Müller of Schaffhausen; this was followed by the first geological survey of the Alps, by Conrad Escher von der Linth (*Geognostische Nachrichten über die Alpen*, 1795). Patriotic associations sprang up, like the New Helvetian Society; they encouraged such initiatives and oriented their own activities toward civic education. Schiller's great play *Wilhelm Tell* (1804) was performed in Lucerne shortly after its creation. It is the drama of the Swiss people, its subject being less the personal fate of the hero than the struggle of a nation to free itself from tyranny. A remarkable feature of the play is the incidental emphasis it lays on the Alpine setting of the story. Even before that, in the 1790s, landscape studies of the Swiss Alps and Jura were being painted by the Austrian artist Joseph Anton Koch.

These foreign influences contributed much to the awakening of a national consciousness in Switzerland, and their effects were to be felt throughout the nineteenth century. The history paintings of this period on Swiss themes, so long stacked away in the storerooms of Swiss museums, belong to a collective wave of patriotism which also found expression in rifle meetings, choral societies, and athletic festivals, in literature and scholarly research into folklore, old records, and local legends. What the educated public wanted was information and illustration: both wishes were met by the landscape and the history painters.

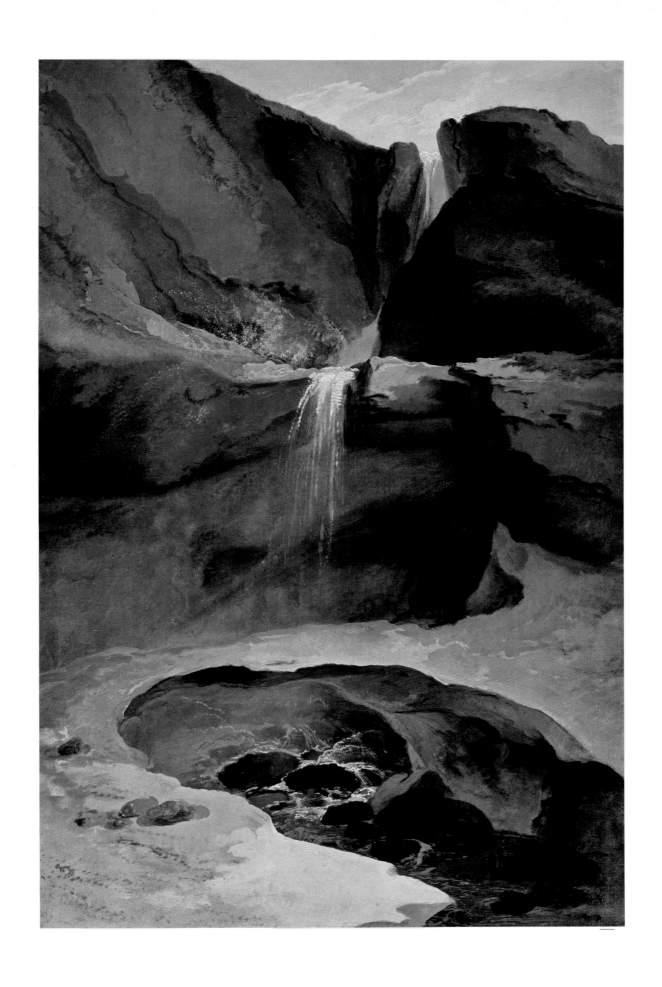

Caspar Wolf (1735-1798)
The Geltenbach Falls in Winter. c. 1778
Oil on canvas, 32¼ × 21¼"
Oskar Reinhart Foundation, Winterthur

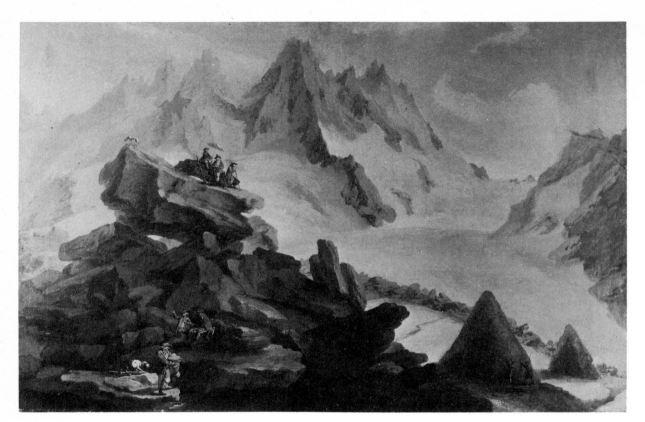

Literature, science, and art became aware of the Alps at about the same time. The Genevese physicist and traveler Horace Bénédict de Saussure published his famous *Voyages dans les Alpes* (1779-1796), and Caspar Wolf of Aargau was the first artist to go on rambles in the mountains in search of picturesque scenery. His picture of the *Lauteraar Glacier* (1776) was based on a drawing made on the spot; it inspired a colored print published in 1785 as part of a set of *Remarkable Views of the Swiss Mountains*. In the 1790s Johann Heinrich Wüest of Zurich painted the *Rhone Glacier* after some landscape studies which he had made on the spot in 1776 for an English tourist. Instead of mere topographical views, both painters succeeded in creating genuine works of art, Wolf by catching the delicate gradations of the Alpine colors, Wüest by bringing out the tonal contrasts between the glacier ice massed in its bed and the cloud-patterned sky overhead. In both paintings the mighty sweep of the mountains is thrown into relief by the presence of tiny figures.

While the watercolor by Heinrich Zeller represents a trio of climbers resting after their ascension of the 10,000-foot Titlis peak (one of them is sketching the view), David Alois Schmid's picture of the terrible Goldau landslide of 1806, which buried four villages, emphasizes the danger of the mountains.

Thus the Alps entered art in the shape of picturesque views or panoramas or records of personal adventure, all testifying to the changed relation between man and his environment.

To you has fate no Vale of Tempe given,
The clouds you drink oppress with frost and flash,
Torpid winter curtails spring's tardy weeks,
And ice-bound peaks enclose your chilly dale.
All this your honest lives have overcome
And grudging nature magnifies your bliss.

Albrecht von Haller, *Die Alpen*, Bern, 1728-1729

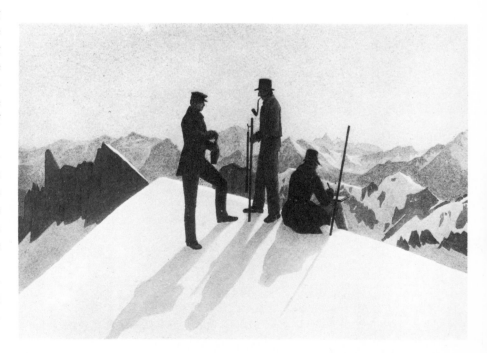

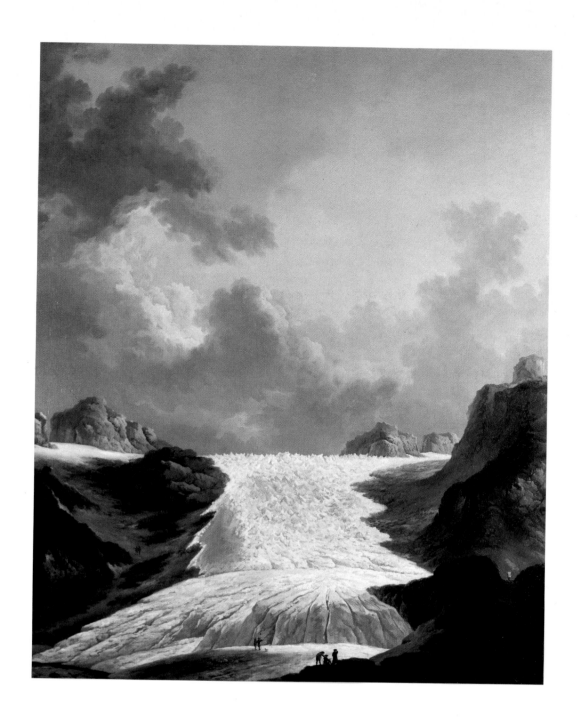

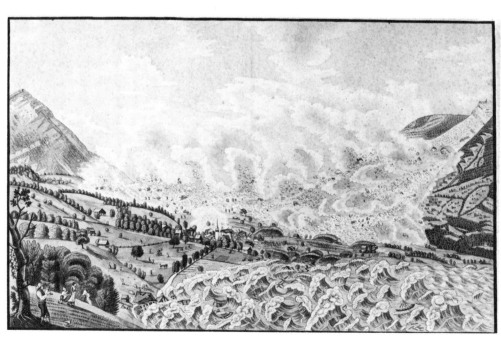

Caspar Wolf (1735-1798)
◁ *The Lauteraar Glacier.* 1776
Oil on canvas, 21 ⅝ × 32 ½″
Öffentliche Kunstsammlung, Basel

Heinrich Zeller (1810-1897)
◁ *On the Summit of the Titlis.* c. 1833
Watercolor, 4 ⅜ × 6 ⅛″
Kunsthaus, Zurich

Johann Heinrich Wüest (1741-1821)
The Rhone Glacier. c. 1795
Oil on canvas, 49 ⅝ × 39 ⅜″
Kunsthaus, Zurich

David Aloïs Schmid (1791-1861)
The Goldau Landslide of 1806
Pencil and watercolor, 16 ⅞ × 25″
Collection Max Felchlin, Schwyz

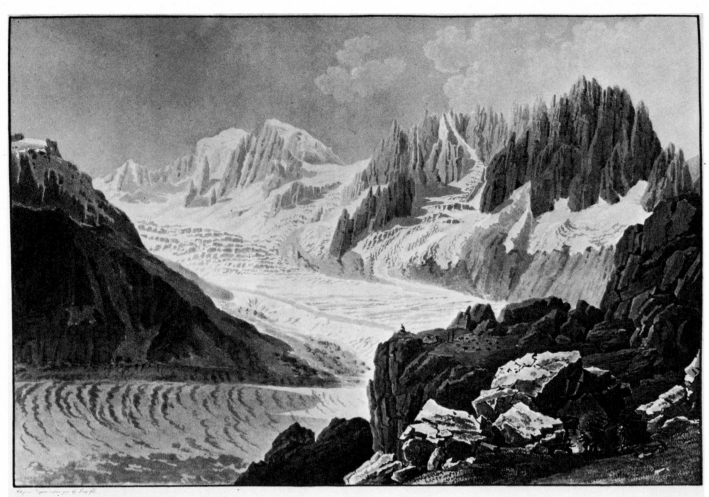

VUE DU MONT BLANC

By the early nineteenth century, views of Switzerland were being produced in large numbers in the form of colored prints with pleasant landscape motifs. They soon spread throughout Europe, making the Swiss Alps a household name and attracting tourists in droves; and many were only too keen to take home a souvenir view of the Alps. Oil paintings too were in demand, chiefly with the nobility. By the mid-nineteenth century every valley, lake, and mountain had been explored in search of picturesque views, and much of the resulting imagery can only be described as patrioteering Kitsch. A significant exception in the generation after Wolf and Wüest is the work of the Genevese artist Jean-Antoine Linck. His drawings and watercolors provide an accurate delineation of the Alps around Geneva and Chamonix. Linck's sensitive pencil records incidental or less attractive landscape features which others, like the Lorys, usually disdained. In his rhythmic patterns of darker and lighter masses we have already a foretaste of Hodler.

The two Lorys, father and son, natives of Bern, were professional view painters. Their *Journeys in Switzerland* provide a set of prints of outstanding historical and artistic interest. The *View of Mont Blanc* keeps to tried and schematic rules of composition. Here Gabriel Lory the Younger is representative of a whole school of Swiss little masters.

Rodolphe Toepffer of Geneva, son of the landscapist Wolfgang Adam Toepffer, worked in quite a different spirit. He was primarily a caricaturist and as such has a topical interest beyond any other Swiss artist of the nineteenth century. His visionary drawing of the Anterne Pass in the Mont Blanc massif, reminiscent of Victor Hugo's eerie drawings, contrasts with the idyllic views of the little masters.

Gabriel Lory the Younger (1784-1846)
View of Mont Blanc
Colored print, 7¾ × 11″
From *Voyage pittoresque aux
glaciers de Chamouni*, Paris, 1815

Rodolphe Toepffer (1799-1846)
The Anterne Pass. 1843-1844
Pencil, pen and India ink wash,
7½ × 5⅝″
Musée d'Art et d'Histoire, Geneva ▷

Jean-Antoine Linck (1766-1843)
*View of Mont Blanc from the Top
of the Brévent.* Watercolor, 18½ × 23½″
Musée d'Art et d'Histoire, Geneva ▷

Traveling
and
Sightseeing

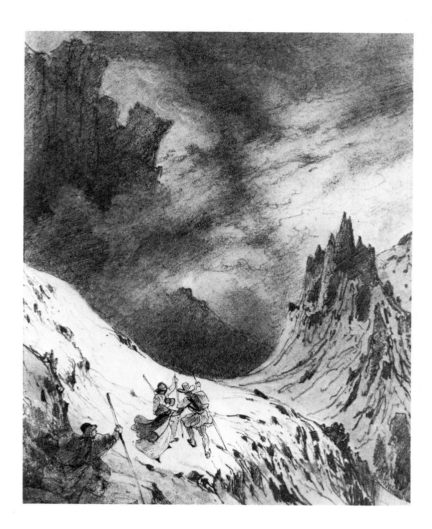

*The first known strangers attracted to Chamouni, out
of curiosity to see the glaciers, must have regarded this valley
as a haunt of bandits, for they came here armed to the teeth,
accompanied by their servants, who were also armed...*

Horace-Bénédict de Saussure, *Voyages dans les Alpes,* 1779

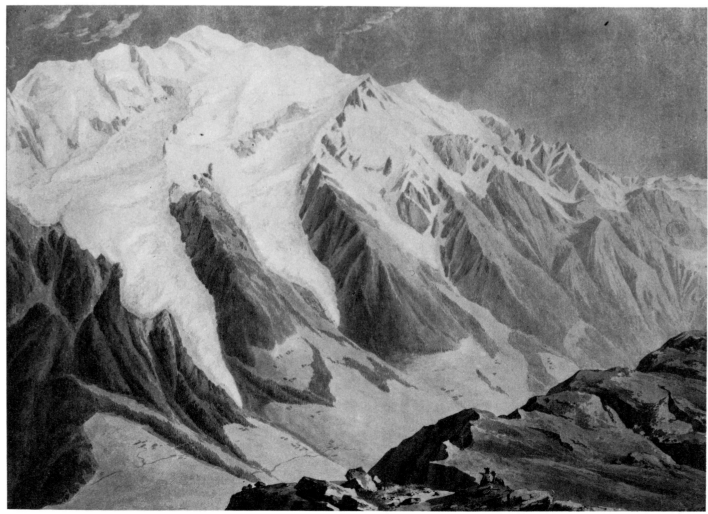

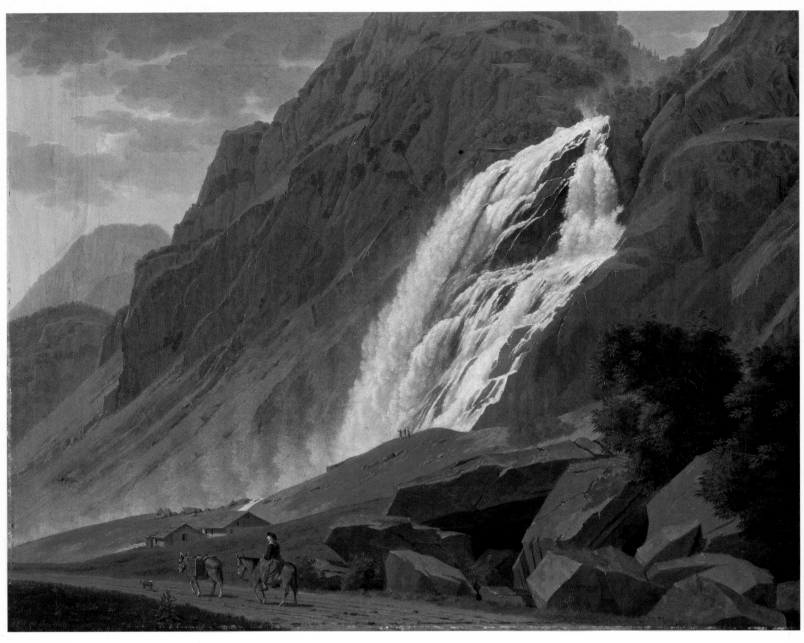

Johann Jakob Biedermann (1763-1830)
The Pissevache Waterfall in the Valais. 1815
Oil on canvas, 20¾ × 26″
Kunstmuseum, Winterthur

*We knew that we were nearing the celebrated
waterfall of Pissevache and hoped for a ray
of sunlight, which the shifting clouds gave us
some expectation of... The airy, foaming waves
gush down from the top and when, in a fleeting
spray, they cross the lines of the rainbow rising
before our eyes, they take on flame-colored
tints, without assuming the familiar shape
of a bow. And so instead there is an ever-changing
fiery movement...*

Goethe, *Briefe aus der Schweiz,* 1779

As early as 1729 Albrecht von Haller described the Staubbach ("spray-brook")
falls near Lauterbrunnen, in the Bernese Oberland, as the eighth wonder of the
world; Goethe saw them in 1775, during his journey in Switzerland, and they
inspired his poem *Gesang der Geister über den Wassern* (1779). The Staubbach
descends over a height of nearly a thousand feet, and these and other great
cascades symbolized to a whole generation the majestic presence of God in
nature. Lord Byron made an extensive tour of Switzerland in 1816, and *Manfred*
and Canto III of *Childe Harold* contain memorable word-pictures of Alpine
scenery, including the Lauterbrunnen falls. The German-Swiss painter Franz
Niklaus König accompanied King William I of Württemberg on a journey
through the Bernese Oberland in 1804 and for him painted a set of three pictures
of three of the most famous falls: the Staubbach, the Giessbach, and the Rei-
chenbach (where Sherlock Holmes was later to disappear). Johann Jakob Bieder-
mann's picture of the Pissevache cascade (Valais), on the main road through the
Upper Rhone Valley, was also painted to order for a collector, after an earlier
drawing. A landscapist and portraitist from Winterthur, Biedermann stands

Gorges and Waterfalls

apart from the common run of Swiss view painters, thanks to the cool luminosity of his palette and his accurate rendering of atmospheric effects. His works have become very much sought after today. Like Linck, he sees nature with a clear and rational eye, in contrast with the emotional aura which Diday and Calame cast over similar themes.

Throughout the nineteenth-century Swiss landscapists found a challenging and attractive subject in the waterfalls of the Valais and the Bernese Oberland. Calame, Barthélemy Menn, Johann Jakob Ulrich, Rudolf Koller, Robert Zünd, Otto Frölicher, and finally Ferdinand Hodler all tackled this theme. But Hodler alone broke away from the traditional approach and reordered nature in his own terms. No longer does man set the scale of the landscape: free of any perspective effect, the patterned surface vibrates with the interplay of recreated forms.

Franz Niklaus König
(1765-1832)
The Staubbach Falls
in the Bernese Oberland. 1806
Oil on canvas, 53⅝ × 42½″
Kunstmuseum, Bern

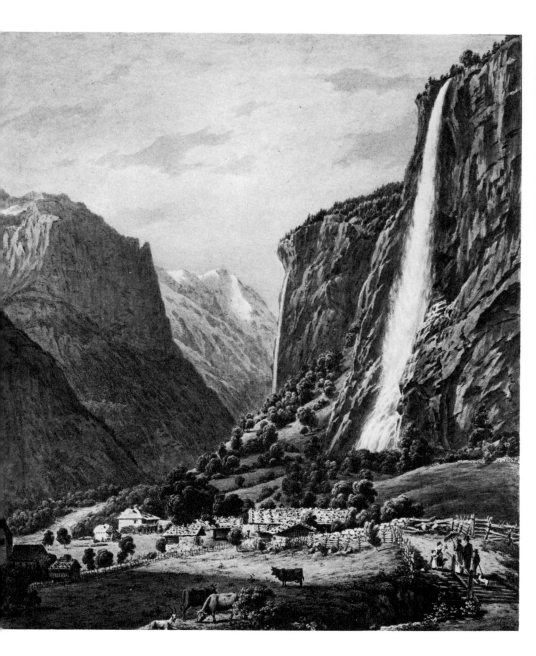

Ferdinand Hodler (1853-1918)
Waterfall near Néris. 1915
Oil on canvas, 41⅜ × 17⅜″
Private Collection, Geneva

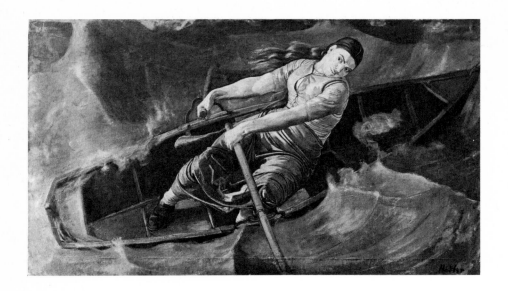

Ferdinand Hodler (1853-1918)
The Brave Woman. 1886
Oil on canvas, 39 × 67 ½"
Öffentliche Kunstsammlung, Basel

Lake Scenery

Johann Jakob Biedermann (1763-1830)
Lake of Lowerz with Shepherds
Oil on canvas, 30 × 39¾"
Private Collection, Zumikon (Zurich)

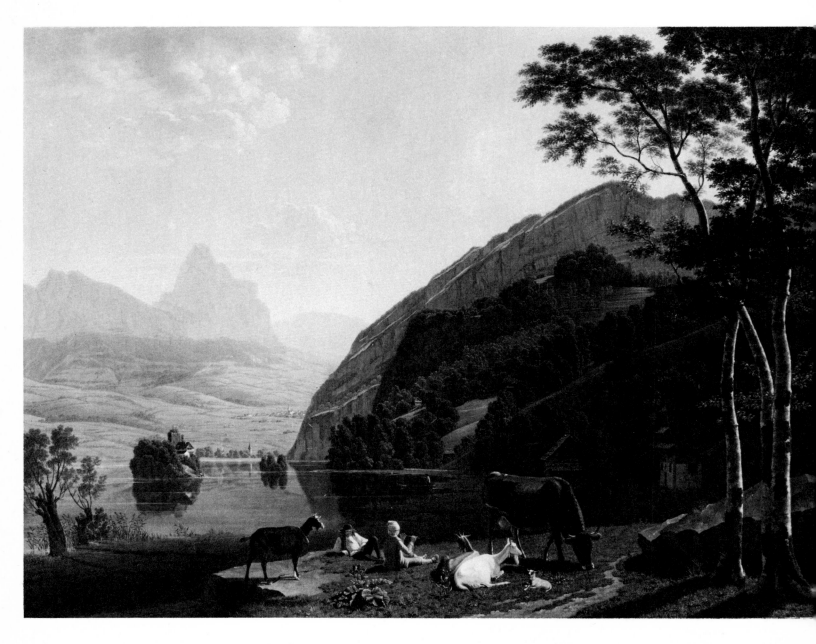

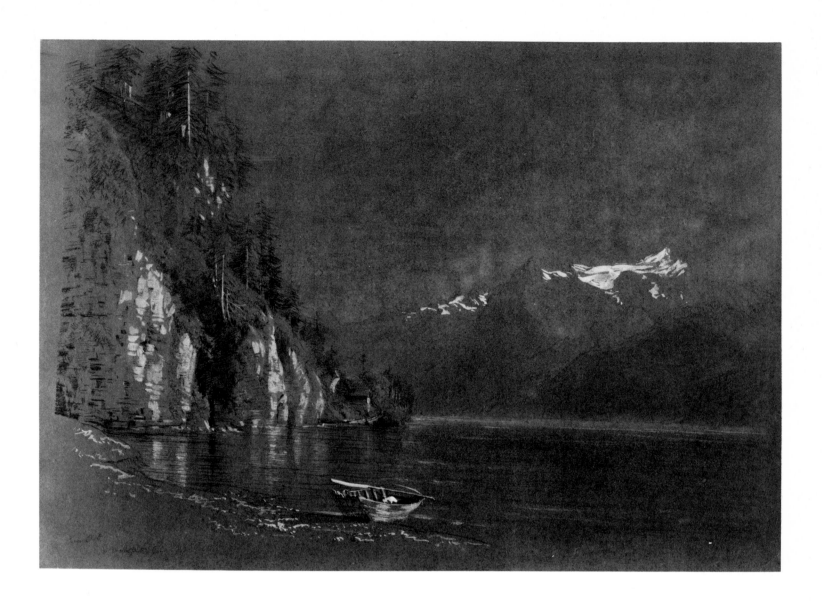

Johann Jakob Ulrich (1798-1877)
Lake of Lucerne with the Uri-Rotstock. 1844
Chalk, gouache, and watercolor, 11 × 15⅜"
Private Collection, Itschnach (Zurich)

Like its mountains, the lakes of Switzerland—and there are some 13,000 of them—are a prominent feature of the landscape. Again and again they inspired the view painters, not only the majestic reaches of the Lake of Geneva and Lake Constance but also the nameless tarns of the Upper Alps. In addition to the ever varied beauty of trees, rocks, and peaks reflected in the water, the lakes had a vital importance for the local inhabitants, as a convenient means of communication, a fish preserve, and a protective barrier against enemy attack. The Lake of Lucerne was at the center of the William Tell legend. After shooting the apple off his son's head, Tell was placed in a boat to be conveyed across the lake as a prisoner, when a storm arose; because of his great strength he was given charge of the rudder, steered shoreward and leaped from the boat to freedom. This crossing of the stormy lake has been interpreted as an allegory of human destiny, and it is the underlying theme of Hodler's *Brave Woman* fighting for her life against the elements.

A completely different mood is captured in Johann Jakob Biedermann's *Lake of Lowerz with Shepherds,* an idyllic and indeed idealized scene typical of this artist's crystal-clear style. In the background is the wooded islet of Schwanau with its castle; and above, blurred by distance, loom the two peaks of the Great and Little Mythen.

The Zurich landscapist Johann Jakob Ulrich belonged to the next generation and was trained in Paris. His view of the *Lake of Lucerne with the Uri-Rotstock,* with the setting sun gleaming on the lakeside cliffs and the faint shapes of the snow-covered mountain, marks the rise of "intimate landscape," concerned with fleeting effects rendered in terms of tonal values. View painting gives way to poetry, and line to tone and color.

The Swiss Folk Tradition

Like the ancients, these peasants have, at the same time, a strong feeling for the decorative and a feeling for life. They are true artists.

Ferdinand Hodler, recorded by Daniel Baud-Bovy

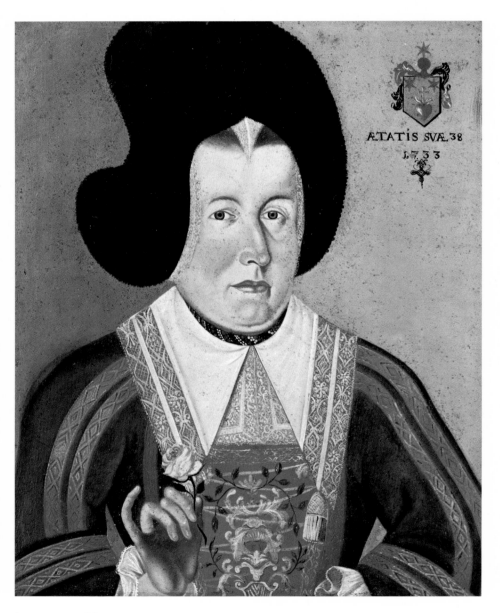

Anonymous Master
Portrait of Barbe de Preux. 1733
Oil on canvas, 20½ × 18⅛″
Collection Léon de Preux,
Château d'Anchettes (Valais)

Ludwig Vogel (1788-1879)
Woman's Costume in the Canton
of Nidwalden. 1814
Landesmuseum, Zurich ▷

**Charles-Frédéric Brun,
called Le Déserteur** (?-1871)
Marie Jeanne Bournissay
Inscribed: "Housewife at Légier Fragnier,
Neuchâtel, born in 1812, married in 1830"
13⅝ × 9¼″
Collection H. Bonvin, Fully (Valais) ▷

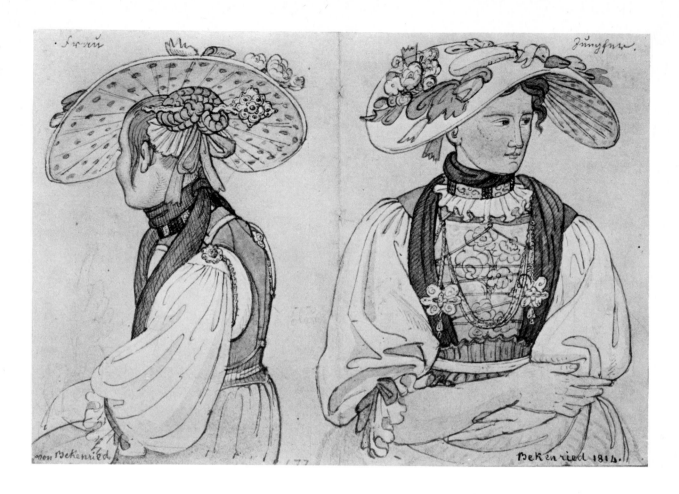

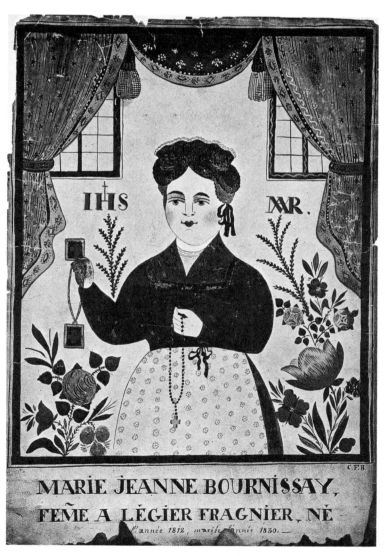

MARIE JEANNE BOURNISSAY,
FEME A LÉGIER FRAGNIER, NÉ

Art has been defined as "controlled ingenuity that is aware of its objective" (Ralph W. Church). In addition to his own talent or genius, every artist draws on a private fund of more or less extensive knowledge of world art previous to his own time. One of these earlier sources is folk art, which is essentially naive, nonacademic, untutored art, and this source has become a favorite one today with contemporary artists. Interest in it has never been greater. More and more exhibitions and museum space are being devoted to artifacts from the past, made for daily use or ornament by craftsmen without formal training; they designed them for a specific purpose, not in furtherance of "artistic aspirations."

The twentieth century has shown an unprecedented appreciation of such works, in reaction against the stale sentiment of so much of the "high art" of the past. Folk art knows nothing of style, fashion, and changing tastes. It is ignorant of the great masterpieces, and no knowledge of the latter is of any help to the spectator—indeed it may be a handicap—in understanding folk art, whose traditional patterns and designs are handed down by craftsmen in the home, often in out-of-the-way localities.

For folk art or peasant art is a direct expression of the people, and of local or regional peculiarities rather than national characteristics. It is rarely to be found in an urban setting. It still thrives

Anonymous Master
Panel of an armoire from Stein (Appenzell)
1745. Painted wood
Landesmuseum, Zurich

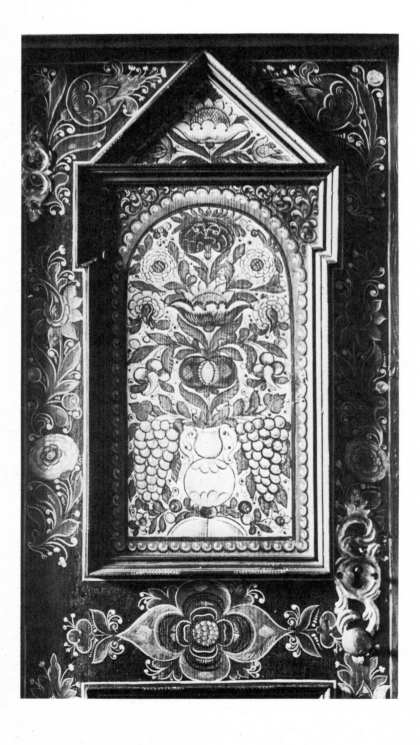

today in the remoter glens and highlands of Switzerland.

In some highland regions, especially in the cantons of Vaud, Valais, and Bern, the Swiss peasants decorated their walls with paper cutouts instead of pictures, using them also as bookmarkers and for appliqué work on furniture. One of the masters of this form of peasant art is still remembered: Johann Jakob Hauswirth of Saanen (Gessenay) in the Bernese Oberland. He was an unschooled farmhand who in his spare time made scissorcuts which he hawked from door to door. Some of them he colored by hand. They are intricate and beautiful works, on a far higher plane than that of mere decoration. Hauswirth possessed amazing powers of invention and imagination, and whether they are designed symmetrically or asymmetrically no two sheets are alike.

While the scissorcuts and silhouettes are sometimes works of art in their own right, the painted peasant furniture is an expression of naive traditionalism. Such furniture—cupboards, chests, commodes, etc.—was generally given as a wedding present. The painted panels, often executed with endearing awkwardness, copy subjects from court painting of both past and present, especially in the ornamental designs. Floral motifs predominated in the first half of the eighteenth century, figure scenes appearing only later. These furniture makers and decorators are invariably anonymous; they were conscientious and unpretending craftsmen in the service of their customers. Before it died out in the mid-nineteenth century, the folk tradition of painted furniture produced some of the most charming and authentic delineations we have of Swiss peasant life in earlier days.

As we can see from the works of Ludwig Vogel, C.F. Brun (better known as "Le Déserteur"), and other artists working in the folk tradition, what counted for them was the subject. Vogel is unusual in being a trained professional. But he early recognized his limitations and drew a complete series of peasant costumes of the different cantons which today are of great historical interest. The so-called Deserter was a vagrant who wandered about the canton of the Valais. Only recently rediscovered, his work shows him to have been a highly talented naive painter. The charm of his pictures lies in the attractive surface patterning and the engagingly simplified figures.

Johann Jakob Hauswirth (1808-1871)
Colored paper cutout. 1854. 10 × 13¾″
Collection C. Bernoulli, Basel

Jean Huber (1721-1786)
Winter Landscape
Paper cutout

146

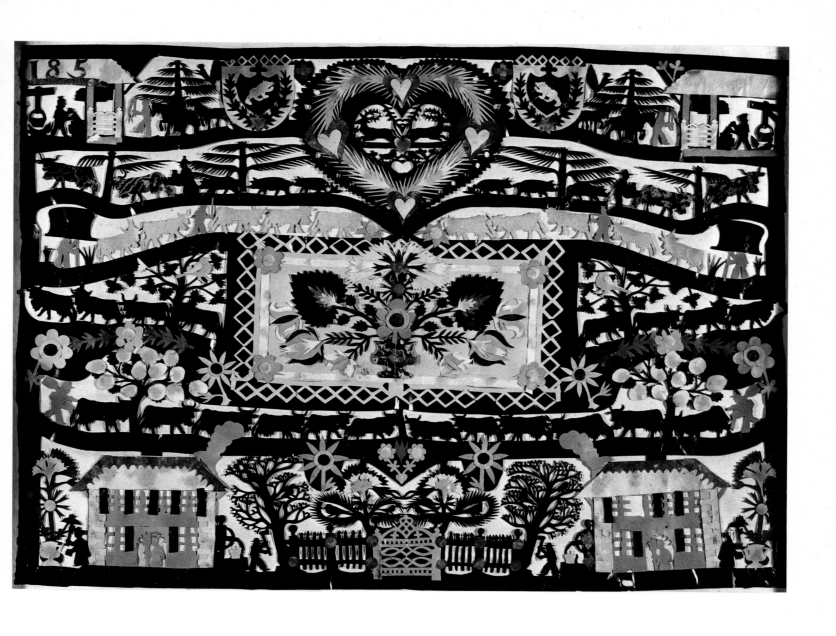

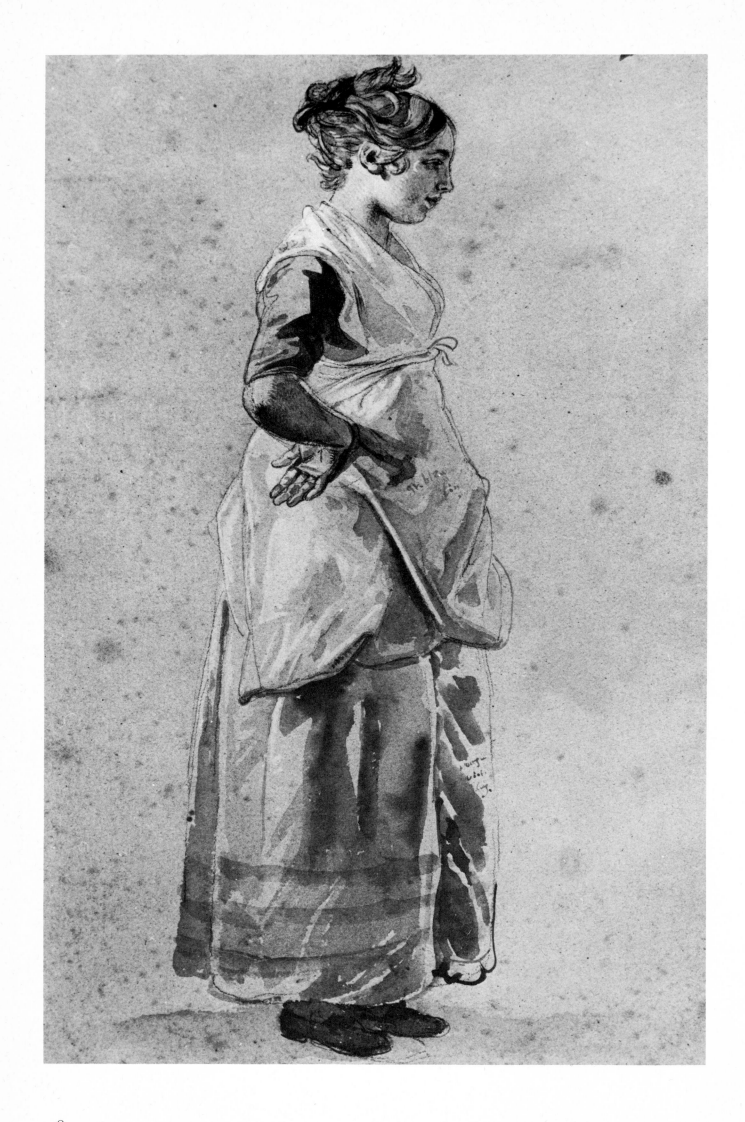

148

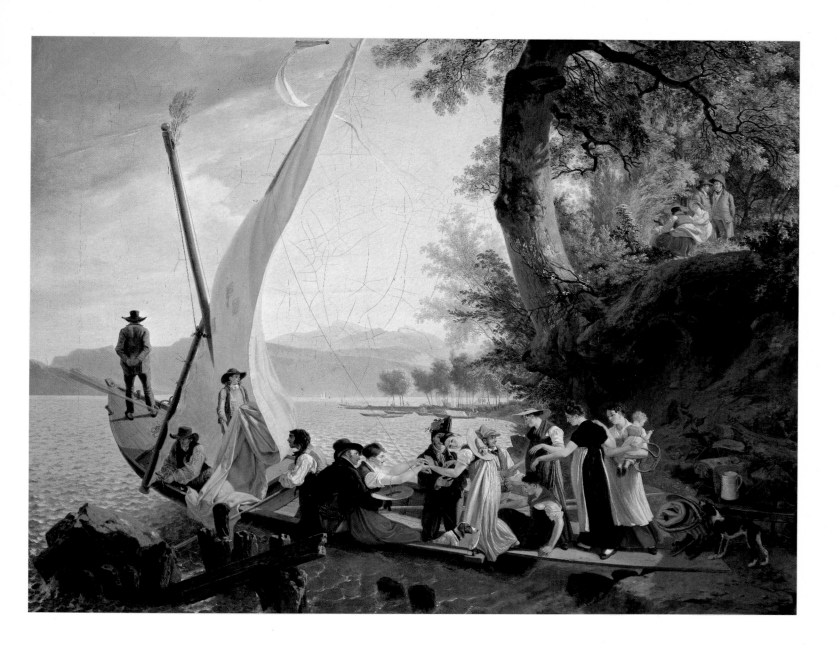

Country Life
in the Art
of W.A. Toepffer

Wolfgang-Adam Toepffer (1766-1847):

Wedding Party on the Lake of Geneva. 1814
Oil on canvas, 33 ¼ × 41 ⅜ ''
Musée d'Art et d'Histoire, Geneva

◁ *Genevese Peasant Girl*
Watercolor, 11 × 7 ⅛ ''
Musée d'Art et d'Histoire, Geneva

In the spirit and subject matter of his art, Wolfgang Adam Toepffer is one of the first unmistakably Swiss artists of the nineteenth century. He achieved a synthesis, on a high level of sensibility and technique, of the imagery of earlier view painters and little masters: with him, landscape, figures, and folklore are fused together.

Born in Geneva of a German father, he was a close friend of De La Rive, Agasse, and the portraitist Firmin Massot. Although he was trained in Paris just before the Revolution, later became drawing master to the Empress Josephine, and traveled widely, Toepffer's best works breathe the very atmosphere of the Genevese landscape and its inhabitants. The *Wedding Party on the Lake of Geneva* shows his delicate response to landscape. The figures, given due prominence in the foreground, are in a holiday mood and tally perfectly with the romantic lakeside setting; apart from the crew, busy with the tackle, they are worthy burghers. The fine watercolor on the opposite page represents a Genevese peasant girl with arms akimbo.

W.A. Toepffer stands midway between the playful Rococo of Watteau and the Neoclassical world-weariness of Gleyre, who both treated the theme of a boating trip: Watteau in his famous *Embarkation for Cythera*, Gleyre in his *Evening or Lost Illusions*. Many reminiscences of the eighteenth century linger on in Toepffer, yet on the whole his *Wedding Party* looks forward to the new era ahead: its charm and cheerfulness herald the smiling, good-humored drawings of his more famous son Rodolphe Toepffer.

149

The school of Geneva is remarkable in nineteenth-century Swiss painting for its unflagging continuity. The puritanical taboos that had stifled the arts there since Calvin's time were gradually relaxed in the eighteenth century; the municipality opened a School of Design in 1751, and in 1772 a public-spirited group of art lovers founded a Society for the Advancement of the Arts. By the end of the eighteenth century Geneva was a flourishing art center, in close touch with the art world of Paris. The young painters Agasse and Reverdin were studying in David's Paris studio when the outbreak of the French Revolution forced them to return home. Agasse left Geneva again in 1800 and settled in London, where he lived, with some interruptions, until his death; but he remained in touch with his Geneva friends and many of his works found their way back to Switzerland. In London, absorbing the influence of Stubbs, Agasse specialized in pictures of dogs and horses, which appealed to the English taste for such subjects; his genre scenes, admirably composed, crisp and sparkling though they often are, met with less success. He lived a lonely life, unmarried, content with a few patrons, and was described as "very unassuming, detesting intrigue, proud, independent and ingenuous as a child." The best collections of his work are to be seen in Geneva (Musée d'Art et d'Histoire) and Winterthur (Oskar Reinhart Foundation).

Himself an admirable horseman, Agasse was a first-rate animal painter with a thorough knowledge of anatomy. Unlike some of his English contemporaries (Landseer, for example), his interest in animals was pictorial rather than anecdotal or sentimental. When, generally at the instance of its owner, he painted the "portrait" of a particular thoroughbred, he produced more than a recognizable likeness: he gave fresh insights into animal life. For him, as for Géricault, the horse symbolized the free life. For George IV, Agasse painted some of the exotic animals in the Royal Menagerie in Windsor Park, like the Nubian giraffe given to the King in 1827 by Mohammed Ali Pasha of Egypt. As an animal painter, he can hold his own with Delacroix and Géricault.

The Playground is a late work; it is listed in the artist's manuscript catalogue under the year 1830, when he was sixty-three. It was painted in London and the scene is probably Hampstead Heath. One version (another is in Geneva)

The Romantic
Realism
of J.L. Agasse

Jacques-Laurent Agasse (1767-1849):

Two White Horses with a Groom and Hound
India ink wash and sepia, 6⅞ × 9⅝"
Musée d'Art et d'Histoire, Geneva

The Playground. 1830
Oil on canvas, 21¼ × 17¾"
Oskar Reinhart Foundation, Winterthur

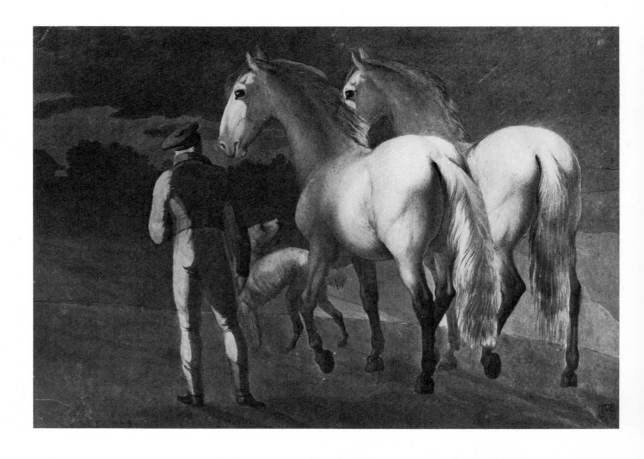

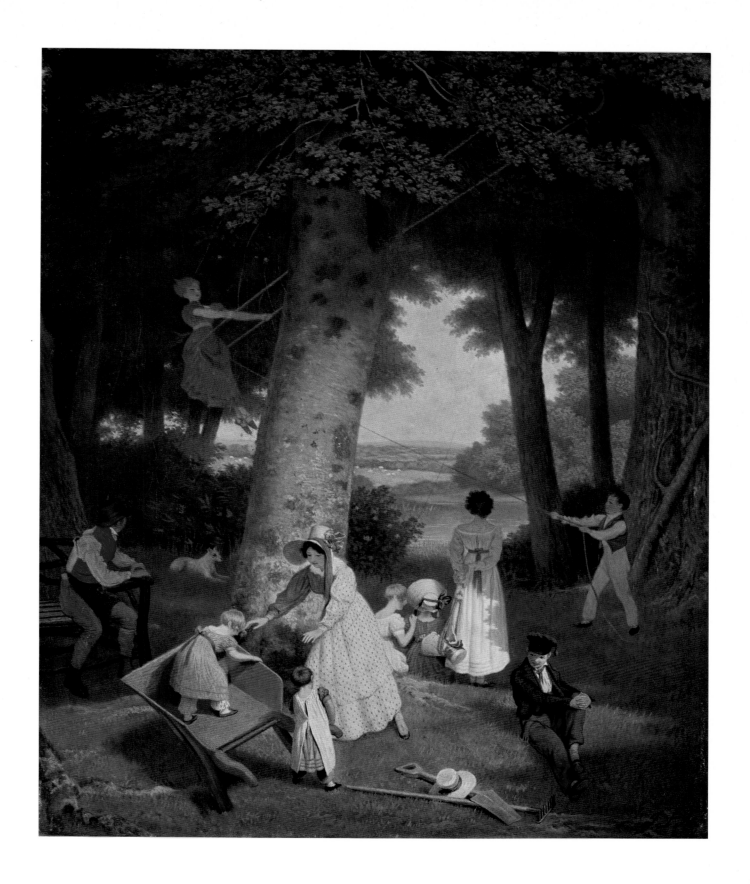

was exhibited at the British Institution in 1831 under the title *Hold Fast!* As with W.A. Toepffer, with whom Agasse had studied in his youth, the figures are well integrated into the natural setting. Their carefree mood and the serene stretch of landscape are imbued with the Romantic spirit, while recalling similar themes in Rococo painting of the previous century. But these are not the puppets of so much Rococo art; they are real children frolicking in the open, and the whole picture is enlivened with well-observed details and bright spots of color. Admirable, too, is the sound, four-square design of the composition. Agasse is a most attractive minor master, certainly the most original and spirited artist of the early nineteenth-century Genevese school.

There are a number of Swiss artists of the first half of the nineteenth century who are remembered not so much for a whole body of work as for certain themes which they treated and made their own. One of them is the Neuchâtel aristocrat Maximilien de Meuron, who was important both as a painter and as a quickening influence on the art life of Neuchâtel, which he galvanized into activity. His *View of the Great Eiger from the Wengern Alp* is a key picture in the annals of Romantic landscape painting in Switzerland. Rodolphe Toepffer admired it and paid tribute to it: "This scene," he wrote, "which he felt as a poet and treated as an artist, at a time when mere tinting in blue and green was the usual method of rendering the upper Alpine landscape, then considered as a purely visual phenomenon, opened up a new realm of art." Here, instead of a "view" answering to stock formulas, we have the distinctive personality of the mighty peak as it glides out of the clouds into clear weather. Meuron's landscapes, with their poetic simplicity buoyed up by a grandiose vision, mark the transition from the early Alpine view painters to the heroic mountainscapes of Calame.

Alexandre Calame, a native of Vevey on the Lake of Geneva, early made a reputation with his pictures of storms and waterfalls in the Alps. They found purchasers all over Europe, from France to Russia. His name, like that of his rival, François Diday of Geneva, is still synonymous with emotive evocations of Alpine scenery, so that it is difficult to arrive at an objective appreciation of his undoubted talents. Many Swiss painters followed in the wake of Calame, as others did in that of Léopold Robert. Calame himself did much to debase his style of art by producing stereotyped replicas of his favorite subjects. His finest,

Romantic Landscape: Meuron, Diday, and Calame

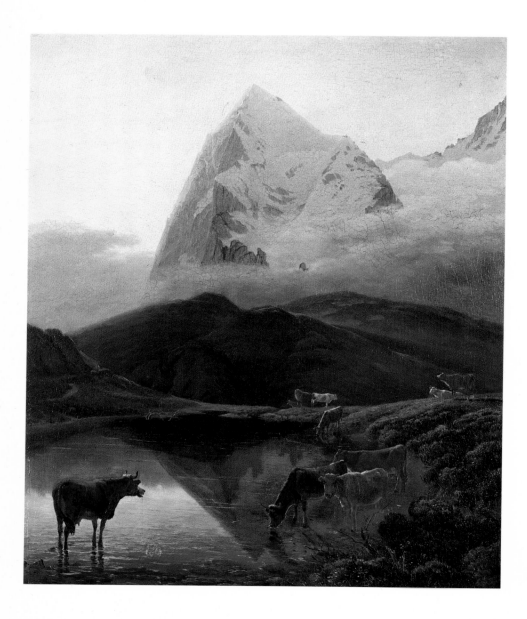

Maximilien de Meuron (1785-1868)
View of the Great Eiger from the Wengern Alp in the Bernese Oberland
Oil on canvas, 20 ⅛ × 16″
Musée d'Art et d'Histoire, Neuchâtel

Alexandre Calame (1810-1864)
The Rosenlaui in the Bernese Oberland
Charcoal with white highlights, 11½ × 15½″
Kunstmuseum, Winterthur

François Diday (1802-1877)
The Giessbach Falls in the Bernese Oberland
Pencil, 13⅜ × 10¾″
Musée d'Art et d'Histoire, Geneva

freest efforts are to be found in his drawings and studies, often done in the open air, on the spot, and often having no connection with his large studio compositions. It is in these works that Calame approximates to the "intimate landscape," the "slice of nature" which we associate with the Barbizon School. For while the studio pictures which sold so well still belong to Romanticism, his oil sketches and drawings mark the beginnings of Realism in Switzerland: the motif is seen steadily and whole, unprettified. Many of Calame's oil sketches represent the lakes and fir woods of Central Switzerland; the wild scenery of the Lake of Lucerne and the views from the Uri-Rotstock peak were favorite themes with him and his contemporaries. Calame's many lithographs and etchings retain the freshness and spontaneity of his well-observed sketches.

Léopold Robert

Born near Neuchâtel in 1794, Léopold Robert is the archetypal Swiss painter of the Romantic period. Like many of his countrymen, he was trained in Paris in the famous studio of Jacques-Louis David. He was on the point of winning the Grand Prix for engraving when the political changes of 1815 restored Neuchâtel to Prussia and Robert was struck off the list of competitors as a foreigner. Returning to Switzerland, he was lucky enough to find a patron, Roullet de Mezerac, who by a timely loan enabled him to go to Italy in 1818. He settled in Rome and became famous for his pictures of the South Italian peasantry and his scenes of brigandage. Hereditary neurasthenia aggravated by a hopeless passion for Princess Charlotte Bonaparte led him to commit suicide in Venice in 1835. Thanks to his voluminous correspondence, a good deal is known about his romantic life.

The art of Léopold Robert, like that of Gleyre, has been variously appreciated. Celebrities in their day, both were all but forgotten in the early twentieth century. Both, today, are enjoying a revival of interest. One French critic described Robert's art as "unacceptable Romanticism, because contrived and

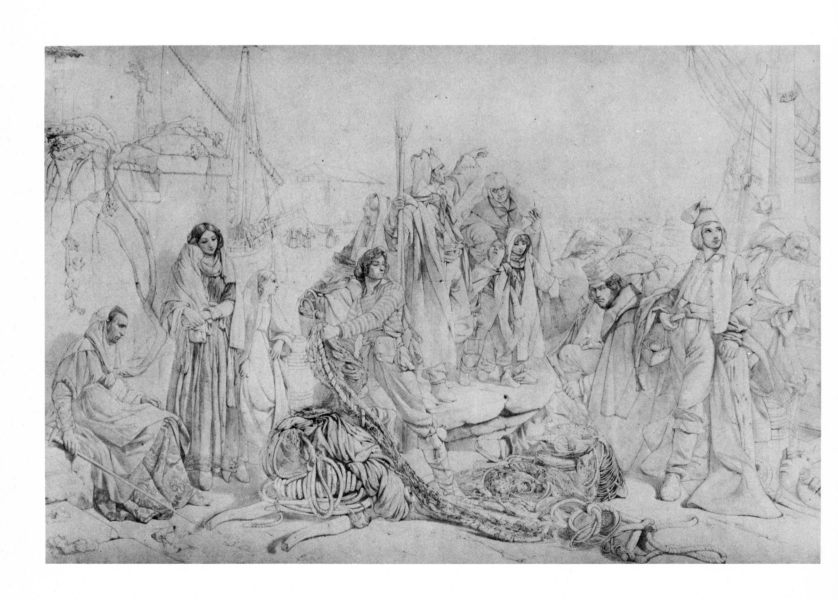

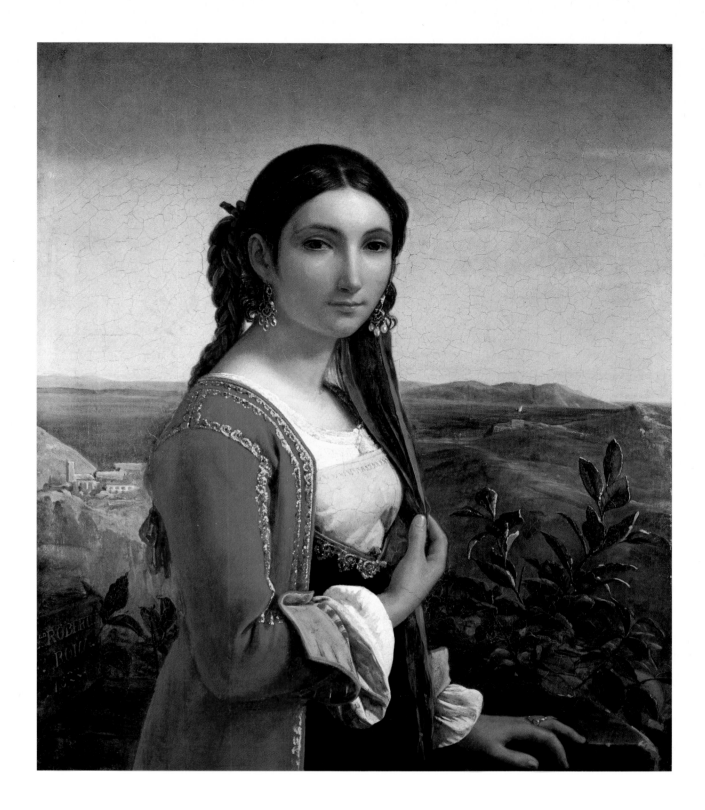

Léopold Robert (1794-1835):

◁ *Ox-Drawn Cart in the Roman Campagna*
Pen and ink sketch, 6½ × 9½″
Oskar Reinhart Foundation, Winterthur

◁ *The Fishers of the Adriatic*. 1834
Study for the fourth picture
in his cycle of *The Seasons*. Pencil, 20⅛ × 29½″
Stanford University Museum of Art,
Stanford, California

Italian Girl from Retuna. 1822
Oil on canvas, 32½ × 25¼″
Oskar Reinhart Foundation, Winterthur

artificial''; he detected a Germanic element in it. Similar criticisms have been
made of Gleyre and Vallotton. It is true that Robert's drawings, rather than his
paintings, have some affinity with the work of the German Romantic painters in
Rome. But his portraits of young Roman and Neapolitan women, in their classi-
cal purity, are quite different from theirs. And the four great pictures forming a
cycle of the seasons in Italy, which occupied him from 1827 until his death,
present all the signs of "style painting." The last of the four was *The Fishers of
the Adriatic*: the figures, bringing to mind the heroes of Greek mythology, seem
to move in a timeless world.

After his tragic suicide in Venice at the age of forty-one, Léopold Robert
became something of a legendary figure; his brother Aurèle, who lived on until
1871, did much to create the Robert legend. His art was admired all over Europe
and its influence lived on in Salon painting down to the time of Bouguereau.

Like Léopold Robert, Gleyre has been described as a "Neoclassical Romantic." Both of them aimed primarily at achieving perfection of form in large figure compositions. For them, drawings and studies were simply working material in the service of that overriding ambition. Both were outstanding draftsmen and in their paintings kept voluntarily to a subdued color scheme, except in a few unguarded oil sketches.

A native of the canton of Vaud, Gleyre was trained in Paris, in Hersent's studio, the Académie Suisse, and the galleries of the Louvre. After several years of study in Italy and three years of adventurous wanderings in Greece, Egypt, Nubia, and Syria (1834-1837), he returned to Paris. There he established himself

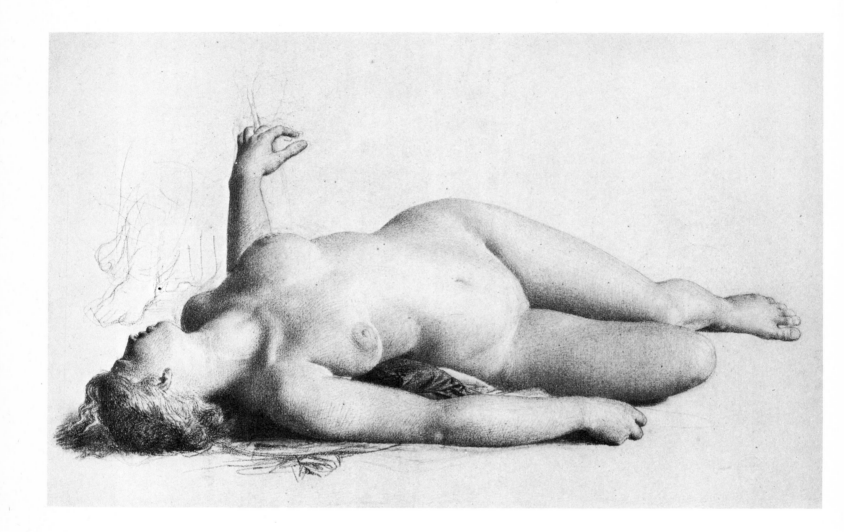

as a Salon painter and a teacher, "one of the great teachers of the nineteenth century" (Kenneth Clark). Over five hundred art students passed through his studio, among them Whistler, Monet, Renoir, Sisley, and Bazille. He remained in close touch with his native land, and most of the Swiss artists who went up to Paris to study applied to him; Anker and Bocion, for example, were trained by Gleyre. The prevailing mood of his big Salon paintings is one of sadness and nostalgia. The drawing of a reclining Bacchante was a study for a monumental picture now lost, symbolizing a society sinking into chaos. The figure of Ruth working in the fields and the delicate modeling of the oil study of *Two Women and a Bunch of Flowers* reveal Gleyre's fine qualities much better than his large compositions, which are too laboriously worked out to be very appealing today. To his disadvantage, Gleyre has been compared to Ingres, but the comparison is not really apt. Belonging to the generation after Ingres, the Swiss artist aimed at the expression of emotions which, all too often, fail today to elicit any response. He remains memorable as a great teacher and a master draftsman.

Charles Gleyre (1806-1874):

Reclining Nude. Study for
The Dance of the Bacchantes
Black chalk, 10⅝ × 17½"
Musée Cantonal des Beaux-Arts, Lausanne

Two Women and a Bunch of Flowers
Oil study on canvas, 22⅞ × 27⅝"
Musée Cantonal des Beaux-Arts, Lausanne ▷

Figure study for *Ruth and Boaz*
Pencil, 6⅞ × 10¾"
Musée Cantonal des Beaux-Arts, Lausanne ▷

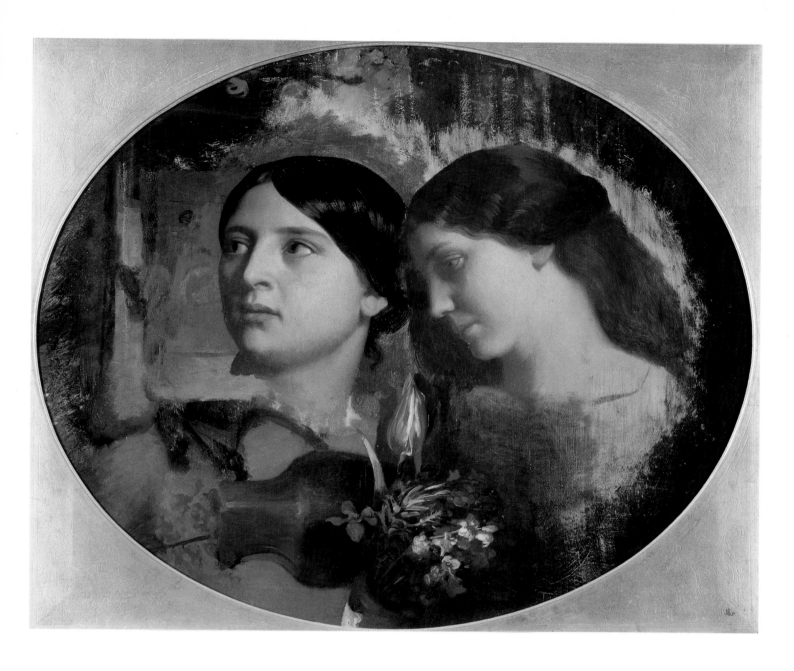

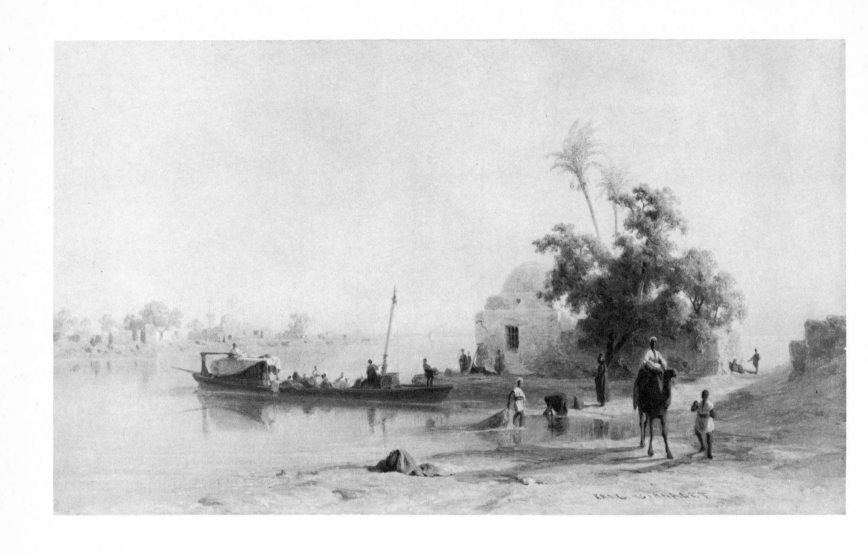

North Africa and Egypt: Girardet and Buchser

When he embarked on his Egyptian campaign in 1798, Napoleon took with him, not only a French army, but also a committee of artists and archaeologists. From that moment Oriental themes began to appear in French painting, notably in the work of Gros. A second wave of Orientalism swept over French art in the 1820s in the wake of the Greek war of independence against the Turks. And in 1820 Jules-Robert Auguste returned to Paris from a long journey through the Levant, and his pastels of Arabs and their horses were seen and admired by Delacroix and Géricault, who both took up Oriental themes. But it was not until 1832 that Delacroix himself visited North Africa: his Moroccan pictures, exhibited at the Salon, set a fashion for these exotic themes which was to last throughout the nineteenth century. The first Swiss artists to travel in North Africa were Gleyre (1834-1837) and Kaspar Weidenmann of Winterthur who visited Algiers and Constantine in 1838-1839. They were prompted not

only by an interest in new, picturesque themes, but by a certain weariness with European civilization and the hope of finding in the East authentic vestiges of antiquity.

In 1842 the brothers Karl and Edouard Girardet visited Egypt. Natives of Neuchâtel and members of a family that had produced several gifted artists, they had been commissioned by King Louis Philippe to paint a series of pictures on the Napoleonic epic for the historical gallery at Versailles. Karl Girardet brought back hundreds of sketches from Egypt, and from these, in his Paris studio, he made the finished paintings which retain all the charm and freshness of the sketches made on the spot.

One of the key figures in nineteenth-century Swiss painting is Frank Buchser. The son of a Solothurn peasant, he spent much of his working life abroad, traveling in Europe, the Balkans, North Africa, and the United States. Restless and adventure-loving, he brought back from each journey a rich store of oil sketches and drawings which he then worked up in his Solothurn studio. Buchser remains an interesting reporter, capable of recording his experiences in attractive and spirited imagery. A finer colorist than Girardet, Buchser is seen at his best in his colorful market scenes from Algeria and Morocco, treated in his characteristic "shorthand." He knew such scenes from the inside; his travel diary, *Ritt ins dunkle Marokko* ("Ride into Darkest Morocco"), shows how easily and zestfully he adapted himself to native life. From 1866 to 1870 he lived in the United States, traveling widely and recording his impressions in some fine studies of Blacks and Indians and a series of river and prairie landscapes. His copious and many-sided output is the fruit of an exuberant temperament which knew nothing of the self-critical misgivings which often afflicted Gleyre and Léopold Robert.

Karl Girardet (1813-1871)
◁ *Landscape on the Banks of the Nile*
Oil on canvas, 10 × 16⅜"
Private Collection, Wädenswil (Zurich)

Frank Buchser (1828-1890):

◁ *Fording the Sebu in Morocco.* 1858
Pen and ink, 13½ × 8⅜"
Kunstmuseum, Olten (Solothurn)

Street Scene in Algiers
Oil on canvas, 10⅞ × 17⅜"
Private Collection, Urdorf (Zurich)

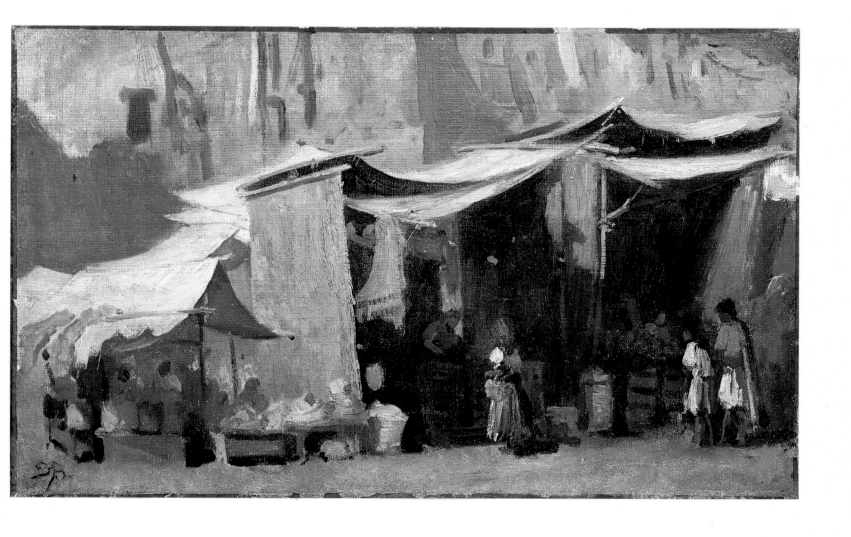

Structure and Light in Menn and Bocion

On the way down from Coinsins, he went on: "Look, another picture. That small gnarled oak threatened by a quarry, that road scored with ruts, those wayside thornbushes, that sky with a lengthening cloud. There is almost nothing superfluous in it, and almost nothing lacking. But it is a scene not from a novel, but from a drama..."

Daniel Baud-Bovy, *Barthélemy Menn*, Geneva, 1943

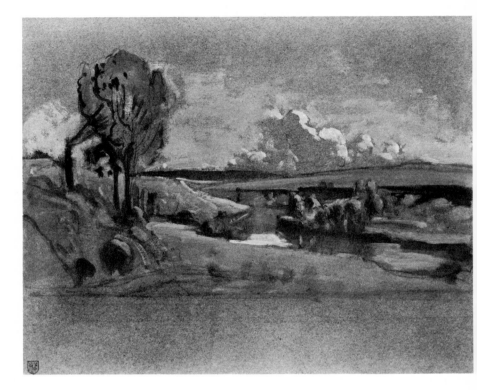

Together with Wolfgang Adam Toepffer and Alexandre Calame, Barthélemy Menn was one of the leading Genevese painters of the nineteenth century. After his early training in Geneva, he studied under Ingres, first in Paris, then in Rome. In Paris again from 1838 to 1843, he was on friendly terms with Corot and the Barbizon painters; at the same time he systematically copied old master paintings in the galleries of the Louvre. Poverty forced him to return to Geneva in 1843, at a time when Calame's Alpine landscapes held the field there. From the start, he set himself up in opposition to Calame's ambitious style of art and found his landscape themes in the Genevese countryside, whose quiet, unpretending beauties he painted again and again. He thus developed a characteristic landscape design of his own, lines and volumes forming a solid groundwork with color subordinated to them, and established himself as the leading Swiss exponent of the "intimate landscape." He transmitted his ideals

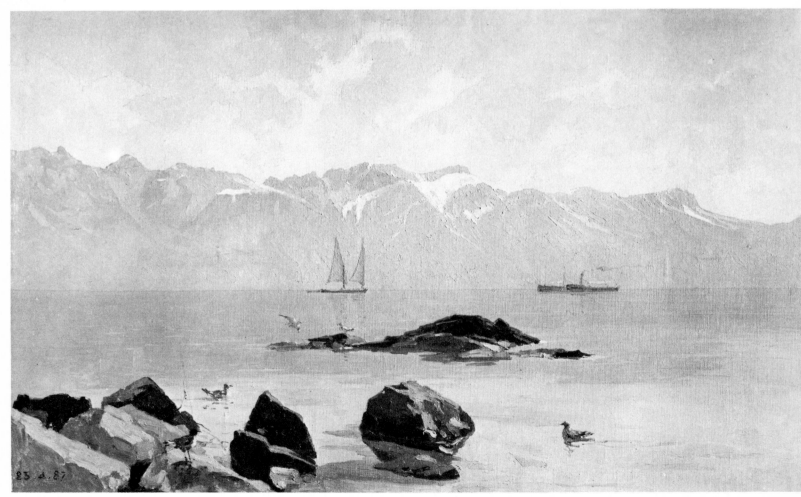

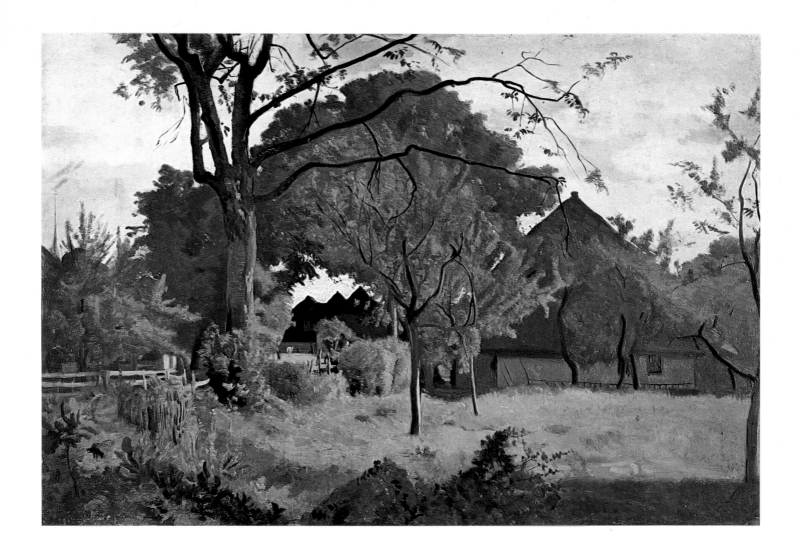

and methods to some gifted pupils, such as Pierre Pignolat, Daniel Ihly, and Edouard Vallet. He also discerned the genius of the young Hodler, who all his life remained grateful for the encouragement he received from Menn.

Menn's early Arcadian compositions were followed by a long series of kindred yet ever renewed landscapes depicting the Genevese countryside; many of them are minor masterpieces. Like Corot in France, Menn and Bocion in French Switzerland represent the final achievement of pre-Impressionist landscape painting. Menn played a leading part in the cultural life of Geneva, where he organized exhibitions of the work of his French friends; unfortunately they were not very successful. He was a persuasive and stimulating teacher, and even late in life he continued to conduct a debating circle where aesthetic and pedagogical problems were argued out; another prominent member of that circle was the Symbolist painter and architect Albert Trachsel.

François Bocion of Lausanne became famous as the painter of the Lake of Geneva. One of Gleyre's first pupils in Paris, he then spent the rest of his life as a landscapist and drawing master in Lausanne. Like Menn, he lived the quiet, hard-working life of an exile in his own country. Only a few years younger than Eugène Boudin, Bocion has something in common with him in his manner of rendering water and atmosphere. Living aloof from the main centers of European art, Bocion created a highly personal, self-contained oeuvre imbued with a French charm and delicacy of touch. He and Menn together point the way to Hodler, who in his landscapes successfully adapted Menn's structural soundness to the broad reaches of the Lake of Geneva.

The Serene World
of Albert Anker

Belonging to the same generation as Zünd, Koller, Bocion, Buchser, and Böcklin, Albert Anker still remains today, in Switzerland, the best-loved Swiss artist of the nineteenth century, for his themes of home and family life appeal directly to his countrymen.

Hard-working and purposeful, Anker organized his life and his art with strict discipline in order to make the most of his talents. He was born and grew up at Ins (in French, Anet), a small country town midway between Bern and Neuchâtel, on the language frontier between French- and German-speaking Switzerland. Yielding to his father's wishes, he studied for the ministry and was ordained, but thereafter devoted himself to art. Going to Paris, he entered Gleyre's studio and the Ecole des Beaux-Arts, where he received a solid technical training in the best French tradition. For the next thirty years he followed roughly the same routine, spending the winters in Paris and the summers in his native town of Ins.

In spite of his close ties with French art, Anker drew his subject matter almost exclusively from the Bernese peasant life which he knew so well. He made those themes peculiarly his own, and within these narrow limits he achieved a perfection which his homely subjects are apt to make one overlook.

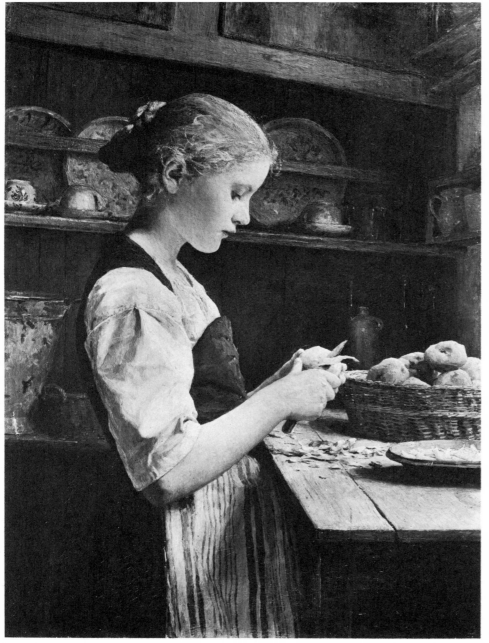

Albert Anker (1831-1910):

Swiss Peasant Boy
Pencil, 11 × 8⅛″
Municipal Library, Zofingen (Aargau)

Girl Peeling Potatoes.
Oil on canvas, 27¾ × 20¾″
Private Collection, Meilen (Zurich)

Little Girl Playing with Dominoes
Oil on canvas, diameter 14½″
Private Collection, Zurich ▷

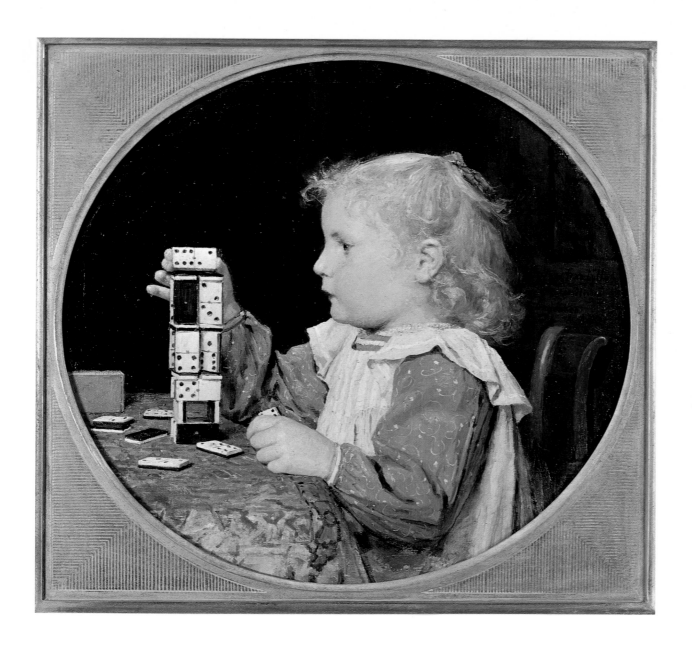

He focused his attention on village life, the figure groups at church services or in the schoolhouse, and single figures engaged in their daily occupations at home or in the fields. A girl peeling potatoes or a child playing with dominoes can give us genuine, unsentimental insights into this serene world. As a painter, his workmanship is firmly based on the principles inculcated by Gleyre, and he is one of the few painters in whom drawing and color are perfectly blended. His still lifes, almost the only ones in nineteenth-century Swiss painting, effectively combine a painterly treatment of surfaces with a linear structure of objects. The world he pictured is still very much alive and little changed in the Bernese countryside. Anker illustrated a French edition of Jeremias Gotthelf's novels of Bernese peasant life. But while Gotthelf, a village pastor in the Emmenthal, dealt memorably with the depths of passion and sin, Anker remained on the anecdotal surface of things—one reason, no doubt, why his work has aroused so little interest outside Switzerland.

No evolution can be detected in Anker's work. As soon as he had a studio of his own, he arrived at once at his characteristic style of tonal values. In later life he came to prefer watercolor painting, which in his opinion (in this he differed from Koller) was a medium rich in unexplored possibilities. In his native town and canton, Anker was elected to several public offices; like other Swiss artists (Koller, Buchser, and Trachsel, for example), he believed in assuming his civic responsibilities. It was thanks to the efforts of Anker's generation that the Swiss government began to encourage the arts.

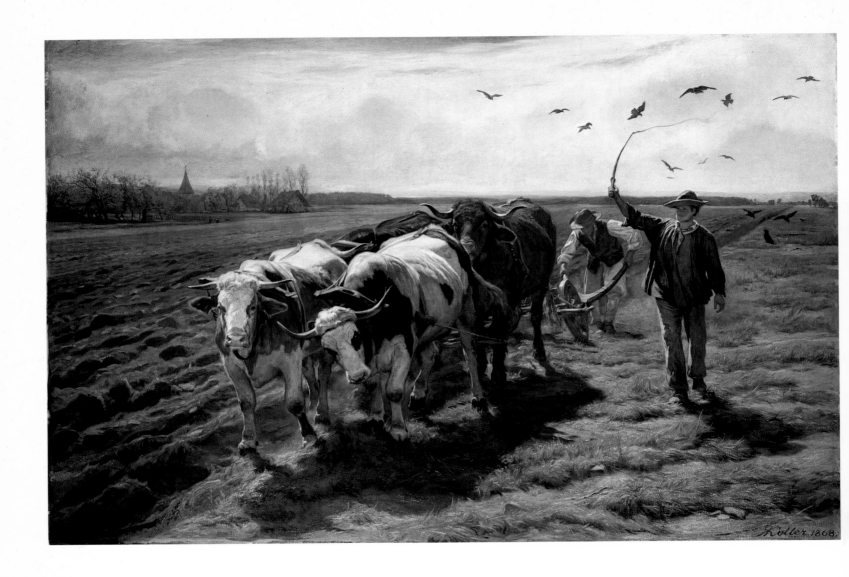

Landscape painting is of key importance in nineteenth-century Swiss art, and the stage of outright realism was reached in the work of Rudolf Koller and Robert Zünd. For both, realism meant an unadorned rendering of nature in terms of their personal vision, always with a firm sense of the underlying structure of mountains, lakes, forests, and fields. Picturesque views give way to a straightforward delineation of visual appearances. Each "slice" of reality is so searchingly observed that the whole surrounding environment makes its presence felt. Yet nature remains a part of the divine creation, every detail answering to an inner order and belonging to an all-embracing whole.

Rudolf Koller, son of a Zurich butcher and innkeeper, devoted himself to landscape and animal painting. For him, as for Brascassat and Troyon in France, animals retained something of the primal innocence lost by man; they combined harmony of form with natural vitality. Koller and Robert Zünd of Lucerne were close friends and usually traveled together during the summer months. For both, the sketch was only a means to an end. Art for them meant large, carefully composed canvases representing landscapes, animals, or figures, while the oil sketches and drawings that appeal to us today were left unregarded in a dusty corner of the studio. The contrast between the open-air study and the studio composition, typical of so many nineteenth-century landscapists, is particularly sharp in the case of Koller and Zünd. Yet a studio composition designed for public exhibition like Koller's *Oxen and Ploughmen* still conveys that strong sense of the union of man, nature, and the animal world which was so warmly praised by Gottfried Keller in 1869.

Three Realists: Koller, Zünd, and Stauffer

Rudolf Koller (1828-1905)
Oxen and Ploughmen. 1868
Oil on canvas, 53¾ × 80¼"
Private Collection, Zurich

164

Karl Stauffer (better known as Stauffer-Bern, from the name of his native town) was born thirty years after Koller and Zünd but worked in the same realist tradition. His pen drawing of the Zurich novelist Gottfried Keller was made as the preliminary design for an etching: he shows here as thorough and searching a realism as Zünd does in his pencil drawing of the Walensee lakeshore. A fine portraitist, Stauffer modeled himself on the early German masters. After his schooling in Bern, he studied art in Munich, Berlin, and Paris. An illfated love affair with Lydia Welti-Escher, who set up the Gottfried Keller Foundation in Zurich, drove him to suicide in 1891. In Swiss art Stauffer exemplifies the tragic destiny of a gifted artist whose career fatally miscarried.

Karl Stauffer-Bern (1857-1891)
Gottfried Keller. 1886
Pen and ink
Haus zum Rechberg, Zurich

Robert Zünd (1827-1909)
The Shore of the Walensee
Pencil, 13 × 19¼″
Private Collection

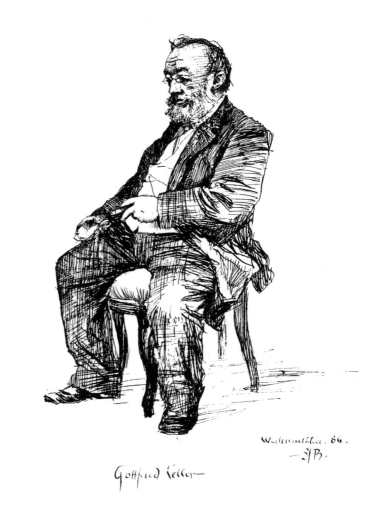

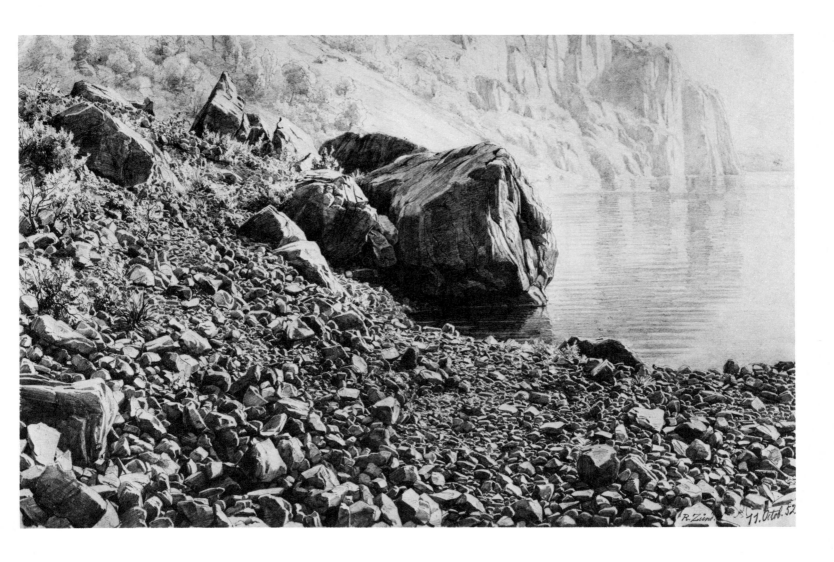

Böcklin had a long and eventful life. Born in Basel and trained in Düsseldorf, Antwerp, Brussels, and Paris, he worked in Switzerland, Italy, and Germany. Initiated into Italian life and history by his friend Jacob Burckhardt, the great Swiss historian of the Renaissance, Böcklin found there not only the glowing light of the South, as so many had done, but also an Arcadian landscape which his eager imagination proceeded to people with nymphs, shepherds, unicorns, and Pan figures. As early as the 1850s he thus personified a pagan conception of nature which Symbolism brought to the fore later in the nineteenth century. His most famous works are pagan allegories of this kind, and on them his reputation rested. In his lifetime they were hailed by some as revelations and ridiculed by others as tasteless and pretentious. What has been written about him since his death in 1901 provides a touchstone for the appreciation of modern art. Views on Böcklin have ranged from breathless tributes to scathing dismissal, and for a long time a critic's judgment of him defined his position in relation to modern art. The case against him was stated in a famous book, *Der Fall Böcklin* ("The Case of Böcklin"), published in 1905 by the German art historian Julius Meier-Graefe, whose complaint was not so much against the painter himself as against the widespread infatuation with his work in Germany (where the bulk of it then was and still is), and the perverse attempts being made to enlist it in the service of German nationalism.

To complete his training, Böcklin went to Paris in 1848—in the midst of the revolution of that year, as it happened. And though he worked in the Louvre for a time, he never took to the French tradition and indeed bypassed it completely. To repudiate Paris, the art center of the world, was most unusual for a nine-

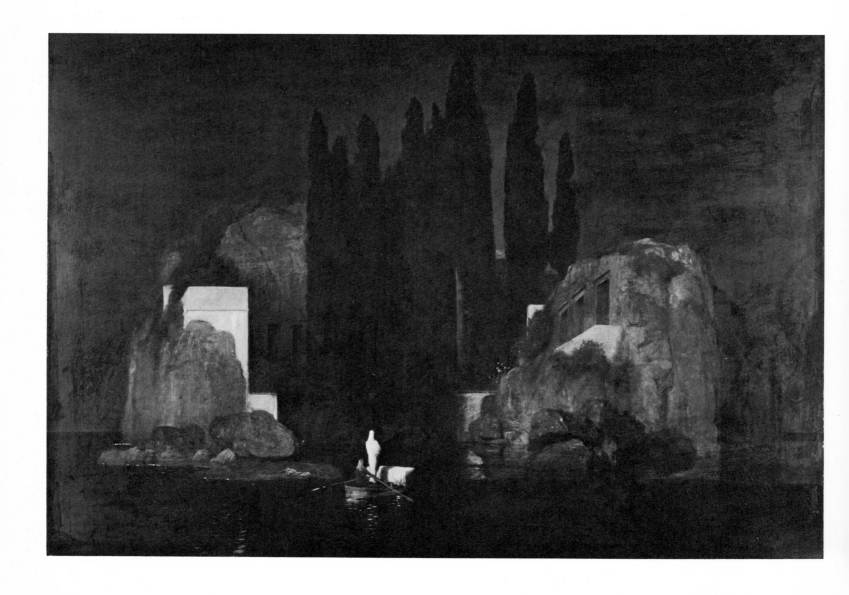

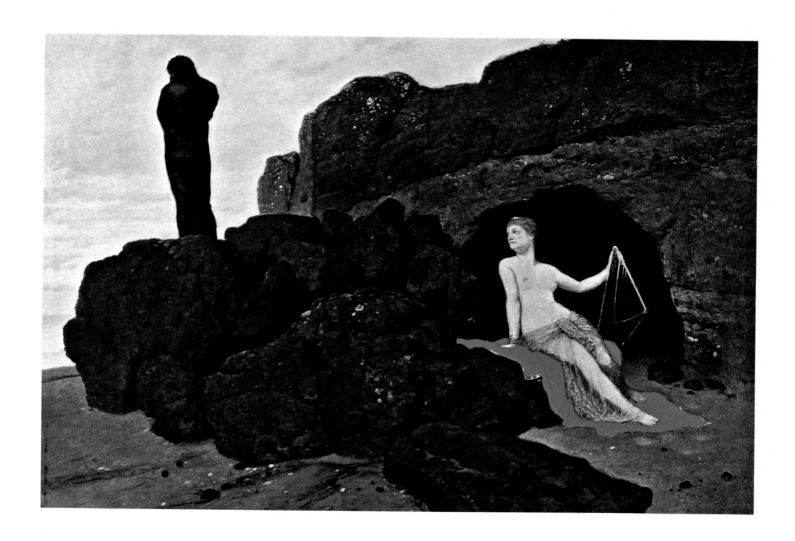

Arnold Böcklin (1827-1901):

Odysseus and Calypso. 1883
Tempera and oil on panel, 41 × 59″
Öffentliche Kunstsammlung, Basel

◁ *The Isle of the Dead*. 1880
Oil on canvas, 29⅜ × 48¼″
Öffentliche Kunstsammlung, Basel

teenth-century Swiss artist. Even men like Ludwig Vogel and Robert Zünd, who had close ties with Munich, rounded out their training in Paris and gained by it; so did Böcklin's pupils Hans Sandreuter and Theophil Preiswerk. For Meier-Graefe, French Impressionism was the all-important movement of the nineteenth century, pointing the way to the future; he therefore disapproved of Böcklin, whose work is the very antithesis of French art, drawing its inspiration from quite different sources.

A painting like *Odysseus and Calypso* of 1883 is highly characteristic of Böcklin. In spite of its Mediterranean theme, it illustrates the gulf between his conceptions and the Latin tradition. Its effect depends on the tension between the two Homeric figures of the man and the woman. The whole picture is designed in terms of that tension; it underlies the polarization of contours, movements, colors and expression. The antagonism is conveyed in psychologically simple terms and with impressive solemnity; it is clearly felt even by the spectator ignorant of the story of Odysseus and his wanderings. Intent on conveying the feelings that had prompted his picture, Böcklin departed from some of the principles that had always been taken for granted in painting. Thus the local colors of the fabrics clashing with the brown keynote of the rocky setting, the awkward posture of Calypso and the insistent creation of mood all run counter to the French tradition of "style painting." These were some of the points made by Böcklin's detractors, and they are still valid today. Yet it is only fair to add that he has qualities of his own, and they have been recognized by his twentieth-century admirers. For power of imagination and resourceful invention of subject matter he has few equals in Swiss painting; only Fuseli and Hodler can compare with him. Many of his paintings strike one as the only convincing statement of a given theme. Take his famous *Isle of the Dead*. Its morbid intensity and its stately, spirit-haunted landscape became for several generations the

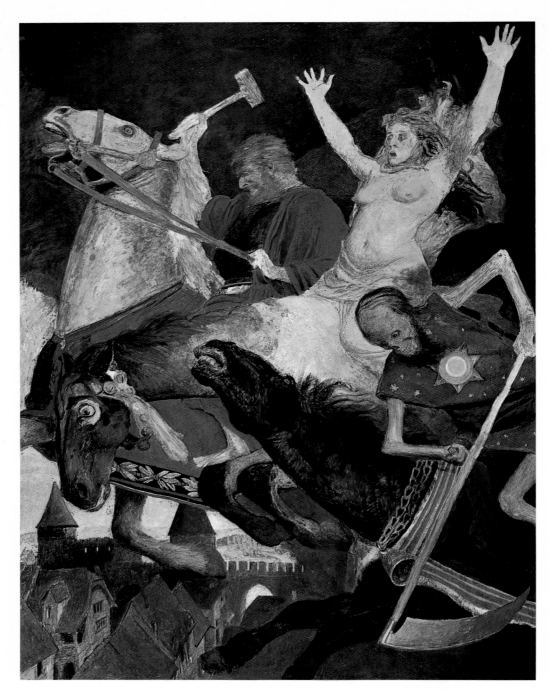

Arnold Böcklin (1827-1901)
War. 1896
Tempera on canvas, 86½ × 67″
Kunsthaus, Zurich, on deposit from the
Gottfried Keller Foundation

very symbol of man's inevitable passing from this world. Even a late work like
War, in spite of the crude allegorizing, is one that sticks in the mind. Böcklin
contrives to make the improbable compelling. His centaurs, naiads, and fabulous
creatures come to life.

Today we can begin to assess the extent of Böcklin's influence on the art of
the twentieth century. The Surrealists were attracted to him, in particular Max
Ernst and Salvador Dali; and the *Isle of the Dead* appears to have had a direct
effect on the artistic development of Giorgio de Chirico, who studied in Munich
at a time (c. 1906-1909) when Böcklin's influence was still paramount in Germa-
ny. All three of these artists have taken up Böcklin's themes or alluded to them
in their pictures. He has been likened to contemporaries of his, such as Hans von
Marées and Anselm Feuerbach in Germany and Gustave Moreau and Puvis de
Chavannes in France, but in the final analysis Böcklin stands out as a unique
personality in the art of the nineteenth century and as a by no means negligible
source of inspiration for that of the twentieth.

Symbolists and Dreamers

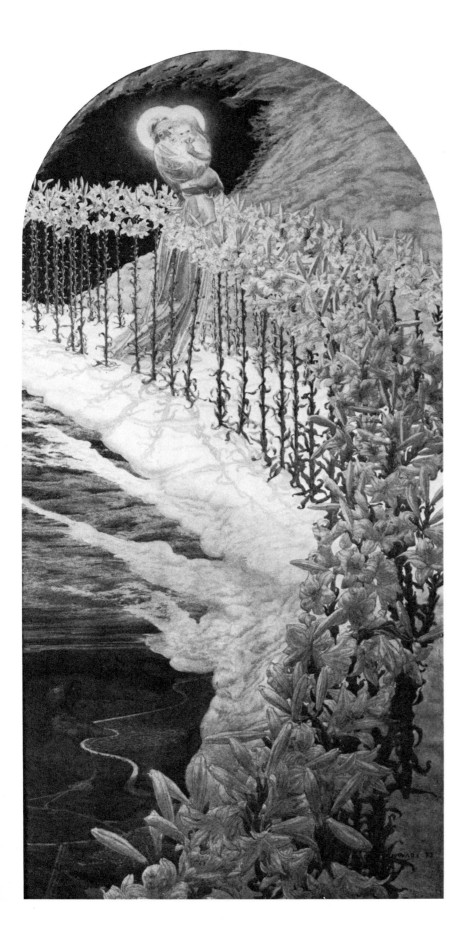

Switzerland contributed largely to the international Symbolist movement, and the significance of this rather unexpected contribution has only recently been appreciated. Creating a subjective world of their own compounded as much of literary as of artistic elements, the Symbolists set out "to clothe the idea in sensuous form," as the poet Jean Moréas put it in a Symbolist Manifesto published in Paris, in the *Figaro*, on September 18, 1886. They turned away from the banalities of daily life and a naturalistic view of things. What mattered for them was the inner life and the visual expression of the mystical and the occult. The sign replaced appearances and only the initiated could fathom its underlying meaning.

One of the most curious manifestations of the Symbolist aesthetic was the Salon de la Rose Croix, held in Paris every year from 1892 to 1897. It was organized by a now forgotten mystagogue named Joseph Peladan, who gave himself the title of Sâr (high priest); the financial backing was provided by Duke Antoine de La Rochefoucauld, whom Peladan had converted to his esoteric doctrines. The poster for the first "Rosicrucian Salon" in 1892 was designed by the Swiss artist Carlos Schwabe. To these exhibitions Peladan welcomed all artists who shared his views on art, which may be summed up as follows: to destroy Realism and to revive the tradition of an ideal beauty, based on myth, legend, and dream. This antinaturalistic program, running counter to the official art of the Third Republic, met with an eager response from many French and foreign artists. Among the Swiss artists who took part in the Salons de la Rose Croix were Ferdinand Hodler, Félix Vallotton, Eugène Grasset, Auguste Rodo de Niederhäusern, Albert Trachsel, and Carlos Schwabe.

Carlos Schwabe (1866-1926)
The Madonna of the Lilies. 1898-1899
Watercolor, 38¼ × 18½"
Collection Robert Walker, Paris

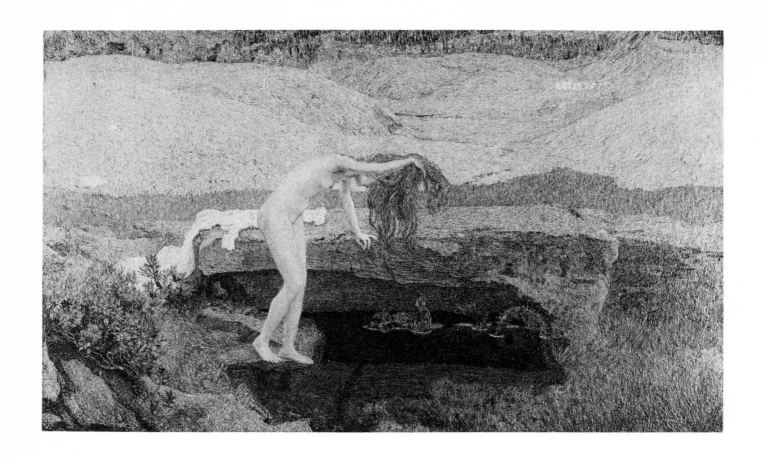

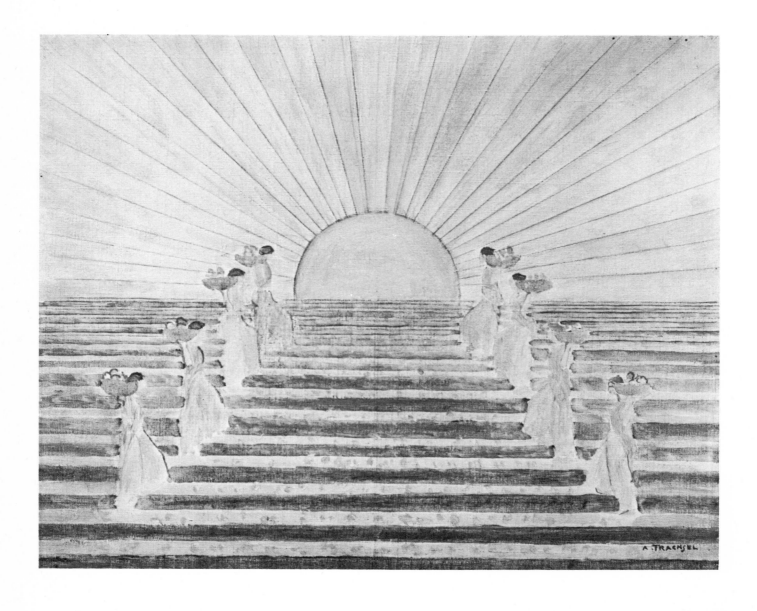

Carlos Schwabe, Rodo de Niederhäusern, and Albert Trachsel had all grown up in Geneva, where an intellectually stimulating atmosphere prevailed in the last decades of the nineteenth century, thanks above all to some outstanding men of letters. Through the Symbolist poets Louis Duchosal and Edouard Rod and the writer Mathias Morhardt, future editor of the Paris newspaper *Le Temps*, the artists of Geneva were kept well abreast of the latest trends in Paris. While the Lausanne artist Eugène Grasset had been living in Paris since 1871, his younger Swiss contemporaries Félix Vallotton, Rodo, and Schwabe all went there around 1880; Vallotton and Schwabe settled there for good.

Like Böcklin, Schwabe was an artist of uncommon imaginative power, and his inventive compositions, among them book illustrations inspired by Baudelaire, Zola, and Maeterlinck, perfectly exemplify the antirealistic, rather overblown world of the Symbolists. To that same world belongs the early work of

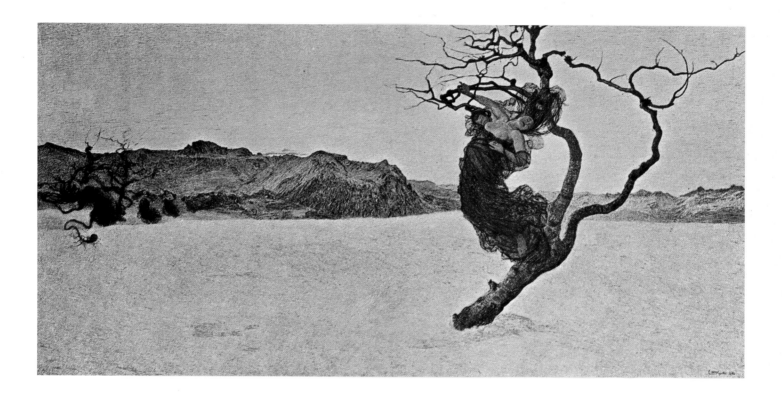

Albert Trachsel, who produced a cycle of paintings built up around imaginary architectural motifs designed to express different states of mind and symbolize natural events. Both Schwabe and Trachsel were masters of line, handling it with a deftness that is unusual in Swiss art and sometimes brings to mind the Pre-Raphaelites in England.

Giovanni Segantini was an Italian painter who spent the last thirteen years of his life in Switzerland, chiefly at Savognin and Maloja in the Grisons. There, before Hodler, he studied mountain life and became the painter of the Alps. His purpose was not to explore them, but to exalt the purity of the Alpine world as against the spiritual and material degradation of city life. In his later work, taking over the Neo-Impressionist technique, he followed up the ideas of the French Symbolists and treated similar themes: old folk legends, personifications of virtue and vice, and allegories of life and death. The *Unnatural Mothers* are infanticides who wander through the world, finding peace nowhere; the woman gazing into a mountain lake sees, not her own beauty, but the dragon of vanity. Many of his best works, including the unfinished allegorical triptych *Becoming, Being, Dying*, can be seen at the Segantini Museum, which was opened at Saint Moritz in the Engadine in 1909.

Giovanni Segantini (1858-1899):

◁ *Vanity*. 1897
Oil on canvas, 30¾ × 49½″
Private Collection, Milan

The Unnatural Mothers. 1894
Oil on canvas, 41⅜ × 79″
Kunsthistorisches Museum, Vienna

Albert Trachsel (1863-1929)
◁ *The Worship of the Sun*
Oil on canvas, 13 × 16⅛″
Private Collection, Solothurn

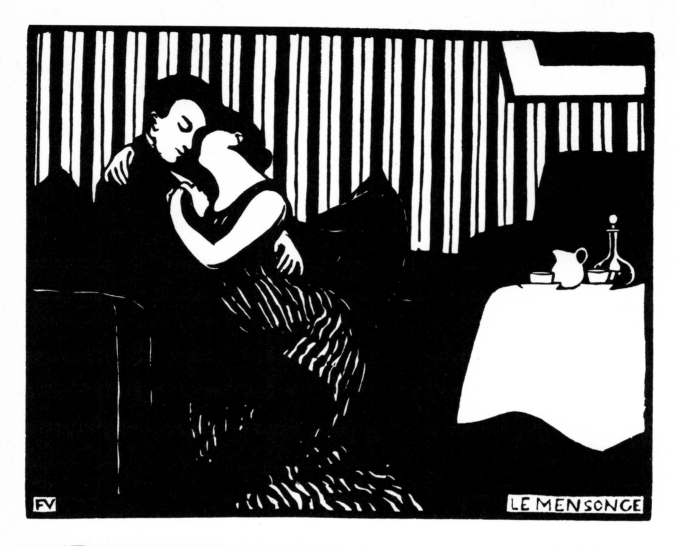

LE MENSONGE

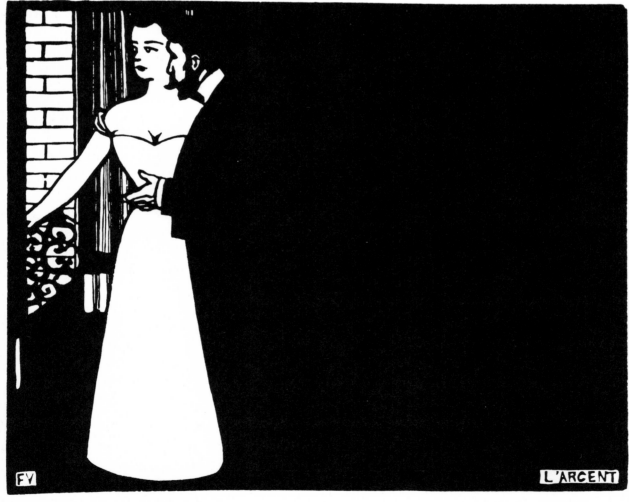

L'ARGENT

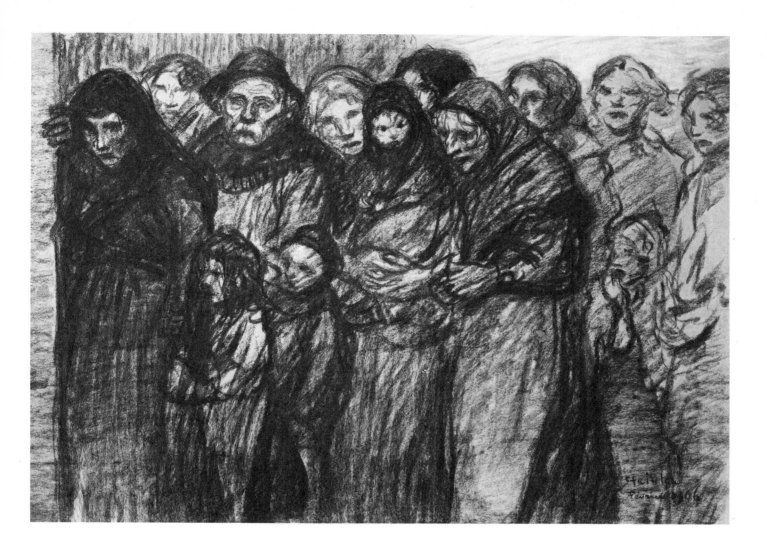

Vallotton and Steinlen

Félix Vallotton (1865-1925)
◁ *The Lie (Intimacies I)*. 1897
◁ *Money (Intimacies V)*. 1898
Woodcuts, each 7 ⅛ × 8 ⅞″

Théophile-Alexandre Steinlen (1859-1923)
Paris Street Scene
Charcoal, 19 ¼ × 25 ⅜″
Musée d'Art et d'Histoire, Geneva

Gleyre and Bocion, both from Lausanne, or near by, were followed after the mid-century by two other Lausanne artists of note, Vallotton and Steinlen. Both—Steinlen all his life and Vallotton up to about 1900—worked chiefly in black and white; and both settled early in Paris and remained there, becoming French nationals.

The young Félix Vallotton moved in Symbolist circles and made woodcut portraits of the leading Symbolist writers. But he was no idealist. His cool, rational mind was intent on observing the complexity of human relations in Paris society and depicting the fin-de-siècle bourgeoisie with an unsparing eye for its failings. In this he may be likened to Edvard Munch, with whom he also has in common the sinuous line of Art Nouveau. But where Munch openly displays feelings, Vallotton subtly suggests the coming catastrophe. His set of woodcuts called *Intimacies*, with scenes like *The Lie* and *Money*, is not only a graphic masterpiece but telling social criticism.

Steinlen earned his living as an illustrator for French satirical papers like *Le Chat Noir*, *Le Mirliton*, and *Le Gil Blas Illustré*. On the side, he sketched sharply observed scenes of working-class life in Paris: they mark practically the first appearance in art of the modern proletariat and they influenced the early Picasso. With Jules Chéret and Toulouse-Lautrec, Steinlen was one of the creators of the modern poster and did much to develop the technique of color lithography. As a socially committed illustrator, he stands at the beginning of the movement that led to the expressionistic social satire of the German-American George Grosz and the Swiss Robert Schürch. Steinlen's influence in Germany was strong, especially at the time of the founding of the famous satirical weekly *Simplicissimus*, in Munich in 1896.

Hodler and the Beginnings of Twentieth-Century Art

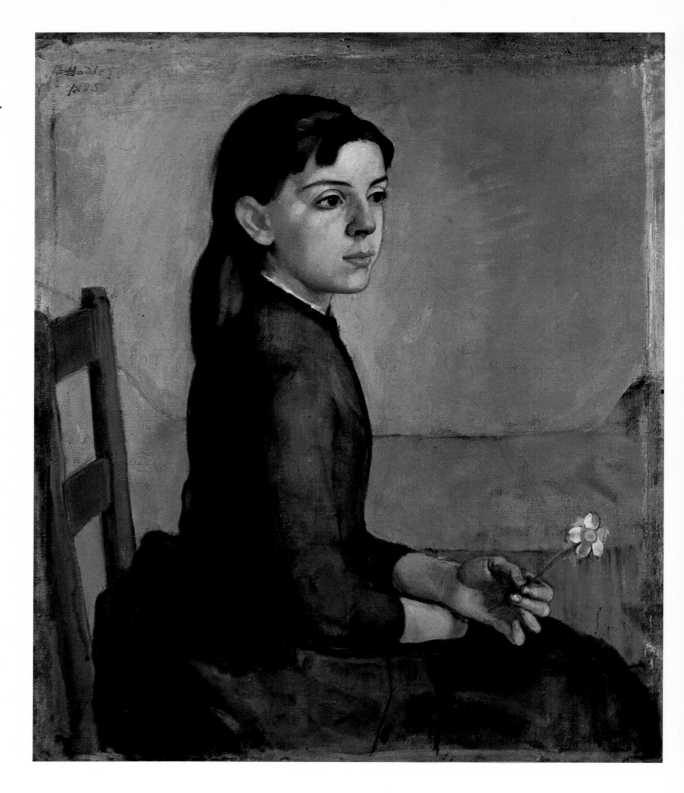

As time passes and he recedes into history, the figure of Hodler looms steadily larger in the Swiss art of the nineteenth and twentieth centuries. Much that was only latent or suggested in his nineteenth-century predecessors found full expression in Hodler's work, and its lessons were weighed and studied by nearly every Swiss painter active in the first half of the twentieth century.

To understand Hodler and his art, it is important to know something about his early life. He was born in Bern in 1853, the eldest of six children. His father was a joiner; his mother worked as a cook and laundress. While still a child he lost his parents and most of his brothers and sisters. At fifteen he was apprenticed to Ferdinand Sommer, in Thun, who painted views and souvenirs of Switzerland for the tourist trade in the Bernese Oberland. Eager to make his own way, Hodler moved to Geneva in 1872, when he was nineteen; he was to live there for the rest of his life. He attended courses in the natural sciences at the

Ferdinand Hodler (1853-1918)
Louise-Delphine Duchosal. 1885
Oil on canvas, 21 ⅝ × 18 ⅜″
Oskar Reinhart Foundation, Winterthur

university and copied Calame and Diday in the Musée Rath. There he attracted the attention of Barthélemy Menn, with whom he studied for the next few years. In 1874 a landscape of his was awarded first prize in the Calame competition. At that time regular competitions were organized by the city of Geneva on a set theme, either a figure composition or a landscape. They were of considerable importance in Hodler's development, not only for the prize money, which he needed to make ends meet, but for the stimulus they gave him, prompting him to tackle ever more exacting pieces of work. Hodler took part in these competitions until 1895, when he was over forty.

He visited Spain in 1878-1879, remaining in Madrid the better part of a year. On the way he may have stopped in Paris, but until 1891 his only other journeys abroad were short visits to Munich and Lyons. He did, however, travel a good deal in Switzerland, mostly in the Bernese Oberland. During a visit to the art museum in Basel in 1875 he admired Holbein and the early German masters. Acting on Menn's advice, he made a careful study of Dürer's theory of proportions. These early years were hard ones for Hodler, for he had no regular source of income, depending on occasional commissions for decorative paintings in cafés or banqueting halls, like those for the Taverne du Crocodile in Geneva in 1886. He remained a poor man until about 1890.

By 1880 his work had begun to attract some attention. His first one-man show took place at the Cercle des Beaux-Arts in Geneva in 1885; it was followed by another in 1887 at the Kunstmuseum in Berne. During the 1880s a small circle of writers and artists had begun to meet regularly in his Geneva studio,

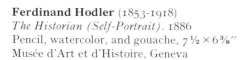

Ferdinand Hodler (1853-1918)
The Historian (Self-Portrait). 1886
Pencil, watercolor, and gouache, 7 ½ × 6⅜"
Musée d'Art et d'Histoire, Geneva

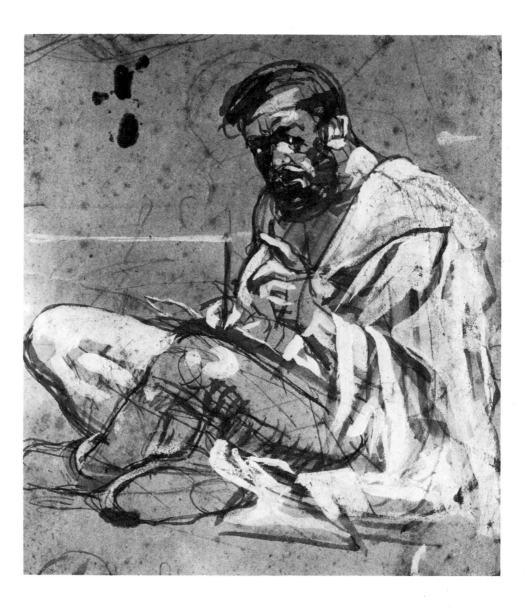

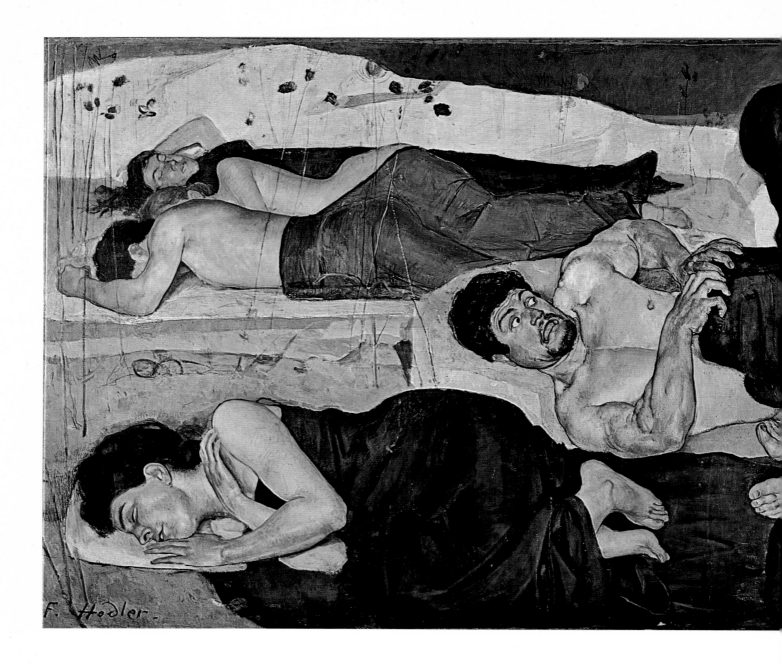

among them the poet Louis Duchosal, the artist and architect Albert Trachsel, and the composer Emile Jaques-Dalcroze.

In his early work Hodler kept to dark colors. Then, from 1875 on, he began to see things in a different light. Menn's teaching awakened in him a self-awareness that led him to paint his first masterpieces, like the self-portrait known as *The Student* (1874, Zurich). In the late 1870s, still under Menn's influence, he painted open-air landscapes in the neighborhood of Geneva, some portraits, and some compositions with several figures, among them *The Gymnasts' Dinner* of 1876, inspired by Plato's *Symposium*. Around 1880 he painted two versions of *Prayer*; in front of them, it is difficult to believe that Hodler had never seen original works by Manet or Degas. They are the outcome of his early contacts with religious circles in the canton of Bern; both versions powerfully convey the devotional experience of group prayers. The bold sky blues and pinks depart from the tradition of local color, to fine effect, in a way never seen before in Swiss painting.

From then on the Geneva critics could no longer ignore him, but they complained that his figures were ugly and devoid of charm. Equally disturbing were his portraits, like that of Louis Duchosal's sister, Louise-Delphine (1885), as compared with the prevailing style of portraiture in Switzerland at that time. Sitting bolt upright in a chair, the girl stands out against a bare wall, as if

Ferdinand Hodler (1853-1918)
Night. 1889-1890
Oil on canvas, 46 × 118″
Kunstmuseum, Bern

176

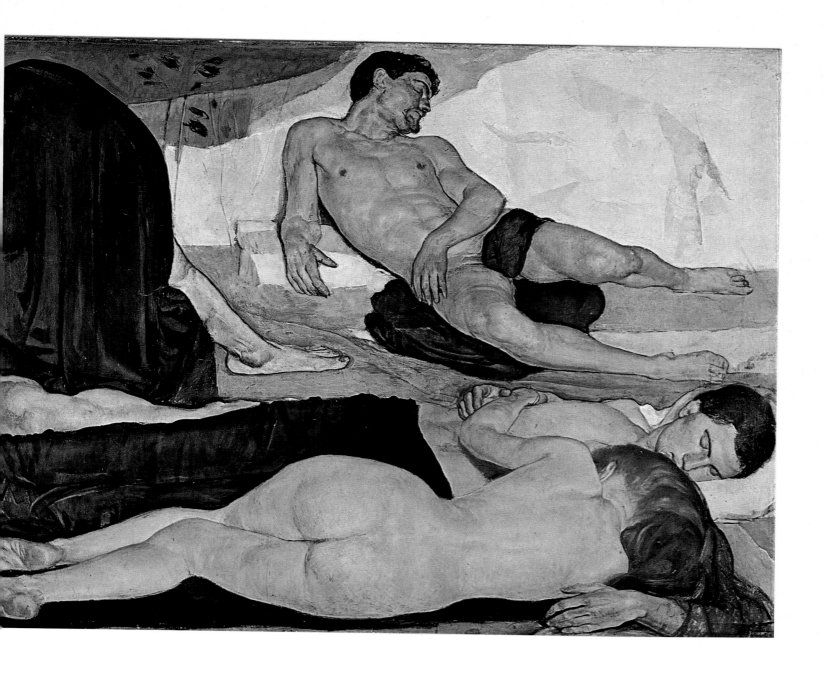

utterly removed from her usual surroundings. All details that might have added charm or sentiment to the picture of a girl have been sternly excluded, except for the flower. The spare effect is like that of a poster. A comparison with Renoir's portraits of girls of that same period, for example *Irene of Cahors* (Collection E.G. Bührle, Zurich), shows that Hodler had created a distinctive style of his own. Renoir lingers over outward appearances; every detail brings out the natural grace and beauty of little Irene. Hodler's approach is the very opposite: he rejects these outward attractions. Even the girl's hand has the size and strength of a man's, in singular contrast with the narcissus she is holding; her figure is roughly modeled with powerful strokes.

Hodler portrayed himself as a historian in a forceful drawing of 1886. It was one of the designs for his cycle of mural decorations of that year in the Taverne du Crocodile in Geneva. It is a remarkable drawing in its searching self-assessment. In the long sequence of self-portraits that span his whole working life, but were most numerous in his earlier and his later days, *The Historian* marks the transition from the still rather attitudinizing self-portraits of his youth to those of middle life and old age in which he gives full expression to his rugged personality. A comparison between *The Historian* (1886) and Böcklin's *Self-Portrait with Death Playing the Fiddle* (1872) suggests that the latter's inspiration was external, while Hodler was intent on self-probing.

In 1890 Hodler finished his masterpiece, *Night*. With this large figure painting, treated like a fresco, he caught up at one stroke with the main trends of contemporary art and assumed a leading position in the Symbolist movement. He himself wrote about it as follows: "It is not one night, but a combination of night impressions. The ghost of death is there not to suggest that many men are surprised by death in the middle of the night, but it is there as a most intense phenomenon of the night. The coloring is symbolic: these sleeping beings are draped in black; the lighting is similar to an evening effect after sunset, showing the approach of night, but the effect is completed by those black draperies which partly cover the figures everywhere; they are the low, muffled notes of an austere harmony, which is merely a transcription of the effects of night. But the most striking feature is the ghost of death and the way, both harmonious and sinister, in which this ghost is represented, hinting at the unknown, the invisible."

The means employed were as novel as the theme itself. The landscape setting and the figures are painted in cool, almost colorless tones: the black and white areas set up a rhythmic pattern that does away with spatial relations. The tension between the realism of the handling—powerfully summed up in the female nude seen from behind—and the idealism of the subject gave the picture a spiritual dimension that was compulsively felt by the public of the 1890s. *Night* aroused great interest in Geneva, especially after the mayor insisted on its being withdrawn from the municipal exhibition of 1891, whereupon Hodler had it exhibited to eager crowds in a private gallery. Shown in Paris in 1892 at the Salon du Champ-de-Mars, it created a sensation. That same year in Paris Hodler exhibited *The Disillusioned* at the Salon de la Rose Croix, at the personal request of Count Antoine de La Rochefoucauld, the financial backer of the Rose Croix exhibitions, who had gone down to Geneva to invite him to take part.

Ferdinand Hodler (1853-1918)
The Chosen One. 1893-1894
Tempera and oil on canvas, 86 × 116½"
Kunstmuseum, Bern, on deposit
from the Gottfried Keller Foundation

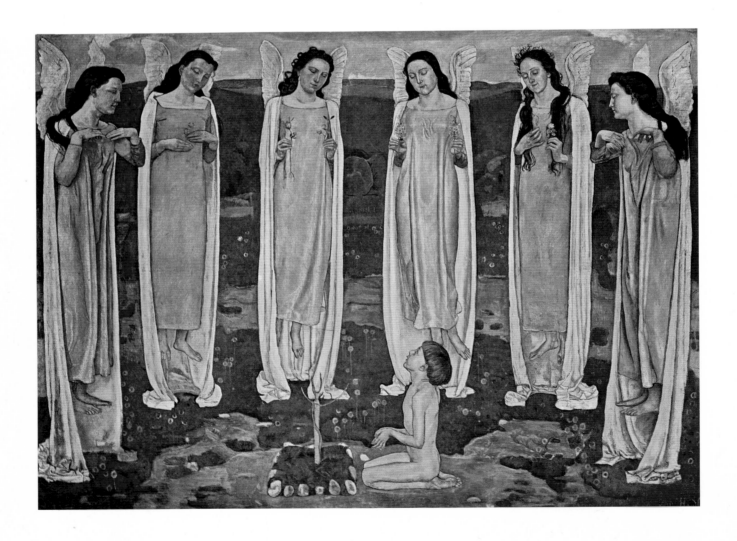

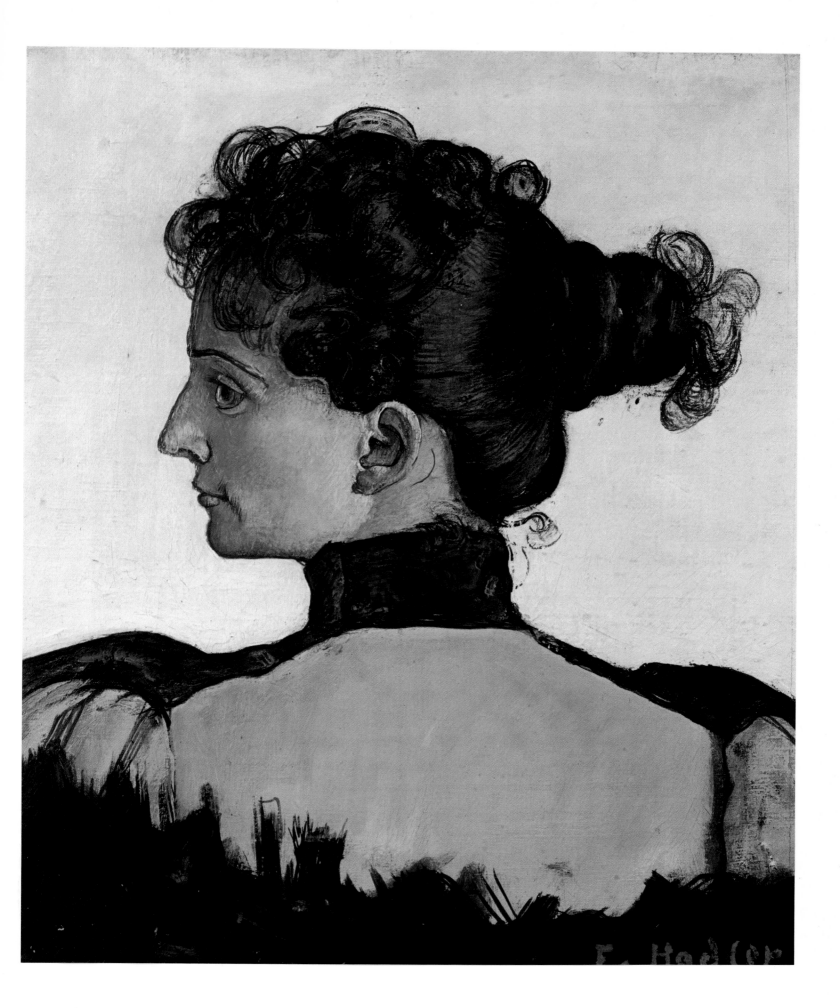

Ferdinand Hodler (1853-1918)
Berthe Jacques, the Artist's Second Wife. 1894
Oil on canvas, 13¼ × 11″
Collection A. Stoll, Arlesheim (Basel-Land)

Night was followed by other large compositions in which a gradual evolution from Symbolist themes to eurhythmic allegories can be traced. Until now Hodler in his work had drawn largely on his early familiarity with the mysteries of birth and death (both his mother and father had died in their thirties, and most of his brothers and sisters had died young of tuberculosis). After 1890 he moved into a new phase of inspiration. But once more, in *The Chosen One* of 1893-1894, he harked back to these earlier sentiments. Fairy-like angels, with flowers in their hands, watch over a kneeling boy—Hodler's only son, Hector, then six years old—and lavish their good wishes upon him. Hodler himself described the painting succinctly: "A child surrounded by female figures. This picture is like a rose. What is a rose? Similar forms grouped round a center." The vertical figures of the women hovering in mid-air answer to the artistic principle of parallelism which Hodler set forth and developed in his theoretical writings. By parallelism he meant not only the repetition of forms but the resulting spiritual force and unity of feeling. He explained his views in a lecture given at Fribourg in 1897, which he called " The Mission of the Artist."

Hodler is often grouped with the Art Nouveau painters, chiefly because of the influence he exerted on the Berlin and Vienna Secession, whose artists best expressed the ideals of Jugendstil (as Art Nouveau was called in Germany). While some of the formal elements of Art Nouveau already appear in his work in the 1880s, he never subscribed to its decorative aestheticism. In the *Portrait of Berthe Jacques* (1894) the vibrant and emphatic outline, though very much in the spirit of Art Nouveau, is thoroughly integrated into the pictorial structure. The sharp contours of face, neck, and shoulder make an effective contrast with the lines and curls of the hair and the jagged, sketchy edging of the dress. Hodler had just met Berthe Jacques, a French teacher in a Geneva high school; she became his wife in 1898. His portrait of her is remarkable for its bold design and the personal radiance of the young woman.

After the success of his *Night* in Paris in 1891, Hodler found himself famous. He traveled abroad more frequently, to Paris in 1891, to Antwerp and Brussels in 1894, to Paris twice in 1900. Fame brought him commissions, museums purchased his works, and he was awarded gold medals at the International Exhibition in Munich (1897) and the Paris World's Fair (1900). In 1897 he won a government-sponsored competition for a large fresco, *The Retreat from Marignano*, for the Swiss National Museum in Zurich. Although the Museum director opposed his design and mounted a vehement campaign against it, Hodler stood his ground and carried out the work. Completed in 1900, this great three-part fresco marks a turning point both in Hodler's art and in Swiss painting.

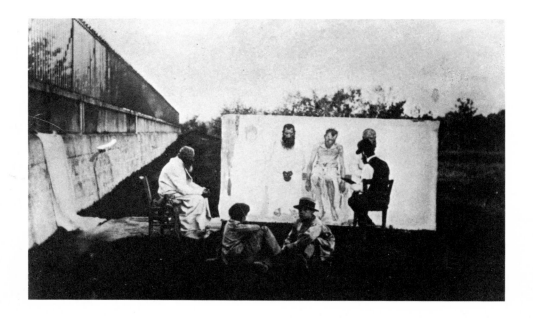

Ferdinand Hodler
painting
The Disillusioned
in 1892
beside the Cemetery
of Saint George
in Geneva
Photograph
by Marc Odier,
courtesy
Jura Brüschweiler

Selected Bibliography
List of Illustrations
Index of Names and Places

Selected Bibliography

General Works

Daniel BAUD-BOVY, "La peinture suisse," *L'art et les Artistes*, Paris, July-August 1913. — Daniel BAUD-BOVY, *Les maîtres de la gravure suisse*, Geneva, Jullien, 1935. — François FOSCA, *Histoire de la peinture suisse*, Geneva, 1945. — Joseph GANTNER and Adolf REINLE, *Kunstgeschichte der Schweiz von den Anfängen bis zum Beginn des 20. Jahrhunderts*, 4 vols., Huber, Frauenfeld and Leipzig, 1936-1962. — Paul GANZ, *Die Malerei der Schweiz in Farben*, Urs Graf, Olten, 1953. — Walter HUGELSHOFER, *Schweizer Zeichnungen von Niklaus Manuel bis Alberto Giacometti*, Stämpfli, Bern, 1969. — *Die Kunstdenkmäler der Schweiz*, 60 vols., Gesellschaft für schweizerische Kunstgeschichte, Basel, 1927-. — Peter MEYER, *Schweizerische Stilkunde von der Vorzeit bis zur Gegenwart*, Schweizer Spiegel, Zurich, 1942. — *Schweizer Maler aus fünf Jahrhunderten von Konrad Witz bis zu Ferdinand Hodlers Tod*, Rascher, Zurich, 1945. — Dietrich WALO and Hermann SCHWARZ, *Die Kultur der Schweiz*, Frankfurt, 1967.

Part I

Swiss Art or Art in Switzerland?
The Beginnings of Painting

Ellen J. BEER, *Die Glasmalereien der Schweiz vom 12. bis zum Beginn des 14. Jahrhunderts*, Corpus Vitrearum Medii Aevi, Schweiz I, Birkhäuser, Basel, 1956. — Ellen J. BEER, *Die Glasmalereien der Schweiz aus dem 14. und 15. Jahrhundert*, Corpus Vitrearum Medii Aevi, Schweiz III, Birkhäuser, Basel, 1965. — Beat BRENK, *Die romanische Wandmalerei in der Schweiz*, Francke, Bern, 1963. — Florens DEUCHLER, *Schweiz und Liechtenstein*, Reclam, Stuttgart, 1968. — Hans DÜRST, *Alte Glasmalerei der Schweiz*, Office du Livre, Fribourg, 1971; in French, *Vitraux anciens en Suisse*, Fribourg, 1971. — Albert KNOEPFLI, *Kunstgeschichte des Bodenseeraumes*, Vol. 1: *Von der Karolingerzeit bis zur Mitte des 14. Jahrhunderts*, Thorbecke, Constance, 1961. — Adolf MERTON, *Die Buchmalerei in St. Gallen vom 9. bis zum 11. Jahrhundert*, 2nd ed., Hiersemann, Leipzig, 1923. — Erwin POESCHEL *Die romanischen Deckengemälde von Zillis*, Rentsch, Erlenbach and Zurich, 1941.

Part 2

Late Gothic and Renaissance Art

General Works

P. Venanzio BELLONI, *Bellinzona: Affreschi in Santa Maria delle Grazie*, Genoa, 1975. — Pierre BOUFFARD, *L'art gothique en Suisse*, Lucien Mazenod, Editions contemporaines, Geneva, 1948. — Aldo CRIVELLI, *L'art renaissant en Suisse*, Lucien Mazenod, Editions contemporaines, Geneva, 1948. — Joseph GANTNER, *Histoire de l'art en Suisse*, Vol. 1: *Des origines à la fin de l'époque romane*, and Vol. 2: *L'époque gothique*, Attinger, Neuchâtel, 1956. French translation of the first two volumes of his *Kunstgeschichte der Schweiz* (see General Works above). — Paul GANZ, *Die Basler Glasmaler der Spätrenaissance und der Barockzeit*, Schwabe, Basel and Stuttgart, 1966. — Paul GANZ, *Ges-*

chichte der Kunst in der Schweiz von den Anfängen bis zur Mitte des 17. Jahrhunderts, Schwabe, Basel, 1960. — Paul GANZ (editor), *Handzeichnungen schweizerischer Meister des XV.-XVIII. Jahrhunderts*, 3 vols., Helbing & Lichtenhahn, Basel, 1904-1908. — Paul GANZ, *Die Malerei des Mittelalters und des 16. Jahrhunderts in der Schweiz*, Birkhäuser, Basel, 1950. — Paul GANZ, *La peinture suisse avant la Renaissance*, Paris, 1925. — Frédéric GYSIN, *Tapisseries suisses de l'époque gothique*, Holbein, Basel, 1940. — Hans Robert HAHNLOSER *Chorfenster und Altäre des Berner Münsters*, Benteli, Bern, 1950. — Walter HUGELSHOFER, *Schweizer Handzeichnungen des 15. und 16. Jahrhunderts*, Urban, Freiburg, 1928. — Hanspeter LANDOLT, *One Hundred Master Drawings of the Fifteenth and Sixteenth Centuries from the Basle Print Room*, Swiss Bank Corp., Basel, 1972. — Maurice MOULLET, *Les maîtres à l'oeillet*, Holbein, Basel, 1943. — Walter MUSCHG, *Die schweizer Bilderchroniken des 15. und 16. Jahrhunderts*, Atlantis, Zurich, 1941. — Alfred SCHEIDEGGER, *Die Berner Glasmalerei von 1540 bis 1580*, Benteli, Bern, 1947. — Alfred A. SCHMID, *Die Buchmalerei des 16. Jahrhunderts in der Schweiz*, Urs Graf, Olten, 1954. — Georg SCHMIDT and Anna Maria CETTO, *Schweizer Malerei und Zeichnung im 15. und 16. Jahrhundert*, Holbein, Basel, 1940. — Jenny SCHNEIDER, *Kabinettscheiben des 16. und 17. Jahrhunderts* (from the Swiss National Museum, Zurich), Haupt, Bern, 1956. — Wilhelm SUIDA, *La pittura del Rinascimento nel cantone Ticino*, Milan, 1932. — Friedrich THÖNE, *Museum zu Allerheiligen, Schaffhausen: Die Zeichnungen des 16. und 17. Jahrhunderts*, Zurich, 1972. — Lucas Heinrich WÜTHRICH, *Schweizerischen Portraitkunst von der Renaissance bis zum Klassizismus*, Haupt, Bern, 1971. — Robert L. WYSS, *Bildteppiche des 15. und 16. Jahrhunderts* (from the Swiss National Museum, Zurich), Haupt, Bern, 1955.

Jost Amman: Andreas ANDRESEN, *Jost Amman 1539-1591: Graphiker und Buchillustrator der Renaissance*, Danz, Leipzig, 1864; reprinted, Hissink, Amsterdam, 1973. — C. BECKER, *Jost Amman: Zeichner und Formschneider, Kupferätzer und Stecher*, Leipzig, 1854; reprinted, Nieuwkoop, 1961. — R. METTLER, *Jost Ammans Kunst- und Lehrbüchlein*, Stuttgart, 1971. — Alfred WERNER, *293 Renaissance Woodcuts for Artists and Illustrators: Jost Amman's Kunstbüchlein*, Dover, New York, 1968.

Urs Graf: Emil MAJOR and Erwin GRADMANN, *Urs Graf*, Home & Van Thal, London, 1947.

Joseph Heintz: Jürgen ZIMMER, *Joseph Heintz der Ältere als Maler*, Konrad, Weissenhorn, 1971.

Hans Holbein: Paul GANZ, *Les dessins de Hans Holbein le Jeune*, Boissonnas, Geneva, 1939. — Paul GANZ, *Handzeichnungen Hans Holbeins des Jüngeren in Auswahl*, Birkhäuser, Basel, 1943. — Paul GANZ, *The Paintings of Hans Holbein*, Phaidon, London, 1956. — K.T. PARKER, *The Drawings of Hans Holbein in the Collection of His Majesty the King at Windsor Castle*, London, 1945.

Daniel Lindtmayer: Friedrich THÖNE, *Daniel Lindtmayer der Jüngere, 1552-1606/1607*, Zurich, 1975.

Niklaus Manuel Deutsch: Daniel Baud-Bovy, *Nicolas Manuel*, Skira, Geneva, 1944. — Conrad de Mandach and Hans Koegler, *Niklaus Manuel Deutsch*, Urs Graf, Basel, 1940. — Paul Zinsli, *Der Berner Totentanz des Niklaus Manuel (ca. 1484-1530) in den Nachbildungen von Albrecht Kauw (1649)*, Haupt, Bern, 1953.

Tobias Stimmer: Max Bendel, *Tobias Stimmer: Leben und Werke*, Atlantis, Zurich and Berlin, 1940.

Konrad Witz: Daniel Burckhardt, "Aus der Vorgeschichte des Konrad Witz und von den Höhepunkten seiner ersten Basler Tätigkeit," *Zeitschrift für schweizerische Archäologie und Kunstgeschichte*, Basel, Vol. 5, No. 2, 1943. — Joseph Gantner, *Konrad Witz*, 2nd ed., Schroll, Vienna, 1943. — Paul Ganz, *Meister Konrad Witz von Rottweil*, Urs Graf, Bern, 1947. — Molly Teasdale Smith, "Conrad Witz's *Miraculous Draught of Fishes* and the Council of Basel," *The Art Bulletin*, New York, Vol. 52, June 1970.

Part 3

From the Baroque Era to the Age of Enlightenment

General Works

Daniel Baud-Bovy, *L'ancienne école genevoise de peinture*, Boissonnas, Geneva, 1924. — Daniel Baud-Bovy, *Peintres genevois 1702-1849*, 2 vols., Le Journal de Genève, Geneva, 1903-1904. — Linus Birchler, *L'art baroque en Suisse*, Lucien Mazenod, Editions contemporaines, Geneva, 1949. — Adrien Bovy, *La peinture suisse de 1600 à 1900*, Birkhäuser, Basel, 1948. — Waldemar Déonna, *Les arts à Genève, des origines à la fin du XVIIIe siècle*, Musée d'Art et d'Histoire, Geneva, 1942. — Ugo Donati, *Artisti ticinesi a Roma*, Istituto editoriale ticinese, Bellinzona, 1942. — Marcel Fischer and others, *Zürcher Bildnisse aus fünf Jahrhunderten*, Atlantis, Zurich, 1953. — Louis Gielly, *L'école genevoise de peinture*, Sonor, Geneva, 1935. — Erwin Gradmann and Anna Maria Cetto, *Schweizer Malerei und Zeichnung im 17. und 18. Jahrhundert*, Holbein, Basel, 1944. — Walter Hugelshofer (editor), *Schweizer Kleinmeister*, Fretz & Wasmuth, Zurich, 1943. — Hanspeter Landolt, *Schweizer Barockkirchen*, Huber, Frauenfeld, 1948. — Arnold Neuweiler, *La peinture à Genève de 1700 à 1900*, Jullien, Geneva, 1945. — Pierre-Francis Schneeberger, "Les peintres sur émail genevois au XVIIe et au XVIIIe siècle," in *Genava*, Geneva, new series, Vol. 6, July 1958. — Schweizerisches Institut für Kunstwissenschaft, *Schweizer Stilleben im Barock*, exhibition catalogue, Zurich, 1973. — Sven Stelling-Michaud, *Unbekannte schweizer Landschaften aus dem 17. Jahrhundert*, Niehans, Zurich, 1937.

Felix Maria Diogg: Walter Hugelshofer, *Felix Maria Diogg: Ein Schweizer Bildnismaler 1762-1834*, Zurich and Leipzig, 1940.

Henry Fuseli: Frederick Antal, *Fuseli Studies*, London, 1956. — Gert Schiff, *Johann Heinrich Füssli, 1741-1825: Text und Oeuvrekatalog*, 2 vols., Prestel, Munich, and Berichthaus, Zurich, 1973. — Tate Gallery, *Henry Fuseli 1741-1825*, exhibition catalogue, text by Gert Schiff and W. Hofmann, London, 1975. — P. Tomory, *The Life and Art of Henry Fuseli*, London, 1972.

Salomon Gessner: Paul Leemann-Van Elck, *Salomon Gessner*, Füssli, Zurich, 1930.

Anton Graff: Ekhart Berckenhagen, *Anton Graff: Leben und Werk*, Deutscher Verlag für Kunstwissenschaft, Berlin, 1967.

Jean-Etienne Liotard: François Fosca, *La vie, les voyages et les oeuvres de Jean-Etienne Liotard*, Bibliothèque des Arts, Lausanne and Paris, 1956. — Giovanni Previtali, *Jean-Etienne Liotard*, I Maestri del Colore, No. 240, Fabbri, Milan, 1966. — Pro Helvetia, *Exposition Jean-Etienne Liotard, 1702-1789; Johann Heinrich Füssli, 1741-1825*, exhibition catalogue, Musée de l'Orangerie, Paris, 1948.

Matthäus Merian: Lucas Heinrich Wüthrich, *Die Handzeichnungen von Matthäus Merian dem Älteren*, Bärenreiter, Basel, 1963. — Lucas Heinrich Wüthrich, *Das Druckgraphische Werk von Matthäus Merian dem Älteren*, 2 vols., Bärenreiter, Basel, 1966-1972. — Martin Zeiller, *Topographia Helvetiae Rhaetiae et Valesiae*, Frankfurt, 1654; new edition, Bärenreiter, Kassel and Basel, 1960.

Conrad Meyer: Conrad Meyer (illustrator), *Die Kinderspiele*, 1657; new edition, Berichthaus, Zurich, 1970.

Pier Francesco Mola: R. Coke, *Pier Francesco Mola*, Oxford, 1972.

Giuseppe Antonio Felice Orelli: Virgilio Gilardoni, *I pittori Orelli da Locarno*, Istituto editoriale ticinese, Bellinzona, 1941.

Giuseppe Antonio Petrini: Edoardo Arslan, *Giuseppe Antonio Petrini*, Società ticinese di belle arti, Lugano, 1960.

Giovanni Serodine: Roberto Longhi, *Giovanni Serodine*, Sansoni, Florence, 1954.

Joseph Werner: Jürgen Glaesemer, *Joseph Werner, 1637-1710*, Zurich, 1974.

Part 4

The Sense of a Common Heritage from the late Eighteenth to the Early Twentieth Century

General Works

René Creux, *Arts populaires en Suisse*, Editions de Fontainemore, Paudex/Lausanne, 1970. — Detroit Institute of Arts, *French Painting 1774-1830: The Age of Revolution*, Detroit, 1975. Catalogue of an exhibition first shown at the Grand Palais, Paris, in 1974, then at the Detroit Institute of Arts and the Metropolitan Museum of Art, New York, in 1975. — Liselotte Fromer-Im Obersteg, *Die Entwicklung der Schweizerischen Landschaftsmalerei im 18. und frühen 19. Jahrhundert*, Basler Studien zur Kunstgeschichte, No. 3, Birkhäuser, Basel, 1945. — Vera Huber, *Schweizer Landschaftsmaler: Das intime Landschaftsbild im 19. Jahrhundert*, Manesse Verlag, Zurich, 1949. — Max Huggler and Anna Maria Cetto, *La peinture suisse au XIXe siècle*, Holbein, Basel, 1943. — Gotthard Jedlicka, *Zur schweizerischen Malerei der Gegenwart*, Rentsch, Erlenbach and Zurich, 1947. — Paul Nizon *Diskurs in der Enge: Aufsätze zur schweizer Kunst*, Kandelaber, Bern, 1970. — Roy Oppenheim, *Die Entdeckung der Alpen*, Frauenfeld, 1974. — Fritz Schmalenbach, "Die Struktur der Schweizer Malerei im 19. Jahrhundert," in *Neue Studien über*

Malerei des 19. und 20. Jahrhunderts, Rota, Bern, 1955. — *Schweiz im Bild — Bild der Schweiz: Landschaften von 1800 bis Heute*, traveling exhibition in Switzerland, 1974. — Hans Christoph VON TAVEL, *Ein Jahrhundert schweizer Kunst: Malerei und Plastik von Böcklin bis Alberto Giacometti*, Skira, Geneva, 1969; French translation, *Un siècle d'art suisse, Peinture et sculpture de Böcklin à Giacometti*, Geneva, 1969. — Paul WESCHER, *Die Romantik in der schweizer Malerei*, Huber, Frauenfeld, 1947. — Franz ZELGER, *Heldenstreit und Heldentod: Schweizerische Historienmalerei im 19. Jahrhundert*, Zurich, 1973.

Albert Anker: Max HUGGLER, *Albert Anker: Katalog der Gemälde und Ölstudien*, Kunstmuseum, Bern, 1962. — Conrad DE MANDACH, *136 Gemälde und Zeichnungen von Albert Anker*, Fretz & Wasmuth, Zurich, 1941. — *Le peintre Albert Anker, 1831-1910, d'après sa correspondance*, Stämpfli, Bern, 1924. — Hans ZBINDEN, *Albert Anker in neuer Sicht*, Haupt, Bern, 1961.

Johann Jakob Biedermann: Heinz KELLER, "Johann Jakob Biedermann: Der Pissevachefall," *Hauptwerke des Kunstmuseums Winterthur*, 40-44, Kunstverein, Winterthur, 1949.

François Bocion: Paul BUDRY, *François-Louis Bocion: Le peintre du Léman*, Spes, Lausanne, 1925. — Fritz SCHMALENBACH, "François Bocion," in *Neue Studien über Malerei des 19. und 20. Jahrhundert*, Bern, 1955.

Arnold Böcklin: *Arnold Böcklin*, Basel, 1951, catalogue of a memorial exhibition on the fiftieth anniversary of his death. — *Arnold Böcklin*, exhibition catalogue, Kunstmuseum, Düsseldorf, 1974. — Henri LANSEL, *Arnold Böcklin*, Lausanne, n.d. — Julius MEIER-GRAEFE, *Böcklin und Holbein*, Berlin, n.d.

Charles-Frédéric Brun ("Le Déserteur"): Jean GIONO, *Le Déserteur*, Fontainemore, Paudex/Lausanne, 1966.

Frank Buchser: *Frank Buchser 1828-1899*, exhibition catalogue, Thunerhof, Thun (Switzerland), 1967. — *Frank Buchser in America, 1866-1871*, exhibition catalogue, Schlösschen Vorder-Bleichenberg, Biberist (Switzerland), 1975. — Paul GANZ, "Frank Buchser: Painter of Light," *Palette*, Basel, No. 37, 1971.

Alexandre Calame: Daniel BUSCARLET, *Une lignée d'artistes suisses: Müntz-Berger, Alexandre et Arthur Calame*, Delachaux et Niestlé, Neuchâtel, 1969. — Alfred SCHREIBER-FAVRE, *La lithographie artistique en Suisse au XIXᵉ siècle: Alexandre Calame, le paysage*, La Baconnière, Neuchâtel, 1966. — Franz ZELGER, "Alexandre Calame," *Palette*, Basel, No. 40, 1972.

François Diday: Alfred SCHREIBER-FAVRE, *François Diday, 1802-1877: Fondateur de l'école suisse de paysage*, Jullien, Geneva, 1942.

Karl Girardet: René BURNAND, *Les Girardet au Locle et dans le monde*, La Baconnière, Neuchâtel, 1957.

Charles Gleyre: Schweizerisches Institut für Kunstwissenschaft, *Charles Gleyre ou les illusions perdues*, exhibition catalogue, Zurich, 1974.

Ferdinand Hodler: Daniel BAUD-BOVY, *Les Hodler au Musée d'Art et d'Histoire de Genève*, Musée d'Art et d'Histoire, Geneva, 1940. — Jura BRÜSCHWEILER, *Ferdinand Hodler: Anthologie critique*, Rencontre, Lausanne and Paris, 1971. — Walter HUGELSHOFER, *Ferdinand Hodler: Eine Monographie*, Rascher, Zurich, 1952. — C.A. LOOSLI, *Ferdinand Hodler: Leben, Werk und Nachlass*, 4 vols., Sluter, Bern, 1921-1924. — Peter SELZ, *Ferdinand Hodler*, University Art Museum, Berkeley, Calif., 1972. Catalogue of an exhibition shown at the University Art Museum, Berkeley, 1972; the Solomon R. Guggenheim Museum, New York, 1973; and the Busch-Reisinger Museum, Cambridge, Mass., 1973.

Rudolf Koller: Hans LÜTHY, *Rudolf Koller aus seinen Skizzenbüchern*, Berichthaus, Zurich, 1966. — *Rudolf Koller*, exhibition catalogue, Helmhaus, Zurich, 1966.

Gabriel Lory, father and son: Conrad DE MANDACH, *Deux peintres suisses: Gabriel Lory le père (1763-1840) et Gabriel Lory le fils (1784-1846)*, Lausanne, 1920.

Barthélemy Menn: Daniel BAUD-BOVY, *Barthélemy Menn, dessinateur*, Editions du Rhône, Geneva, 1943. — Jura BRÜSCHWEILER, *Barthélemy Menn, 1815-1893: Etude critique et biographique*, Fretz & Wasmuth, Zurich, 1960.

Léopold Robert: Dorette BERTHOUD, *Vie du peintre Léopold Robert*, Neuchâtel, 1961. — Georges Berthold SEGAL, "Der Maler Louis Léopold Robert, 1794-1835: Ein Beitrag zur Geschichte der romantischen Malerei in der Schweiz," thesis, Basel, 1973.

Giovanni Segantini: Dr Karl ABRAHAM, "Giovanni Segantini. Essai psychanalytique" (1911), in *Oeuvres complètes 1907-1925*, 2 vols., Payot, Paris, 1965-1966. — Piero BIANCONI, Louis DEROUSSEAUX and Peter KASPER, *Giovanni Segantini et le Musée Segantini à Saint-Moritz*, Engadin Press, Samedan/St-Moritz, 1974. — Luciano BUDIGNA, *Giovanni Segantini. Con una appendice di scritti autobiografici*, Bramante, Milan, 1962. — Gottardo SEGANTINI, *Giovanni Segantini*, Rascher, Zurich, 1949.

Karl Stauffer-Bern: Lee VAN DOWSKI, *Genie und Eros*, H. Kossodo, Geneva, 1969.

Théophile-Alexandre Steinlen: Ernest de CRAUZAT, *L'œuvre gravé et lithographié de Steinlen*, Société de propagation des livres d'art, Paris, 1913. — L.H. HUGUENIN, *Théophile Alexandre Steinlen, 1859-1923*, Pully/Lausanne, 1960. — Francis JOURDAIN, *Un grand imagier: Alexandre Steinlen*, Cercle d'Art, Paris, 1954. — Maurice PIANZOLA, *Théophile-Alexandre Steinlen*, Rencontre, Lausanne and Paris, 1971.

Rodolphe Toepffer: Paul CHAPONNIÈRE, *Notre Toepffer*, Payot, Lausanne, 1930. — Pierre COURTHION, *Genève ou le portrait des Toepffer*, Grasset, Paris, 1936. — Marianne GAGNEBIN, *Rodolphe Toepffer*, Editions du Griffon, Neuchâtel, 1947. — Rodolphe TOEPFFER, *Oeuvres complètes*, 14 vols., Skira, Geneva, 1943-1945.

Wolfgang Adam Toepffer: Walter HUGELSHOFER, *Wolfgang Adam Töpffer*, Niehans, Zurich, 1941.

Félix Vallotton: Hedy HAHNLOSER, *Félix Vallotton, 1865-1925*, 2 vols., Kunsthaus, Zurich, 1927-1928. — Hedy HAHNLOSER-BÜHLER, *Félix Vallotton et ses amis*, Sedrowski, Paris, 1936. — Rudolf KOELLA, *Félix Vallotton im Kunsthaus Zürich*, exhibition catalogue, Kunsthaus, Zurich, 1969. — Maxime VALLOTTON and Charles GOERG, *Félix Vallotton, Catalogue raisonné de l'oeuvre gravé et lithographié/Catalogue Raisonné of the Printed Graphic Work*, Bonvent, Geneva, 1972.

List of Illustrations

Index of Names and Places

Unless otherwise stated, pictures mentioned as being in the following cities are in the principal musum, as follows: Basel, Öffentliche Kunstsammlung; Bern, Kunstmuseum; Geneva, Musée d'Art et d'Histoire; Lausanne, Musée Cantonal des Beaux-Arts; Winterthur, Oskar Reinhart Foundation; Zurich, Landesmuseum.

Published July 1976

Text and illustrations printed by
Imprimeries Réunies S.A., Lausanne.

Photo Credits

Peter and Margrit Ammon, Lucerne *(p. 116)*; Arts graphiques de la Cité,
Paris *(p. 169)*; Atelier Baillod, Neuchâtel *(p. 152)*; Maurice Babey, Basel
(pp. 99, 147); Benziger, Graphischer Betrieb, Einsiedeln *(p. 29)*; Victor Bouverat,
Geneva *(pp. 84, 94, 95, 121, 138, 147, 172)*; Arno Carpi, Bellinzona *(p. 57)*;
Ciba-Geigy Photochimie S.A., Fribourg *(p. 53)*; Karl Engelberger, Stansstad
(p. 19); Alberto Flammer, Locarno *(p. 54)*; Geiger, Flims *(p. 21)*; Walter Greuter,
Stein am Rhein *(p. 78)*; André Held, Ecublens *(pp. 104, 105, 157, 179)*;
Leo Hilber, Fribourg *(p. 32)*; Hans Hinz, Basel *(p. 77)*; Gerhard Howald, Bern
(pp. 30, 33, 102); H. Humm, Zurich *(p. 153)*; Giovanni Luisoni, Mendrisio
(p. 104); S.A. Natale Mazzuconi, Lugano *(p. 108)*; Meyer, Vienna *(p. 87)*;
Preisig, Sion *(p. 144)*; Benedikt Rast, Fribourg *(pp. 46, 49)*; C. Seltrecht,
Saint Gall *(p. 22)*; Schiefer, Lugano *(p. 108)*; Henri Stierlin, Geneva *(p. 29)*;
Vicari, Lugano *(p. 109)*; Weber-Odermatt, Stans *(p. 134)*; H. Wullschleger,
Winterthur *(p. 154)*; and the photographic services of the following museums:
Basel, Historisches Museum *(p. 51)*; Basel, Öffentliche Kunstsammlung (Kunst-
museum and Kupferstichkabinett) *(pp. 34, 48, 63-66, 69, 71, 74, 77-80, 85, 86,
98, 125, 136, 142)*; Berlin, Staatliche Museen Preussischer Kulturbesitz,
Kupferstichkabinett *(p. 60)*; Bern, Burgerbibliothek *(pp. 52, 53)*; Bern, Histori-
sches Museum *(pp. 81, 82)*; Bern, Kunstmuseum *(pp. 45, 46, 82, 100, 120, 141)*;
Cambridge, Mass., Fogg Art Museum *(p. 66)*; Geneva, Musée d'Art et d'Histoire
(pp. 111-115, 120, 121, 139, 150, 153); Hamburg, Kunsthalle *(p. 102)*; Heidelberg,
Universitätsbibliothek *(p. 26)*; Karlsruhe, Staatliche Kunsthalle *(p. 58)*; Lugano,
Museo Civico di Belle Arti *(pp. 106, 107)*; Munich, Neue Pinakothek *(p. 116)*;
Munich, Staatliche Graphische Sammlung *(p. 48)*; Schaffhausen, Museum zu
Allerheiligen *(p. 76)*; Stanford, Stanford University Museum of Art *(p. 154)*;
Stockholm, Nationalmuseum *(p. 96)*; Vienna, Kunsthistorisches Museum *(pp. 86,
87)*; Warsaw, National Museum *(p. 106)*; Winterthur, Kunstmuseum *(p. 140)*;
Winterthur, Stiftung Oskar Reinhart *(pp. 112, 135, 155, 174)*; Zofingen,
Stadtbibliothek *(p. 162)*; Zurich, Kunsthaus *(pp. 47, 75, 83, 96, 118, 125,
126, 136, 137)*; Zurich, Landesmuseum *(pp. 10, 16, 28, 47, 50, 83, 97, 103, 145,
146)*; Zurich, Schweizerisches Institut für Kunstwissenschaft *(pp. 84, 88, 101,
117-119, 123, 124, 128, 137, 141-143, 148, 150, 155-160, 162, 164, 170, 173,
175)*; Zurich, Zentralbibliothek *(pp. 27, 83)*.

Printed in Switzerland